THE PRINT
IN GERMANY
1880–1933

PRINTS FROM THE DEPARTMENT
OF PRINTS AND DRAWINGS
IN THE BRITISH MUSEUM
Frances Carey and Antony Griffiths

WITH A SECTION OF ILLUSTRATED BOOKS
FROM THE BRITISH LIBRARY
David Paisey

Published for
The Trustees of the British Museum
by British Museum Publications Limited

The Print in Germany 1880–1933

THE AGE OF EXPRESSIONISM

Published by British Museum Publications Ltd,
46 Bloomsbury Street, London WC1B 3QQ

British Library Cataloguing in Publication Data

Carey, Frances
 The print in Germany 1880–1933.
 1. Prints, German—Exhibitions 2. Prints—
 19th Century—Germany—Exhibitions
 3. Prints—20th century—Germany—
Exhibitions
 I. Title II. Griffiths, Antony III. Paisey,
David IV. British Museum. *Department of
Prints and Drawings* V. British Library
769.943´074 NE651

ISBN 0–7141–1621–1

Designed by Roger and Sarah Davies

Set in Photina
and printed in Great Britain by
Jolly & Barber Ltd, Rugby

231

Contents

Foreword

The first fruits of the British Museum's efforts to build up its collection of twentieth-century works of art on paper were exhibited to the public in 1980 in an exhibition entitled *American Prints 1879–1979*. The present exhibition is the second of the kind devoted to prints. We hope in future years to continue the sequence with further exhibitions of twentieth-century printmaking.

This exhibition is called *The Print in Germany* because so many foreign artists, such as Munch, Kandinsky, El Lissitzky, Moholy-Nagy, worked in Germany and directly affected the history of German printmaking. The artists are listed in the sequence that seems most coherent, though this is not easy as so many styles coexisted within a very short space of time and artists moved so rapidly from one allegiance to another. The group of illustrated books from the British Library which we are delighted to be able to include in the exhibition will enable the prints to be seen in a wider context. We are most grateful to David Paisey for making the selection and for writing the catalogue entries, and to his colleagues in the British Library for their collaboration. In the main catalogue the entries on the members of *Der Blaue Reiter* and the Bauhaus, and on Grosz, Dix and the Constructivists, are the work of Frances Carey; the others are by Antony Griffiths, who has also contributed the essay on Brücke techniques of printmaking. The introduction has been written in collaboration.

They wish me to express their thanks to a number of people. First among them are Jacob and Ruth Kainen in Washington. Next is Roman Norbert Ketterer of Campione d'Italia, who has kindly supplied and allowed us to publish a new document about Brücke lithography. Colleagues in Germany have offered great assistance, among them Dr Peter Dreyer and Dr Alexander Dückers in Berlin, Dr Margret Stuffmann in Frankfurt and Dr Werner Schmidt in Dresden. A large number of dealers in Britain, Germany and America have found the prints needed for this exhibition, and have often contributed valuable information. Many museum and academic colleagues in London have offered counsel and encouragement, while the catalogue could not have been written without the availability of the books of the British Library in Bloomsbury, and access to the library of the Tate Gallery, whose staff have been unfailingly helpful.

JOHN ROWLANDS
Keeper
Department of Prints and Drawings

Preface

The group of prints in this catalogue were made in Germany in the half century between the triumph of Naturalism and the seizure of power by Hitler. It is a period dominated by the rise of Expressionism, when German art attained a level of importance within European art which it had not reached since the Renaissance. Its products however have never been readily accepted in Britain. The first significant exhibition was only held in London in 1938 at the New Burlington Art Galleries as a counter to the Nazis' touring exhibition entitled *Entartete Kunst* (Degenerate Art); Beckmann himself came to London to give a lecture, but its impact was more political than artistic. In post-War years many further exhibitions have been organised by the Arts Council, but there are still very few works of this period in British public or private collections. The Tate Gallery and Victoria and Albert Museum possess some good examples, but the best collection is that most enterprisingly assembled by the Leicestershire Museums and Art Gallery since the early 1940s, of which a fully illustrated catalogue was published in 1978. Nevertheless, in the field of printmaking it has not been possible to grasp the full measure of the German achievement in this period from works in British public collections.

Of the 234 prints (plus four loans) in this catalogue, 170 are recent acquisitions (72 per cent of the total). The weakness of the British Museum's collection in the area of German Expressionism had become all the more noticeable as recognition increased of the commanding position that German prints occupied within the field of original printmaking in the twentieth century.

The greatest benefactor of the Department this century was its former keeper, Campbell Dodgson, who in 1948 bequeathed his entire collection of over 5,000 mostly late nineteenth- and early twentieth-century prints to the Museum (see the introduction to the 1978 exhibition catalogue, *From Manet to Toulouse-Lautrec*). Dodgson's taste was very wide ranging, and it is to him that we owe the outstanding group of prints by Käthe Kollwitz, of which only a part can be included in this exhibition, and numerous works by Liebermann and Corinth. But he clearly and explicitly disliked Expressionism, and acquired nothing by any member of the Brücke, *Der Blaue Reiter* or any later movement, with the exception of an interesting group of Nolde's early etchings. The first of these were presented to the Department jointly by Dodgson and Nolde himself in 1909: the British Museum was, astonishingly, one of the first public collections in the world to possess any of Nolde's work.

It might be thought that the Department of Prints and Drawings would have stood to benefit from the generosity of some of the many refugees who fled to Britain from Germany before the Second World War. And indeed in 1942 Mr Erich Goeritz (see 59) offered fifteen portfolios or albums of prints by Corinth, Slevogt, Barlach, Kokoschka and, most importantly, the first two portfolios published by the Bauhaus. This handsome gift was accepted by the Trustees of the British Museum on the recommendation of the Keeper, A.M. Hind. A decade later, in the early 1950s, Dr Rosa Schapire (see 224) offered her almost complete collection of the prints of Schmidt-Rottluff; she had been a close friend of the artist since 1907, and in 1924 had written what is still the standard catalogue of his work. This offer, as has been noted in the November 1983 issue of the *Burlington Magazine* (p. 690), was refused by Hind's successor, A.E. Popham. As a result, although Dr Schapire's three Schmidt-Rottluff paintings went to the Tate Gallery, her print collection was divided among fifteen museums, thirteen in Germany and only two (the Victoria and Albert and

Leicester Museums) in Britain. In the late 1960s the Trustees' concern over the state of the twentieth-century collection resulted in a few purchases, and some generous gifts were received from Lord Croft. Nevertheless only five of the works included in this exhibition were acquired in the thirty years between Dodgson's death and the end of 1978.

The Prints

Introduction

In 1914 H.W. Singer, the director of the Dresden printroom, published a large volume entitled *Die moderne Graphik*.[1] Eight years later Curt Glaser, who was to become the director of the Berlin Kunstbibliothek in 1924, published a volume of very similar size and format entitled *Die Graphik der Neuzeit*.[2] Both are historical surveys of nineteenth- and twentieth-century European printmaking with especially thorough treatment of the German contribution; indeed, they are still the most useful histories available. But the difference between the approaches of the two authors could hardly be more marked. Singer, an admirer of craftsmanship and the English etching tradition, devoted most of his pages to artists who are now almost completely forgotten and who find hardly a mention in modern literature. Long accounts are given of the Munich school of reproductive etching founded by Peter Halm, of the Karlsruhe group of colour lithographers and of the etchers of the Dresden Secession. By contrast none of the new generation of young German printmakers of the first decade of the twentieth century is mentioned by name. Munch is grudgingly admitted, but only to be castigated: 'Munch is quite clearly the father and immediate stimulus for all that is, so to speak, out of all bound in the most recent printmaking'. Singer asks pardon for his inability to appreciate 'a sick, and intellectually unhealthy art'.[3] Glaser has no such embarrassment when faced with the new developments, and provides an assessment which would be shared by most historians today. He recognises the central position of the artists of the Brücke, and his acute remarks on others like Beckmann (whom he sees as finding himself in the First World War) and Rohlfs (whom he thinks essentially an imitator) show that he clearly welcomed the challenge of coming to terms with the new.

Different though their judgements of quality and importance may be, they concur on one thing: both see the history of modern printmaking in Germany as beginning with the work of Max Klinger. It may seem odd that a figure who is now only known to a few should be credited with such importance, and it is necessary to give some historical background to show that their judgement is fully borne out by the evidence. The middle of the nineteenth century in Germany, as in other European countries, saw the art of original printmaking at a low ebb. The central figures in German art of the time did not in general make prints: none is known by Arnold Böcklin, Anselm Feuerbach or Hans von Marées. On the other hand, the printmaking industry was booming as new techniques of lithography and photomechanical reproduction were invented and as new machines multiplied output many times over. The whole of this production was dependent on specialist craftsmen, trained in the processes of reproduction, and it was the possibilities made available by harnessing their skills that drove thoughts of original printmaking out of the heads of most artists. This is seen clearly in the case of Adolph Menzel (1815–1905), who spent much of his life supplying drawings for book-illustration to wood-engravers whose work he carefully supervised (as Turner did that of the engravers who were employed to etch his watercolours). The artistic success of Menzel's own attempt at autographic printmaking in the set of lithographs published in 1851 under the title 'Versüche auf Stein mit Pinsel und Schabeisen' did not lead him to change his course. They remained a brilliant exception as did the handful of etchings made by the great realist painter Wilhelm Leibl (1844–1900) in 1874.[4]

Klinger's importance is most simply expressed by stating that he was the first major German artist for decades who made his own prints (in his case etchings)

a fundamental and unignorable part of his work. Klinger leapt to attention in 1878 when two sets of his pen drawings were exhibited in Berlin. Their perplexing originality caused a sensation. It was apparently the dealer Hermann Sagert who suggested to Klinger that they be engraved, doubtless expecting the work to be handed over to professionals. Klinger, however, taught himself to etch, and in the next five years produced nine sets of prints which constitute his most serious claim to enduring recognition as an artist.[5] This statement would perhaps have horrified him; as is explained in the biography on p. 43, his status as a grand old man of German art in his own lifetime rested on a series of inflated paintings and pompous polychrome marble statues made from the late 1880s onwards. But the original and individual Klinger is found in the early works. Living for months as a recluse in capitals of Europe in which he knew hardly a person, he created series of meticulous and detailed drawings of imagined, often impossible, events. He told mystified friends that his best ideas came to him in the morning, in the time between sleeping and waking, but refused to help them by providing any explanations of the meaning of his images. The classic example of the side of Klinger that made the Surrealists claim him as one of themselves is the 'Glove' series (1–10); other fine examples could be chosen of his re-imagining classical mythology (cf. 231) or Grimmelshausen. But Klinger, like Goya, could also turn his vivid imagination and exact draughtsmanship to subjects that could quite well come from real life. One of the sagas that comprise the sequence 'Dramen' is taken from a contemporary newspaper (13–15); another (18–20) is pure fantasy, but so compellingly thought out and with such a wealth of detail that many commentators, to Klinger's annoyance, made the absurd mistake of seeing a revolution set in Berlin and the clothing of the 1880s as the historical revolution of 1848. Yet other early works, such as 'Eve and the future' of 1880 (not in this exhibition), show a 'philosophical', almost mystic, side which belongs to the strange German tradition of mysterious 'idealist' subjects of which Arnold Böcklin is the best-known representative.

Klinger was a highly intellectual artist, and very widely read. 'Dramen' was inspired by his reading of Zola, and a later series 'On Death II' by Schopenhauer. His own theoretical writings are of some interest, and indeed importance. His treatise *Malerei und Zeichnung* was first published in 1891, but the ideas in it were already developed in a letter of 1885 to his patron, Julius Albers. In it he puts forward the view that drawing (meaning by this all monochrome productions) is the true vehicle for fantasy in art; painting, by presenting too much definition, leaves nothing to the imagination. This theory had a liberating effect on the next generation of artists, particularly Käthe Kollwitz, as it provided a defence of the self-sufficient status of the graphic arts as a vehicle for certain types of subject which were beyond the scope of painting or sculpture. The draughtsman or printmaker need no longer be regarded as a purveyor of a second-class type of effect.

Klinger's rise to national fame was slow. In the 1880s, as the small edition sizes of his portfolios show, appreciation was confined to a small circle. A three-month exhibition in the museum in Leipzig in 1892 was his first general public recognition and set in motion the steady rise in prices that was to make him by 1914 one of the most expensive of all printmakers. But by this time Klinger had virtually abandoned printmaking, and it was left to a host of imitators to take advantage of the taste he had created for classicising compositions with nudes and mythological fantasies. As Glaser disparagingly put it: 'Cycles of etchings

poured out in their hundreds in which the eternal rewarding themes of Women and Love and Death and the Beyond were treated with much deep meaning and aquatint [mit viel Tiefsinn und Aquatinta].[6] Klinger the proto-surrealist had no direct follower; Klinger the realist was to inspire Käthe Kollwitz.

In this catalogue there is a gap of eight years between Klinger's 'Dramen' and the next works, the soft-ground etchings made by Liebermann in 1891. Liebermann was, however, ten years older than Klinger, and the fact that he should only have taken up printmaking seriously in his forties is significant. His awakened interest was due to the encouragement of friends – encouragement from dealers was in Germany a later development. As Schiefler records, sales of Liebermann's portfolio of 1893 were very poor, despite the fact that Liebermann was already one of the best-known artists in Germany.[7] But much had been happening in the years between 1883 and 1891. The so-called 'etching revival' had begun in England and France in the 1860s: in France its most important manifestation had been the foundation of the Société des Aquafortistes in 1862, which regularly distributed sets of prints by its members to subscribers.[8] The first German society founded on this pattern was the Weimar Gesellschaft für Radierkunst in 1876. Its productions, however, soon degenerated into the treatment of anecdotal subjects, and the first important successor was the Berlin Verein für Originalradierung in 1886, followed in its turn by similar societies in Munich in 1892 and Karlsruhe in 1894. These societies are less important for their actual prints than for the critical interest they elicited in the subject from such weighty authorities as Wilhelm von Bode (later General-Direktor of the Berlin museums) who published an article on the Berlin painter-etchers in 1890.[9] They also helped lure some of the many professional reproductive engravers, first, to reproductive etching and thence to the cause of original etching. The most important of these were Peter Halm (1854–1923) and Karl Köpping (1848–1914), who worked in Munich and Berlin respectively. Both had started life as reproductive engravers, before turning to reproductive etching in the 1870s. Both ran influential schools where many of the major figures of the period received instruction. In the 1880s one can trace a marked hesitation over the proper use of the medium of etching. On the one hand, Klinger's friend, Karl Stauffer-Bern (1857–91), who trained under Halm in Munich but moved to Berlin, made thirty-seven remarkable original etchings, mostly portraits, in which much use is made of the burin, in the five years between 1884 and 1888. He then abandoned printmaking for sculpture before his early death.[10] But the other virtuoso who came to prominence in these years, Ernst Moritz Geyger (1861–1941), devoted five years to making an etching after Botticelli's *Primavera*. With Halm's conversion to original etching in 1887, followed by Köpping's in 1890, the question was decisively settled.

The movement, however, still had to find a public. The existing market for prints was small and confined to the specialist collector whose eye had been trained in the aesthetics of the reproductive print. The few connoisseurs of the new painting of the Impressionists and post-Impressionists were probably not interested in printmaking as a medium. The creation of a new type of collector in the 1890s proved perhaps slow, but not difficult, and was the precondition for the enormous increase in the rate of production in the first decade of the twentieth century. By then, of course, a new *avant-garde* had arisen, and it took the printmakers of the Brücke yet another decade to establish general recognition for their revolutionary work.

But any consideration of the public for printmaking has to be set into the context of the remarkable developments in art in the 1890s throughout Europe. To attempt to mention all of these would go beyond the scope of this introduction. Some, like art nouveau, and the craze for posters, were short-lived; others, such as the rise of the dealer at the expense of the Academies, affected the whole future course of artistic production. Some phenomena, like the new interest in the applied arts, are found throughout Europe; others, like the Secessions which took place from the established artists' exhibiting societies, are unique to the German-speaking countries. Of immediate significance for print-making was the foundation of a number of illustrated magazines. Some, like the Munich journals *Jugend*[11] and *Simplicissimus*,[12] carried no original prints, but supplied work for many gifted draughtsmen: Nolde and Barlach both achieved their first recognition through them. Others, of which the most significant was *Pan*,[13] carried large numbers of original prints, which by these means were first brought to the attention of a wide public. The various portfolios put together by the etching clubs had been distributed to those already converted. Even the admirable Viennese periodical *Die graphischen Künste* which was published by the Gesellschaft für vervielfältigende Kunst[14] looked like a magazine for the initiated. *Pan*, on the other hand, addressed itself to all manner of interests: it included original poems and essays as well as critical articles and reviews, and its interest ranged throughout Europe. Julius Meier-Graefe (1867–1935)[15] acted as artistic adviser, and was responsible for commissioning a colour lithograph from Toulouse-Lautrec. Although Meier-Graefe was sacked for this, and the magazine collapsed after five years, its liberating effect can hardly be exaggerated.

The print production of the 1890s is very varied in character, and lack of space has meant that no justice is paid to it in this catalogue. There are none of the decorative prints, often in colour, that were produced in large numbers, whether by artists now forgotten or still remembered in some other context, such as Peter Behrens.[16] Many of these hover on the borderline between original and reproductive printmaking. It was the recent technological perfection of the line and half-tone block which gave the impetus for the whole Jugendstil movement in illustration and book design. Publishers for the first time had the possibility of commissioning drawings which would be accurately transformed by photomechanical means into process blocks. The original print, with its laborious and expensive methods of printing, was not what they were looking for, at least in the first place. But as the movement gathered strength it created a new interest in originality. This is most clearly seen in woodcut, a medium which was brought back to life in the 1890s.[17] The three most influential figures were Beardsley, Nicholson and Vallotton. Aubrey Beardsley (1872–98) worked exclusively for the process block; William Nicholson (1872–1949) made woodcuts but published them in large editions as lithographic transfers; the Swiss Felix Vallotton (1865–1925) cut and published his designs as wood-cuts, in signed and numbered editions. Their aesthetic, however, remained very much that of the line-block – there was no reason why they had to be cut in wood. As we shall see, it was Munch and later the members of the Brücke who went beyond this to the cutting of images which deliberately emphasised the material from which they were printed. The colour woodcut was also revived, but the impetus for this came from the Japanese rather than from the new technology.

The 1890s are represented in this catalogue by two figures besides Lieber-mann of very different character: Kollwitz and Munch. The one more rooted in tradition was perhaps Käthe Kollwitz. Since she did not paint, printmaking and drawing were her only forms of artistic expression until she took up sculpture after the turn of the century. The determining factor in her own development was seeing Klinger's cycle 'Ein Leben' exhibited in Berlin in 1884: 'I then knew my path'.[18] She drew artistic inspiration from other sources – Leibl, Meunier, even Munch – but the content remained Zolaesque throughout the 1890s. She suddenly came to general notice with the success of the 'Weber' series (21–3) at the 1898 salon, and confirmed her status with the completion of the 'Bauern-krieg' cycle in 1908. As a technician Kollwitz was largely self-taught, but, like the members of the Brücke later, turned this handicap to good account by devising a range of textures and tones which had few precedents in intaglio printmaking. Her turning away from intaglio towards transfer lithography and, later, woodcut marks a decline in her art which accompanied a more committed view of its purpose. With typical honesty, she analysed this change in a memoir written in 1941. She noted the socialist environment in which she had been brought up, but stressed: 'The real reason why I almost invariably chose scenes from the lives of the workers was that the motifs chosen from this ambience gave me simply and straightforwardly what I found beautiful . . . characters from bourgeois life held no interest for me at all . . . Only later, when, mainly through my husband, I discovered the hardship and tragedy of the life of the proletariat, when I got to know women who came to visit my husband and then saw me, did the fate of the proletariat in all its manifestations grip me with its full horror . . . I must stress yet again that originally pity and sympathy were very minor elements in my choice of scenes from working class life; I simply found them beautiful. As Zola or someone once said: "The beautiful is the ugly".'[19] By 1910 she recognised that she was now part of the old guard against the new school around Pechstein.[20] Much later, in 1922, she noted that, unlike Schmidt-Rottluff and his like, her art had a purpose.[21] By this time, her position was completely isolated: the only artist whom she still admired was Barlach, who had himself long been living in retreat in Güstrow.

Edvard Munch was of course Norwegian, and the character of his art was largely formed by the time of his first exhibition in Germany, at the Verein Berliner Künstler in 1892. The scandal that this caused made his reputation and induced him to move to Berlin. It was there that he took up printmaking in 1894, originally as a means of trying to capitalise on the fame of his paintings which no-one was actually buying. This catalogue can give only a hint of Munch's epoch-making achievements in the medium by including one example of each of the principal techniques he handled, chosen to demonstrate as clearly as possible the nature of his influence on his successors. In the case of the etching (69) the influence is most clearly seen in Kollwitz. The woodcut of *The Old Fisherman* (71), however, looks further forward to the woodcuts of the Brücke in its use of the gouge and the grain of the block. Munch's most extraordinary and original achievements were his colour woodcuts using multiple blocks, often sawn into pieces for separate inking: *Melancholy* (72) is the only example of one of these in the British Museum's collection. It is of a complexity and scale which is far ahead of anything that a German artist ever attempted, but such technical devices as the sawn block were later to be used by Heckel (88).

Munch's exhibition in 1892 had threatened to split the Verein Berliner

Künstler. The actual Secession, however, did not take place till much later, in 1898, over the relatively trivial matter of the rejection of a painting by Walter Leistikow (1865–1908)[22] from the annual salon. By this time the circumstances were much more favourable.[23] The sixty-five members, with Liebermann as president and Leistikow as moving force, had no difficulty in raising the funds to build their own exhibition hall, and entrusted the business management to the hands of Paul Cassirer (1871–1926). Cassirer had begun business as a painting dealer early in 1898, and soon made himself a fortune selling Impressionist and post-Impressionist paintings to the new millionaire German industrialists. In his effort to make the German public more aware of new painting, he showed such works both in his own gallery, and in the Secession's building, a policy which had the support of Max Liebermann, himself the owner of a distinguished collection of French Impressionist paintings. He could also rely on the support of critics such as Julius Meier-Graefe and enlightened museum directors such as Hugo von Tschudi at the Berlin Nationalgalerie. Thus, despite official ministerial disapproval, the future of the Secession was secure and Berlin artists firmly associated with international developments. Since Berlin had by 1900 taken over from Düsseldorf and Munich as the artistic centre of Germany, the regular exposure to the latest novelties from Paris was of fundamental importance. Even in relatively provincial Dresden the members of the Brücke, as we shall see, had no difficulty in seeing a mass of work by van Gogh, Gauguin and more recent paintings by the Fauves. The contrast with the situation in Britain, where such works were hardly seen before Roger Fry's exhibitions in 1910 and 1912 in the Grafton Gallery, could scarcely be more pronounced.

But there were periodic eruptions of discontent from the most varied sources. In 1905 Meier-Graefe's attack on the German idealist tradition as represented by the enormously popular Arnold Böcklin (*Der Fall Böcklin*) gave rise to a rejoinder by Henry Thode, the professor of the history of art at Heidelberg, and the polemics over the merits of French as against German art re-echoed for several years. In 1911 another row erupted with the 'Protest deutscher Künstler' organised by Carl Vinnen against the purchase of a van Gogh painting by the Bremen museum. This attracted such unlikely signatures as that of Käthe Kollwitz, although she later regretted that she had signed.[24]

Vinnen, although a minor painter, is interesting as having started his career as a member of the artists' colony at Worpswede. Numerous such colonies, inspired by notions of returning to the land and the people and rejecting the corruptions of urban life, were founded throughout Europe in the last decades of the nineteenth century and attracted many adherents.[25] Worpswede was simply the most successful and famous of them in Germany. Most of its members had been trained at the Düsseldorf Akademie, and there was nothing revolutionary in the content of their paintings. But since it was only a loose association, without dogma or programme, it allowed scope for the most varied talents. The most curious of them was Heinrich Vogeler, who made his name as an etcher, illustrator and designer. He was such an extreme idealist that he sacrificed his wife, his house, his art and finally himself to his ideals. His extraordinary career was to lead him to Communism, a new life as a revolutionary agitator and a final sad death as a victim of Stalin. Whereas Vogeler was only a minor artist, Paula Modersohn-Becker was the best painter in Germany in the few years before her premature death in child-birth. Her few prints are only marginal to

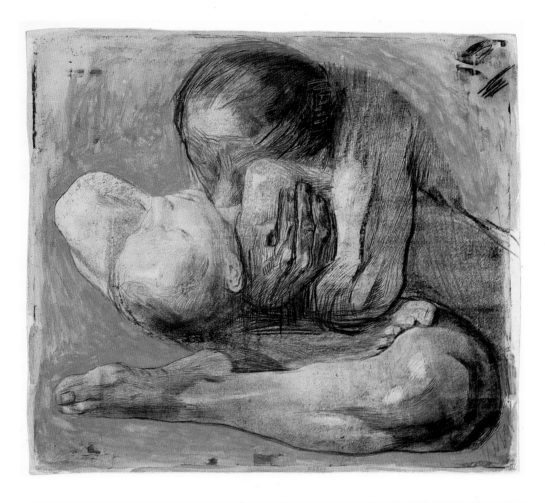

29

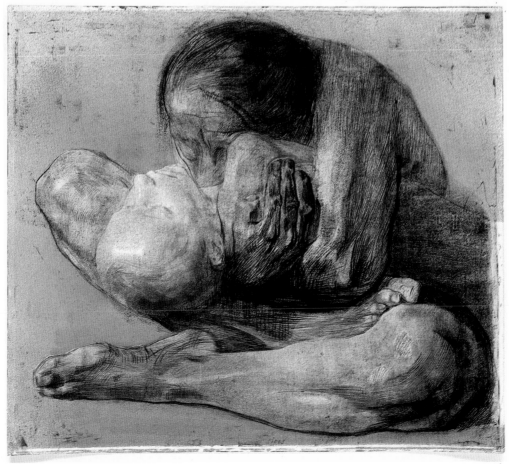

30

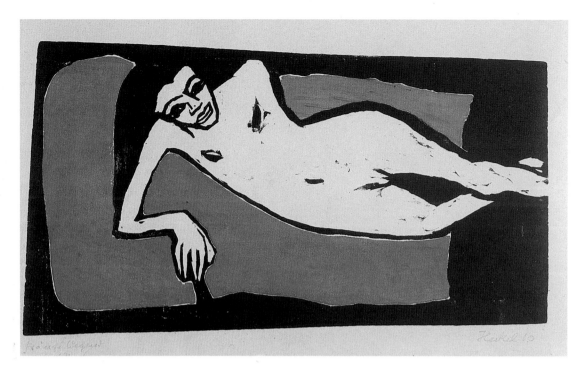

88

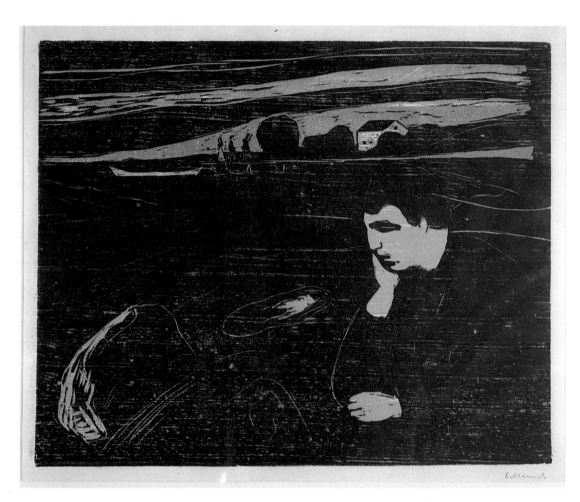

72

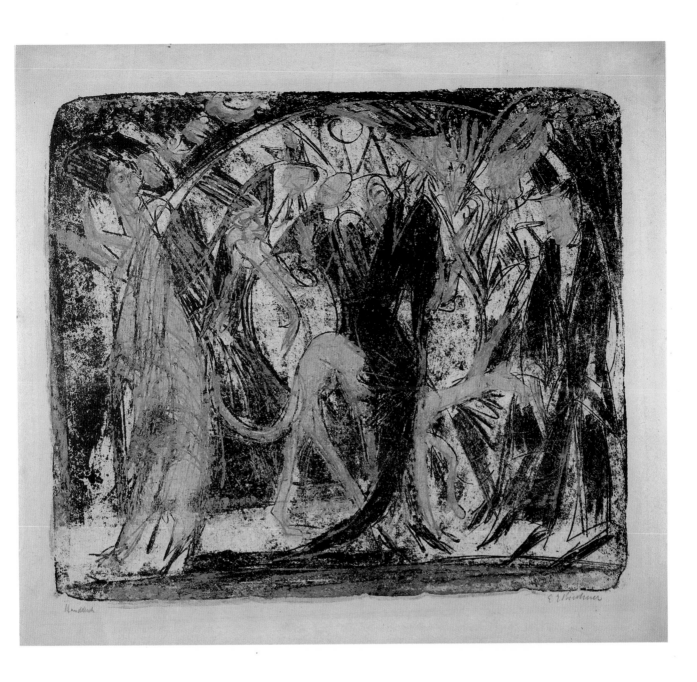

Handdruck E L Kirchner

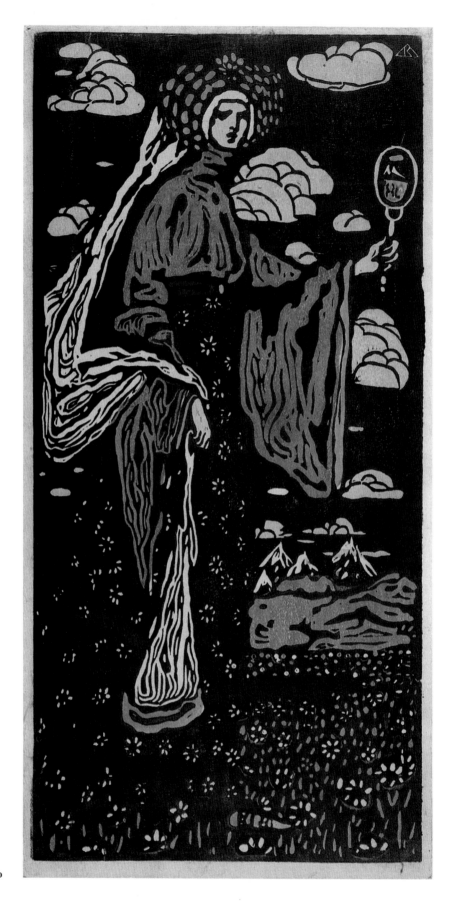

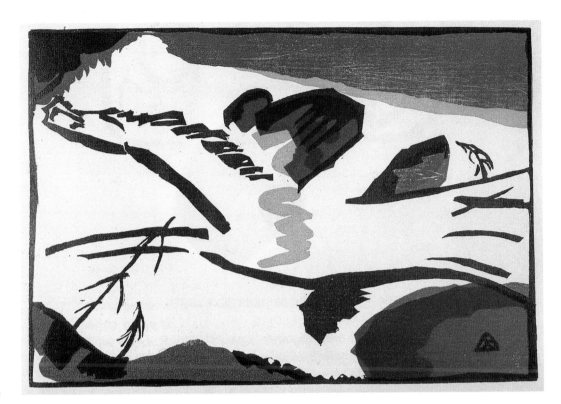

240

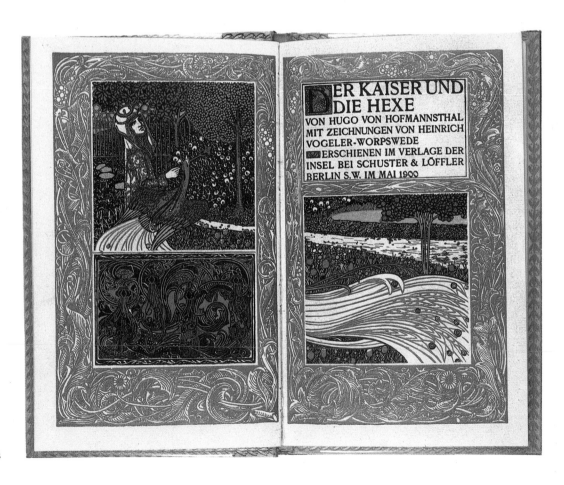

232

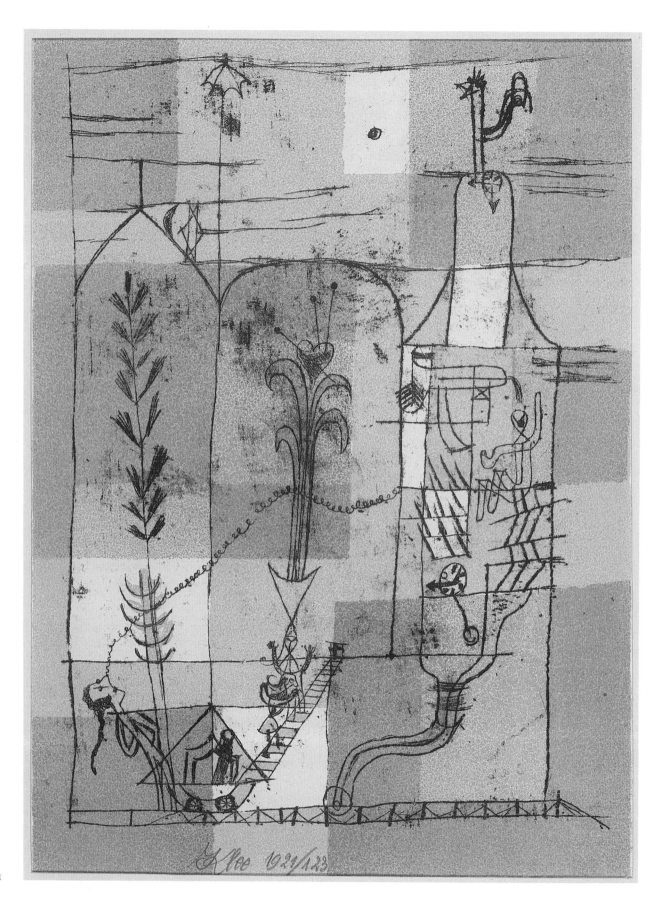

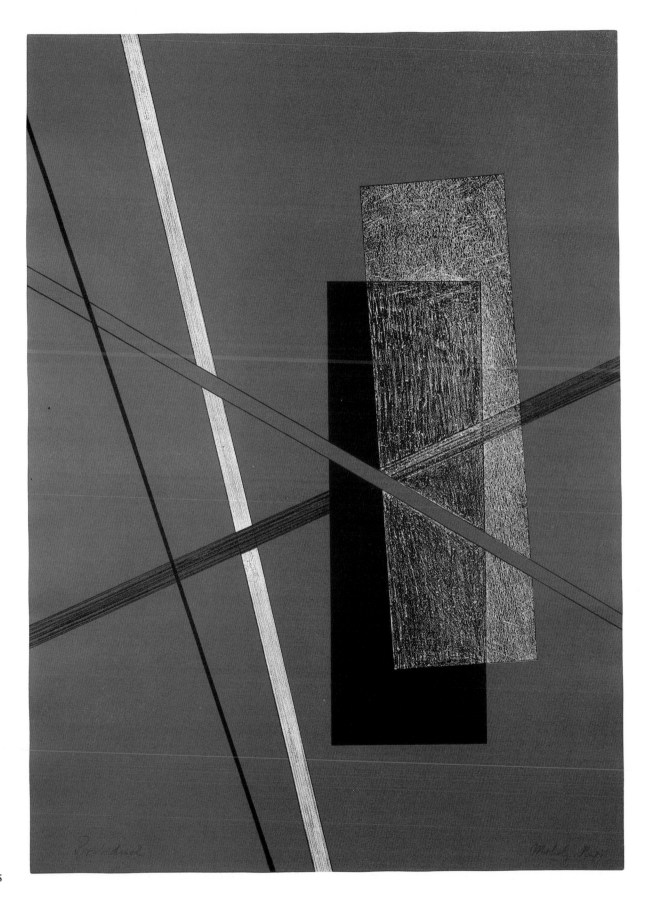

215

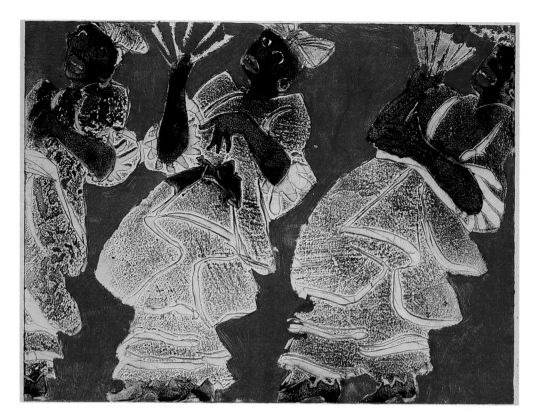

223

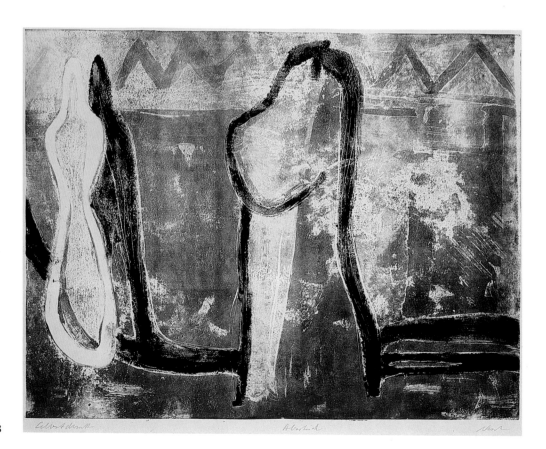

228

her main oeuvre in painting, but they include some haunting images of outstanding quality. Worpswede was too small to provide a stimulus for her talents, and she spent much of her time in Paris, deriving inspiration from Gauguin and Cézanne as well as Rainer Maria Rilke, who was then employed as Rodin's secretary and was married to her closest friend Clara Westhoff. Other members of the Worpswede colony made numerous etchings, but printmaking never held a central place in its activities.

Quite the opposite is the case with the Brücke, which was founded in Dresden by four young architectural students in June 1905. It was in essence a combination of exhibiting society and artists' colony. The home of the colony was nowhere more exotic than the suburbs of Dresden, where they worked together much of the time in each other's studios drawing the nude model in free movement so as to find poses far removed from academic clichés. Old photographs show the bizarre decorations they carved and painted for their studios, which were in fact shops which led directly off the street. A visitor in 1910 remarked on their extreme Bohemian way of life, and left convinced they lived only on coffee, cakes and cigarettes; they cooked an extraordinarily strong Mokka and smoked Jubektabak of a strength which he had never come across again.[26] In the summer they departed for months on end, when they could afford it, to the coast, to Dangast, Fehmarn, or the Kurische Nehrung on the Baltic, taking with them their current girl-friends who served as models for the paintings and drawings. If this was not possible, they took the suburban railway line out of Dresden to Moritzburg, where in the grounds of the Duke of Saxony's hunting lodge they could find isolated spots to paint their nude models.[27]

Of the four founding members only Ernst Ludwig Kirchner had had any formal training in art, during a few months in Munich in the winter of 1903–4. Both he and his close friend, Fritz Bleyl,[28] had completed their degrees in architecture; Erich Heckel and Karl Schmidt-Rottluff dropped out from their courses soon after the Brücke was founded. Quite who chose the title (*Brücke* means 'bridge') is uncertain; the most plausible explanation of its meaning was given in 1978 by Georg Reinhardt, who pointed to a passage in Nietzsche's *Also sprach Zarathustra*: 'What is great in man is that he is a bridge and no end'.[29] The manifesto of the group was imprecise in the extreme: 'We call all youth together, and as youth which bears the future, we wish to create for ourselves freedom of movement and life against the entrenched older forces. Everyone belongs to us, who sets down immediately and truthfully whatever drives him to creation'. This is founded in Nietzsche's belief in the importance of the creative spirit, a belief which was very influential in the pre-War years in Germany. The manifesto was so general as to impose no restriction in style, and the members of the Brücke were open to the most diverse influences, from Gauguin, van Gogh and the Fauves, to African and Melanesian art. Their subject-matter was, at least initially, entirely traditional, being centred on figure-drawing and landscape. What was new was the immediacy of effect that they sought. The laborious craftsmanship and meticulous finish of the academies was rejected; instead pure colours were laid directly onto the canvas, which was in many places left bare. Drawing became very important, not as a means to work out the composition of a painting, but as a medium in its own right. In a drawing the artist could capture the essence of the scene in front of him in the shortest space of time; thus it became possible to portray actual city life or the movement of models without having to freeze them into artificial poses. The

same immediacy was brought to their approach to printmaking, and enabled them to make a radically fresh departure in the history of the medium.

One of the group's first moves was to make further recruitments: the first of these was Emil Nolde, who was then just beginning to make himself known, the second was Max Pechstein. Later recruits were of less importance, and many, like Nolde, resigned within a year or two. Edvard Munch, whom the Brücke made strenuous efforts to enroll, was by now too famous and too far-gone into his alcoholic collapse, and left their invitations unanswered.[30]

Although the three central members of the Brücke came from solid middle-class homes and were supported to some extent by their parents in the early years, and although Heckel worked for some years in an architect's office, they needed to earn money as well as make themselves known. Since they were still teaching themselves how to paint, printmaking offered itself as the obvious vehicle. Thus the earliest works exhibited by any of the members were some woodcuts submitted to local exhibitions in Dresden in 1905. They soon went beyond this, to organising their own exhibitions in establishments in Dresden, and sending out touring exhibitions to as many cities of Germany as possible; Georg Reinhardt has recorded no less than fifty-seven such exhibitions before the end of 1910.[31] Another move was to create a circle of so-called 'passive members' of the Brücke among friends and supporters. For an annual subscription of 12 Marks (raised in 1911 to 25 Marks), they received a portfolio of prints, a membership card, a list of members and an account of the year's activities.[32] The first three portfolios of 1906–8 contained a miscellany of prints by all the members, but from 1909 to 1912 each portfolio contained three prints by one member alone (taken in turn) placed loose inside a folded cover with a woodcut design by another member. Each year the colour of the cover was changed, but the size remained constant, thus creating a series that cumulatively presented an attractive appearance. The number of passive members increased from twenty-two in 1907 to sixty-eight in 1910. The largest group came from Hamburg, recruited in the first instance through Ada Nolde; all came from German-speaking countries, with one extraordinary exception – a Miss Edith Buckley from Crawley, England, who joined in 1909 and about whom nothing is known.

The importance of printmaking to the Brücke developed far beyond its original economic usefulness. As the members became more interested in the medium, their style developed beyond its origins in Jugendstil; they took up etching and lithography in addition to woodcut, and they devised for themselves a range of techniques and styles of unprecedented originality and remarkable ambition. The size of their output was astonishing: over 2,000 prints by Kirchner, over 1,000 by Heckel, 663 by Schmidt-Rottluff and 850 by Pechstein. Their works are the heart of this catalogue, as they are the centre of any history of twentieth-century printmaking, and one of the turning-points in the history of the medium. Never before had processes so closely tied to craft traditions been so cavalierly treated. The laboriously worked effects of conventional print-making might as well never have been devised. For the first time in its five-hundred-year history the print looked the direct product of the immediate creative impulse. Thus in the classic Brücke print not only each image but each impression is individually re-created by the variations inherent in the printing. Not only modern critics but Kirchner himself liked to draw analogies with the German Renaissance, where likewise printmaking, especially woodcut, was an

essential vehicle for artists, and quite independent of, and often unrelated to, their painting. A full account of Brücke techniques would go beyond the scope of this introduction, and has been set apart in a separate essay (pp. 29–39), while the historical development is discussed in the catalogue entries.

If it took the Brücke a long time to achieve widespread public success – the process only began after the members had moved to Berlin in late 1911 – this was thanks to their uncompromising approach which produced prints looking like no others: the rawness of their effects, and the apparent crudity of their methods bewildered connoisseurs.[33] It was not through any lack of interest in printmaking as such. The position had been transformed since the early 1890s. From 1900 onwards the Berlin Secession held annual winter 'Schwarz-Weiss' exhibitions, devoted entirely to works on paper by its own members and invited guests. The catalogues make startling reading: in 1903–4 a very large group of works by Beardsley and Munch were to be seen; half a dozen drawings by Matisse were shown in 1907–8.[34] Paul Cassirer also regularly showed prints in his own gallery, and was responsible for encouraging many artists to consider the medium, especially after he set up his own Pan-Presse and studio in 1908, or soon after, apparently with printers brought over from Paris.[35] Thus it was he in 1910 who persuaded Ernst Barlach to take up lithography, and who commissioned a number of lithographs from Max Beckmann in 1909–12. Max Liebermann, who was contracted to Cassirer, took up printmaking again in 1900, having abandoned it in 1896, and subsequently produced many hundreds of works. Lovis Corinth, who had likewise abandoned printmaking through lack of a market after making some remarkable etchings in 1894–5, was also encouraged by Cassirer to try again in the years from 1906.

Cassirer's taste was rooted in Impressionism, and it was only a small group of collectors and critics who recognised the importance and originality of the generation of the Brücke. The outstanding figure among these was Gustav Schiefler (1857–1935), a Hamburg judge. He was not a rich man, and had begun subscribing to the Vienna *Graphische Künste* in the late 1880s; the first contemporary German print he bought was a Klinger in 1890. A talk by Alfred Lichtwark, the director of the Hamburg Kunsthalle in 1892, started an interest in French prints which he later extended to Liebermann. As his interest grew, he travelled round Europe in order to organise an exhibition held in the Kunsthalle in 1903–4 of all the best prints by the best contemporary artists, some 1,750 in all. He further began to write numerous articles and reviews, as well as catalogues raisonnés, first of local Hamburg artists (1902), and then of Liebermann and Munch (both 1907). He was the first to recognise Nolde's quality and was an original passive member of the Brücke. The catalogues that he wrote, particularly those of Nolde and Kirchner, are still unrivalled for their thoroughness and precision; in this he was helped by his hobby as a botanist and his thorough acquaintance with printmaking techniques learnt through his friend Arthur Illies.[36] Another Hamburg resident, Dr Rosa Schapire, an art-historian by training, became Schmidt-Rottluff's most important patron and wrote the catalogue of his prints (see 224). Others, like Paul Fechter, who reviewed some of the earliest Brücke exhibitions in Dresden, and Botho Graef (see 79), whose enthusiasm opened the eyes of many others, were critics rather than collectors.

The central figure of the second decade of the twentieth century has not yet been mentioned. This was Herwarth Walden (1878–1941), who combined the

roles of dealer, publisher, critic and collector. Originally a composer and pianist, he became a literary critic working for various reviews, and married the poet Else Lasker-Schüler (cf. 264). In 1910 he founded *Der Sturm*, a magazine that included poems, essays and original prints and which appeared with greatest frequency between 1910 and 1923 but continued until 1932,[37] the year of Walden's emigration to Moscow. He remained there until his death in 1941 in a Russian concentration camp. *Der Sturm* was the springboard for a remarkable range of publishing and artistic activities through which Walden sought to create an international *avant-garde* focused on Berlin. Lothar Schreyer, a close associate of Walden's, attempted to define the phenomenon in his memoirs: 'Herwarth Walden was the founder of the *Sturm* and the director of the *Sturm* from first to last. What was the *Sturm*? A journal, an exhibition, a publishing house, an art school, a stage – but that doesn't cover it. It was not a society of artists, not an organisation. It was a kind of turning-point in European art. This was a magnet which irresistibly attracted the artists who were to change the direction of art in the first decades of the twentieth century. This magnet was one man, Herwarth Walden. Artists from all countries, Expressionists, Futurists, Cubists entrusted their works to him, knowing that this man truly appreciated them, sensing that this man was endowed with the driving power to push them and their works not merely to success but to total victory! Herwarth Walden committed his whole life's energy unconditionally till this goal was reached.'[38]

Although Walden died as a political exile, it was only after the First World War that he became a Communist and *Der Sturm* was not conceived primarily as a vehicle for political propaganda, unlike its chief competitor, *Die Aktion*, which appeared over an almost identical period of time, 1911–32.[39] '*Die Aktion* was the journal of the word of action, or at least of the word aspiring to action and certainly of the politically loaded word. (The fact that it also displayed exceptionally good woodcuts was in the nature of a bonus.) And the *Sturm* – although Else Lasker-Schüler's poems, glosses and verbal quips appeared in it – was really the trail blazer for the painters.'[40] Whereas the prints in *Die Aktion* appeared within a framework of social criticism, those published in *Der Sturm* were only tendentious insofar as they advanced an artistic cause. Walden's interest in the graphic arts began in 1910 with reproductions of drawings by Kokoschka, his first major discovery; Kokoschka's illustrations to his own violent drama *Mörder, Hoffnung der Frauen* alienated a sizeable proportion of *Der Sturm*'s subscribers, but the editor, undeterred, proceeded to commission a limited edition poster from Kokoschka for the journal, which remains one of his most arresting images.[41] Walden entered the critical arena for the visual arts with a polemical defence of the Brücke artists in 1911; during the same year numerous reproductions of their woodcuts and drawings, principally Kirchner's, appeared.

In a new departure in December 1911, a woodcut (by Arthur Segal) was printed directly from the original block, the first of a large number of original prints published in the magazine. In January 1912[42] Walden began to market separate editions of such prints in limited numbers signed by the artists; these were entirely woodcuts or linoleum cuts, with the exception of the reproductions of Kokoschka's drawings. By 1913 the prints of Marc, Pechstein, Kandinsky, Morgner, Münter, Helbig, Schmidt-Rottluff, Segal, Campendonk and Kokoschka were being offered for sale in this way, in an attempt to sustain the precarious finances of the journal. The number of these special issues

declined by the middle of 1914 when the expansion of Walden's other publishing ventures and dealing activities had begun to provide alternative sources of income. However, *Der Sturm* continued to include original prints, presenting the work of a huge range of artists, many of whom are now almost totally unknown outside Germany: members of the Neue Secession in Berlin like Georg Tappert, César Klein, Richter-Berlin and Karl Gerlach or Czech Cubists such as Emil Filla, Vincenc Beneš and Vlastislav Hofman. After the war the Dadaists and Constructivists, most notably Schwitters and Moholy-Nagy, produced a few original prints for *Der Sturm*. By the mid-twenties it had begun to reflect the shift away from autographic printmaking towards typographical design and photography.

As a celebration of the hundredth issue of *Der Sturm*, Herwarth Walden announced in February 1912 that he had decided to show a selection of the work of Hodler, Kokoschka, Munch and some young French artists; but when the exhibition opened the following month the advertisement referred to 'Der Blaue Reiter, Franz Flaum, Oskar Kokoschka, Expressionisten'. It marked the beginning of a particularly close relationship between the artists of *Der Blaue Reiter* and *Der Sturm* and one of the earliest significant public usages of the term 'Expressionist' as applied to the visual arts. *Der Sturm*'s claim to be a major international forum was irrefutably established by the second exhibition in April 1912 of the Italian Futurists, and, above all, by the Erster Deutscher Herbstsalon of 1913, Walden's most astonishing *tour de force*, at which 366 items were exhibited by seventy-five artists from twelve different countries, representing the *avant-garde* of both Eastern and Western Europe. The selection, unlike its prototype, the French Salon d'Automne, was made entirely by Walden and his second wife Nell. They travelled indefatigably during the months preceding the exhibition, soliciting expert advice from members of the *avant-garde* in the main European centres; the painter Robert Delaunay and the critic Guillaume Apollinaire, for example, made suggestions for the French contingent. The financial backer for this ambitious enterprise was Bernhard Koehler,[43] a Berlin manufacturer and collector who was already the main patron of the artists of *Der Blaue Reiter* in Munich.

The *Blauer Reiter* group came into being at precisely the juncture at which Walden was contemplating a more active proselytising role in the visual arts. Although it was rooted in a distinctive Munich Jugendstil tradition, Walden succeeded in capturing the movement for *Der Sturm* in Berlin, identifying the spiritual aspirations of Kandinsky, Marc, Macke, Campendonk, Jawlensky, Gabriele Münter, Kubin and, later, Feininger with 'Expressionism'. As a group, however, the artists of *Der Blaue Reiter* were never a close-knit fraternity like the Brücke. They came together to produce the almanac whose first and only issue appeared in May 1912, edited by Marc and Kandinsky who had seceded from an earlier progressive exhibiting society, the Neue Künstlervereinigung,[44] in order to compile a journal which would reflect 'the secret connection of all artistic production'. In the prospectus of January 1912 Marc announced the editors' intention 'to reveal subtle connections with Gothic and primitive art, with Africa and the vast Orient, with the highly expressive, spontaneous folk and children's art and especially with the most recent musical movements in Europe and the new ideas for the theatre of our time'.[45] *Der Blaue Reiter* was published by Reinhard Piper, whose Munich firm also brought out Kandinsky's 'Über das Geistige in der Kunst' in 1911 and 'Klänge' in 1913. Piper was a

cautious business-man, insisting upon guarantees to cover the basic costs of production. He subsequently reappears as publisher to the Marées-Gesellschaft (see 128–48), but despite the distinction of the Piper Verlag, it cannot be compared as a creative influence with Herwarth Walden or J.B. Neumann's 'Graphisches Kabinett' in Berlin.

Kandinsky's far-reaching achievements in original printmaking easily surpassed those of his colleagues in *Der Blaue Reiter* who took inspiration from his woodcuts. He used the technique as a vital step towards non-objectivity, with a daring and originality which transcended the diminutive scale of many of his most remarkable prints. Kandinsky's reputation as a printmaker was already established before *Der Sturm*, and it was principally the work of Marc, Campendonk and Gabriele Münter, comparative novices in the field, that Walden published. By 1914 he was circulating exhibitions of prints which travelled as far as Stockholm, Tokyo and London, before his activities were curtailed by the First World War. Wyndham Lewis reviewed one of these exhibitions which was shown in the Twenty-One Gallery in London, in what is virtually the only critical response to contemporary German art in pre-War England. He described the German woodcut as a form of miniature sculpture evoking primitive African art: 'Marc, Bolz, Kandinsky, Helbig and Morgner would make a very solid show in one direction. Bolz's ''Maskenfest'' is a kermesse of black strips and atoms of life . . . Morgner drifts into soft Arctic snow-patches. Marc merges once more in leaves and sun-spotting the protective markings of animals, or in this process makes a forest into tigers.'[46]

Another group of native German artists Walden could claim as his discovery were Die Pathetiker whose corporate identity was first established at the eighth exhibition of *Der Sturm* in the autumn of 1912. The three members, Ludwig Meidner, Richard Janthur and Jakob Steinhardt, borrowed their epithet from the circle of Expressionist poets and writers with whom they were linked, the Neopathetisches Cabarett, formed in 1909, which included Jakob van Hoddis, Georg Heym, Alfred Lichtenstein and Ernst Blass. Die Pathetiker were characterised by apocalyptic visions executed in a nervous, etched, linear style which owed much to the literary temper of the period.

It has already been observed that the term 'Expressionism' made an official appearance at the first *Sturm* exhibition in Berlin in 1912, and it was largely through the activities of this Gallery that it gained common currency during the next decade. Initially the term had a more clearly defined literary than visual frame of reference; in the visual arts, indeed, it was applied with apparent inconsistency to artists as diverse as Chagall, Archipenko, Klee, and Matisse.[47] One contemporary, recalling the important exhibition of 'Rhineland Expressionists' held in Bonn in 1913, described several surprising candidates among the pictures: 'Heinrich Nauen's two peasant children in blue smocks, one of whom is clutching a huge loaf of fresh bread to her bosom. Macke's avenue with flâneurs, flooded with the red light of our summer . . . Then the Rhineland Madonna by Franz Henseler, the constructivistic ghosts of machine-men by the splendidly fanatical Max Ernst. Gentle English landscapes by Paul Seehaus, landscapes by Campendonk, and a series of pictures from Soest by Christian Rohlfs.'[48]

For a while 'Expressionism' was attached to any number of *avant-garde* groups, with the exception of the most obvious contender, the Brücke. Herwarth Walden reproduced their work in the early issues of *Der Sturm* but later it was only former

members like Pechstein and Schmidt-Rottluff, affiliated to the Neue Secession in Berlin, who were represented among the contributors of original prints or the exhibitors at the Sturm Gallery. Walden was principally interested in discovering new talent and for this reason an artist of Kirchner's standing remained outside the *Sturm's* immediate circle. However, the Brücke's pioneering role in creating new forms of expression was readily understood. Franz Marc in his article on the 'German Fauves' in *Der Blaue Reiter*, rightly identified the Brücke, the Neue Secession and the Neue Kunstlervereinigung as the three centres of assault on traditional artistic values. In *Der Blaue Reiter's* second exhibition of February 1912, limited to prints, drawings and watercolours, Marc included the work of Nolde, Kirchner, Heckel and Pechstein, despite Kandinsky's reservations, thereby creating the most complete statement at that time of Expressionism as we now understand it. For Marc a revision of the formal means of expression could only be accomplished through a regeneration of the spiritual values of every form of artistic endeavour. Walden, too, shared this creed, embracing music, poetry, literature and the theatre; when the inauguration of a *Sturm* art school was announced in 1916, its prospectus specified instruction in the 'expressionistic art of the stage/drama/elocution/painting/poetry/music.' While Expressionism remained a vital force it retained its nebulous definition as an attitude of mind and emotion: the narrower conception of its embodiment as a style only arose with historical hindsight.

The critic, Adolf Behne, did attempt a brief analysis of the stylistic components of Expressionism in a review of a *Sturm* exhibition of December 1914, showing the work of Marc, Campendonk and Kokoschka: 'Cubism informs the language used by many, though not all of the Expressionists. Futurism is the name for the emotional currents which have acted as the stimuli.'[49] The Futurist exhibition of 1912 at the Sturm Gallery was a tempestuous affair in both a literal and visual sense, which galvanised the style of a whole generation of young German artists, providing them with a vocabulary appropriate to the apocalyptic mood of the next decade. Images of stark despair and impending doom proliferated among the writings of the 'Neo-pathetic' poets, for example, long before the First World War translated them into actual experience. Many of the artists represented here were directly affected by the harsh realities of warfare, which left deep psychological scars. Even among those who were non-combatants, Kirchner collapsed during military training and left Germany for psychiatric treatment in Switzerland, while Käthe Kollwitz was profoundly disturbed by the loss of her son Peter. In artistic terms the consequences of wartime service were critical for those who emerged to lead a new *avant-garde* after 1918. Although Grosz, Dix and Moholy-Nagy ultimately rejected Expressionism, it had initially equipped these artists with a means of describing their terrifying experiences. Grosz, by 1917, had evolved a rebarbative manner with which to capture the 'terrible adjacency and chaos' of the hectic Berlin milieu, and Dix, though his style took longer to mature, had executed literally hundreds of drawings on the Western Front which provided the inspiration for his monumental print cycle, 'Der Krieg', of 1924. Even Beckmann, who had already achieved a considerable reputation as a painter in the Berlin Secession, and had engaged in a controversy with Marc on the side of conservatism in 1912, felt it necessary in 1915 to change his style completely and begin afresh. For him, as for Lovis Corinth, recovering from a near-fatal stroke, Expressionism at first offered the only means equal to the task of articulating their changed perception of reality.

By the end of the War artistic allegiances had significantly altered; Expressionism had been diluted and institutionalised, provoking a reaction by a new *avant-garde* deeply hostile to it. Richard Huelsenbeck, who brought the Dada movement from Zurich to Berlin in 1917, was conscious of what he felt to be Expressionism's failure to reflect Germany's dire predicament as the country's military and political structure collapsed. 'With the most transparent logic Expressionism had developed in Germany into the official art movement. Its tendency to inwardness, its call for the mysticism of the Gothic cathedrals, its proclamation of humanity was taken as a beneficial reaction against the horrible slaughter in the trenches . . . The Dadaist saw Expressionism as a withdrawal, a flight from the hard edginess of things . . .'[50] The Dadaists sought more spontaneous and nihilistic means of communication which allowed no place for the tradition of autographic printmaking. Kurt Schwitters's interesting but limited attempts in this direction were, in a sense, an aberration; the photomontages of Raoul Hausmann and John Heartfield were more prophetic of the course of printing innovation during the 1920s.

However, the Expressionist tradition was by no means vitiated in the eyes of all progressive parties in 1918. When Walter Gropius published the programme of the Staatliches Bauhaus in Weimar in April 1919, he chose for its title-page, Lyonel Feininger's woodcut *Cathedral*, evocative of the utopian idealism which Huelsenbeck regarded as so discredited. The programme culminated in an exhortation 'to create a new guild of craftsmen without the class distinctions that raise an arrogant barrier between craftsmen and artist! Together let us desire, conceive and create the new structure of the future which will embrace architecture and sculpture and painting in one unity and which will one day rise toward heaven from the hands of a million workers like the crystal symbol of a new faith.'[51] It was this credo which held a special attraction for some of the first Bauhaus masters like Johannes Itten and Lothar Schreyer, who were recruited from the *Sturm* school. But within a very short space of time the position of the more extreme disciples of Expressionism became untenable as Gropius was forced to demand a pragmatic approach towards accepting profitable outside commissions, which were essential to the Bauhaus's viability. The early years of the Bauhaus in Weimar were relatively unproductive, due to the confused objectives and endless internal dissension. Gerhard Marcks, talking of the flurry of activity in Weimar in September 1923, during the Bauhaus week, its first public relations exercise, remarked: 'And the reason for all this? In the museum there are a few cabinets full of little pots and little woven things. This is what Europe is all excited about. Poor Europe'.[52]

Marcks was perhaps unduly pessimistic, and his laconic dismissal of the Bauhaus's efforts did no justice at all to the considerable achievement of the printing workshop under the aegis of Feininger as Master of Form and Carl Zaubitzer as technical supervisor. The relationship between the Bauhaus painters and their master craftsmen in Weimar was always problematic, but Feininger did not experience with Zaubitzer the acute difficulties Paul Klee encountered in the Bookbinding Workshop with the entrenched conservatism of Otto Dorfner. The workshop was equipped with facilities for etching, lithography and woodcut, but not offset printing; it was intended primarily to act as a training ground for apprentices and a means for experimentation by the students and staff. Between 1921 and 1924 it received a series of important commissions for ten large portfolios whose sale was expected to produce some profit for the Bauhaus.[53]

The most ambitious of these commissions was the group of five portfolios entitled 'Neue europäische Graphik', announced in a prospectus of 1921: 'For the first time, we offer the collector the chance to purchase an international collection of graphic works, which, in the current economic situation is otherwise impossible to obtain. The collection is of fundamental importance as a representation of the most significant artists of Germany, France, Holland, Italy and Russia . . .'[54] Gropius solicited donations of original prints from a wide range of artists in order to produce 'a document which will demonstrate how the artistic generation of our times shares the ideas of the Bauhaus and is willing to make sacrifices . . .'[55]

In the event, only two of the portfolios, nos I and III, were published as planned in 1922, devoted respectively to prints by the Bauhaus Masters and German artists.[56] Portfolio V, also containing the work of German artists, appeared with certain modifications in March 1923; portfolio IV, of Italian and Russian artists, was not ready even in its abbreviated form until the beginning of 1924, while the second portfolio, intended to cover the work of living French artists, was a casualty of strained Franco-German political relations. The existing portfolios, despite their failure entirely to fulfil the claims of the prospectus, remain the most diverse publishing venture in the field of original printmaking in Germany during the post-First World War period, and give a remarkable conspectus of the European *avant-garde*. The first portfolio is included here in its entirety (see 191) while from the third are taken the two posthumously printed works of Franz Marc and August Macke (see 117, 119). The first portfolio's restriction to the prints of the Bauhaus Masters contributed to its relatively greater success, as it ensured a closer collaboration between the artists and the craftsmen in the workshop who were responsible for the printing.

The anticipated financial rewards from the publication of 'Neue europäische Graphik' failed to materialise, as the venture succumbed to the ravages of Germany's catastrophic inflation between mid-1922 and November 1923. The advertised prices of 5,000 Marks for the de luxe copies, and 2,200 Marks for the standard copies became meaningless and the distributors failed to adjust them with sufficient speed to the wildly fluctuating exchange rate. Even the costs of production were not covered by the income from the portfolios; when the currency was stabilised at the end of 1923 the market for lavish print publications was an immediate victim of the ensuing shortage of capital. The repercussions of this situation extended far beyond the Bauhaus. The Kestner-Gesellschaft in Hanover, which commissioned portfolios of lithographs in 1923 from Lissitzky and Moholy-Nagy, among others, abandoned all further production after the sixth portfolio, despite the success of some of their sales. Leunis and Chapman, the lithographers used for the Kestner portfolios, were also printing money in 1923,[57] a characteristic inflationary activity which helped to create the reservoir of ready capital that speculators were eager to convert into material investments.

With the end of the inflation the impetus collapsed behind the printmaking activities of the majority of the post-War artists represented here. Kokoschka virtually abandoned lithography after 1923 for more than twenty years; Beckmann, after a tremendous spate of production from 1922 to 1923, came to an equally abrupt halt; Dix, whose 'Krieg' series had been commissioned in 1923, although it did not appear until 1924, allowed his printmaking to peter out by 1926; Lissitzky, Moholy-Nagy and Schwitters produced no further portfolios after 1923 and Kandinsky and Klee from the mid-1920s concentrated on the extremely limited editions of prints commissioned by the small number of subscribers to

the societies formed in their names by a Braunschweig merchant, Otto Ralfs.

There were, of course, artistic as well as economic reasons for the decline in original printmaking, first and foremost of which was the exhaustion of the Expressionist tradition which had endowed this activity with so much importance. Expressionism survived, inevitably, in an attenuated form throughout the 1920s and some of its exponents, most notably Kirchner, continued to make prints, as the nature of his work had never required expensive published editions. The initiative passed, however, to experimentation with mechanical and photo-mechanical techniques which dominate the inter-War period. For the Dadaists, photomontage offered greater scope than conventional printmaking for the exercise of their zany wit and left-wing polemic. When the Bauhaus moved to Dessau in 1925 the printing workshop was completely transformed by the sub-stitution of mechanical presses and moveable type for the old hand-printing equipment. The Constructivist artists were particularly interested in advertising techniques and typographical design, and the role of the commercial artist assumed a new respectability. Photography's potential, as an artistic and journalistic medium, was vigorously promoted by Moholy-Nagy in his Bauhaus Book of 1925, *Malerei, Photographie, Film* (see 267). By the end of the 1920s it had become the most exciting means of visual communication, as was demon-strated in the exhibition *Film und Foto*, held in Stuttgart in 1929.

Yet the rough, hand-made print is the central German contribution to twentieth-century printmaking and it is thus appropriate that the final artist in this section of the catalogue should be Rolf Nesch, who sustained an isolated and eccentric activity as a printmaker throughout the later 1920s in Hamburg, and then in Norway after his emigration in 1933. In one way he is a direct follower of Kirchner, with whom he spent six weeks in 1924; at the same time he looks forward to much of the experimental printmaking that is so characteristic of the 1950s, by his invention of the metal-print and by the later introduction of a startling range of colour into his work. His influence on post-War European and American printmaking has been immense, and through him the Expressionist tradition has been handed on to later generations.

Oskar Schlemmer touched upon an issue crucial to the political perception of art in Germany after the First World War, when he commented à propos of the Bauhaus, in a letter of 1923, 'The Russian Kandinsky will probably, or certainly be followed by the Hungarian Moholy-Nagy (Itten's successor). Now I understand why Klee corrected a phrase of mine in a Bauhaus essay to read "art in Germany" instead of "German art".'[58] The internationalism of the German *avant-garde* which Herwarth Walden had so energetically promoted and which was central to the Bauhaus ideal, was bitterly resented by the right-wing. Thus in July 1924 the Association for the Protection of German Culture in Thuringia attacked the Bauhaus: 'In spite of claims to the contrary by the Bauhaus masters, art cannot be comprehended scientifically, but is the most deeply inward experience, a feeling rooted in the subconscious, in human instinct. Our healthy instinct tells us that truly authentic art cannot consist of colour-composition alone, or of the filling-in of flat areas, or technical construction, or any other kind of one-sided approach. All the mechanical games, the arrangements of materials, the colour effects, each distorted idiot's head and bizarre human body, all the schizoid scribblings and experiments in embarrassment which we find in exhibitions and publications of the State Bauhaus in Weimar are decadent values, theatrically inflated into art by the director and the Masters of the Bauhaus, and lacking

artistic creativity . . . Such a bloodless diseased artistic instinct . . . as that . . . at the Bauhaus . . . is assisting the collapse of our culture.'[59]

This narrow sectarian view, with its spurious ideal of a uniquely German culture, triumphed in 1933 when the National Socialists assumed political control. They closed the Bauhaus in Berlin and the art schools were immediately purged of all their most innovative teachers. A tragic period ensued when virtually every artist in this catalogue who was still alive was deprived of employment and had his work vilified in the *Entartete Kunst* exhibitions of 1937. Many were forbidden to exhibit or were driven into exile. Expressionism and Neue Sachlichkeit which are now regarded as quintessentially 'Germanic' forms of art were as much the victims of right-wing nationalism as the more obviously foreign elements like Constructivism, although the Nazis were divided in their attitudes towards Barlach and Nolde. The latter was the only major figure to identify with National Socialism, but his work too was proscribed in 1937. Schlemmer noted the paradox in the Nazis' persecution of Nolde in his diary in 1935: 'Just read Nolde's *Jahre der Kämpfe . . . he* is *the* German artist whom the National Socialists would make their standard bearer, if they knew what they were doing.'[60]

Lothar Schreyer visited Herwarth Walden in 1932, just before the latter departed for Soviet Russia, when all that remained of the *Sturm* enterprise was a little art gallery on the Kurfürstendamm. 'The art revolution had no radiant centre any more. The Sturm time was over. Herwarth Walden knew that his work for the art revolution was finished. He still had hopes of aligning Expressionist Art, which had started off as an intellectual revolution, with the political revolution, in effect with the Communist Revolution'.[61] This was not to be; the next 'Expressionist' revolution was Abstract Expressionism, whose 'radiant centre' was New York.

Notes

1. Hans W. Singer, *Die moderne Graphik*, Leipzig 1914.

2. Curt Glaser, *Die Graphik der Neuzeit*, Berlin 1922.

3. Singer, *op. cit.*, p. 428.

4. The British Museum has recently purchased the set of Leibl's etchings in the Fritz Gurlitt edition (inventory numbers 1981–6–20–1(1–11)).

5. This should perhaps be more accurately said of his drawings, since most of the prints are very exact transcriptions of pen and ink drawings. Nevertheless, many of the later prints go beyond the drawings in their use of aquatint.

6. Glaser, *op. cit.*, p. 466.

7. Gustav Schiefler, *Meine Graphik-sammlung*, ed. G. Schack, Hamburg 1974, p. 15.

8. J. Bailly-Herzberg, *La Société des Aquafortistes*, 2 vols, Paris 1972.

9. W. von Bode, 'Die Berliner Maler-radierer' in *Die graphischen Künste*, XIII, 1890, pp. 45–60.

10. Cf. Max Lehrs, *Karl Stauffer-Bern, ein Verzeichnis seiner Radierungen und Stiche*, Dresden 1907, and Otto Brahm, *Karl Stauffer-Bern, sein Leben, seine Briefe, seine Gedichte*, Leipzig 1892.

11. Published 1896–1940. See L. Koreska-Hartmann, *Jugendstil, Stil der 'Jugend'*, Munich 1969.

12. Published 1896–1944. See the Darmstadt exhibition catalogue of 1978, *Simplicissimus*.

13. Published 1895–1900. See Jutta Thamer, *Zwischen Historismus und Jugendstil. Zur Ausstattung der Zeitschrift 'Pan'*, Frankfurt 1980. Its even more famous Austrian counterpart *Ver Sacrum* (1898–1903) also carried original prints: see C. M. Nebehay, *Ver Sacrum*, Vienna 1975.

14. The society, which was founded in 1872, published *Die graphischen Künste* quarterly from 1878; from 1898 it also distributed 'Jahresmappen'. See the essay by A. Weixlgärtner in *Die graphischen Künste*, XLIV, 1921.

15. Meier-Graefe was the greatest critic of his day, and did more than anyone to establish the reputation of the French Impressionists and post-Impressionists in Germany. See Kenworth Moffett, *Meier-Graefe as art critic*, Munich 1973.

16. See Hans Hofstätter, *Jugendstil Druckkunst*, Baden-Baden 1973.

17. See the catalogue of the recent exhibition *The artistic revival of the woodcut in France 1850–1900*, University of Michigan Museum of Art, Ann Arbor 1984.

18. Letter to Max Lehrs of 29 August 1901 (*Käthe Kollwitz, Briefe der Freundschaft und Begegnungen*, Munich 1966, p. 22).

19. K. Kollwitz, *Tagebücher und Briefe*, Berlin 1948, p. 22.

20. K. Kollwitz, *Ich sah die Welt mit liebevollen Blicken*, Hanover 1968, entry for April 1910.

21. K. Kollwitz, *Tagebücher und Briefe*, Berlin 1948, entry for November 1922.

22. See the memoir by his close friend Lovis Corinth: *Das Leben Walter Leistikows*, Berlin 1910. Leistikow made some fine etchings.

23. The first Secession occurred in Munich in 1892, and was followed by others in Düsseldorf, Dresden, Karlsruhe, Weimar and Vienna. By 1897 Berlin was the only major German artistic centre without one. Lying behind each one was the overcrowding in the annual salons which were the main vehicle for selling paintings. The Secessions were self-defined élites who objected to showing *en masse*, and presupposed no particular aesthetic stance. See the excellent monograph by Peter Paret, *The Berlin Secession*, Cambridge (Mass.) 1980.

24. For both of these see Paret, *op. cit.*, pp. 170–99.

25. Ed. Gerhard Wietek, *Deutsche Künstlerkolonien und Künstlerorte*, Munich 1976.

26. Gustav Schiefler, *Meine Graphik-sammlung*, 1974, p. 57.

27. This practice resulted in a prosecution in 1910; the judge dismissed the case. See Pechstein's *Erinnerungen*, Wiesbaden 1960, p. 43.

28. Bleyl got a job teaching in Freiburg in late 1906 and left the Brücke in 1907. See the publication of Bleyl's memoirs by Hans Wentzel in *Kunst in Hessen und am Mittelrhein*, VIII, 1968, pp. 89–105, and Günther Krüger 'Fritz Bleyl, Beiträge zum Werden und Zusammenschluss der Künstlergrüppe Brücke' in *Brücke-Archiv* 2/3, 1968–9, pp. 27–53.

29. Georg Reinhardt 'Die frühe Brücke, Beiträge zur Geschichte und zum Werk der Dresdner Künstlergruppe Brücke der Jahre 1905 bis 1908' in *Brücke-Archiv* 9/10, 1977–8, pp. 28–31. Reinhardt's 215 page study is of fundamental importance for the study of the early years of the Brücke.

30. See the exhibition catalogue *Die Brücke – Edvard Munch*, Munch Museum, Oslo 1978, which contains a full account by Arne Eggum, based largely on the archival publication of Marit Werenskiold 'Die Brücke und Edvard Munch' in *Zeitschrift des Deutschen Vereins für Kunstwissenschaft*, XXVIII, 1974, pp. 140–52.

31. Georg Reinhardt, *op. cit.*, pp. 192–4.

32. The 'Jahresmappen' of 1906–12 and other documents were catalogued and reproduced by Hans Bolliger and E. W. Kornfeld on the occasion of an exhibition held in Berne (Kornfeld and Klipstein) in 1958. The 'Jahresberichte' have been reprinted in the exhibition catalogue *Brücke 1905–13, eine Künstlergemeinschaft des Expressionismus*, Folkwang Museum, Essen 1958.

33. A symptom of this is the fact that Heinrich Stinnes, a doctor from Cologne, and the greatest collector of contemporary prints in Germany, possessed few of their works and was not a passive member. He had, however, a staggering group of prints by Liebermann, Corinth and even Munch. He also subscribed for the first copy of each of the Kestner portfolios. After his death in 1932 his collection of over 200,000 prints was auctioned in a series of sales; his ugly collector's mark 'HS' (Lugt 1376a) is frequently seen on outstanding impressions of prints.

34. Extracts from them are reprinted in Donald E. Gordon, *Modern Art Exhibitions 1900–1916*, 2 vols, Munich 1974.

35. There were of course earlier printing establishments catering for artists' needs: the signatures of Felsing and Voigt appear on many prints in this catalogue.

36. Illies (1870–1952) is now virtually unknown outside Hamburg, but is one of the best of the German Jugendstil printmakers, and a pioneer in colour intaglio printmaking. See Gerhard Schack's new edition of Schiefler's catalogue, *Das graphische Werk von Arthur Illies*, Hamburg 1970.

37. The pattern of *Der Sturm's* publication was as follows: 1910–13 weekly; 1913–16 fortnightly; 1916–23 monthly; 1923–4 half yearly; 1925–9 monthly; 1930–2 irregularly.

38. Lothar Schreyer, *Erinnerungen an Sturm und Bauhaus*, Munich 1956, p. 7, as translated in Paul Raabe, *The Era of German Expressionism*, London 1974, p. 193.

39. Franz Pfemfert (1879–1954) the equally single-minded editor and producer of *Die Aktion* became a Trotskyist; he fled from Berlin in 1933 and ultimately settled in Mexico in 1941.

40. Walter Mehring, 'Berlin avant-garde' in Raabe, *op. cit.*, p. 109.

41. *Sturm Plakat* (Wingler-Welz 32). The edition of fifty, selling at 5 Marks apiece, seems to have been additional to the regular printing designed for actual use as a poster.

42. The following advertisement appeared in no. 93: 'The original woodcut by Max Pechstein in this issue is signed by the artist and hand-coloured with three colours. The numbered edition (100 examples) on heavy paper is only available at three Marks for each impression through the 'Sturm' publishing house.' For the purposes of this catalogue all direct quotations from *Der Sturm* are taken from the reprinted edition published by Kraus in Nendeln, Liechtenstein 1970, of which there is a copy in the British Library.

43. Koehler was introduced to the work of major French late nineteenth-century artists by August Macke, his niece's future husband, who was also instrumental in encouraging his taste for Delaunay, and the artists of *Der Blaue Reiter*. For further references to Koehler see the biographical entries on Marc and Macke.

44. The Neue Künstlervereinigung, of which Kandinsky was a founder member, held its first exhibition in December 1909.

45. Klaus Lankheit, *The Blaue Reiter Almanac*, London 1974, p. 252.

46. Review in 'Blast' 1914, reprinted in *Wyndham Lewis on Art, Collected Writings 1913–56*, ed. W. Michel and C. J. Fox, London 1969, pp. 39–40.

47. On the changing reference of 'Expressionism', see Donald E. Gordon, 'On the origin of the word "Expressionism"', *Journal of the Warburg and Courtauld Institutes*, XXIX, 1966, pp. 368–85.

48. Karl Otten on 'Heidelberg, Bonn, Strasbourg' in Raabe, *op. cit.*, p. 142.

49. *Der Sturm* 17/18, December 1914, p. 114.

50. Raabe, *op. cit.*, p. 352.

51. Hans Wingler, *The Bauhaus*, Cambridge (Mass.) 1969, p. 31.

52. *Ibid.*, p. 57.

53. The other portfolios besides 'Neue europäische Graphik' were Feininger, 'Twelve Woodcuts', 1920–21; Kandinsky, 'Kleine Welten', 1922; Schlemmer, 'Game with Heads', 1923; Marcks, 'The Song of Wayland in the older Edda', 1923; 'Masters' Portfolio from the Bauhaus', 1923.

54. Wingler, *op. cit.*, p. 48.

55. *Ibid.*, p. 49.

56. These are the only portfolios in the British Museum. The prints in the third portfolio which have not been included in this catalogue are by Rudolf Bauer, Willi Baumeister, Heinrich Campendonk, Walter Dexel, Oskar Fischer, Jacoba van Heemskerck, Bernhard Hoetger, Johannes Molzahn, Kurt Schwitters, Fritz Stuckenberg, Arnold Topp, and William Wauer.

57. See Lissitzky's letter of 18 August 1923 to Sophie Küppers in Lissitzky-Küppers, *El Lissitzky, Life – Letters – Texts*, London 1968, p. 36.

58. Letter of 20 March 1923 to Otto Meyer in *The Letters and Diaries of Oskar Schlemmer* selected and edited by Tut Schlemmer, Middletown (Conn.) 1972, p. 137.

59. Frank Whitford, *Bauhaus*, London 1984, p. 205.

60. Entry for 19 September 1935. See Tut Schlemmer, *op. cit.*, p. 341.

61. Raabe, *op. cit.*, p. 199.

The printmaking techniques of the members of the Brücke

Despite the many writings on Brücke printmaking, there is still uncertainty about the techniques that they used and the history of their development. The following essay attempts to summarise the present state of knowledge, or what is thought to be knowledge; undoubtedly much of it is incomplete, misleading or plainly inaccurate, and awaits future correction. It is based primarily on a study of the prints themselves and on the small quantity of published contemporary evidence: Kirchner's own article of 1921 entitled 'Über Kirchners Graphik',[1] Pechstein's essay of 1921 about his own printmaking,[2] the remarks in the introductions to the catalogues written by Schiefler (on Kirchner and Nolde) and Schapire (on Schmidt-Rottluff), and Schiefler's *Meine Graphiksammlung*.[3] It is also greatly indebted to the counsel of Jacob Kainen, to whom I would express my warm thanks.

WOODCUT

The earliest woodcuts were made independently in 1903–4 by Heckel and Kirchner before the foundation of the Brücke. Kirchner's starting point was a linear style based on facial caricature derived from the Munich satirical magazine *Simplicissimus* (founded 1896). Heckel and Schmidt-Rottluff's early works belong to the black-and-white tradition of design devised by Félix Vallotton and William Nicholson in the 1890s and since then widely practised by Jugendstil artists: that is, they rely for the definition of form on contrasting tonal areas of black and white, with a complete avoidance of any half-tones. Thus, edges are sharp (only a knife is used) and no attempt is made to bring out the character of the wooden block. In later years both Kirchner and Schmidt-Rottluff rejected their early works by suppressing them from their catalogue (or, in Kirchner's case, by occasionally antedating them by three to six years).

The development in 1906 is difficult to follow because of the absence of sufficient securely datable works by Kirchner or Heckel.[4] The most useful evidence comes from Pechstein, who joined the Brücke in this year, and who regularly dated his prints as he made them (this is assured by the early form of signature found on the prints). These show that the Brücke were now trying to go beyond the simple opposition of contrasting tones, and arrive at a more lively and less mechanical effect by breaking up solid areas and replacing them by textures. The tool they used for this was the gouge, which had already been adopted by Munch (see 72). This would provide a texture for the background or flesh of irregular lines, which would print black or be blind-stamped as white depending on the inking. Pechstein went the furthest in the deliberate use of blind-stamping at this date, and was also the most assiduous user of coloured or unusually textured paper. The use of coloured inks was another way of lending variety, and Heckel (as also Pechstein) often employed reds, browns and purples in 1906. Nolde took up woodcut in 1906 under the tuition of Schmidt-Rottluff, and was later to develop the use of blind-stamping to a very marked degree (cf. 113). However, as a deliberately engineered effect, blind-stamping seems never to be found in the later work of the other Brücke members. This is not to deny that some exceptional trial proofs of later woodcuts (for example, the set in the Kunsthalle, Hamburg, of Heckel's 1915 *Wounded soldiers*, Dube 298ff.) exhibit remarkable relief from embossing.

In 1907 Kirchner made only a few woodcuts, and new developments in the technique seem to have been due to Heckel. In the set of illustrations to Oscar Wilde's *Ballad of Reading Gaol* and other similar prints he broke up the surface of the block in a new way. The wood is cross-hatched in parallel or converging

lines, but the edges are broken down (perhaps with a file or sand-paper) so that no straight line is to be seen. The *Violinist's head* (84) is another work of this year which shows a different sort of attempt to avoid the straight line. Schiefler records that at this time Heckel was devoting much attention to the choice of woods for his blocks and the different possibilities they offered, and this is undoubtedly an important factor affecting the appearance of the prints.[5]

The first classic Brücke style in woodcutting begins in 1908 (cf. 86). It is marked by the abandoning of the black/white contrast of Jugendstil and of the attempt to define form by variations of light and shade. An outline manner of drawing is used; background or flesh is articulated by half-tones. In 1907 half-tones of a sort had been created by the cutting of irregular spots and areas, but these had taken a full charge of black ink. In 1908 such areas appear as grey, a result obtained from lowering the block or grading the angle at the side of a line (with a knife, chisel or gouge) so that decreasing quantities of ink are picked up by the paper. This procedure demands careful printing to take full advantage of the potentialities inherent in the cutting of the block. An ordinary platen press could supply adequate pressure to force the paper into the block if the paper was first dampened. But if it was to provide sufficiently variable pressure to bring out the range of tones in the vital areas, it would need careful 'packing' – that is building up with small pieces of paper attached to the tympan itself. This is a very laborious business, and so the members often took recourse to hand-printing without a press.[6] This could be done by rubbing the back of the paper laid down on the inked block with anything from the back of a spoon or ivory burnisher to a roller. It is often difficult to tell in any individual instance what method has been used, for many variable factors will affect the appearance of the final print: the consistency of the ink, the thickness of the inking, the degree of dampness of the paper, and the type of paper itself, which will take the ink in different ways. All of these variables were constantly exploited by the Brücke, not just in woodcut, but in intaglio and lithography as well.[7]

On the evidence I have seen, the most consistent user of hand-rubbing was Schmidt-Rottluff between 1909 and 1911 (see 96–7). Impressions almost always seem to have burnishing marks on the back (unlike woodcuts by Heckel and Kirchner). As a result the prints of 1909 have a remarkable range of half-tones. In the group of works of 1911 half-tones are less prominent; instead there is an additional subtlety of inking which in some images accentuates the grain of the block (97), and in others (Schapire 69) creates areas of solid grey set against areas of solid black. After 1912 Schmidt-Rottluff stopped printing his blocks himself, and instead entrusted them to the expert hands of professional artists' printers. This was a logical consequence of the course of his own stylistic development, which had led him to larger and simpler forms. Therefore, he no longer needed the nuanced hand-printing which had been essential to bring out the character of his 1909 and 1911 woodcuts (contrast 97 with 98). As a by-product he doubled or tripled the edition size of his woodcuts from less than ten to twenty-five or thirty. Heckel, too, increasingly entrusted the printing of his woodcuts to experts such as Voigt in Berlin after about 1912.

At some point, apparently after *c.* 1912, Kirchner (at least) began to use a copper-plate press for printing his woodblocks – an observation which I owe to Jacob Kainen. The impressions often show a pronounced 'plate-mark' caused by the pressure of the press, which was both intense enough and variable enough (from the blankets over the paper) to pick up a range of half-tones. Kirchner,

however, never (or almost never) let anyone else print his blocks. Wolfgang Werner informs me that J.B. Neumann wanted to publish a portfolio of Kirchner's woodcuts in the same way as he published sets of Heckel (cf. 89) and Schmidt-Rottluff. Kirchner sent him a block (Dube 206) but so disliked the impressions that Neumann had printed that he refused to sign them. The project therefore collapsed.

After 1908 stylistic developments in the Brücke woodcut were not in general matched by changes in technique. From 1910 the influence of primitive art from the Palau Islands and the Cameroons becomes marked, and with the move to Berlin in late 1911 forms become angular and perspective dislocated as a consequence of exposure to Cubist and Futurist art. The major technical developments now centred on colour printing. Early colour woodcuts were produced in the traditional way, using a separate block per colour. Between 1909 and 1911 Heckel adopted from Munch the method of sawing up and separately inking parts of a single block (see 88). He followed this in 1912 with another method using two blocks, one of which carries the design and is printed in black, while the other is not cut at all but simply inked by painting on with a brush as many different colours as are required (cf. 93).[8] This gives this group of woodcuts their appearance of being watercoloured (the most familiar example is *White Horses*, Dube 242), but the ink used, although thinned, is oil-based as can be seen from the discolouration on the backs of impressions.[9]

Kirchner's preferred method of making coloured woodcuts up to 1914 was the multiple-block technique, which he handled with remarkable skill and dexterity. He claimed in 1921 to have arrived 'after many experiments at a new method of working with two to ten blocks without the use of a drawing block carrying the design'. The last part is true of some of the colour woodcuts, but I know no case where he need have used more than four blocks. Most remarkable is the way in which he constantly experimented with changing the number and order of printing of the blocks and the colour of the inks. If all surviving impressions could be examined, it would probably be found that it is unusual for any two to be the same. In a small group of prints made between 1915 and 1917 Kirchner invented an unprecedented technique of colour printing by inking a single block with a brush in varying colours. This is described under 80.

Another development worthy of remark concerns Nolde's deliberate manipulation of the inking of his blocks, often in conjunction with the use of blind-stamping (see 113). This is not paralleled in the work of the other members of the Brücke, who generally laid on the ink with a roller in a straightforward fashion.[10] Kirchner occasionally had difficulties, particularly in the period between 1912 and 1915, with impressions of woodcuts which had not been charged with enough ink so that the blocks came out unevenly; he therefore had to retouch them by hand with black wash.

LITHOGRAPHY

If the members of the Brücke created their finest prints in the medium of woodcut, it was in lithography that their technical originality was most marked. Throughout the nineteenth century it had been taken for granted that the artist would simply make his drawing on the stone with crayon, pen or brush (or in many cases merely on transfer paper) and then leave all the subsequent operations to the professional lithographic printer. A succession of great printers had devoted their skills to devising the correct graining of the stone and

applications of acid and gum arabic (to make the stone resistant to further applications of grease), so that the most precise facsimile possible of what the artist had put on the stone should be conveyed to the paper in the printing. The printer should also see that the stone was capable of printing a full edition and that all impressions came out as exactly alike as possible.

In classic Brücke lithography all these conventions were stood on their head. The artists did not make use of the services of a professional printer; instead they conducted their etching and printing operations themselves, using the simple equipment available in their studios. Their object was no longer to reproduce what they had drawn on the stone. Rather, the drawing was merely the first stage in the process of arriving at an image, which could, and often would, be dramatically affected by the various unconventional methods of etching and printing they devised.

The process began with grinding down the stone to prepare the surface for printing. The conventional wisdom held that a smooth surface was only necessary for lithographs drawn with a brush or pen; for crayon lithography the stone should be given a grain so that the character of the crayon should be evident in the final print. In the case of Kirchner at least we have Schiefler's evidence that he always used a smooth surface precisely because he did not want to give his prints the character of reproductions of drawings.[11] Schiefler, moreover, states that Kirchner on occasion used pencil or coloured printing ink as well as the more conventional crayon or lithographic ink when drawing on the stone.[12]

Schiefler also gives the best description of the next process which the Brücke frequently used – that is, washing the stone with water in which a few drops of turpentine had been mixed.[13] 'Through this both the drawn line and the wetted surfaces undergo a change of substance: the particles of pigment of the crayon or the lithograph wash are loosened and refixed according to the structure of the stone, the line loses its sharp edges, the gaps between thickly laid areas of line are more or less filled up, while on the other hand the darker areas are reduced to a lighter tone. Since moreover small particles of the drawing material are driven over the areas of the stone left untouched in the drawing – a process which is assisted in details by the artist himself – he can achieve with the aid of the structure of the stone a complete scale of tone from light to dark, but in a quite different way from cross-hatching with the crayon.'[14] This turpentine solution could be applied all over the stone to give it an overall texture (as is usual in Kirchner's lithographs of 1914–15), or just locally to particular areas (as is more usual in the years 1910–12) with a brush or a cloth. These areas are often easily distinguishable from the untouched crayon drawn on the stone. In some cases described by Schiefler (e.g. his cat. 236, *Cocottes at Night*) this turpentine treatment was only added in later states of a print.

The character of the drawn line or area could also be changed in the etching process. This is a fundamental part in the making of any lithograph, but conventionally only a weak etch (with a smaller proportion of acid to gum arabic) is employed. The members of the Brücke, however, frequently used a strong etch, so strong that it ate right through the lines and so broke them up into a series of grainy globules. The alterations produced by the turpentine and etching processes are so radical that it can be difficult to tell whether the original drawing was in crayon or lithographic ink.

In the nineteenth century it had been the exceptional artists – Goya, Daumier,

Manet – who had used the capabilities inherent in the medium to produce prints which have a texture and finish that could not have been achieved by drawing directly on paper. Most lithographers had aimed to give their prints the appearance of a drawing, and to this end had drawn in the centre of the stone, so that it is only occasionally that one can see from the embossing or polishing of the margin outside the image that the stone used was very much wider than the drawing. The Brücke, as we have seen, wished to make it immediately apparent that their lithographs were not drawings but prints which had been produced from the surface of a stone. Their first solution, almost invariably employed in 1907–8 by Kirchner and Heckel, was to continue their drawing up to the very edge of the stone, so that its irregular contour was immediately visible; indeed, they gladly employed damaged stones for their interesting shapes (not just because they were cheap), and on occasion used stones which were cracked right through the middle. In 1909, when they were most influenced by the outline style of drawing they found in Matisse and the Fauves, it was obvious that they would not continue to draw up to the edge of the stone. Instead, they left the edges of the stone inked so that its contour should still be evident and the lithographic nature of the image unmistakable. This (as Jacob Kainen has pointed out to me) made the printing more difficult in that the upward pressure of the stone, which rises to meet the scraper bar (which runs over the back of the paper laid down on the stone), had to be maintained up to the end; at this point the stone, as it no longer met any resistance, would jerk upwards and run a real risk of toppling off the press. There would also have been the risk that the leather covering the scraper bar would become dented and no longer provide a uniform scraping pressure. On some occasions impressions were printed by hand, without using a press, by rubbing on the backs of the sheets with a piece of ivory or suchlike (cf. 102).

Blocks of lithographic limestone have never been cheap, and the members of the Brücke never possessed a large number of stones. By measuring and tracing the contours of impressions of their lithographs, it would be possible to work out exactly what stones each of them had in his studio. My rough conclusions, based only on the measurements contained in the standard catalogues, are that the vast majority of Kirchner's lithographs were printed from nine stones,[15] and of Heckel's from seven; it can be shown that they frequently printed from the backs of the stones as well. Schmidt-Rottluff, almost without exception, seems to have used only one stone, printed from both sides, from mid-1908 to 1911, while all the early Pechstein lithographs I have seen come from three stones. This line of investigation is worth pursuing, as it would reveal how often the members of the Brücke made prints using each other's stones, and thus how far their activities really were communal. For what it is worth, I have not yet noticed a case where Heckel used Kirchner's favourite stones, or vice versa.[16]

Schiefler provides a vivid description of Heckel at work: 'As a valuable possession he had got hold of a stone and told me how, often at night, spurred by the creations of his fantasy, he would leap up to put down on the stone the visions of his inner eye; he would etch it, pull a few impressions and then grind off the image again so that he could make another one'.[17] With such a method of working it was obviously impossible ever to reprint a stone, and the number of proofs printed at the time would remain the total edition size. In the case of Schmidt-Rottluff we have Schapire's evidence, supported by annotations on a few prints, that usually four to eight impressions were pulled; a similar figure is

suggested by the numbering on Pechstein's lithographs (cf. 103), and by Kirchner in his account of 1921. The scarcity of impressions of Heckel's lithographs suggests that the same held true for him as well.

There is an historical problem connected with the origins of Brücke lithography. According to the 'Chronik der Brücke' written by Kirchner in 1913,[18] it was Schmidt-Rottluff who 'made the first lithos on the stone'. And it is undisputed that he was making lithographs in 1906, while Kirchner and Heckel only took up the medium in 1907. But in an entry in his diary of 1 March 1923 Kirchner made a different claim: 'Schmidt-Rottluff had tried his hand at lithography at a Dresden printer, but we were only able to appreciate the value of the technique properly when a stone chanced to come into my possession, and after much experimenting I discovered the technical tricks for myself, as well as the process of hand-printing. As I was making my first successful print Heckel came into the studio – I can still see it – and at once recognized the great possibilities of the new technique, and soon we were all three making lithographs.'[19] This might be discounted as a typical case of Kirchner's self-promotion, but there is also the fact that, according to Schapire, Schmidt-Rottluff only began to print his lithographs himself in 1908. This coincides with a fundamental change in his manner of lithography that occurs in mid-1908. To judge from the prints that I have seen, it is fairly clear that only then did he acquire his own stone, ink it up to the edges, and adopt the over-etching and turpentine processes. It does, therefore, seem certain that the invention of the characteristic devices of Brücke lithography must be credited to Kirchner (or possibly Heckel) in 1907.

The Brücke approach to colour lithography was as original as that to black and white. The traditional method involved using a different stone for printing each colour. Since the members in general did not possess more than one stone of a similar size, their first recourse was simply to grind down the stone and use it afresh for each successive colour. This was done by Heckel and Kirchner in (at least) the early years, 1907–9. In a few prints by Pechstein of 1908–9 a much simpler process is found: having printed the design lithographically from the stone in black ink, he then used the same stone as a matrix on which to paint the colours which were then transferred to the print by simple pressure in the fashion for making a monotype.[20]

In Kirchner's colour lithographs of 1912 and later another process is evident. According to Kirchner, writing under the pseudonym L. de Marsalle, it was he who 'found a process of colouring that allowed him to print from a single stone colour lithographs with as many colour plates as desired. Thus, in a process similar to painting he created colour prints of great excitement.'[21] That this is true is shown by the parallel contours found on the prints themselves (see 78). The account, however, does not explain how Kirchner managed the trick, nor does Schiefler help. It is clear that Kirchner was deliberately keeping it secret, although he may have explained it to the other members of the Brücke, since a few works by them seem to use the same process.

The problem is this: the basic drawing is always printed in black in the usual way. The stone could be resensitised and, using the original drawing as a key, extra lines of drawing could be added which were intended to be printed in colour. However, when the stone was desensitised and prepared for printing in colour, the lines of the original design had to be stopped out so that only the newly added lines attracted printing ink. The Dubes suggest that the stone was lightly ground down between the printing of each colour, enough presumably

to prevent the original drawing from printing again, but not so much as to make it vanish and be unusable as a key for further drawing.[22] Another possible clue is given by Schiefler's description of his number 139, *Man and woman bathers*: 'An experiment to find a method of printing aniline coloured inks, in which one renders the stone capable of receiving ink by corroding [etching] only at certain places'. This would help to explain why the colour areas always look as though they are brushed on and are quite unlike the drawing printed in black.

Kirchner frequently, especially in the years 1913–16, printed his lithographs on a yellow paper (as in 78). In a few exceptional cases (e.g. *Camel and Dromedary*, Dube 310, at Frankfurt) he printed impressions on two papers of different colours and then collaged figures cut out of one impression on top of the other.

A final point of curiosity is awakened by Schiefler's statement that Kirchner often made his lithographs directly from nature;[23] Pechstein also records taking a stone with him to the Moritzburg lakes.[24] This is startling: lithographic stones are very heavy; impressions would have had to be taken off by hand without a press; and only if they had taken a second stone would it have been simple to grind off an image. The most they are likely to have done is to have drawn on both sides of the stone, leaving the printing till they were back in their studios.

INTAGLIO

Heckel and Kirchner took up intaglio in 1906, after woodcut but before lithography. According to Kirchner's reminiscences in 1921 it was Heckel who led the way. Their first prints are very uncertain and show that they were having to teach themselves the processes. The majority of their prints up to about 1909 are etchings; between 1910 and 1913 they are almost entirely drypoints. Schmidt-Rottluff, who took up the medium in 1907, made only a few etchings before turning exclusively to drypoint, whereas Pechstein made a large group of etchings in 1908, thereafter making mostly drypoints until his departure for the South Seas in 1913. Many drypoints make use of burr (see 87), but the members used this sparingly, probably because an over-indulgence in burr was a vice of much contemporary printmaking.

From the earliest attempts the Brücke sought to enliven the finish of the prints by producing such effects on the surface as would make it evident that a metal plate had been used. Often the effects were more due to chance than deliberately worked: old plates, or the backs of plates, were used which had random pitting or scratching. Schiefler records giving Heckel and Kirchner a number of rusted copper plates in 1910 on which they made their drypoints of scenes in the town and cabarets of Hamburg.[25] Schmidt-Rottluff on one occasion used an iron plate (Schapire 64), as did Nolde in most of his prints between 1907 and 1918 (according to Schiefler's catalogue). Surfaces such as these would have to have had a film of ink left on them in the wiping if the full range of effects was to be brought out, and this was indeed the case in almost all intaglio prints of the Brücke period, with the exception of Nolde's, which carry so much working that they needed no aid from wiping. But deliberate manipulation of inking to create variant tone on the surface is, in my experience, fairly unusual at this time. Perhaps for this reason both Kirchner and Heckel on occasion had their plates printed for them by expert professional printers: Felsing's signature is occasionally found on impressions, particularly in the early years.[26]

Deliberately added tonal etching is found in a good number of Brücke prints, although probably most of them do not have it. It almost invariably presents

great problems in description, since it is unclear how precisely it was made. Very few of the prints can be classed as conventional aquatints, in that they do not have a regular ground laid on the plate which is stopped out and bitten to different depths. Some seem to have the recognisable 'pooled' effect from aquatint resin given by the acid biting round the individual grains, but the finish is so irregular that either the resin or the acid must have been applied unevenly. Stopping out is rarely seen. Far more frequent than aquatint is a process which produces a variably pitted effect on the plate; from the way it appears on the plate it is evident that it was brushed on and that some corrosive substance must have been employed. In Schiefler's catalogue of Kirchner's prints this is referred to simply as 'Flächenätzung' – 'plane etching' – by which he probably means a direct washing of the plate with acid without any ground at all (what is now called 'open bite'). This could be combined with a coarse resin ground. Another possibility is that they used sulphur. In Hermann Struck's contemporary treatise (*Die Kunst des Radierens*, Berlin 1908, p. 123) a paragraph is devoted to this technique: the powdered sulphur is mixed with oil and brushed onto the plate. This is then warmed, which causes the sulphur to begin to eat into the metal. Heckel and Schmidt-Rottluff, especially in the years after their move to Berlin, frequently used a much simpler method of scratching part or the whole of the surface of the plate with a file (sometimes burnishing down lighter areas) to create a surface texture. In one exceptional etching of 1908 (*Fehmarner Bauernhäuser*, Dube 47) Kirchner seems to have used a mechanical burnisher over the toned area to give an appearance of movement to the leaves of the tree. Both impressions of this print that I have seen are printed in blue ink, and Kirchner, Heckel and Pechstein all used such coloured inks in their etchings on occasion.

After Kirchner's move to Switzerland intaglio printmaking began to occupy a much more important place in his output. Although some are complicated aquatints (cf. 82), the majority are drypoints in which the lines are reduced to the simplest and burr is avoided. Such plates rely for their success almost entirely on the way in which Kirchner printed them. He now deliberately left films of ink on the surface in variable thicknesses: flesh areas, for example, would be more or less clean-wiped while backgrounds would be largely obscured. On occasion so much ink is arranged on the surface of a plate as to make the resulting print virtually a monotype.[27] For these prints Kirchner usually used a shiny chalk-surfaced paper; being non-absorbent it left the nuances of wiping clearly visible, including often thumb prints round the edge.[28] Another technique that Kirchner very occasionally used in these years is the multi-coloured inking of a single plate: an impression of *Alpleben* of 1919 (Dube 250) in Hamburg is inked in green with dabs of red and blue brushed on the surface to define cows and men. But I know hardly any impressions of his prints in any medium which are hand-coloured after printing. The only artists of the Brücke who seem to have done this regularly were Nolde in his early lithographs and Pechstein in a large number of woodcuts and lithographs around 1912.

Nolde was the finest intaglio printmaker of the Brücke. As the 'Chronik der Brücke' phrased it, 'he enriched our exhibitions with the interesting technique of his etchings'. He clearly never explained to his colleagues what these techniques were, for they never employed them themselves. One can only imagine that Nolde, who had discovered them for himself some time before any of the Dresden artists had touched a copper plate, was determined to keep his secrets from

them. In his autobiography he supplied a graphic but technically uninformative description of how he had made his first, and greatest, set of prints, the 'Phantasien' (cf. 105) in a two-week burst of activity in late October 1905: 'I worked, scratched and etched, so that everything around me, linen, carpets, clothes suffered too. "Ghost," "Young Life", "Solicitation", "Joy of Life" were some of the titles that I had to find for the prints, found, that is, after the image was already invented . . . I laid the drawn and more or less covered blank copper-plates in the poison bath, achieved nuanced effects of light and dark that delighted me . . . '[29]

The tonal effects that Nolde achieved in his etchings are scarcely paralleled in the work of any other printmaker; and since there is no conventional descriptive label for them, the entries in this catalogue simply refer to 'tonal effects'. Schiefler observed that 'they recall what is usually called aquatint, but differ in that any uniformity of tone is avoided. The etching ground is obviously laid on the different parts of the plate in differing depths so that the plate is exposed in one place sooner, in another later, to the action of the acid. Moreover the method of the laying on, whether it is with a bristly or a fine brush, a palette knife or the fingers, whether it is spread out or left in a mass, also has its effect and gives the tone sometimes a streaky or cloudy, sometimes a grainy or fleck-like character'.[30] Elsewhere he talks of an 'asphalt technique, similar to aquatint',[31] and this doubtless gives the composition of Nolde's ground. By applying liquid asphaltum with a stiff brush he could thin the ground, or lay bare the surface of the plate to produce his characteristic 'brush-mark' effect (cf. 105). These processes were doubtless repeated several times in order to get the complicated textures seen in so many prints. Nolde heightened the effects, particularly in his earliest etchings, by printing in various unusual colours of ink, among which blues, browns and greens recur.

Schiefler also records that he used iron plates from 1907, partly because they were cheaper than copper, but also because he liked the shining surface.[32] In 1911 he purchased from a Sonderburg shipwright a pile of copper plates intended for cladding the hull of a ship which were severely oxydized. Nolde made a series of drypoints on these plates, liking the appearance of the copper against the dark plate tone, but only then found that they were impossible to print as the pitted, rusted surface held far too much ink. Only after considerable burnishing could reasonable impressions be obtained.[33]

ANTONY GRIFFITHS

APPENDIX: HECKEL ON BRÜCKE LITHOGRAPHY

The following translation has been made from an edited version of a tape-recording of a conversation held between Erich Heckel and Roman Norbert Ketterer on 24 October 1958. I owe permission to publish this extremely important document to the kindness of Herr Ketterer, who retains the copyright; I must also thank Ruth Cole Kainen who approached Herr Ketterer on our behalf. Since this document only arrived at a very late stage in the preparation of the catalogue, there has been no chance to incorporate its contents into the preceding essay. The elucidations in the square brackets have been added by me.

'In 1907 we were given a single lithographic stone by a lithographic printing firm. On this stone E.L. Kirchner and I made in turn the most varied experiments; from these emerged potentialities which were not to be met in normal practice in making lithographs. We were not searching for new techniques, but our methods of working the litho stone gave rise to new possibilities.

'All other artists usually use transfer paper on which they draw with lithographic crayon; they then hand the paper over to a lithographic firm. The printer who is on duty that day transfers the drawing from the paper to a stone, which he prepares according to the established procedures and prints 50 or 100 impressions according to the artist's wish.

'In the case of Kirchner and myself, we ourselves applied the gum arabic to the single stone that we had and pulled impressions with our own hands. In the course of working on the stone new technical possibilities emerged which a conventional litho-printer would never adopt. Kirchner and I found out how to make certain parts of the stone come out grey by reducing the black crayon with the help of acid to a grey tone. No lithographic printer in the world would allow such a thing. He would claim that such a method would damage the surface of the stone and thus make it unusable on future occasions.

'Kirchner and I could create intermediary tones on those parts of the drawing where we wanted them. Thus we had firmly in our grasp all the possible tones which could be given to a lithograph, and we could apply with our own hands effects that looked like accidents. The stone was always wetted before we printed from it, since the stone remains wet in those areas that it has been etched and repels the printing ink. But in those parts where it is greasy, it repels the water and attracts the printing ink. We could wash the whole stone each time with coloured water, either yellow, grey or blue. This coloured water is printed at the same time, so that the design appears on the paper in black printing ink and also with watercolour. So we had a coloured lithograph.

'One can also print colour lithographs from several stones. But Kirchner and I took one and the same stone which we printed in monotype fashion.

'There were obviously also cases where we wanted to print lithographs with the colours one on top of the other. We took our litho stone and polished it down until we could only just see the drawing, and redrew with greasy crayon those places which we wanted blue. This [i.e. printing in blue over the first printing which had been in black] was the second printing operation. Already at the first printing operation we had had to decide, since we only had a limited supply of paper, whether we wanted to print five or more impressions [the polishing down destroyed the original drawing so that it could not be reprinted], and where we would put the black drawing on the stone and where later a blue stroke would be added. If we wanted yet a third colour, we could take yellow and add it to the same stone [presumably after removing the traces of the crayon used to print the blue].

'All these difficulties we would not have had to cope with if we had had several stones. But since we only had the one stone, we took all our impressions from this stone.

'It is interesting to note that in using a lithographic stone one has the possibility of doing a lot of work on it. This is not so with a woodcut; what is cut away there has gone for ever. But with our litho stone we could take a pumice-stone and polish off certain parts of the design; if one then reduces these places with alum, one can then redraw them afresh, so that the resulting drawing gives the impression of being completely new. We could correct the lithographic stone and move whole lines from one place to another without anyone noticing the correction. This obviously has great advantages, especially if one wants to experiment in the way that Kirchner and I did. This was the most interesting thing about the lithographic stone.'

Notes

1. Published in *Genius*, II, 1921, pp. 250–63 under the pseudonym 'L. de Marsalle' and often reprinted (for example by Grisebach, *op. cit.*, note 14). A partial translation is to be found in the English edition of Kristian Sotriffer *Expressionism and Fauvism*, Vienna 1972, pp. 121–3; a full translation is in Victor Miesel, *Voices of German Expressionism*, Englewood Cliffs 1970, pp. 24–7.

2. Published in *Das graphische Jahr, Fritz Gurlitt*, Berlin 1921, p. 101. Translated in Sotriffer, *op. cit.*, p. 123.

3. First published 1927; reprinted with additional material edited by Gerhard Schack, Hamburg 1974.

4. The dates assigned in the Dubes' catalogues have to be treated with great caution. A striking example of the problems that need to be resolved is presented by two impressions of Heckel woodcuts in the Kunsthalle, Bremen (Dube 46 and 155) which were acquired in 1907 and 1908 respectively. Both carry autograph signatures and the date 07, which must almost certainly be accurate. The Dubes, however, date the first print 1905, and the second 1908.

5. *Meine Graphiksammlung*, 1974, p. 54.

6. Jacob Kainen thinks that the members of the Brücke scarcely used a platen press. He comments that pulling the bar handle against the springs is most difficult and requires a knack; they could have printed the small editions of their woodcuts by less strenuous means.

7. Cf. Pechstein's essay, first paragraph (see note 2 above).

8. Such painting on would most probably have been done through a stencil. In the entry for 76 it is argued that Kirchner applied the colour through stencils, though it is unclear whether the colour was applied directly or indirectly. The indirect method of using the stencil in reverse to apply colour to a flat wooden block would give the colour areas in the final impression a printed rather than hand-added texture. This would survive whether the colours were brushed, dabbed or rolled through the stencil. It is quite possible that a high proportion of Brücke colour woodcuts will prove to have been printed this way. Kandinsky must also have used a similar process (cf. 120).

9. An impression of a Schmidt-Rottluff woodcut of 1905, *Sommernächtliche Strasse* (Viotto 8), in the Kunsthalle Hamburg is printed in blue, and is annotated *Aquarelldruck*. It is possible that watercolour might have been used in some of Heckel's colour woodcuts.

10. The exceptions are Schmidt-Rottluff's woodcuts of 1911 and Kirchner's colour woodcuts made by inking with a brush.

11. Schiefler, *Die Graphik E.L. Kirchners*, II, Berlin 1931, p. 33.

12. Schiefler, *Die Graphik E.L. Kirchners*, I, Berlin 1926, introduction.

13. The Dubes describe the process thus: 'the stone is wetted with turpentine and water, this fluid is in some parts allowed to stand, and in others renewed, until the desired gradations of tone are achieved' (*E.L. Kirchner, das graphische Werk*, I, 1967, p. 14). When the stone was dry, it was etched in the usual way. The irregular residue of turpentine, being greasier than the water, gave slightly more resistance to the etch and helped create subtle modulations.

14. Schiefler, *op. cit.*, II (1931), p. 34.

15. He talks in his essay of 1921 of having made lithographs 'in four different formats'.

16. Against this there is the evidence of Heckel: see the Appendix.

17. *Meine Graphiksammlung*, 1974, p. 56.

18. Translated in P. Selz, *German Expressionist painting*, Berkeley 1957, pp. 320–1, and numerous other books.

19. *E.L. Kirchners Davoser Tagebuch*, ed. L. Grisebach, Cologne 1968, p. 74. A similar claim is implied by another statement in the 'Chronik der Brücke' to the effect that 'Kirchner made the first lithos by hand'.

20. An impression of *Kind auf der Bank* of 1908 (Fechter 31), illustrated in *Pechstein Zeichnungen, Druckgraphik*, Kunsthandel Wolfgang Werner KG, Bremen 1981, cat. 38, was certainly printed in this way. Herr Werner tells me that he has seen a second, but weaker, pull from the same stone. Jacob and Ruth Kainen possess an impression of *Variété Tänzerin* printed in the same way. Some of Heckel's colour lithographs of 1912 may have been printed like this.

21. 'Über Kirchners Graphik', see note 1 above.

22. *E.L. Kirchner, das graphische Werk*, I 1967, p. 14. (This is the correct answer: see the Appendix).

23. Schiefler, *Die Graphik E.L. Kirchners*, II, 1931, p. 27.

24. Cf. Pechstein's essay, second paragraph (see note 2 above).

25. *Meine Graphiksammlung*, 1974, p. 56.

26. An impression of Kirchner's *Fehmarner Bauernhäuser* (Dube 47) in blue, with Felsing's signature, is in Hamburg (inv. 1961/118).

27. For example, in the Hamburg impression of *Mädchen im Regen* (Dube 305) of 1920, the streaks of rain are entirely defined by lines wiped clean from a heavy overall surface tone.

28. Jacob Kainen sends me this comment: 'The shiny, chalk-surfaced paper goes against the character of both etching and drypoint. Since the paper is almost impossible to dampen properly, great pressure is required to press the paper into the etched lines to draw out the ink. Often the ink doesn't come out fully and white spots appear in some lines. In drypoint the burr is quickly crushed. In his self-destructive way, Kirchner seemed to court failure as a sign of integrity.'

29. *Mein Leben*, Cologne 1976, p. 141.

30. Introduction to his catalogue of Nolde's prints, *Das graphische Werk bis 1910*, I, Berlin 1911, p. 7.

31. *Meine Graphiksammlung*, 1974, p. 47.

32. *Op. cit.*, 1974, p. 48.

33. *Op. cit.*, 1974, pp. 51–2.

Bibliography

The following books are only a
small selection from the huge number
available which have been of great
value in compiling this catalogue. The
arrangement within the three sections is
by date of publication. The choice is
biased towards works written in English,
and omits all works on individual artists
which are to be found in the individual
bibliographies after their biographies.
The abbreviated references within the
catalogue entries refer to these individual
bibliographies.

Historical and Literary Background

Albert Soergel, *Dichtung und Dichter der
Zeit*, 3 vols, Leipzig 1911–34; new ed by
Curt Hohoff in two vols, Dusseldorf
1961–3. (A very thorough literary
history.)

Siegfried Kracauer, *From Caligari to Hitler:
a psychological history of the German film*,
Princeton 1947

John Willett, *Expressionism*, London 1970

Roy Pascal, *From Naturalism to
Expressionism*, London 1973

Paul Raabe (ed.), *The era of German
Expressionism*, London 1974
(German edn 1965). (An anthology of
source material.)

Gordon A. Craig, *Germany 1866–1945*,
Oxford 1978

John Willett, *The new sobriety, Art and
politics in the Weimar period 1917–33*,
London 1978

Eberhard Roters (ed.), *Berlin 1910–1933*,
New York 1982

Artistic Background, Painting and Sculpture

Paul Ortwin Rave, *Kunstdiktatur im
Dritten Reich*, Hamburg 1949

Nell Walden and **Lothar Schreyer**,
Der Sturm, Baden-Baden 1954

Lothar-Günther Buchheim, *Die
Künstlergemeinschaft Brücke*, Feldafing
1956. (Still useful as a collection of
reproductions.)

German art of the twentieth century,
exhibition catalogue, Museum of Modern
Art, New York 1957. (With essays
by W. Haftmann, A. Hentzen and
W.S. Liebermann on painting, sculpture
and prints.)

Peter Selz, *German Expressionist painting*,
Berkeley 1957. (The standard history,
although seriously out of date.)

Lothar-Günther Buchheim, *Der Blaue
Reiter*, Feldafing 1959

Hans H. Hofstätter, *Geschichte der
europäischen Jugendstilmalerei*,
Cologne 1963

Hans Richter, *Dada, art and anti-art*,
London 1965 (German edn 1964)

Hans M. Wingler, *The Bauhaus*,
Cambridge, Mass. 1969 (German edn
1962, revised edn 1975). (This contains
a full bibliography.)

Eberhard Steneberg, *Russische Kunst
Berlin 1919–32*, Berlin 1969

William S. Rubin, *Dada and Surrealist art*,
London 1969

Helga Kliemann, *Die Novembergruppe*,
Berlin 1969

Wieland Schmied, *Neue Sachlichkeit und
magischer Realismus in Deutschland
1918–33*, Hanover 1969

Wolf-Dieter Dube, *The Expressionists*,
London 1972

Kenworth Moffett, *Meier-Graefe as art
critic*, Munich 1973

Rosel Gollek, *Der Blaue Reiter im
Lenbachhaus München*, Munich 1974

Donald E. Gordon, *Modern Art Exhibitions
1900–1916*, 2 vols, Munich 1974

Tendenzen der Zwanziger Jahre, exhibition
catalogue, Berlin 1977

Georg Reinhardt, 'Die frühe Brücke
1905–1908' in *Brücke-Archiv*
9/10, 1977/8

Dada and Surrealism reviewed, exhibition
catalogue, Arts Council, London 1978

*Neue Sachlichkeit and German Realism of
the twenties*, exhibition catalogue, Arts
Council, London 1978

Paris–Berlin 1900–1933, exhibition
catalogue, Centre Georges Pompidou,
Paris 1978

*The Expressionist Revolution in German
art 1871–1933* (collection catalogue)
Leicestershire Museums and Art Gallery,
1978

Peter Paret, *The Berlin Secession,
Modernism and its enemies in imperial
Germany*, Cambridge, Mass. 1980

*Abstraction: Towards a new art, Painting
1910–20*, exhibition catalogue,
Tate Gallery 1980

Christine Lodder, *Russian Constructivism*,
London 1983

Georg Brühl, *Herwarth Walden und
'Der Sturm'*, Leipzig 1983

German Expressionist Sculpture, exhibition
catalogue, Los Angeles County Museum,
1983

Wolf-Dieter Dube, *Der Expressionismus
in Wort und Bild*, Geneva 1983

Frank Whitford, *Bauhaus*, London 1984

Printmaking

H.W. Singer, *Die moderne Graphik*,
Leipzig 1914

Curt Glaser, *Die Graphik der Neuzeit*,
Berlin 1922

G.F. Hartlaub, *Die Graphik des
Expressionismus in Deutschland*, Stuttgart
1947

*Künstlergruppe Brücke Jahresmappe
1906–12*, exhibition catalogue, Klipstein
& Kornfeld, Bern 1958

Lothar-Günther Buchheim, *The graphic
art of German Expressionism*, Feldafing
1960 (German edn 1959)

Hans M. Wingler, *Graphic Work from the
Bauhaus*, London 1969 (German
edn 1965)

Kristian Sotriffer, *Expressionism and
Fauvism*, Vienna 1972

Gustav Schiefler, *Meine Graphiksammlung*,
Hamburg 1974 (1st edn 1927)

Bilder aus der grossen Stadt, exhibition
catalogue, Kupferstichkabinett
(West) Berlin, 1977

*German Expressionist Art, the Robert
Gore Rifkind collection*, exhibition
catalogue, University of California, Los
Angeles 1977. (Useful for Expressionist
periodicals.)

Die Brücke – Edvard Munch, exhibition
catalogue, Munch Museum, Oslo 1978

*The artistic revival of the woodcut in
France 1850–1900*, exhibition catalogue,
Ann Arbor (University of Michigan
Museum of Art) 1984. (See the essay by
Richard S. Field, the best discussion of
the background to the Brücke woodcut.)

Descriptions of the techniques of
printmaking can be found in two British
Museum publications. Antony Griffiths,
*Prints and Printmaking, an introduction to
the history and techniques*, 1980, and
Paul Goldman, *Looking at prints, a guide
to technical terms*, 1981.

List of Artists included

MAX KLINGER

(1857–1920)

Born in Leipzig, the second son of a wealthy soap manufacturer. Between 1874 and 1876 he studied in Karlsruhe and Berlin under Karl Gussow (a realistic genre painter). He first came to public notice in 1878 with the exhibition in Berlin of his painting *Überfall an der Mauer* and his series of pen drawings, 'Ratschläge zu einem Konkurrenz über das Thema Christus' (Suggestions for a competition on the theme of Christ) and 'Ein Handschuh' (A glove) (see 1–10). For the next twenty-five years he lived in different parts of Europe. He was in Brussels, Munich and Berlin between 1879 and 1882, and spent the following three years mainly in Paris. According to his letters to his family, he lived as a recluse in these cities, concentrating on his drawings and etchings. In 1888 he moved to Italy, where he had a studio in Rome. He returned to Leipzig eventually in 1893, and over the next three years designed and had built a remarkable house and studio on a piece of land owned by his parents. These years also saw his swift rise to national fame; he became wealthy and an important figure in cultural life. He only married in 1919 Gertrud Bock whom he had known since 1910/11. He had previously lived with an extraordinary woman, Elsa Asenijeff, the wife of a Bulgarian diplomat, who seems to have modelled her behaviour on *fin-de-siècle* ideas of the *'femme fatale'* and who bore him an illegitimate daughter in 1900 (cf. the exhibition catalogue, *Max Klinger*, National Gallery of Victoria, Melbourne 1981, p. 6).

Klinger produced most of his prints in sets to which he assigned opus numbers. (The analogy with music was deliberate: Klinger was a fine pianist and counted Brahms, Reger and Richard Strauss as friends.

In 1894 he dedicated his opus XII, 'Brahmsphantasie', to Brahms, and in return was the dedicatee of Brahms's 'Vier ernste Gesänge', opus 121, in 1896.) Most of the sets were produced at the beginning of his career: opus I–IX were produced between 1879 and 1883, when Klinger was not yet twenty-six years old. The remaining opus X–XIV followed at irregular intervals between 1879 and 1915 and are in general of much lower quality. This second group is also marked by a technical distinction; he no longer used simply etching and aquatint, but adopted the engraving tool for modelling and shadow. This he owed to his friend Karl Stauffer-Bern, who had adopted it from the French engraver Ferdinand Gaillard. In 1887 Klinger exhibited the *Judgement of Paris*, a huge painting in an elaborate architectural frame set with his own sculpture (a 'Raumkunstwerk') and he henceforth concentrated on such large paintings and polychrome sculptures. The most famous of these is the huge *Beethoven* which was shown in 1902 in the fourteenth exhibition of the Vienna Secession in a hall designed for it by Josef Hoffmann, with murals by Roller, Böhm and Andri; Klimt's *Beethovenfrieze* was painted for the same occasion (see Peter Vergo, *Art in Vienna 1898–1918*, London 1975, pp. 67–77).

The catalogue of the exhibition spoke of the Viennese artists' reverence for Klinger, 'who, both through his creative activity and his writings, has illuminated our whole view of art'. The position that Klinger held in German art at the time of his death depended very largely on these remarkable monstrosities of his declining years. They are very much products of their time, being influenced by Wagnerian ideas of the 'Gesamtkunstwerk' and the curious view of classical antiquity then prevalent. It seems unlikely that future generations will ever be able to look at them with the awe and

reverence that they were intended to evoke. Klinger's early work, however, which is almost entirely confined to drawings and prints, retains its original interest, and his interior decorations (in so far as they can now be reconstructed) for his own and patrons' houses, are outstanding in their time for their quality and idiosyncrasy.

See 231 for the 'Amor and Psyche' series.

Bibliography

Between the 1890s, when Klinger rose to national fame, and his death in 1920 a very large number of books and articles were devoted to his work. The most useful monograph is by Paul Kuhn, *Max Klinger*, Leipzig 1907. An invaluable collection of reproductions has an introduction by F.H. Meissner, *Max Klinger, Radirungen, Zeichnungen, Bilder, Skulpturen ... in Nachbildungen durch Heliogravure*, Munich (Hanfstaengel) 1897. There is, however, no significant publication of Klinger's early drawings, which are quite as remarkable as the prints. The standard catalogue of his prints is by H.W. Singer, *Max Klingers Radirungen, Stiche und Steindrücke*, Berlin 1909, which contains reproductions of every item. Singer also edited a selection of Klinger's letters – *Briefe von Max Klinger aus den Jahren 1874 bis 1919*, Leipzig 1924. Also of importance in revealing Klinger's ideas is the book edited by H. Heyne, *Gedanken und Bilder aus der Werkstatt des werdenden Meisters*, Leipzig 1925. The modern revival of scholarly interest in Klinger's work began with the catalogue of an exhibition held at the Museum der bildenden Künste in Leipzig in 1970, which contains the best available biography. An important recent study is Alexander Dückers, *Max Klinger*, Berlin 1976. The only work in English is J. Kirk T. Varnedoe with Elizabeth Streicher, *Max Klinger Graphic Works*, New York (Dover) 1977, which gives a good selection of reproductions of his prints with a commentary.

1-10 'Ein Handschuh' (A glove), Opus VI 1881

The ten prints of this series were based on ten drawings which Klinger had exhibited at the Kunstverein in Berlin in April 1878 under the title 'Phantasien über einen verlorenen Handschuh; der Verliererin gewidmet' (Fantasies on a lost glove; dedicated to the lady who lost it). They are his first important works, although the prints were only published three years later. Comparison with photographs of the original drawings (which are now in a private collection in Hamburg) shows that the prints follow them very closely. It should be noted that such series of drawings were not unusual at the time: in the 1878 Akademie der Künste exhibition two other series were on show, Johann Gehrts's 'Ein glückliches Leben' and J.G. Pfannschmidt's 'Das Leiden des Propheten Daniels', each in six sheets.

Klinger gave each plate a one-word title but never published any commentary on the series. The sequence of events is however fairly clear. The first two plates show prosaic scenes from everyday life. Klinger sees a lady in a roller-skating rink, and picks up a glove she has dropped. In the third plate fantasy breaks in as the artist in bed at night begins fantasising and imagines a series of extraordinary adventures into which it leads him. Plates 3 to 6 are optimistic: the escaped glove is rescued and borne in triumph. But in the last four plates, the mood changes as a monster bears the glove off. There is a certain amount of evidence that the drawings were originally envisaged in a different order. This evidence is contained in George Brandes's review of the 1878 exhibition in *The Academy* of 16 November 1878, and in an undated letter from Klinger to his mother (*Briefe*, no. 20); but unfortunately these two sources point to mutually incompatible sequences. Klinger's letter also provides a 'few words of commentary' to correct 'the false and long-winded descriptions of these sheets by critics on all sides', and reference is made to this in the notes in individual plates in this catalogue. A little further light is shed on the prints by the variant titles found on a set of proofs (see J. Kirk T. Varnedoe 1977, p. 81).

To the modern eye the series is strikingly precocious in its interest in dream imagery, for Freud's *Interpretation of Dreams* was only published in 1900. Alexander Dückers has, however, shown (1976, pp. 125–6) that there already existed a substantial literature on dreams on which Klinger could have drawn; Freud's contribution in 1900 was to argue that the source for their imagery lay in the sexual drive. (Freud curiously makes no mention of Klinger in his treatise.) Klinger's interest in dreams is apparent in other early works. Dückers reproduces (pp. 121–3) several early drawings of nightmares which are similar in intensity to some of Goya's most disturbing work. Singer (1909, p. x) records that Klinger told him that he got some of his best ideas in the morning, in the time between sleeping and waking. To this can be added the fact that Klinger himself had suffered a bad attack of warts on his hands in 1875 and had had to wear gloves even at meals for some time (*Briefe* p. 13). The series has been admired both by de Chirico and the Surrealists, and is now probably Klinger's best-known work.

The second date on the last print shows that work on the etchings had begun in 1880. They were first published in 1881. The set exhibited here comes from the fourth edition of 1898. Five others of Klinger's series were reprinted in this year, and sold through Amsler & Ruthardt in Berlin. Their advertisements printed at the end of Max Schmid's *Klinger* (Bielefeld and Leipzig 1899) shows that they were asking 80 Marks for the 'Glove' series. The twelve prints of 'Vom Tode. II Teil' were priced at 900 Marks, though this was a first edition rather than a reprint. A fifth edition of the 'Glove' was published in 1924.

1 PLATE 1 *Ort* (Place)

Etching and aquatint. 346 × 252 mm
Singer 113, fifth state
1980-7-26-33(1)

The two men at the extreme left are Klinger himself (wearing spectacles) and his friend, the painter and sculptor Hermann Prell (1854–1922). They are watching the entrance of a lady at the opposite side of the room. Kuhn (1907, p. 60) identifies her as a Brazilian. He also notes that the frozen movement of the scene is reminiscent of a fashion plate. It has always been assumed by commentators that the series arose out of an actual unhappy love of Klinger's, and this seems most probable, although apparently Klinger never actually confirmed this anywhere.

2 PLATE 2 *Handlung* (Action)

Etching. 297 × 205 mm
Singer 114, sixth state
1980-7-26-33(2)

The Brazilian lady, flanked by two men, skates away in the background having dropped her glove, which is at once picked up by Klinger.

3 PLATE 3 *Wünsche* (Yearnings)

Etching and aquatint. 316 × 132 mm
Singer 115, sixth state
1980-7-26-33(3)

Klinger sits in bed with the glove before him. The scene is set by the candle and glass of water. The wall beside the bed has however opened out into a moonlit landscape. In the distance beside the four stems of the flowering tree is the tiny figure of a woman. Kuhn saw in this scene the influence of Jean Paul's *Titan*, a novel of thwarted and requited love published between 1800 and 1803. This was most famous for its description of landscapes, especially at night. A variant drawing for this plate is illustrated in *Gedanken und Bilder* p. 61.

4 PLATE 4 *Rettung* (Rescue)

Etching. 233 × 174 mm
Singer 116, seventh state
1980-7-26-33(4)

The man in the boat wearing a trilby hat is to be identified as the artist himself.

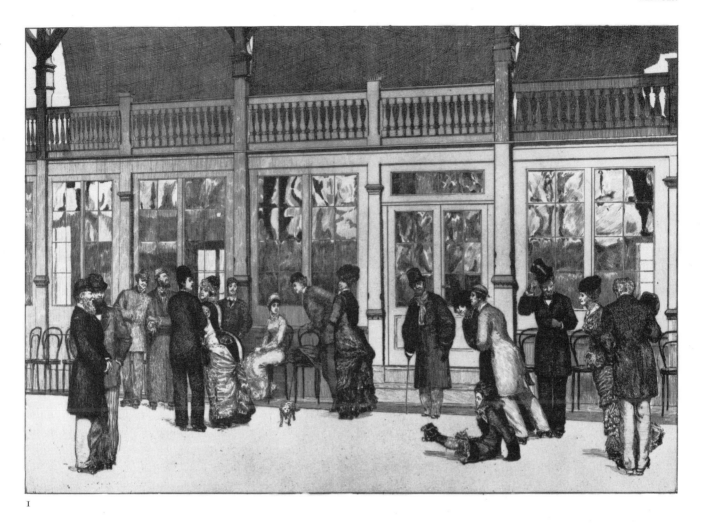

1

5 PLATE 5 *Triumph*

Etching. 137 × 261 mm
Singer 114, fifth state
1980–7–26–33(5)

It is assumed that the rescue of the previous plate has been successful, and the glove is now carried by two sea-horses. The extraordinary chariot made of a shell reminds the modern viewer of Salvador Dali's sofa in the shape of Mae West's lips (cf. Dawn Ades, *Dali*, London 1982, p. 164). Klinger's gift as a designer is to be seen in the ornamental scrolls of foliage into which the waves have been transformed.

6 PLATE 6 *Huldigung* (Homage)

Etching. 153 × 325 mm
Singer 118, fifth state
1980–7–26–33(6)

The glove is placed by the seashore on a rock transformed into a sort of altar by the two torches. The breaking waves are covered with roses.

7 PLATE 7 *Ängste* (Fears)

Etching. 138 × 265 mm
Singer 119, fifth state
1980–7–26–33(7)

This plate introduces the second part of the cycle. The artist is asleep in his bed again; the candle and landscape are the same as in plate 3. The glove, now grown to a monstrous size, seems to threaten him, and in his nightmare a horde of ugly monsters borne by a wave assail him. In Klinger's letter to his mother he states that this plate 'shows how the certainty of handing back the glove oppresses the finder as a nightmare; the dragon is the future personification of the same.'

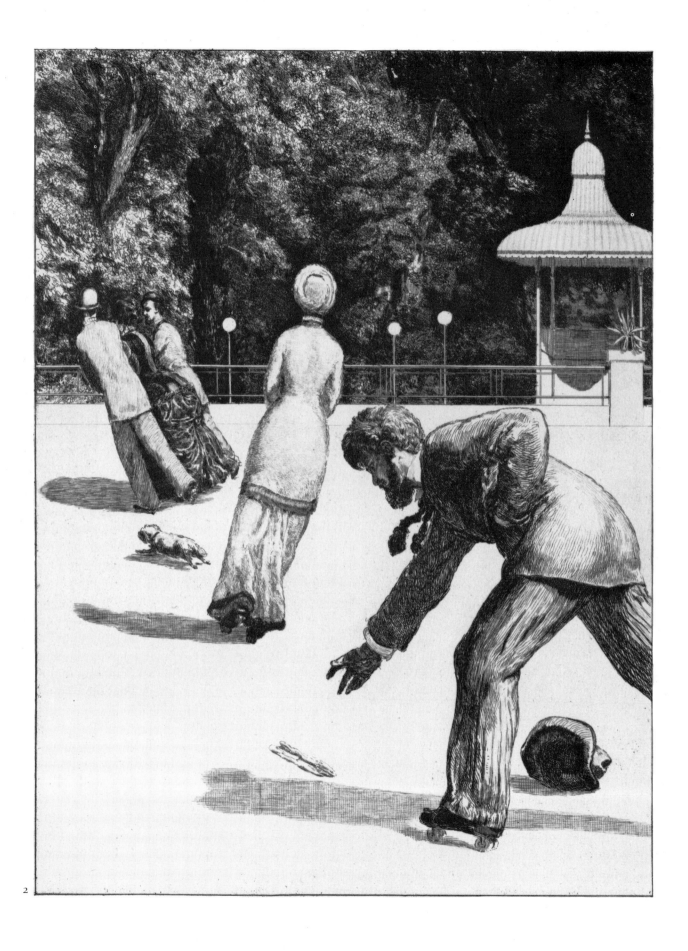

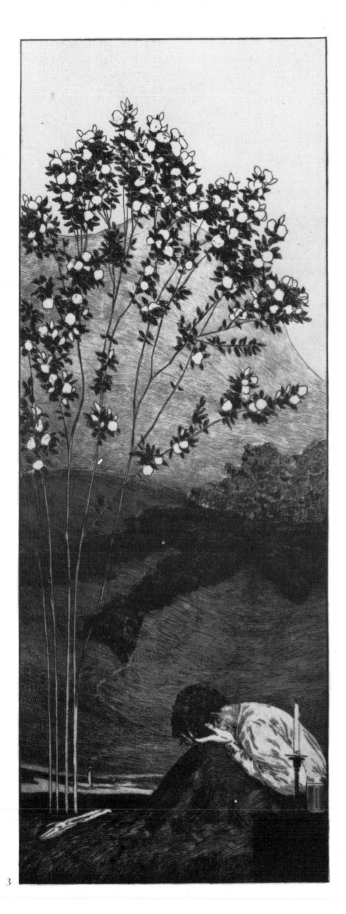

3

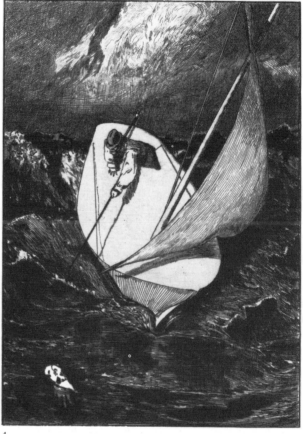

4

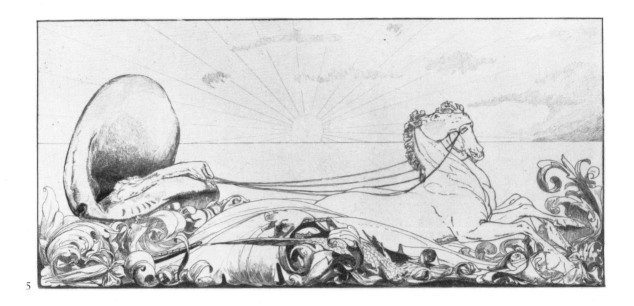

5

6

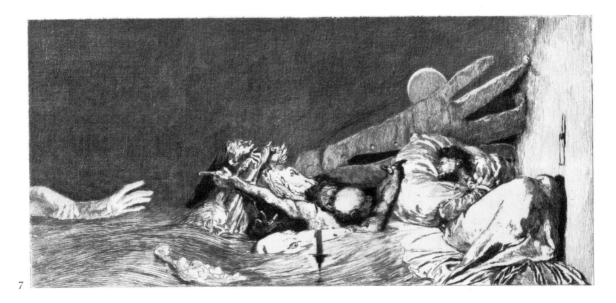

7

8 PLATE 8 *Ruhe* (Repose)

Etching. 137 × 262 mm
Singer 120, fifth state
1980-7-26-33(8)

The glove is placed on a pedestal in a room, the back of which is curtained by a line of gloves arranged in pairs facing alternately around a single glove in the centre. Underneath at the left peers the crocodile-like monster that appeared in the wave in plate 7.

9 PLATE 9 *Entführung* (Abduction)

Etching and aquatint. 115 × 265 mm
Singer 121, fifth state
1980-7-26-33(9)

The 'crocodile' here appears in its full horror as some sort of reincarnation of a prehistoric pterodactyl. The impossible juxtaposition of the broken window out of which the monster appears to have flown, but through which it could never have fitted, is one of Klinger's most brilliant touches. In a proof set of the 'Glove' series (on the New York market in 1977) which bears variant titles in Klinger's own hand, this image is called *Traumes Ende* (The End of the Dream), while the last plate (plate 10) is entitled *Beim Erwachen* (On Awakening). (See J. Kirk T. Varnedoe, 1977, p.81.) In the letter to his mother Klinger says that this plate allegorises the return of the found glove.

10 PLATE 10 *Amor*

Etching. 135 × 260 mm
Singer 122, fifth state
1980-7-26-33(10)

Some commentators have thought that the figure of Amor (Cupid) is here laughing as if to say that all is well and that the previous horrors were only a dream. But in the letter to his mother Klinger says that it shows a tired Amor waking in the morning.

11–20 'Dramen' (Dramas)
Opus IX
1883

The title of the first edition reads: 'Dramen. VI Motive in X Blättern' (Dramas: 6 motifs on 10 sheets), and has a motto from the poem 'Schicksalslied' from Hölderlin's novel *Hyperion*: 'Doch uns ist gegeben auf keiner Stätte zu ruh'n' (yet we are given no place to rest). This serves as keynote for the six tragedies that follow; two of these develop over three plates, the other four occupy single sheets. The dramas begin with the individual in high society, and then move through other orders of society before ending with society itself. In this they echo the following lines of Hölderlin's poem: 'suffering mankind dwindles and falls headlong from one hour to the next, as water thrown from precipice to precipice, down through the years into the uncertain'. Work began on the series at the beginning of 1882 in Berlin; it was published in May 1883 in five different editions in a total of 200 sets. The impressions exhibited here come from a sixth unlimited edition published after Klinger's death, in 1922.

The only preparatory drawing that seems to be known for any of the plates is a study for plate 2 (*Ein Schritt*) contained in a sketchbook of twelve pages in the Dresden printroom, purchased from Klinger himself in 1896. The other pages contain twelve studies for the 'Amor and Psyche' series and two for 'Eine Liebe' (I must thank Dr Werner Schmidt for this information). The drawing is reproduced in *Die Welt Max Klingers*, ed. G. Kirtsch, Berlin 1917.

11 PLATE 1 *In Flagranti*

Etching. 460 × 312 mm
Singer 147, after tenth state
1981-11-7-21

Giorgio de Chirico described this as 'one of Klinger's finest visions'. Klinger evokes the 'romantic sense of modern life', which is 'the nostalgia of railway stations, of the arrivals and departures; the melancholy of ports, with transatlantic liners which slip their moorings and sail away at night over the black water, lit up like cities in festivals'. 'Klinger strongly felt this modern drama

In the etching *In Flagranti* we see this nostalgic aspect of the villa . . . it is a moonlit night, the wall of a villa is to be seen; behind the shutters on the second floor, a man, the husband, has shot at the adulterous couple who were standing on the terrace below. He still holds the smoking rifle. A few doves, woken by the shot, flutter around, white against the black sky, like birds in a Japanese painting. The shot lover has fallen onto the flag-stones of the terrace; only his legs and the flap of his jacket can be seen, the rest of his body is hidden behind a pillar on which is placed a large vase decorated with tentacular reliefs. The woman seized by fear hides, holding her hands against her ears in anxious expectation of a second shot. Plants and large leaves which grow around add to the strangely tragic power of this scene . . . It possesses the dramatic perception of certain scenes in the cinema, where in precisely the same way, characters of the tragedy and of modern life seem transfixed in the ghostliness of a moment, in the middle of scenes of terrifying reality' (Translated from *Commedia dell'arte moderna (scritti di Giorgio de Chirico)*, Rome 1945, pp.51–2).

12 PLATE 2 *Ein Schritt* (A step)

Etching. 450 × 280 mm
Singer 148, after seventh state
1981-11-7-22

The tragedy of descent into prostitution of a young glove-maker (so identified by the shop-sign above her). The procuress in the centre is persuading the girl to step across the rivulet that runs down the street to the dark side, where her client, dressed in cloak, top hat, and with a cigar burning in his mouth, awaits her. The subject of the scene is reminiscent of Goya, an artist for whom Klinger had the greatest admiration.

13 PLATE 3 *Eine Mutter I* (A mother)

Etching and aquatint. 458 × 327 mm
Singer 149, after seventh state
1981-11-7-23

8

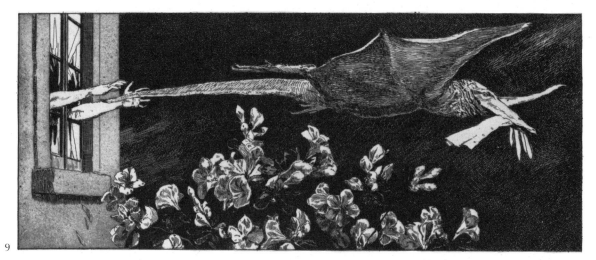

9

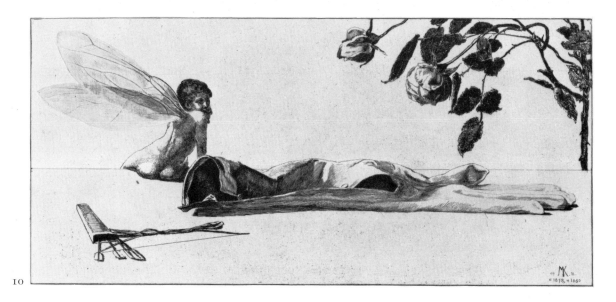

10

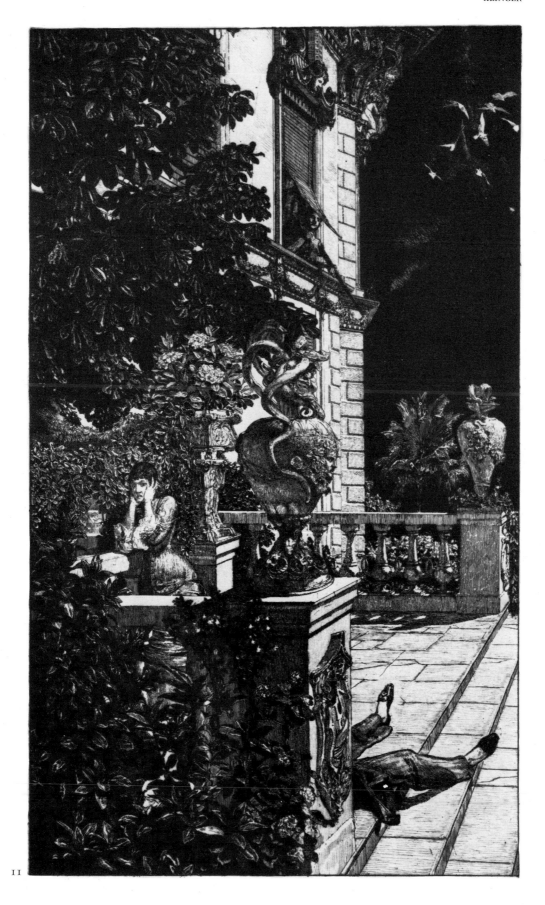

11

12

13

14

14 PLATE 4 *Eine Mutter* II

Etching and aquatint. 460 × 320 mm
Singer 150, after ninth state
1981–11–7–24

15 PLATE 5 *Eine Mutter* III

Etching. 457 × 360 mm
Singer 151, after seventh state
1981–11–7–25

Klinger added a short explanatory text concerning these three prints to the introduction to the fifth edition of 'Dramen'. It can be translated: 'Subject: a family thrown into poverty by bankruptcy. The husband, become a drunkard, mistreats wife and child. She, in utter despair, jumps with her child into the water. The child drowns, she is rescued and revived: prosecuted for manslaughter and attempted suicide – she is acquitted. Berlin assize courts, summer 1881'. The drama is firmly set into a social and historical context. The great crash of 1873, following a huge economic boom after the victory in the Franco-Prussian War, ushered in two decades of slow growth and periodic recession which intensified the problems of the newly expanding cities; the sad tragedy of the mother whose unemployed husband had turned to drink must have been typical in the Berlin of 1881. Klinger enhances the drama by a minute realism in detail of costume and topography, and the contrast in the second scene between the still mourners below and the excited crowd above is very moving. The grand building in the background is inscribed *Akademie* and *deutsche Kunst*, and Klinger would seem to be making an ironical juxtaposition of the pretensions of academic German art and the grim commonplaceness of the subject of his own art.

These plates had a powerful influence on later German artists. The same theme of the mother committing suicide with her child is found in the work of Hans Baluschek (in 1891), Heinrich Zille (in *Simplicissimus*, 1904) and Käthe Kollwitz (in *Simplicissimus*, 1909).

15

16 PLATE 6 *Im Walde*
(In the forest)

Etching. 456 × 320 mm
Singer 152, after seventh state
1981–11–7–26

The hat and folded coat with a letter placed on top indicate a suicide.

17 PLATE 7 *Ein Mord*
(A murder)

Etching and aquatint. 458 × 318 mm
Singer 153, after eighth state
1981–11–7–27

The murderer, still holding his knife, wrestles with a policeman whose helmet has fallen off. The victim lies in the street, attended by a woman. The scene is set on a crossing between the Friedrich and Louisenstrasse. The background shows however the Jannowitz bridge, which Klinger substituted because he found the real Berlin topography too banal. He needed more movement there (*Briefe*, p. 209). Klinger also recounted the trouble he had in persuading an officer from the local police station to pose for him; it cost him two *Thalers*.

16

17

18

19

20

18 PLATE 8 *Märztage I*
(March days)

Etching and aquatint. 451 × 358 mm
Singer 154, after seventh state
1981–11–7–28

19 PLATE 9 *Märztage II*

Etching and aquatint. 458 × 378 mm
Singer 155, after seventh state
1981–11–7–29

20 PLATE 10 *Märztage III*

Etching and aquatint. 452 × 322 mm
Singer 156, after seventh state
1981–11–7–30

The narrative begins with the outbreak of revolution with the looting of a nobleman's palace, and ends with fighting at the barricades and the final leading away of the prisoners by the military. Many critics assumed that the title of these prints alluded to the great 'liberal' revolution of March 1848, in which street fighting in Berlin and other German cities led to a short-lived constituent assembly and the possibility of a genuinely democratic government in Germany. But Klinger specifically denied this, pointing out that 'Märztage' was a term frequently used in political articles of the period to denote a potential revolution. Klinger's scenes are set in contemporary Berlin; the second print shows the Klostergasse, with the Parochialkirche in the background, and an advertising pillar in the foreground, while the first is a mixture of real elements (the firm Joop and the bathing establishment) and invented (the background architecture). In a letter of 1916 to Max Lehrs, Klinger wrote: 'I never thought of the revolution of 1848. I composed the thing in 1883. That was the time of the strongest Social Democratic movement with a revolutionary undercurrent throughout Germany. The possibilities were discussed in bars and in the papers. That was the origin of my fantasy . . . It was the time of my enthusiasm for Zola (to whom I really wanted to dedicate 'Dramen'), for the Goncourt brothers, for Flaubert' (*Briefe*, p. 208). (The series was in fact dedicated to his teacher, Karl Gussow.) Klinger himself was a liberal democrat, and in 1898 stood surety for Thomas Theodor Heine when he was prosecuted for a cartoon in *Simplicissimus* which offended the Kaiser. He seems never to have been a Social Democrat – the German party in the late nineteenth century was based on Marxist premises – and only became a conservative in his old age under the pressure of the German defeat and the subsequent revolution.

KÄTHE KOLLWITZ
1867–1945

Born in Königsberg in East Prussia (now Kaliningrad in Russia). Her father Karl Schmidt was an architect, her maternal grandfather Julius Rupp had founded the Freie Gemeinde, an evangelical Lutheran church. Her brother Konrad was to work for the Social Democratic newspaper *Vorwärts*. Encouraged by her father, she became an art student first in Berlin and then Munich. She became engaged at the age of eighteen to a schoolfriend of her brother, Karl Kollwitz, and married him after he qualified as a doctor in 1891. He took a job working for a health-insurance scheme of the tailors' guild in north Berlin, and they moved to a house which they were to occupy until the last years of her life.

She originally intended to become a painter, but soon became convinced that her real talent lay in drawing and printmaking after reading Klinger's *Malerei und Zeichnung*. Her earliest work is entirely lost, but must have been heavily influenced by Klinger, whose series 'Ein Leben' she first saw in Berlin in 1884. She later rejected these drawings, and recorded in her diary for March 1917 that they were all too anecdotal. Her earliest surviving drawings are of the years 1888–91 (mainly self-portraits) and are masterpieces in the realist style of Wilhelm Leibl owing much to his use of pen to model light and form. In the 1890s the work of Edvard Munch showed her the way to handle emotionally charged subjects, and this led, in 1897, to the set of prints based on Hauptmann's play *Die Weber* (21–3) which at once established her reputation. Her finest prints belong to the following ten years, culminating in the 'Bauernkrieg' cycle, completed in 1908 (34–40).

After about 1911 she more or less abandoned the etching medium; this coincided with the beginning of her sculpture. In printmaking she turned to lithography, occasionally drawing directly on the stone, but more often using transfer paper. She herself recognised that this method was deceptively easy, and that the results were often poor (journal entry for 8 April 1920). Later that year she took up woodcut, seeing it as a way out of her impasse (see 43).

Her younger son Peter was killed at the beginning of the First World War, and this had a shattering effect on her. Despite severe depressions, she stuck to her art, hoping to use it to have an effect on the world. Whereas her earlier work has a particular subject which it illustrates, the later work deals in abstractions and general concepts. Thus she ceased (in general) to make the series of compositional and life drawings that are such a notable feature of her early work, but composed instead directly from her imagination. Partly as a result, the quality of her art suffered, and it often became infected by sentimentality.

In post-War years her horror of war made her a fervent Inter-nationalist and thus sympathetic to the most effective such movement, Communism; she made posters for Communist causes (cf. 268) and visited Russia in 1927. She always, however, remained a Socialist and never became a Communist herself (see the journal for October 1920 and 28 June 1921). In 1933 she was forced to resign from the Berlin Akademie der Künste (to which she had been elected in 1919), and certain works of hers were removed from exhibitions. She was, however, never forbidden to work or classified as 'degenerate', nor were her works (with a few exceptions) purged from German museums. This was perhaps because many of her images lent themselves equally well to Nazi as to Communist propagandising, and some were indeed so used (without her name or – of course – her authorisation). She died on 22 April 1945, a few days before the end of the Second World War, in the castle of Moritzburg, where Prince Ernst Heinrich of Saxony had offered her refuge.

Bibliography

Kollwitz wrote ten volumes of journals covering the years 1908 to 1943, which are now kept in the Akademie der Künste in West Berlin. These have not been published in full, but selections from them have been edited by her son Hans Kollwitz. *Tagebuchblätter und Briefe*, Berlin 1948, which includes her reminiscences of her childhood, a short autobiography written in 1941, and some important letters, was reissued with adjustments under various titles in subsequent years. The selection published under the title *Ich sah die Welt mit liebevollen Blicken*, Hanover 1968, includes much new material, and is arranged by themes rather than chronologically. Hans Kollwitz also edited a selection of his mother's letters, *Briefe der Freundschaft und Begegnungen*, Munich 1966. The two other fundamental works are the catalogues of her prints and drawings. August Klipstein, *Käthe Kollwitz, Verzeichnis des graphischen Werkes*, Bern 1955, builds on two earlier catalogues, by J. Sievers (1913) and A. Wagner (1927). Otto Nagel (rev. by W. Timm), *Käthe Kollwitz, Die Handzeichnungen*, Berlin 1972 (2nd slightly enlarged edn, Stuttgart 1980) catalogues and illustrates over 1,300 drawings. (The dating of some works in both catalogues needs to be revised.) There are also some interesting reminiscences published by friends, of which the most important is Beatus Bonus-Jeep, *Sechzig Jahre Freundschaft mit Käthe Kollwitz*, Boppard 1948 (reprinted Dresden 1963).

Apart from these books, the student of Kollwitz is not well served by the existing literature. There is a large number of volumes of reproductions and exhibition catalogues with introductory essays of variable quality. Many confine their appreciation to the moral worthiness of her subject-matter, and say next to nothing about her art. More ambitious

studies are usually written from a Marxist or feminist standpoint, and rarely concern themselves with the evidence for Kollwitz's own philosophy which is revealed in her letters, and which is neither Marxist nor feminist (though of course she was very conscious of her position as a woman and as an artist, and realised that in many respects the aims of her art in later life were the same as those recommended by Communist theory). A few works of real value to the art historian are the catalogue of the exhibition held in Kettle's Yard, Cambridge, in 1981 with two essays by Frank Whitford and Keith Hartley, and the article by Werner Schmidt 'Zur künstlerischen Herkunft von Käthe Kollwitz' in *Jahrbuch der Staatlichen Kunstsammlungen Dresden*, 1967, pp. 83–90. The best general introduction is Werner Timm, *Käthe Kollwitz*, with twenty-eight plates, Berlin 1980 (German edition 1974).

21–4 'Ein Weberaufstand' (A Weavers' revolt) 1897

The published series consists of six plates, three etchings and three lithographs, of which only the three included here are in the collection of the British Museum. They relate to the celebrated play, *Die Weber*, by Gerhart Hauptmann (1862–1946, winner of the Nobel prize for literature in 1912), which was published in 1892. Hauptmann had achieved immediate fame in 1889 with his first play *Vor Sonnenaufgang* (Before Sunrise). It was staged at the Freie Bühne, a private theatre club founded by Otto Brahm earlier that year specifically to produce *avant-garde* plays without any need to worry about the box-office or the official censorship. Its first performance caused a celebrated fracas, and established Naturalism (that is the development of realism linked with Zola and Ibsen) in the German theatre. The staging of *Die Weber* was even more controversial. The first version, written in a strong Silesian dialect, was not passed for performance by the censorship; it was held to instil class-hatred, and it was feared that the dialect was intended to make the play more comprehensible to contemporary weavers and thus encourage disaffection. A second version with much less dialect was

also banned (a verdict against which Hauptmann later successfully appealed in the courts). As a result the first performance was held in the Freie Bühne on the afternoon of 23 February 1893, a performance which was attended by Käthe Kollwitz, who already knew Hauptmann from nine years earlier when she had met him during a visit to Berlin. She was, according to her own account, enormously impressed; it was a turning-point in her career, for she abandoned a projected series of prints to illustrate Zola's *Germinal* and took up 'Ein Weberaufstand' instead. (See her reminiscences of 1941, *Tagebuchblätter*, pp. 37 and 41.)

The action of the play describes a historical event, the riots of the impoverished Silesian weavers in 1844. Hauptmann's grandfather had begun life as a weaver, and Hauptmann himself toured Silesia in 1891 to see conditions for himself and gather reminiscences of the 1844 rising. This had caused much concern at the time; Heine, for instance, had written a famous poem 'Die schlesischen Weber', and C.W. Hübner had exhibited a painting of the same title to raise funds for the weavers. Hauptmann's play had for its hero the weavers as a group, driven by despair to loot the house of their employer Dreissiger. The riot leads to the intervention of the military, and in the fighting the old man Hilse, who was opposed to the rising, is killed by a stray bullet. Kollwitz's six plates follow the sequence of the drama from destitution to the rising and subsequent fighting, but not one is an exact illustration of a scene from the play. Thus, for example, Act 2 is set in a weaver's cottage and shows the misery of their conditions, but at no point in the act does a child die, as is shown in the first two plates. The riot in plate 5 takes place off the stage, and the death of old Hilse, which concludes the drama, does not seem to be the subject of the last plate, which shows three bodies. That Kollwitz entitled the series 'Ein Weberaufstand' rather than 'Die Weber' shows that she intended the series to parallel rather than follow the action of the play.

Kollwitz had intended to prefix the series with Heine's poem on the weavers and dedicate it to her father. But his death made her lose interest in exhibiting

the set, and it was left to a friend of hers, Anna Plehn, to submit it to the annual salon held in the state exhibition hall in the Lehrterstrasse in 1898. According to her reminiscences of 1941 (*Tagebuchblätter*, p. 41). Menzel voted that it be awarded a small gold medal, but Kaiser Wilhelm II vetoed this. But a document published by Peter Paret (*The Berlin Secession*, Cambridge, Mass. 1980, p. 21) shows that the recommendation of the jury (on which Menzel served) was forwarded to the Kaiser by the minister of culture with a covering note which stated that 'in view of the subject of the work, and of its naturalistic execution, entirely lacking in mitigating or conciliatory elements, I do not believe that I can recommend it for explicit recognition by the state'. The Kaiser, therefore, was only following advice. The series was nevertheless a great critical success, and Kollwitz leapt straight into the first rank of artists. (On the history and background of *Die Weber*, see the introduction by M. Boulby to the edition of the play in the Harrap's German Classics series, London 1962.)

21 PLATE I *Not* (Need)

Lithograph, printed in black on a thin golden-brown paper applied to a thick wove white paper. Signed in pencil and annotated *Weber B* I. 155 × 152 mm
Klipstein 34, second state, from an early edition but with a later signature.
1951–5–1–74. Bequeathed by Campbell Dodgson Esq.

In her reminiscences of 1941 (*Tagebuchblätter*, p. 41), Kollwitz recalled that the work on this series was difficult and protracted. 'My technical ability in etching was still so slight, that my first attempts failed. It was for this reason that the first three plates of the series were lithographed and only the last three etchings succeeded technically.' She saw the play performed in February 1893; it therefore took over four years to finish the six prints. In a letter of 1901 to Max Lehrs (*Briefe der Freundschaft*, p. 23) she explained that her two children allowed her little time to work, and that her etching was largely self-taught; she had only had a few lessons from a local artist in Königsberg in the months before she went to Berlin.

This account is, however, rather

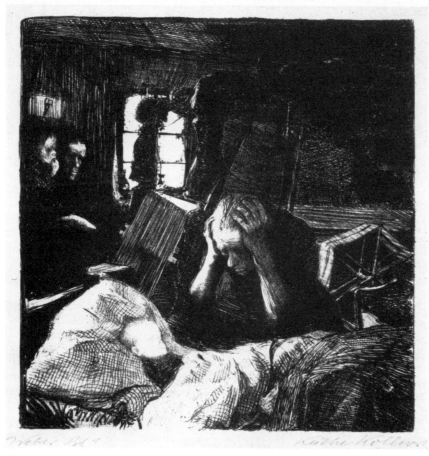

21

surprising. Kollwitz's first etchings were made in Berlin in 1891–3. They are some twenty in number and are of remarkable technical competence and artistic quality; certainly they give no impression of an artist struggling with the process. When she began work on the 'Weber' series in 1893, the medium chosen was etching, and early etched versions survive for all three compositions that were later published as lithographs. Examination of the etched version of *Not* made in 1893–4 (Klipstein 23) shows that the print is perfectly successful, and of fully comparable quality to the three etched plates which were actually published in the series.

Whatever may be the explanation for the abandonment of work on the early versions of the plates of the series made in 1893–6, it is interesting to note how closely Kollwitz followed in her lithograph of *Not* the character of an etching. The chalk lines on the child's bed and pillow are similar to those of a soft-ground

etching, while the pen and ink lines which define the mass in the right foreground and much of the background are like those of an ordinary etching.

As noted before, the theme of the mother in despair over her sick or possibly dead child does not occur in Hauptmann's play. It derives rather from Munch's painting of the *Sick Child*, of which the first version was painted in 1885–6 (see 69).

22 PLATE 5 *Sturm* (Riot)

Etching with stippling. Annotated in pencil *Weber 5* and signed by the printer (*O Felsing Berlin gdr*). 246 × 295 mm
Klipstein 33, second state, before the edition in *Zeitschrift für bildende Kunst*, 1905. On thick wove paper.
1949–4–11–3944. Bequeathed by Campbell Dodgson Esq.

This and other prints in the exhibition bear the tiny and almost illegible signature of Otto Felsing, who was the leading copper-plate printer employed by artists

in Berlin in the late nineteenth and early twentieth centuries: see for example Nolde (105). The abbreviation *gdr* stands for *gedruckt* (i.e. printed).

It is not easy to determine how the stippled effect seen on this and many following plates was produced. Kollwitz in the course of her career developed perhaps a greater range of tonal devices than had ever before been used by a single printmaker. At this early stage in her career she probably used a simple device like pressing sand or sandpaper into the ground on the plate. Later she pressed the weave of textiles or the textures of heavily grained papers directly into the ground in conjunction with soft-ground etching (cf. 31). This technique is described by Hermann Struck in his treatise *Die Kunst des Radierens*, Berlin 1908, p. 119.

23 PLATE 6 *Ende* (The End)

Etching with aquatint and stippling. Signed in pencil by the artist and the printer (*O Felsing Berlin gdr*). 247 × 306 mm
Klipstein 37, second state. On Japan paper.
1949–4–11–3938. Bequeathed by Campbell Dodgson Esq.

Two highly finished preparatory pen and wash drawings in reverse for this and the previous plate survive (Nagel 133 and 135). They show how carefully Kollwitz prepared these final plates. The lines of smoke that waft through the open door are created by burnishing out the aquatint.

24 *Aus vielen Wunden blutest Du, O Volk* (From many wounds you bleed, O People) 1896

Etching with aquatint and engraving. With the blind-stamp of the publisher von der Becke. 127 × 340 mm
Klipstein 29, fourth state. A late impression printed after 1931.
1979–10–6–68

This symbolic plate was originally planned as a conclusion for the 'Weber' cycle, but was excluded on the advice of Julius Elias (according to his own account in *Kunst und Künstler*, XVI, 1917, p. 540). The source of the quotation of the title has not been identified.

The iconography of the scene is far from clear in the absence of any surviving explanation by Kollwitz herself. The outstretched figure of the 'Volk' is

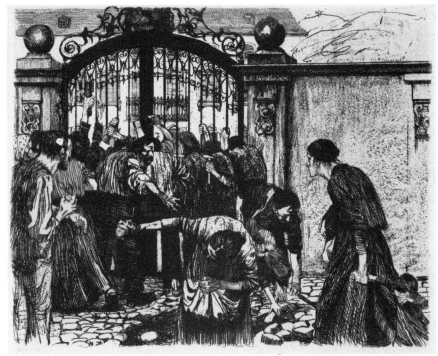

22

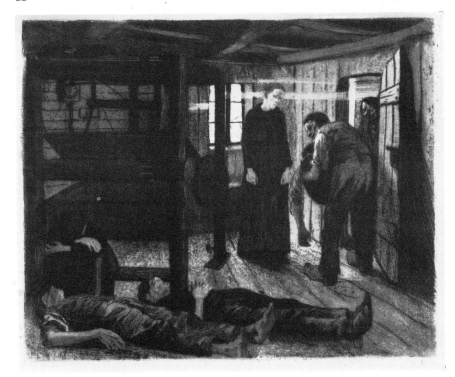

23

identified with Christ by the crown of thorns and the wound in the side, as well as its obvious derivation from Holbein's famous painting of the dead Christ in the museum at Basle, or its more recent rehandlings in paintings by Böcklin, Klinger and Stuck. The leaning figure should perhaps be identified from the sword as Justice, in which case Justice is playing the role of the doubting Thomas, who needs to touch the wound before it can believe. The two bound female figures flanking the central scene are even less readily interpretable. A contemporary critic called them 'Marterpfähle der Not' – 'stakes of Need'. (See the essay 'Beweinung-Transformation eines christlichen Motivs' by Renate Hinz in the catalogue of the 1973 Kollwitz exhibition at the Frankfurt Kunstverein).

In 1900 Kollwitz recast the image in a drawing (entitled *Das Leben*, Life, Nagel 158) and an etching (entitled *Zertretene*, The Downtrodden, Klipstein 48). In this the central scene remains the same, but one wing becomes a father who hands a noose to a mother with a dead child, while the other has in the drawing a bound nude with a starving woman (perhaps Need and Shame) and the artist's self-portrait in profile (this last is not to be seen in the print).

This is the only occasion that Kollwitz ever attempted to elevate the subject-matter of her realist prints by transposing it into the idiom of contemporary symbolism. The effort seems odd and misplaced to the modern viewer, but it is revealing of Kollwitz's artistic formation that she should ever have made it.

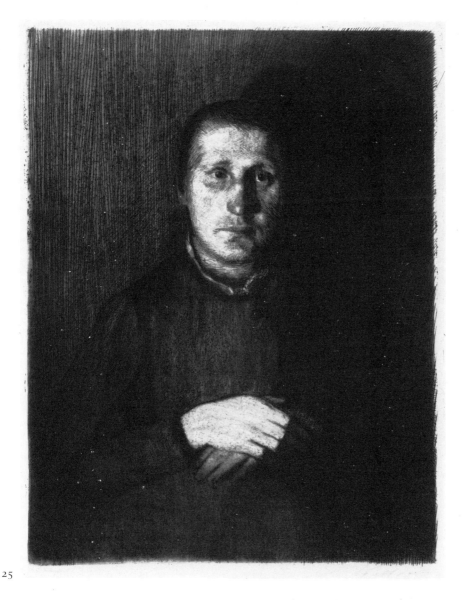

25

bowed but undefeated ancient, she produced as impressive a sequence of self-portraits as any artist after Rembrandt. See Otto Nagel, *Die Selbst-bildnisse der Käthe Kollwitz*, Berlin 1965.

27 Working-class woman in profile, looking left
1903

Lithograph, printed in black on grey paper. Signed in pencil. 448 × 328 mm
Klipstein 67, second state. From the edition published by Richter, *c.* 1920.
1951–5–1–75. Bequeathed by Campbell Dodgson Esq.

The title given this print defines the sitter as a working-class woman, and it is characteristic of Kollwitz's early work that it should do so. After the First World War she would not have made this print. It would not have been a portrait of an individual at all, let alone one from an identifiable social class, but an image of a woman suffering one of the ills of humanity – need, grief or despair.

The head and hands of the woman are drawn on the stone in chalk, while the background and her body are covered with a uniform obliterating black wash (though in the first state the wash is applied more lightly and the individual brush-marks are evident). This device derives directly from Munch's *Self-portrait with skeleton arm* (70), and it is interesting that Kollwitz used it for the first time in a portrait of her son Hans (Klipstein 30) only a year after Munch's portrait.

28 Female nude seen from the back
1903

Lithograph, printed in grey with a green tint-stone on grey-brown paper. Signed in pencil. 575 × 440 mm
Klipstein 69, second state
1951–5–1–19. Bequeathed by Campbell Dodgson Esq.

A monumental figure, and the finest of Kollwitz's studies of the nude. The body is drawn in lithographic crayon, with considerable use of scraping to model the shoulders, while the background (printed in green) is brushed in with wash. On some impressions of the first state Kollwitz used an additional blue stone, and an impression of the second state in Berlin has blue wash added by hand in the background to the left of the body.

25 Woman with folded hands
1898

Etching with stippling, and engraving; printed with heavy surface-tone. Signed in pencil by the artist and the printer (*O Felsing gedr.*). 286 × 229 mm
Klipstein 41, third state. Printed on thin China paper applied to a thick white wove paper
1949–4–11–3939. Bequeathed by Campbell Dodgson Esq.

A heavy surface tone has been left by the printer in wiping most of the plate; only the hands and face of the unidentified woman have been clean-wiped. Later commentators have described the woman as being pregnant, which seems quite possible. The preparatory drawing is Nagel 143.

26 Self-portrait, facing left
1901

Lithograph, printed in black with a brown tint-stone on grey-blue paper. 268 × 204 mm
Klipstein 50, second state. Printed on laid paper, which has caused the pattern of parallel uninked lines.
1951–5–1–81. Bequeathed by Campbell Dodgson Esq.

This is the earliest of Kollwitz's self-portraits included in this catalogue, but it had been preceded by no less than seven other prints, as well as numerous superlative drawings. Throughout her life she kept returning to this subject, which even in her later life inspired work of the highest quality. In portraying her development from eager youth to a

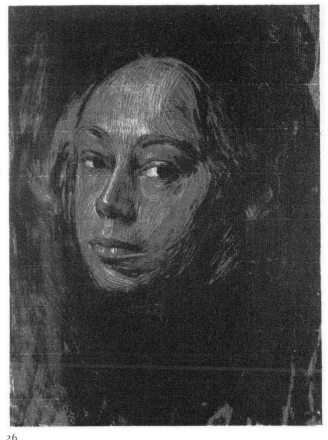

26

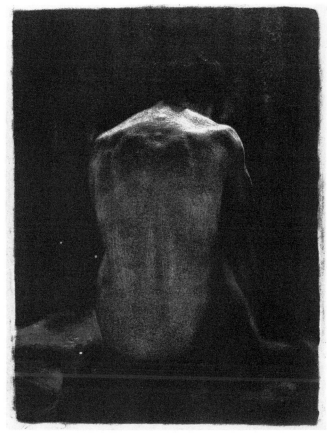

28

29 *Woman with dead child*
1903

Soft-ground etching with engraving, over-worked with gold and pencil. 476 × 419 mm (the wash extends into the margins)
Klipstein 72, third state
1949-4-11-3926. Bequeathed by Campbell Dodgson Esq.
See colour illustration

The sequence of three impressions of different states of this plate is the most remarkable treasure of Campbell Dodgson's collection of Kollwitz's work. A discussion of how she developed the plate is given under 31 below.

30 *Woman with dead child*
1903

Soft-ground etching with engraving, over-printed lithographically with a gold tone-plate. 476 × 419 mm
Klipstein 72, sixth state
1949-4-11-3927. Bequeathed by Campbell Dodgson Esq, who must have bought it before 1913, since Sievers mentions it as belonging to him.
See colour illustration

The combination of etching with lithography seen in this experimental impression is most unusual, not only in Kollwitz's work, but in the entire history of printmaking. Even Munch, who was the great innovator in combining woodcut and lithography, never seems to have tried this mixture. It therefore remains uncertain who suggested this approach to her. However, she evidently had had it in mind for several years. She wrote to Max Lehrs in August 1901: 'I devote myself to lithography next to etching, and promise myself great things from a mixing of the two techniques – I

now have my own press to hand for experiments' (*Briefe der Freundschaft*, p. 24). In a later letter of 1929 to Heinrich Becker she recalled that at the time when she was working on this plate she had made 'all possible experiments', but that she later had come to reject completely these combinations of techniques (*Käthe Kollwitz an Dr Heinrich Becker, Briefe*, Bielefeld 1967, p. 3).

Max Lehrs (*Die graphischen Künste*, XXVI, 1903, pp. 59, 66–7) records three other prints with a similar combination of etching and lithography: one is of workers returning by lantern light, another is of a girl with an orange (both these are from three plates, two aluminium and one copper), while the last is of a cabaret scene (from one aluminium and one copper plate). The first of these is an unrecorded variant of Klipstein 54, the second is Klipstein 56, while the last is an unrecorded variant of Klipstein 58. Another impression of the *Woman with dead child* with a

gold lithographed background is in the Städtischen Museum, Bielefeld, and a gold-painted impression of the fourth state from the Schocken Collection was sold at Hamburg in 1967 (Hauswedell auction 152 lot 708; later with C.G. Boerner, Düsseldorf, *Neue Lagerliste 50*, 1968, no. 21).

31 *Woman with dead child* 1903

Soft-ground etching with engraving, over-worked in green and gold wash. Signed in pencil. 476 × 419 mm
Klipstein 72, seventh state
1949-4-11-3928. Bequeathed by Campbell Dodgson Esq.

The sequence of development of the three states of the print included here is typical of Kollwitz's habits with her large and ambitious plates. She began with a number of carefully developed preparatory drawings (Nagel 239–45), which, according to an undated letter to Arthur Bonus, began with a drawing she had made with the aid of a mirror of herself holding her seven-year old son Peter (Arthur Bonus, *Das Käthe-Kollwitz Werk*, Dresden 1930, p. 7; the drawing is possibly Nagel 239). One of these (apparently the drawing now in Stuttgart, Nagel 242) served as basis for the transfer to the plate. In the second state of the plate she added the texture of the laid paper by pressing a sheet of Ingres paper onto the plate prepared for a soft-ground etching, and in the third certain engraved lines. In the fourth to sixth states new layers of tone were added, again through soft-ground etching and by emery-paper pressed directly into the ground. The seventh state has more engraved lines added. Before the plate was finally completed in the eighth state, a new layer of tone was applied to darken the whole plate.

A peculiarity of the three impressions included here is the rich and rather surprising application of gold to the background. This has nothing to do with defining corrections to the image which might then be incorporated into a subsequent state of the plate. It is entirely decorative and ornamental in function and makes a rather beautiful image out of what is in fact one of Kollwitz's rawest and most brutal compositions. The vampyrish pose of the

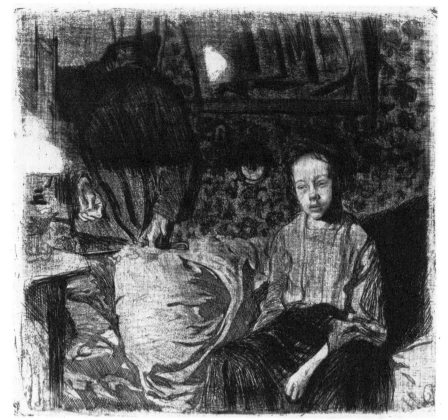

32

mother feels closer to such terrifying works as Goya's painting of *Saturn devouring his children* than to traditional mother and child iconography. The group is conceived in sculptural terms, and it is interesting to find that in 1904, when she was attending sculpture classes at the Académie Julian in Paris, she wrote in a letter: 'What I should like best if I could get hold of a model quickly would be to start on a plastic group with a dead child' (quoted by Werner Timm, *Käthe Kollwitz*, Berlin 1980, opposite plate 10).

32 *Young couple* 1904

Etching and engraving, with the impressed texture of the weave of cloth. Signed in pencil. 293 × 313 mm (sheet size; trimmed within plate-mark)
Klipstein 73, third state, but before steel-facing. Printed on a stiff card-like paper.
1949-4-11-3925. Bequeathed by Campbell Dodgson Esq.

This magnificent print is a reworking of a composition first etched in 1893

(Klipstein 18). Its subject was taken from a play by Max Halbe (1865–1944) entitled *Jugend*, first published in 1893 and performed with immense success at the Residenztheater in Berlin on 23 April of the same year.

Halbe belonged to the same wave of Naturalist authors as Hauptmann, and his play must have appealed to Kollwitz for the same reasons. The story is Strindbergian in theme, and treats of two ill-starred lovers; in the dénouement the girl is shot dead by her jealous half-brother.

The print of 1893 is the clearest evidence of the profound influence of the work of Munch, which she must have seen for the first time in the previous year, and which was already noticed by Julius Elias, a contemporary critic writing in *Die Nation* of 27 July 1893 (though scarcely mentioned by Kollwitz herself). It is evident in the opposition of the man and woman, whose lack of contact is emphasised by their facing in opposite directions. The preparatory drawings (Nagel 84 to 88) show two interesting

things: that the composition originally showed the two figures half-turned towards each other, and that she used herself and her husband as the models.

33 *Self-portrait, full face* 1904

Lithograph, printed in three colours (chocolate-brown with green and yellow-brown tint-stones) overworked with black wash. Signed in pencil. 530 × 405 mm (maximum dimensions of sheet, which is irregular)
Klipstein 75, only state
1951–5–1–73. Bequeathed by Campbell Dodgson Esq.

This is one of the grandest of Kollwitz's self-portraits, and seems to survive in only a few impressions. Another is in the Kupferstichkabinett of West Berlin.

34–40 'Bauernkrieg' (The Peasants' Revolt) 1908

The subject of this cycle of prints is the Peasants' Revolt of 1522–5, one of the subsidiary upheavals that attended the course of the Reformation in Germany, but which had its origins rather in the wretched conditions of the peasantry than in Protestant fervour. In an undated letter of *c.* 1907 to Arthur Bonus, Kollwitz gave some valuable information about the series: 'Tell Herr Stolterfoth the following: the motifs of the plates of the "Bauernkrieg" are not taken from some literary source or other. After I had made the small plate with the woman flying above, I concerned myself with the same theme further and hoped to be able to portray it once and for all so that I was finished with it. Then I read Zimmermann's "Bauernkrieg", and there he talks of "Black Anna", a peasant woman, who urged on the peasants. I then made the large sheet with the crowds of peasants breaking out. With this, I received the commission for the whole cycle. Everything followed on this already completed plate. Six plates are ready . . .' (*Tagebuchblätter*, 1948, p.142).

This needs little commentary. The only plate with any connection with an identifiable historical event or character is plate 5, *Losbruch*, in which 'Black Anna' appears. Wilhelm Zimmermann's *Allgemeine Geschichte des grossen Bauernkrieges* was first published in 1841–2, and went through many later editions. The 'small plate' is *Aufruhr* (Klipstein 44), which was exhibited in the Berlin Secession in 1899; the later works on the theme of the revolt, but which precede *Losbruch* of 1903, must be Klipstein 59–61, all of which are lithographs (see also 34). The commission for the whole series came from the Verbindung für historische Kunst (Society for historical art), which published and distributed the seven plates to its members in 1908.

Technically, the plates exhibit a bewildering variety of transferred tonal textures and all were taken through a large number of states in which texture was added on top of texture before completion. Since these textures are very confusing it is worth trying to analyse them. The best starting points are the lithographs, Klipstein 82 and 83. These are experiments using different sorts of transfer paper, and since the grain produced is identical to that found in

35

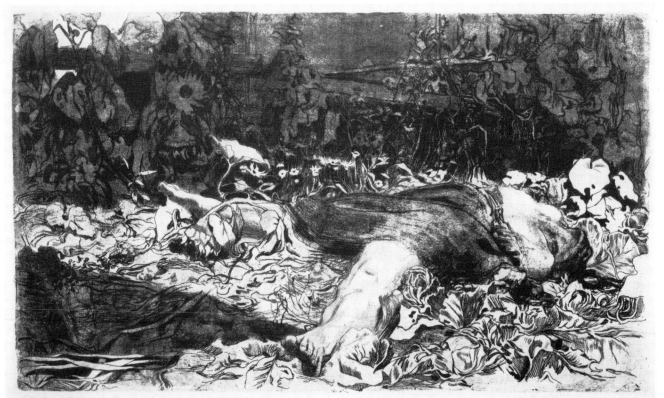

many etchings, it is reasonable to assume that these same papers were also used in her etchings over soft-grounds. Sievers identifies one, which gives a grain of a thickly textured laid paper, as Ingres paper. The other, which has an irregular mottled appearance, is called 'geleimtes Kornpapier' – sized grain paper.

Other textures vouched for by Sievers use 'Schmirgel' (emery-paper) or textiles pressed directly through an etching ground. The most unusual texture however has never received any comment. It is referred to here as a 'mechanical grain' because it exhibits unmistakable rows of tiny parallel dots. Kollwitz first apparently used it in 1903 (it appears in *Woman with dead child*), and almost invariably thereafter (the only plate of the 'Bauernkrieg' cycle in which it is not found is *Losbruch*). Although very similar to the grain of a photogravure, it is certainly not always photographically transferred from a drawing since it is often only added in later states. It seems rather to be an early version of the 'Ben Day' dots used for creating tone in advertising, and is used by Kollwitz in two ways. Either it is found in wide expanses showing no differentiation, or it defines drawn lines that look like soft-ground lines and can easily be mistaken for them. See also 42.

34 PLATE 1 *Die Pflüger* (The ploughmen) 1906

Etching with tonal textures and aquatint, and engraving. Signed in pencil. 315 × 453 mm
Klipstein 94, sixth (final) state
1949–4–11–3940. Bequeathed by Campbell Dodgson Esq.

This was one of the first images of the series that Kollwitz worked on. Two lithographs of 1902 (Klipstein 60, 61) show the same composition. In Lehrs's catalogue published in 1903 (*Die graphischen Künste* XXVI, pp.66–7) lithographed versions of *Pflüger* and *Bewaffnung in einem Gewölbe*, both made in 1902, as well as the etching *Aufruhr* of 1899, are described as being for a 'Bauernkrieg' cycle. The etching of *Losbruch* followed in 1903 (or late 1902, if the date on an impression in the Dresden Kupferstichkabinett is accurate). It must have been after receiving the commission from the Verbindung für

historische Kunst that Kollwitz decided to make the entire series as etchings of uniform large size; thus *Aufruhr* was eliminated, and the lithographed versions of plates 1 and 4 replaced by new etched versions.

An etching (Klipstein 92) which Sievers dates 1905 shows a different composition of the same subject. The preparatory drawings catalogued by Nagel (196–7, 199–212) show the difficulty she had in arriving at the final composition. The last two drawings (210–11) are in reverse to the final print. The Berlin Kupferstich-kabinett possesses a complete set of all six states of this etching.

35 PLATE 2 *Vergewaltigt* (Raped) 1907

Etching with tonal textures and engraving. Signed in pencil. 306 × 525 mm
Klipstein 97, fifth (final) state
1949–4–11–3930. Bequeathed by Campbell Dodgson Esq.

Seven preparatory drawings for this print are known (Nagel 417–23), of which four are meticulous studies of foliage and plants. In the drawings the head of the child looking over the fence in the background is more easily noticed.

Werner Schmid (*Jahrbuch der staatlichen Kunstsammlungen Dresden* 1967, p.86) made the interesting discovery that Kollwitz's source for the figure was a drawing by Constantin Meunier (1831–1905) of a dead man, which was used as frontispiece for the 1885 Paris edition of Camille Lemonnier's *Le Mort*. The way in which the foreshortened head is dominated by the horseshoe shape of the jaw in both images is very noticeable. Kollwitz reused the same figure in a woodcut *The widow* of 1922–3 (Klipstein 181: plate 5 of the 'Krieg' cycle).

36 PLATE 3 *Beim Dengeln* (Whetting the scythe) 1905

Etching with tonal textures, and engraving. Signed in pencil. 295 × 293 mm
Klipstein 90, third state. The only recorded impression of this state.
1949–4–11–3942. Bequeathed by Campbell Dodgson Esq.

36a Another impression. Overworked in parts with pencil. Signed in pencil.
295 × 293 mm
Klipstein 90, eighth state. One of two recorded impressions of this state.
1949–4–11–3941. Bequeathed by Campbell Dodgson Esq.

This print, like many of Kollwitz's most important plates, went through many successive elaborations and reworkings before she was satisfied with the effect. In the third state three different layers of tone can be distinguished. Along the left margin can be seen the overlapping contours of two applications of a stipple-like grain, probably transferred from an Ingres paper through a soft-etching ground. The third grain (seen most clearly along the bottom margin, next to the signature) comes from a mechanically ruled screen, and was added in the third state (Berlin has an impression of the second state which lacks this grain). By the eighth state many new layers of tone had been added to build up the heavy final texture, in addition to the major alteration in the sixth state with the change in the right hand. The possible corrections indicated in pencil on this impression of the eighth state were never carried out, and in this form the plate, with added lettering, was published in 1905.

Kollwitz worked on the plate at the same time as two related compositions, *Woman with scythe* and *Inspiration* (Klipstein 89 and 91), and they develop from the same preparatory drawings. The drawing used as the basis for the first state must be the one now in San Francisco (Nagel 397). The arm added in the sixth state is the subject of two later studies (Nagel 398 and 399).

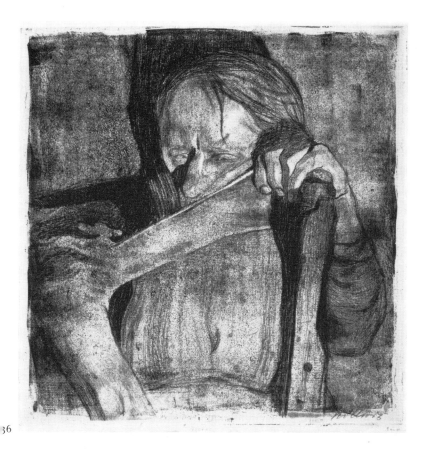

36

5a

37 PLATE 4 *Bewaffnung in einem Gewölbe* (Seizing arms in a cellar)
1906

Etching with tonal textures, and engraving. Signed in pencil. 497 × 330 mm
Klipstein 95, sixth state (with engraved address of Felsing)
1949–4–11–3929. Bequeathed by Campbell Dodgson Esq.

Like *Die Pflüger*, this plate seems to have given Kollwitz considerable trouble. The first version of this composition (Klipstein 59), dated 1902, is a lithograph, and the six preparatory drawings catalogued by Nagel (213–18) relate rather to this than to the 1906 composition (which is in the reverse direction).

38 PLATE 5 *Losbruch* (Outbreak)
1903

Etching with impressed textile texture and lift-ground aquatint, with engraving. Signed in pencil. 494 × 566 mm (maximum dimensions: the sheet is cut irregularly)
Klipstein 66, fourth state. Printed on a thick brown paper.
1949–4–11–3948. Bequeathed by Campbell Dodgson Esq.

This is the earliest of the published 'Bauernkrieg' plates to be finished. Four compositional drawings for the whole plate are known (Nagel 187–90) and four for the woman with raised arms (Nagel 191–4); for the open-mouthed figures to her left there are a drawing (Nagel 195) and three etchings (Klipstein 63–5), which are fascinating as experiments with varieties of grain from soft-ground etching and sugar-lift aquatint. In many ways the print can be seen as a rethinking of the etching of 1899, *Aufruhr*, with which she took up the subject of the Peasants' War.

The central figure is identified in the letter Kollwitz wrote to Arthur Bonus (see p.67) as 'Black Anna'. It is one of the most haunting figures in her entire work, and it is therefore all the more remarkable to find that it is in fact derived from an illustration by Arthur Boyd Houghton of a scene in the Paris Commune published in *The Graphic* of 8 April 1871 (reproduced Paul Hogarth, *Arthur Boyd Houghton*, London 1981, p.115).

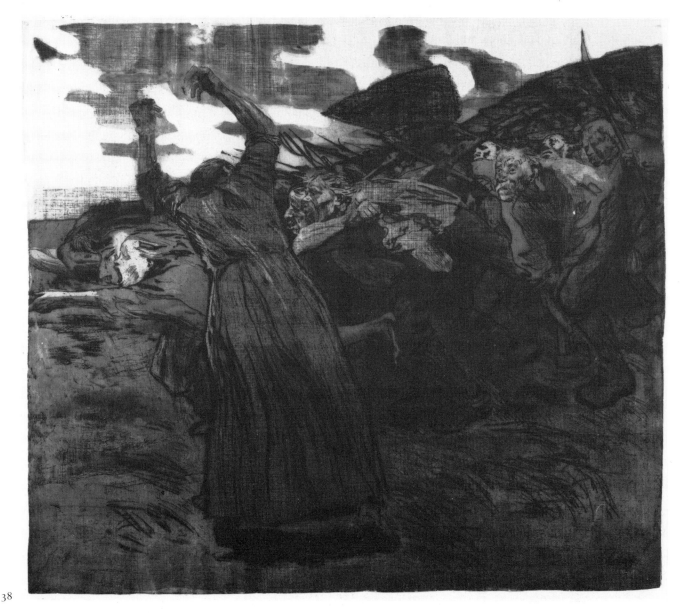

38

39 PLATE 6 *Schlachtfeld*
(Battlefield)

1907

Etching with tonal textures and aquatint, and
engraving. Signed in pencil. 412 × 530 mm
Klipstein 96, sixth state
1949-4-11-3946. Bequeathed by Campbell
Dodgson Esq.

A mother is searching for her dead son
after the battle in which the peasants
have been defeated. This is perhaps the
plate in which the mechanically ruled
grain is most prominent, which accounts
for much of its flatness. Nagel illustrates
three more or less finished drawings of
the composition (410, 411, 410a).

40 PLATE 7 *Die Gefangenen*
(The prisoners)

1908

Etching with tonal textures and engraving,
overworked with grey wash. Signed in pencil.
327 × 423 mm
Klipstein 98, third state. The only recorded
impression of this state.
1949-4-11-3931. Bequeathed by Campbell
Dodgson Esq.

The drawing used for preparing the print
is certainly Nagel 430 (Kunstmuseum,
Basel), in which new squares of paper
have been stuck on in two places to allow
corrections. Nagel also catalogues a large
number of preparatory studies (425–40).

These show that her son Peter was the
model for the boy slumped against the
rope, centre right.

The Kupferstichkabinett in West Berlin
possesses impressions of the first two
states of this print. The first shows a
combination of stippling (perhaps from
the 'geleimtes Kornpapier') and etched
lines; a piece of paper carrying a drawn
correction is stuck over the head of the
third figure from the right in the
foreground; and there is a brown wash
over many of the figures which was used
to define areas for the added grains in the
second state. These are of two kinds: a
textile texture over most of the clothing

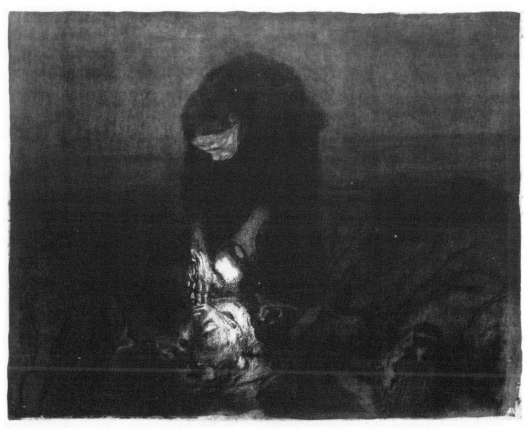

39

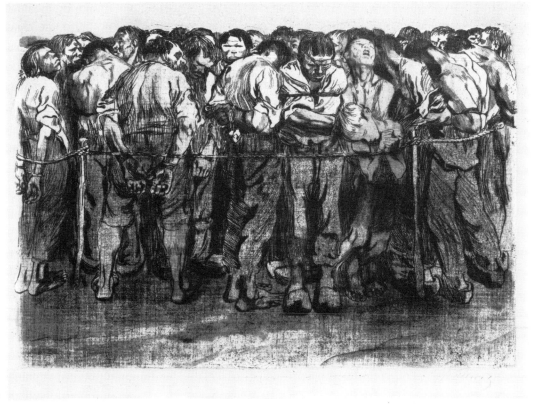

40

and some of the flesh of the prisoners, and a faint mechanical grain over some of the backs at the right. The correction indicated on the added piece of paper has been affected by dint of vigorous burnishing of which the marks are easily visible. A series of pinholes at the top of the first state impression shows that Kollwitz stuck it on the wall in front of her as a guide while she worked on the plate.

Keith Hartley has observed that the source of the heroic, muscular poses of the prisoners is to be found in the sculpture of Rodin, whom Kollwitz had visited in Paris in 1904. He compares in particular Rodin's *Burghers of Calais* (see 1981 Kettle's Yard exhibition catalogue, p. 31).

41 *Unemployment*
1909

Etching and tonal textures, with engraving. Signed in pencil by the artist and the printer (*O Felsing Berlin gedr.*). Annotated (not by the artist) *Druck von der unverstählten Platte (nur 13 Drucke)*. 449 × 544 mm
Klipstein 100, sixth (final) state. According to the annotation, one of 13 impressions before the plate was steel-faced.
1949–4–11–3945. Bequeathed by Campbell Dodgson Esq.

The source of this composition is a well-known drawing commissioned by *Simplicissimus*, where it was published on 19 July 1909. In *Simplicissimus* the drawing was titled *Das einzige Glück* (the only redeeming feature) and had a caption 'If they didn't need soldiers, they would also put a tax on children'. There is good reason to think that Kollwitz had nothing to do with this text, which was added by the editors, and that the title given to the print corresponds to her intentions.

The original drawing used by *Simplicissimus* is now in the National Gallery of Art in Washington (Rosenwald collection: Nagel 545). Kollwitz, however, based the print on a variant drawing now in Frankfurt (Nagel 544), but retained the figure of the man from the Washington drawing. An impression of the first state of the print in Berlin is annotated with marks for the addition of future layers of tone.

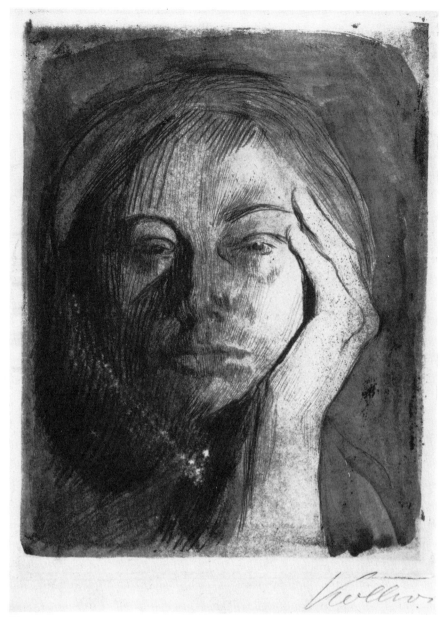

42

42 *Self-portrait, with head resting on hand*
1910

Mechanical grain with engraving, overworked with brown wash and pencil. Signed in pencil. 222 × 170 mm
Klipstein 107, second state
1949–4–11–3934. Bequeathed by Campbell Dodgson Esq.

This is an interesting example of a print in which the mechanically ruled grain is the only tone in the plate, which suggests that we are here dealing with a photogravure. The engraved lines were only added in the second state. (The possibly unique impression of the first state was sold at Kornfeld in Bern in June 1969, auction 132, lot 730.) The area along the left side of the jaw which looks as if it has been abraded has in fact suffered from faulty transfer.

43 *Memorial sheet for Karl Liebknecht*
1920

Woodcut. Signed in pencil. 355 × 496 mm
Klipstein 139, fourth state. A proof before the
edition of 1920
1984-10-6-1

The print bears the legend: *Die Lebenden dem Toten. Erinnerung an den 15 Januar 1919* (The living to the dead. Remembrance of 15 January 1919). The first words invert the title ('Die Toten an die Lebenden') of a famous poem by Ferdinand Freiligrath (1810–76) about the victims of the March Revolution of 1848. In Kollwitz's 'Erinnerungen' she recalled the 'indelible impression' made on her as a child by her father's reading the poem to the family (*Tagebuchblätter*, p.25).

Karl Liebknecht, the leader of the German Spartacists (from January 1919

the German Communist party) was murdered on 15 January 1919, along with his fellow leader Rosa Luxemburg, by members of the Freikorps raised at the request of the Social Democrat Government among soldiers returning from the Western Front in order to prevent the possibility of a Communist putsch. The murders caused a great stir of revulsion at the time, and are still among the best-remembered incidents in modern German history. On 25 January Kollwitz was invited by members of Liebknecht's family to draw the corpse (*Ich sah die Welt*, p.192), and six of these drawings survive (Nagel 766–71).

The idea of making a print of the subject followed soon after, but caused her considerable problems. For the composition, which recalls the type of the lamentation over the dead Christ, she had recourse to an earlier lithograph of

1914 (Klipstein 127) which showed mourners at the bier of Ludwig Frank, the Social Democrat leader of the Reichstag, who was killed at the Front on 3 September 1914. The same composition was refined through 1919 in a series of preliminary drawings (Nagel 773–90), which were then turned into an etching (Klipstein 137) and a lithograph (Klipstein 138). Neither, however, was successful as a print, and neither was published.

Kollwitz's journal of these years records her increasing doubts and uncertainties about the proper technique of her printmaking. She found that she could no longer make etchings, and was increasingly dissatisfied with the specious ease and feeble effect of transfer lithography. An entry of 8 April 1920 shows that she was beginning to think of making woodcuts, and after seeing some woodcuts of Barlach exhibited in the

43

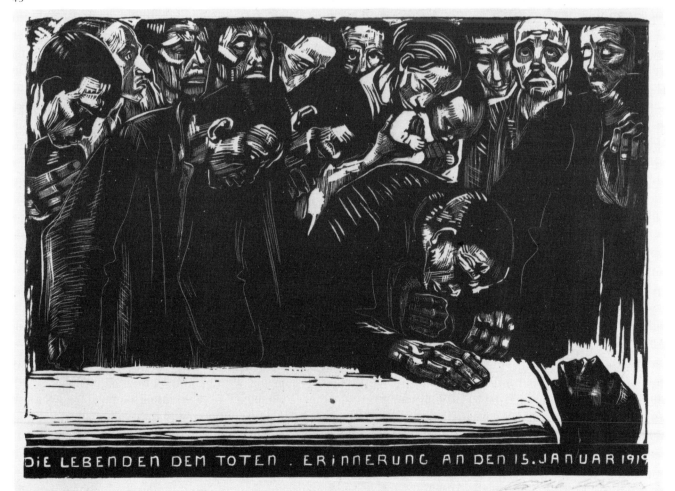

DIE LEBENDEN DEM TOTEN . ERINNERUNG AN DEN 15. JANUAR 1919

Secession on 25 June she decided to take the plunge. On 11 July she recorded: 'My first woodcut has succeeded to some extent. Now I am working with renewed hope on the preliminary work for the Liebknecht woodcut'.

The print must have been finished within the year, for it was published in two editions: a numbered edition of a hundred signed by the printer Voigt, and an unlimited edition sold at a very low price at the 1920 Arbeiter-Kunstausstellung in Berlin. In a journal entry of October 1920 she discussed the significance and legitimacy of the print: 'I have as an artist the right to extract from everything its content of feeling, to let it take effect on me and to express this outwardly. Thus I also have the right to portray the workers taking their farewell from Liebknecht, and even to dedicate it to them, without thereby being a follower of Liebknecht in a political sense. Or not?'

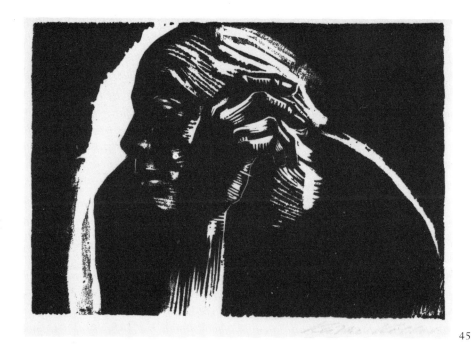

45

44 *Self-portrait*
1924

Lithograph. Signed and dated 1924 in pencil. 305 × 222 mm
Klipstein 198(b), from the edition of 100 printed on laid paper for distribution to the Kreis graphischer Künstler und Sammler, Arndt-Beyer, Leipzig.
1930-1-11-41. Presented by the Contemporary Art Society.

This is perhaps the finest of the later self-portraits. The original transfer drawing, signed and annotated *Lithozeichnung*, is in the National Gallery of Art in Washington (Rosenwald collection; reproduced Herbert Bittner, *Käthe Kollwitz drawings*, New York 1959, plate 106; not in Nagel).

45 *Self-portrait*
1924

Woodcut. Signed in pencil. 208 × 300 mm
Klipstein 202, apparently sixth state. On soft Japan paper.
1980-1-26-85

This print is mentioned in the journal entry for 14 May 1924: 'I am working on two small things for a publisher, the Visitation of Elizabeth and Mary [Klipstein 232-4] and a self-portrait with raised hand. Both woodcuts.' These are now two of Kollwitz's most widely admired woodcuts, and it is curious that

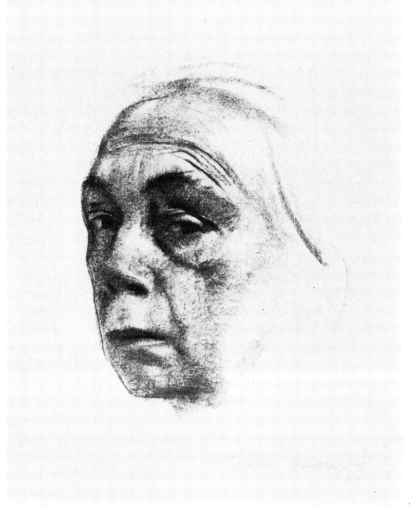

44

she referred to them so disparagingly. The reason for their popularity, apart from their quality, is the soft and almost crumbly texture of the impression which is very different from the hard and schematic appearance of many of her woodcuts which can sometimes look rather like line-blocks. The explanation of the difference is not obvious. There is however an interesting remark in the journal for February 1922 concerning her woodcuts: 'With the soft wood, which is more entertaining to cut, I find it impossible to work since it produces too many accidents and mistakes. And the hard wood, in the way I handle it, very easily slips into the academic.' This suggests the possibility that she may in these two instances have reverted to using soft wood. Indeed, on a proof of K232 noted by Klipstein is an annotation 'This is good' and 'Experiment in plywood'. There is no obvious source for the self-portrait, but the *Visitation* was inspired by a painting in the Berlin gallery by Konrad Witz (journal entry for 6 February 1922; see Walter Timm, *Käthe Kollwitz*, 1980, plate 22).

The print went through seven states in all. In the first four the block extended 212 mm further at the bottom, and the artist's left hand and forearm were to be seen lying horizontally at the centre of the block. The differences described in Kornfeld's catalogue from the fifth to seventh states are very slight; this impression however seems to correspond exactly to his illustration of the sixth state. In the seventh state, the print was published in an edition of 125 in *Die Schaffenden* (5th year, 1st Mappe) (cf. 194). The impressions from *Die Schaffenden* are much harder and sharper, with little of the softening of the form which is so effective in this impression. This is partly a matter of the high quality Japan paper and the care taken in the printing.

MAX LIEBERMANN

1847–1935

Born into a family of millionaire Jewish manufacturers in Berlin. After a short period in the philosophical faculty of Berlin University, he became a student at the Weimar Kunstakademie in early 1868. After achieving a great success with the exhibition of his painting *The Goose-Pluckers* he moved to Paris, which remained his base for the five years 1873–7, during which he sent works to exhibitions in the different artistic centres of Europe. In 1878 he moved to Munich, but made regular visits to Holland, and Dutch subjects subsequently bulk large in his paintings. On his marriage in 1884 he returned to Berlin, which remained his home for the rest of his life. In the 1870s and 1880s he worked in a late Naturalistic style, but in the 1890s adopted a lighter palette and more fluid brush-stroke, mainly under the influence of the work of Manet and the Impressionists, of whose paintings he assembled a remarkable collection. Liebermann's art had always been controversial in Germany; as the most prominent of the so-called German 'impressionists', he was subject to even greater official suspicions, although his distinction was recognised in 1897 with the award of a large gold medal at the Berlin Salon. He was, therefore, the obvious choice as President of the Berlin Secession when it was founded in 1899, and its enormous success owed much to his good judgement and openness to new ideas. In 1920, as the 'grand old man' of German art, he was appointed president of the Prussian Akademie der Künste, and further honours came on his eightieth birthday in 1927. After the Nazi *coup d'état* in 1933 he resigned his honorary presidency, and died two years later. His eighty-five-year-old widow committed suicide in 1943 to escape deportation to Poland.

517 intaglio and lithographic prints by Liebermann have been catalogued, as well as a number of woodcuts cut by others from drawings he had made on the block. With the exception of a few early attempts, his prints begin in 1890, when Liebermann was in his forties, and continue to his death, with a break between 1896 and 1900.

(For *Nach dem Kampf* see 252.)

Bibliography

Liebermann's own essays have been collected under the title *Die Phantasie in der Malerei*, ed. Günter Busch, Frankfurt 1978. Of the many early monographs, the standard work is Erich Hancke, *Max Liebermann, sein Leben und seine Werke*, Berlin 1914 (new edn with extra material 1923), which contains a catalogue of the paintings. The prints were catalogued by Gustav Schiefler, *Max Liebermann, sein graphisches Werk*, 3rd edn Berlin 1923 (1st edn 1907). The most significant modern contribution is the huge catalogue to the exhibition *Max Liebermann in seiner Zeit* held in Berlin (Nationalgalerie) and Munich (Haus der Kunst) in 1979–80. This contains an essay on Liebermann's prints by Sigrid Achenbach, whose 1974 Heidelberg dissertation *Die Druckgraphik Max Liebermanns* contains a fuller study and a supplementary catalogue of those prints produced after Schiefler's publication of 1923.

46 *In the dunes near Katwijk* 1891

Soft-ground etching and drypoint. Signed in pencil. 178 × 237 mm
Schiefler 19, fifth state. On Japan paper.
1911-4-17-8. Presented by the artist and Bruno Cassirer.

Liebermann's first etching was made in 1876 under instruction from the reproductive etcher Karl Koepping (1848–1914) and lessons were later given to him by Peter Halm (1854–1923). But it was not until the Dutch etcher Jan Veth (1864–1925) taught him the technique of soft-ground etching in 1890 that his interest in the medium was really awakened. Between the end of 1890 and the end of 1892 he made twenty-one soft-ground etchings of

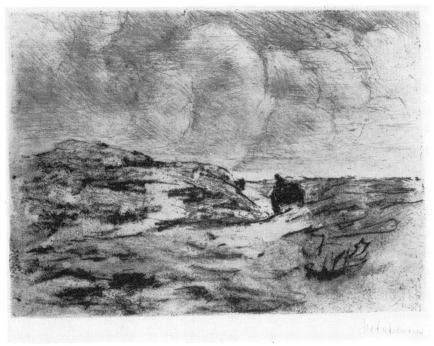

46

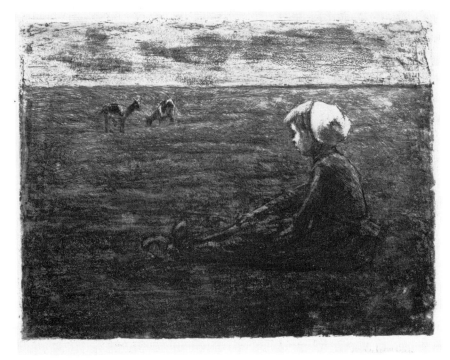

47

which eighteen were collected together in a portfolio published by the Berlin Photographische Gesellschaft in an edition of a hundred in 1893, with an introduction by Richard Graul. This was not a commercial success initially, and Schiefler was amazed to find that sets were still available several years later (*Meine Graphiksammlung*, 1974, p.15). But it contains almost all his best prints, and the four in this catalogue all come from it.

Almost all the prints in the portfolio are related to paintings or drawings of which they are further developments rather than reproductions. In their searching for tonal and atmospheric qualities, they continue the concerns evident in a large number of chalk drawings and pastels of the years 1887–90. This etching looks back to a drawing of 1887 (private collection; 1979 Berlin catalogue no. 230), made at the same time as the painting *Cart in the dunes* (Berlin no. 58), which was painted directly from nature. When he decided to make an etching of the motif he made a further finished preparatory drawing (now Kunsthalle, Bremen) from which to work.

47 *Goatherd*
1891

Soft-ground etching and drypoint. Signed in pencil. 179 × 240 mm
Schiefler 20, fifth state. On Japan paper.
1911–4–17–9. Presented by the artist and Bruno Cassirer.

The starting-point for this etching is a pastel of *c.* 1890 which is now in the Hermitage (cf. 1979 Berlin catalogue no. 422). In the Berlin catalogue Achenbach observes that the subject derives from the work of the Dutch painter and etcher Jozef Israels, and in particular from his etching *Fisher girl on the shore* of the 1860s.

In 1911 Liebermann presented thirty-three of his etchings to the British Museum in association with his publisher, Bruno Cassirer. The group included ten prints which came from the 1893 portfolio. Since all bear signatures (unlike the sheets published in 1893) one must conclude that Liebermann signed them later before presenting them to the British Museum.

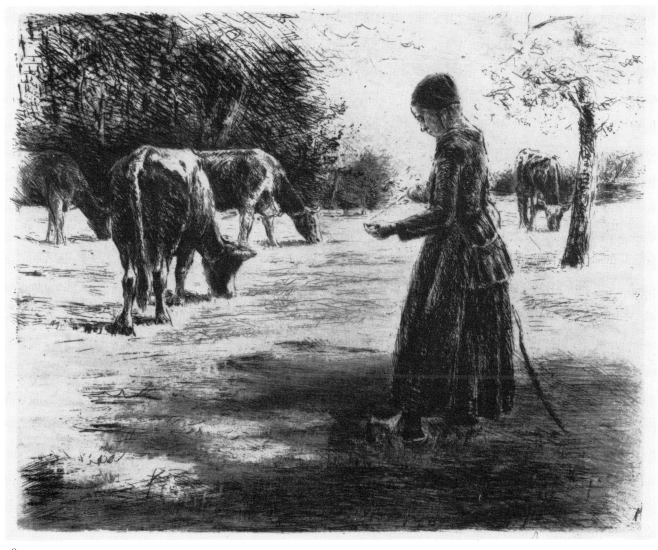

48

48 *In the pasture*
1891

Soft-ground etching, etching and drypoint.
Signed in pencil. 193 × 238 mm
Schiefler 21, sixth state. On Japan paper.
1911–4–17–10. Presented by the artist and
Bruno Cassirer.

The scene is taken near Delden in
Holland, and shows in reverse the
composition of the painting *The Cowherd*
now in the Kunsthalle, Bremen (1979
Berlin catalogue, colour plate IV).
Liebermann began work on the painting
in 1890; when he exhibited it in 1891 it
was heavily criticised for its harsh
composition. This etching was made some
time later that year, and shows him
experimenting with slight changes to the

background: the cow behind the girl's
back, for example, was added in the
print. Liebermann must have been pleased
with the effect, for in 1894 he reworked
his painting, adding the cow and making
various other changes.

49 *Under trees*
1892

Soft-ground etching with drypoint. Signed in
pencil. 129 × 180 mm
Schiefler 24, tenth state. On Japan paper.
1911–4–17–11. Presented by the artist and
Bruno Cassirer.

The subject is the women's alms-house
in Laren. A finished preparatory drawing
from which this etching was prepared is

illustrated in Hancke's monograph of
1914 (p.287), but its present
whereabouts seem to be unknown.

After 1896 Liebermann gave up
printmaking for a few years. When he
resumed in 1900 he abandoned soft-
ground etching in favour of drypoint and
(especially after 1909) transfer
lithography. These later prints are built
up of open lines and have none of the
atmospheric qualities which make the
group of forty-five works made in
1890–6 so successful.

HEINRICH VOGELER

1872–1942

Born in Bremen; studied at the
Düsseldorf Akademie 1890–3. In
1894 he settled in Worpswede, a
village north of Bremen in which
was established an artist's colony
founded by Fritz Mackensen and Otto
Modersohn in 1889 and largely
composed of former Düsseldorf
students. He quickly became very
successful, first as an etcher, then as
book designer and illustrator (see
232) and finally as architect and
interior decorator. For the many
rooms for which he received
commissions he designed all the
fittings, from the furniture to the
glass and cutlery. These are
accomplished but routine exercises
in the fashionable Mackintosh-
Viennese style, enlivened by forms
taken from art nouveau. In 1901 he
married Martha Schröder, from a
local peasant family, after having
had her educated for several years to
match his ideal of her. Photographs
of Vogeler of this time show him
modelling his appearance on the
Nazarenes in wistful pre-Raphaelite
poses. The First World War, during
which he served as draughtsman to
various army units, transformed
him and his art. He turned the
'Barkenhoff', the house he had built
for himself at Worpswede, into a
commune and workers' school, and
in 1923 joined the Communist
Party. He had separated from his
wife in 1920, and in 1923 left for
Russia with Sonia Marchlewska, the
daughter of a close associate of
Lenin, giving the 'Barkenhoff' to the
Rote Hilfe as a home for the children
of persecuted Communists. During
the 1920s he moved between Berlin,
where he gave political lectures, and
Moscow, finally settling in Russia
in 1931, where he was given
commissions to make illustrations of
the lives of peasants and workers.
In 1941, after Hitler's invasion of
Russia, he was deported as a German

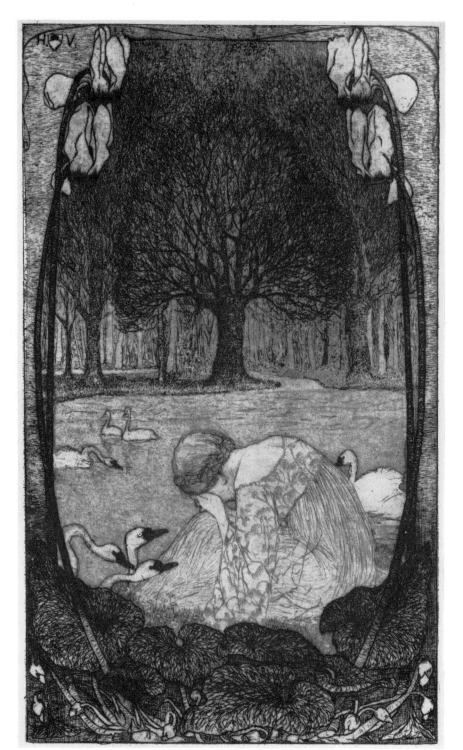

50

emigré to Kazakhstan, where he died in atrocious conditions the following year.

Bibliography

Vogeler, among all his other activities, was a prolific writer. His early poems, *Dir*, first published in 1899, had a certain success. His various post-War tracts are collected in *Das neue Leben . . . ausgewählte Schriften zur Revolution*, ed. Dietger Pforte, Darmstadt 1973. A posthumous volume of heavily edited reminiscences, *Erinnerungen*, was published in Berlin in 1952. A popular biography is H.W. Petzet, *Von Worpswede nach Moskau, Heinrich Vogeler, ein Künstler zwischen den Zeiten*, Cologne, 4th edn 1977. The earliest essay on his work is contained in Rainer Maria Rilke's *Worpswede*, Bielefeld and Leipzig, 1903. There are numerous recent studies on many aspects of his work; a well-illustrated introduction is to be found in the catalogue of the exhibition held in the Staatliche Kunsthalle, Berlin, in 1983 by the Neue Gesellschaft für bildende Kunst: *Heinrich Vogeler, Kunstwerke, Gebrauchsgegendstände, Dokumente*. The standard catalogue of his prints is by Hans-Herman Rief: *Heinrich Vogeler, das graphische Werk*, Bremen 1974 (3rd edn 1977).

50 *The seven swans* 1898

Etching and aquatint. 250 × 148 mm
Rief 23, second state on Japan paper but without a signature. As published by the Gesellschaft für vervielfältigende Kunst in Vienna in 1898.
1920–1–31–21. Presented by Campbell Dodgson Esq.

Vogeler was taught etching by Hans am Ende, a fellow resident at Worpswede, in 1894; the following year he acquired his own press. The thirty-five etchings he made in the years up to 1902 are the most striking examples of the idyllic and romantic side of his art, and are strongly influenced by the medieval fairy-tale pre-Raphaelitism associated with Morris and Burne-Jones. The young women, pairs of lovers or fairy-tale subjects are usually set in frames composed of flowers, like the cyclamen seen in this print. The story that it illustrates must be Grimm's tale of the six princes turned into swans by their

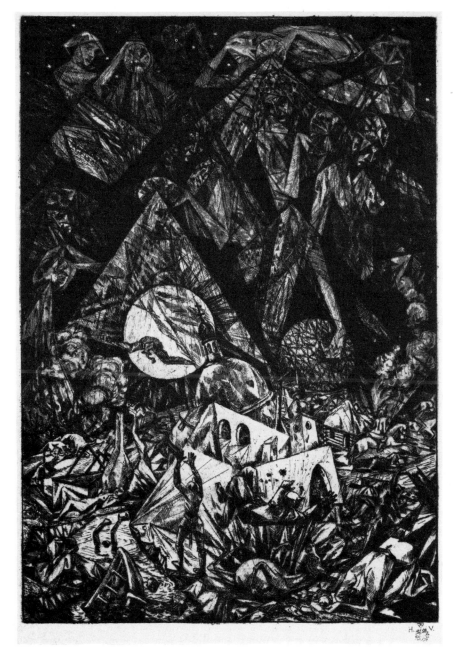

51

wicked step-mother, and only freed by the efforts of their sister, who knitted a coat of nettles for each of them which turned them back into human form.

The high point of his early etching is the portfolio 'An den Frühling' (To Spring) of ten prints published in 1899. After 1902 he only made a dozen more prints before the First World War broke out. Almost all his early etchings were reprinted in successive editions into the 1920s and the plates survive in the Worpswede archive.

51 *The seven vials of wrath* 1918

Etching and drypoint. Signed in pencil by the artist's widow *Original Radierung von Heinrich Vogeler* and, outside platemark, *gez. Martha Vogeler z. Geburtstag von H. H. Wolff-Rumbler*. 354 × 258 mm
Rief 50, second state. A posthumous impression, probably printed in the 1950s.
1982–11–6–9

In August 1914 Vogeler had hastened to volunteer his services in the army. Highly placed protectors kept him from the front,

but his principles led him on 20 January 1918 to address a letter to the Kaiser protesting at the conditions forced on Russia at the treaty of Brest-Litovsk. As a result his military career came to a quick end and he was put under observation in the Bremen madhouse. He took an active part in the November Revolution and in the short-lived Bremen Spartacist Republic in early 1919, when he was again arrested. His zeal for Communist ideals led him to turn his house, the 'Barkenhoff' into a children's home, and to redecorate it with a series of frescoes that reflected his new outlook on life (painted 1920–6, officially covered with curtains in 1927, after a celebrated scandal, as being corrupting of children's morals, destroyed 1939). The first of these frescoes was based on this etching, although this, being two years earlier, cannot have been designed with the fresco in mind (so Petzet 1977, p. 152).

It is one of his first works to show a wholesale adoption of the forms of the now fashionable Expressionism. The subject is taken from the Apocalypse, chapters 15 and 16, which are fairly precisely illustrated. 'And I saw another sign in heaven . . . seven angels having the seven last plagues . . . and one of the four beasts gave unto the angels seven gold vials full of the wrath of God'. The angels empty their vials in turn, bringing destruction to mankind. 'And there were voices, and thunders, and lightnings; and there was a great earthquake, such as was not since men were upon the earth . . . and every island fled away, and the mountains were not found.' The visionary subject of the print parallels in a curious way the mystical nature of the text of his letter to the Kaiser of January 1918 (reprinted in Pforte *Das neue Leben* and in Uwe M. Schneede *Die zwanziger Jahre, Manifeste und Dokumente deutscher Künstler*, Cologne 1979, p. 16).

According to Rief's catalogue this print went through fifteen different states. The plate survives in the artist's estate, and impressions printed after his death were signed by his first wife, who lived in Worpswede until her death in 1961.

PAULA MODERSOHN-BECKER
1876–1907

Born in Dresden into a cultured middle-class family; her father worked for the German railway and transferred to Bremen 1888. From an early age she wished to become an artist, but her parents persuaded her to qualify first as a teacher-trainer before they were prepared to support her as an artist. In 1896–8 she studied at the Berlin School of Art for Women. In the autumn of 1898 she set up residence in Worpswede. She spent the first part of 1900 studying in Paris; on her return to Worpswede she became engaged to Otto Modersohn (whose first wife had died earlier that year) and married him in May 1901. In the following years she made several visits of one or two months to study in Paris, and in February 1906 settled there indefinitely, feeling it the place where her art could best develop; in this year she spent much time in the company of her old Worpswede friends, Rainer Maria Rilke and his wife Clara Westhoff. She returned to Worpswede in the early spring of 1907, and died in November that year of a heart attack three weeks after giving birth to a daughter.

Although scarcely known outside Worpswede in her lifetime, Modersohn-Becker is now generally recognised to have made the best paintings produced in Germany in

52

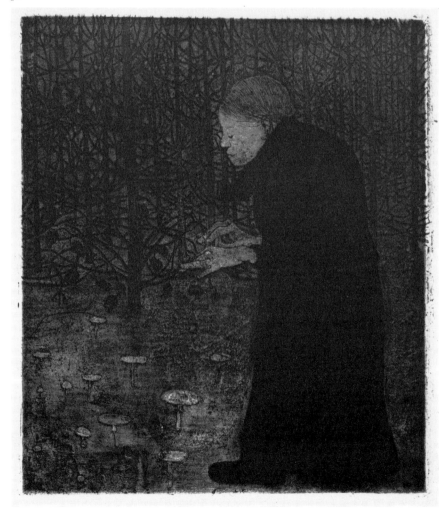

the first years of this century. In the eight or nine years of activity she made a remarkable progression from Worpswede lyricism to a radical simplification of form and abstraction of colour, while her preferred subjects moved from the particulars of the landscape and peasants of Worpswede to generalised treatments of the themes of mothers and children.

Twelve etchings by her are known, made in the early years of her career, between 1899 and 1902.

Bibliography

The standard edition of Modersohn-Becker's own writings is that edited by Günter Busch and Liselotte von Reinken, *Paula Modersohn-Becker in Briefen und Tagebüchern*, Frankfurt 1979, which contains a full bibliography. It has been translated into English by A.S. Wensinger and C.C. Hoey, New York 1983. The standard monograph in German is Günter Busch, *Paula Modersohn-Becker, Malerin, Zeichnerin*, Frankfurt 1981. There is also a monograph in English by Gillian Perry: *Paula Modersohn-Becker*, London 1979. A catalogue raisonné of her paintings, prints and drawings is currently being compiled by Günter Busch, Anne Röver and Wolfgang Werner. In the meantime the most useful sources of information are the catalogues of the centenary exhibition held in Bremen in 1976, and, for the prints, the catalogue *Paula Modersohn-Becker, Oeuvreverzeichnis der Graphik*, by Wolfgang Werner, Bremen 1972.

52 *Blind woman in a wood*
c. 1902

Etching, aquatint and roulette. Signed in pencil bottom left *F.P. Modersohn-Becker, O. Modersohn*. 156 × 140 mm
Werner 4, third state. On wove paper.
1981-11-7-16

This haunting image is perhaps Modersohn-Becker's finest print, and shows well her ability to devise a composition of great formal simplicity, but by expressive distortion (seen in the way the head rests on the shoulders and in the outsize groping hands) to convey a strong emotional charge without the least hint of sentimentality.

The print is not dated, but on technical and stylistic grounds seem to belong to the same period as the etching *The woman with the goose*, which is known to have been made in 1902. It therefore belongs to the years when she was most fascinated by the occupants of the poorhouse in Worpswede, and their remoteness and strangeness (see Perry, 1979, pp. 98–104). As with all her more elaborate etchings, it was preceded by at least one compositional drawing of the same size and in the same direction (cat. 258 in the 1976 Bremen exhibition).

None of her etchings was published in her lifetime. In 1913 Otto Modersohn, encouraged by Heinrich Vogeler, had an edition of the nine plates that could be found printed by Felsing in Berlin. He then signed all the impressions on his dead wife's behalf – hence the signature seen on this print. Later editions were published in the 1920s signed on occasion by her daughter Tille (Mathilde).

LOVIS CORINTH
1858–1925

Born in Tapiau in East Prussia; his father ran a tannery which Corinth's mother had inherited from her first husband. He was educated at the gymnasium in Königsberg, and in 1876 went to the Akademie there. He pursued his studies at the Munich Akademie, where he spent four years (1880–4) under Ludwig Löfftz, and in Paris at the Académie Julian (1884–7) under Bouguereau and Robert Fleury. He then spent almost a year in Berlin in 1887–8, but returned to Königsberg, where his father was dying. His ambitions, however, could not be satisfied in such a provincial setting, and so in 1891 he moved his residence to Munich, where he gradually began to make a reputation, winning a gold medal in the exhibition of 1895. In the last years of the century he began to spend more of his time in Berlin; he took part in the first exhibition of the Berlin Secession in 1899, and in the following year had a one-man show with Cassirer. In the autumn of 1901 he therefore moved to Berlin, and in 1903 married Charlotte Berend (1880–1967), the first pupil to attend his short-lived painting classes.

In the first decade of the twentieth century Corinth was recognised as the foremost of the now fashionable German 'impressionists' after Liebermann, and his large paintings of religious or mythological subjects (which now appear overblown) became very fashionable. A serious stroke at the end of 1911 had immediate consequences for his manner of painting which became more 'expressionist' in its colour and structure. This development reached its climax in a group of remarkable landscapes and portraits from the last six years of his life. These late works were all branded as 'degenerate' by the Nazis; in general, however, they left his early works undisturbed.

918 prints by Corinth have been

catalogued. The first small group of etchings was made in Munich mostly in 1894–5, and is dominated by the remarkable set of nine 'Tragikomödien'. These prints did not sell, and he abandoned the medium until after his move to Berlin. There he was encouraged to make another start by his friend, the professional printmaker Hermann Struck. At first he made only a few prints each year, but from 1908 the pace of production steadily increased, until in the early 1920s he was making over a hundred prints a year. His favoured technique was now drypoint rather than etching, and, especially in the last years, lithography, which he used particularly for the many commissions he latterly received for book illustrations (see 261). In 1919 he experimented with woodcut, but only made eleven in all. The fifteen prints included in this catalogue can only give a partial view of his achievement in printmaking.

Bibliography

Corinth's own collected writings, *Gesammelte Schriften*, Berlin 1920, include a reprint of an article first published in 1907, 'Wie ich das Radieren lernte'. A posthumously published volume of his autobiographical notes *Selbstbiographie mit Bildnissen*, Leipzig 1926, was edited by his widow Charlotte Berend-Corinth. She also published two volumes of reminiscences about her life with Corinth, and compiled the standard catalogue of his paintings, *Die Gemälde von Lovis Corinth, Werkkatalog*, introduced by H.K. Roethel, Munich 1958. The catalogue of his prints up to 1920 was compiled by Karl Schwarz, *Das graphische Werk von Lovis Corinth*, Berlin 1922 (first edn 1917), and is supplemented by Heinrich Müller, *Die späte Graphik von Lovis Corinth*, Hamburg 1960. A large volume compiled by Thomas Corinth, the artist's son, entitled *Lovis Corinth, eine Dokumentation*, Tübingen 1979, publishes a mass of letters and other information, including a large quantity of material relating to the prints and the circumstances of their publication.

53

53 *Menu*
1909

Lithograph printed in four colours. Signed in pencil, and annotated at top left *No 57*.
321 × 273 mm (sheet size)
Schwarz 39
1980-12-13-26

The text in the image reads *Menu. Ihren lieben Gästen gewidmet von Minchen Corinth 13 Oktober 1909* (Menu. Dedicated to her dear guests by Minchen Corinth). This menu card was given to the thirty guests at the celebration of the christening of Corinth's daughter Wilhelmine (born 13 June 1909), known to her family as 'Mine' (or, as in this card, by the diminutive 'little Mine': cf. Thomas Corinth, 1979, p. 131). Corinth made various other lithographed decorations for invitations or menus. The earliest was

of 25 February 1905 (see Thomas Corinth, 1979, p. 342); another was for his own sixtieth birthday party on 21 July 1918. All are humorous in treatment; here the menagerie assembled by devils for the cooking pot is appropriate for a child. In the 1918 menu Corinth himself is presiding at the head of a table at which a couple of pigs are seated, while Death drinks a toast behind his shoulder.

54 *Venus with a mirror*
1916

Drypoint. Signed in pencil 292 × 243 mm Schwarz 223, on wove paper. From an edition of 75 (of which 25 were on Japan paper).
1980-12-13-25

In 1916 Corinth made far more prints and many fewer paintings than in previous years, probably inspired to do so

54

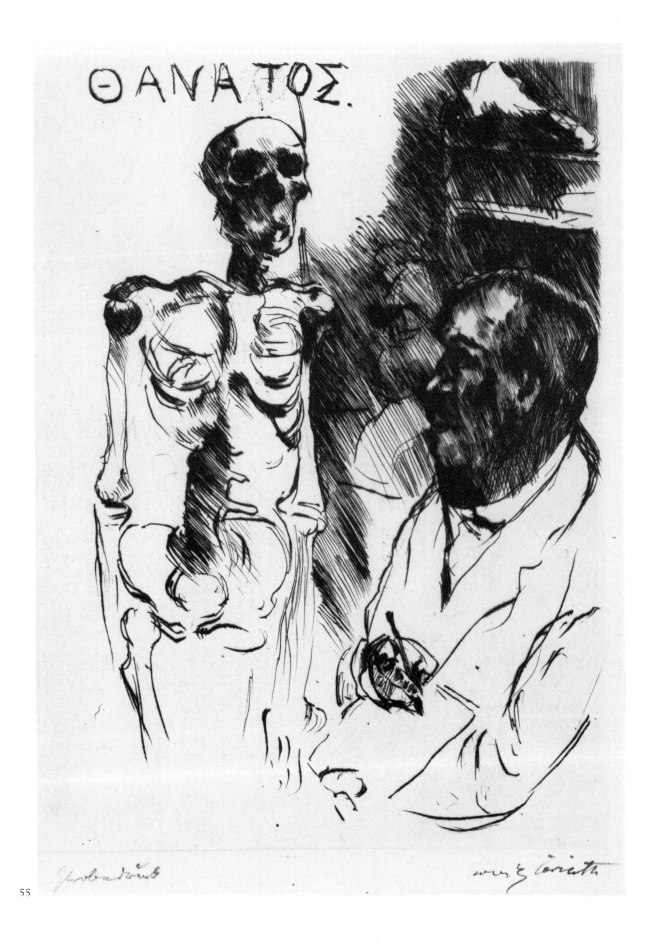

ΘΑΝΑΤΟΣ.

by the help he was giving at this time to Dr Schwarz on the completion of the oeuvre catalogue of his prints. This drypoint is related to a painting of the same title which bears the same date 1916 (Berend-Corinth no. 675, formerly Königsberg city collection, present whereabouts unknown), in which Venus is seated in a chair while Cupid behind her, wearing a crown of flowers, is helping her support the mirror in which she is looking at herself. The etching differs not merely in the arrangement of the poses, but in the addition of an extra youth on the left and in the replacement of Venus by (apparently) a young man. These differences, and the fact that the painting is in the same direction as the drypoint, suggest that Corinth based the former on the latter, while changing the subject from a group of three epicene youths to Venus and Cupid (whose attributes of the quiver and arrow are added in the painting). If this is so, the conventional title of this print is inaccurate.

Like all of Corinth's separate plates produced for some years after 1913, this print was published by Fritz Gurlitt, the Berlin dealers, who seem to have made an exclusive contract with him after the split which tore the Berlin Secession apart in June 1913. Corinth, strangely, remained with the minority and sided against Cassirer and Liebermann. Those of his earlier plates that had been published had been handled by Paul Cassirer; after 1913 Cassirer sold his interest in these earlier plates to Gurlitt, who then republished many of them. In a letter of 29 May 1916 Corinth reported the sale of a whole drawer-full of plates to Gurlitt (Thomas Corinth, 1979, p. 203). This sale led to an exhibition of his prints at Gurlitt's the following year, which was apparently their first significant public exhibition, and first established his reputation as a printmaker as well as a painter (Thomas Corinth, 1979, p. 240).

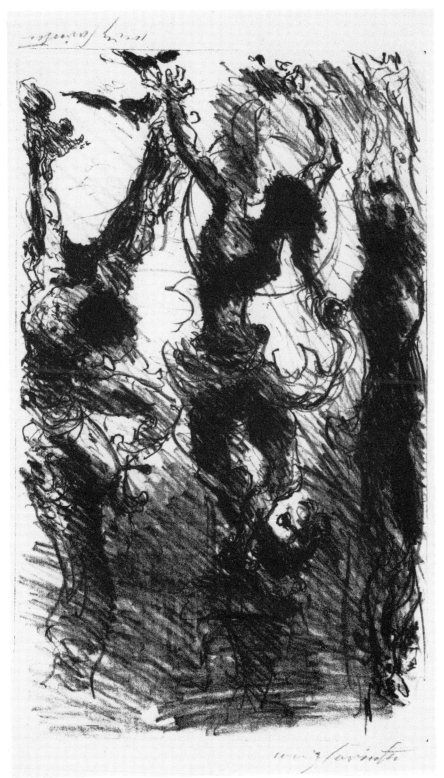

56

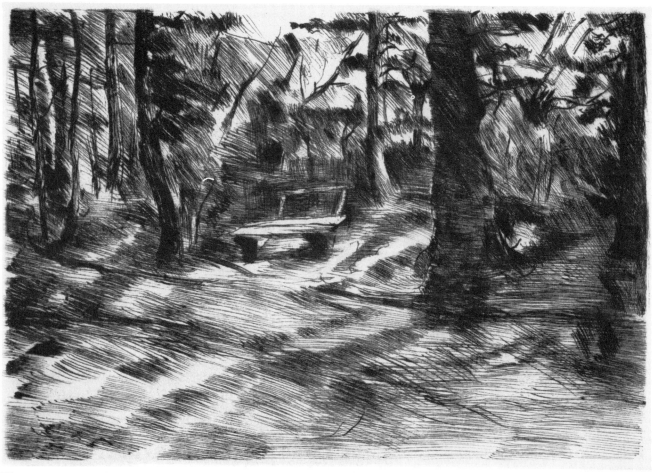

57

55 *Self-portrait with Death*
1916

Drypoint. Signed and annotated *Probedruck* in
pencil. 261 × 195 mm
Schwarz 238, second state after correction of
the lettering; a proof before a total edition of
115.
1980–12–13–27

In the top left corner of the plate is
Thanatos – the Greek for 'death'. Corinth
made a large number of self-portraits
throughout his career: at least forty-two
paintings and probably as many prints.
A *Self-portrait with skeleton* of 1896
(Munich, Berend-Corinth no. 135) is one
of his finest early paintings, and shows
that the theme of the *memento mori* did
not only enter his work after his stroke
of 1911.

In a letter of August 1916 to Heinrich
Schwarz who was compiling the catalogue
of his prints, Corinth lamented the

(temporary) loss of the plate for this
drypoint: 'it annoys me not so much
because Mr Gurlitt and I have already
numbered it for your catalogue, but
because it is definitely the best plate
in my work' (Thomas Corinth, 1979,
p. 209). Schwarz left an account of how
Corinth worked on his drypoints: 'He
gripped the plate like a sketching pad in
his left hand. He worked for preference
with diamond pointed needles, but ran
through large numbers of them since he
kept on breaking the fine points with the
strong pressure he exerted on them . . .
The number of works which he created
in the last decade of his life was
astonishing. When he had stood for
several hours in his studio painting, he
would continue without a break with
work on his prints, since, as he said, this
was not work but a distraction and
refreshment since he could sit down to it'
(Thomas Corinth, 1979, p. 239).

56 *Crucifixion*
1916

Lithograph (zincograph). Signed twice in
pencil, once with the print upside-down.
396 × 244 mm
Schwarz 285, on wove paper. From an edition
of 80 (of which 30 were on Japan paper).
1980–12–13–21

This extraordinary drawing, printed from
a zinc plate, is unrelated to any painting
or other print.

57 *Bench seat in the wood*
1917

Drypoint. 270 × 400 mm
Schwarz 303, on wove paper. From an edition
of 115 (of which 40 were on Japan paper).
1949–4–11–3848. Bequeathed by
Campbell Dodgson Esq.

Landscapes only began to occupy a
significant part of Corinth's oeuvre in
1912, when he spent some months on

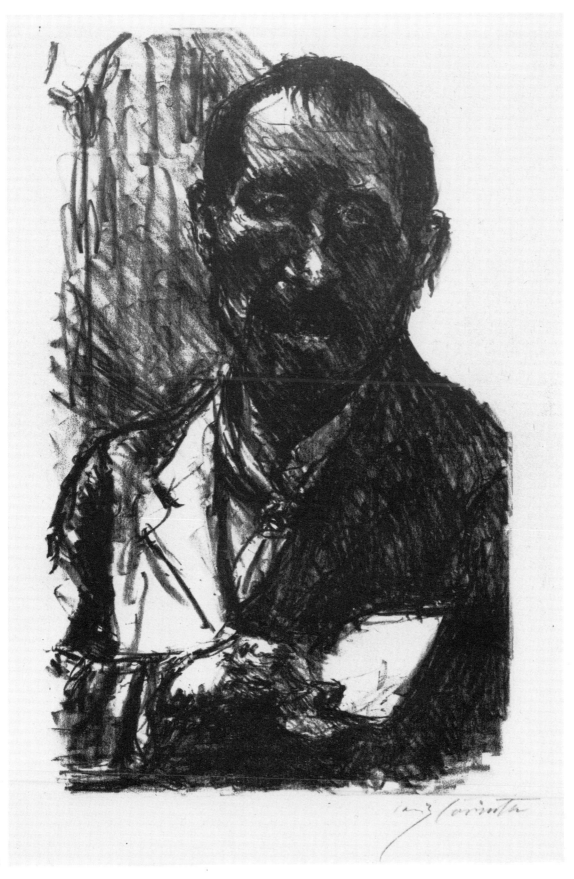

58

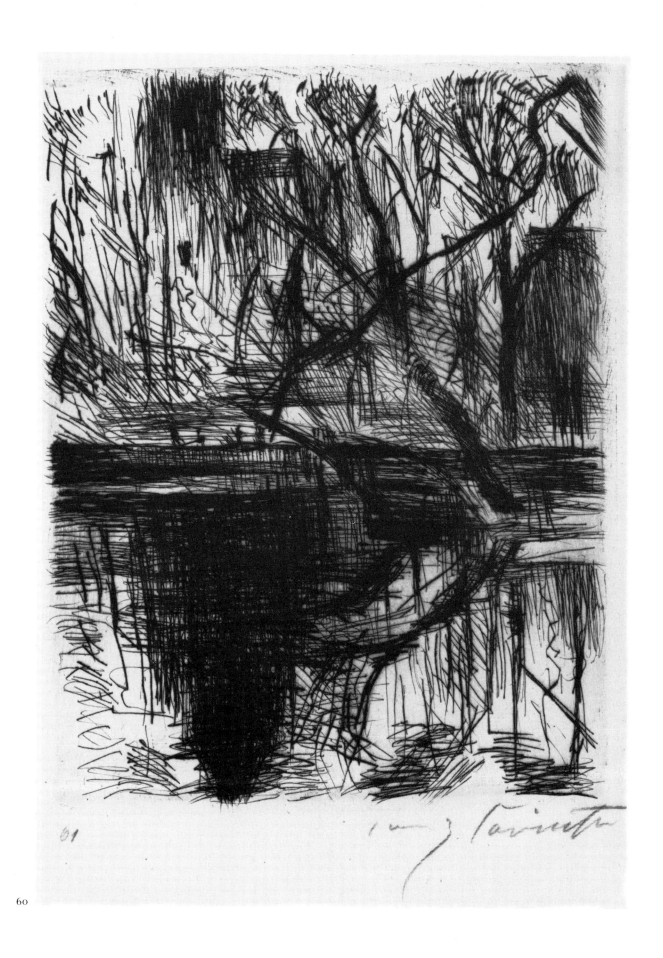

61

60

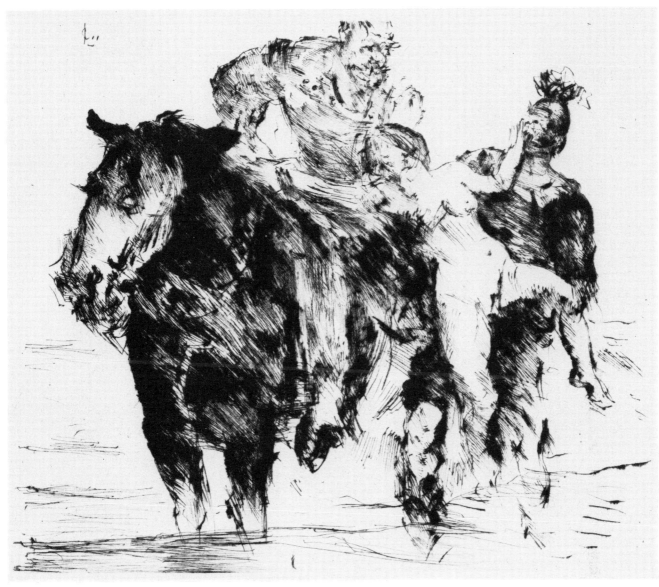

61

the French Riviera recovering from his stroke, but thereafter became increasingly important. This drypoint, like the other two landscapes in this catalogue, was most probably made on the spot somewhere in the Tiergarten, which lies in the centre of Berlin, west of the Brandenburg Gate.

58 *Self-portrait*
1919

Lithograph. Signed in pencil. 397 × 252 mm
Schwarz 354, on wove paper. From an edition of 80 (of which 30 were on Japan paper).
1951–5–1–40. Bequeathed by Campbell Dodgson Esq.

Some of Corinth's most remarkable self-portraits were made at the end of the First World War. Besides this lithograph, there is a drypoint (Schwarz 337) inscribed *Revolution. 10 Nov. 1918*, that is the day of the foundation of the German Republic after Kaiser Wilhelm II's abdication and flight to Holland the previous evening.

59 *In the studio*
Plate I of 'Bei den Corinthern'
1919

Drypoint. Signed in pencil. 320 × 248 mm
Schwarz 380. From 1 of 9 sets printed on van Gelder paper.
1942–10–10–17(1). Presented by Mr Erich Goeritz.

The portfolio entitled 'At the Corinthians' contains fourteen drypoints, which show portraits of members of the artist's family and circle of friends, and views of his studio and houses, both in Berlin, at Klopstockstrasse 48, and in the country at Urfeld by the Walchensee, where he was building himself a house in 1919. In

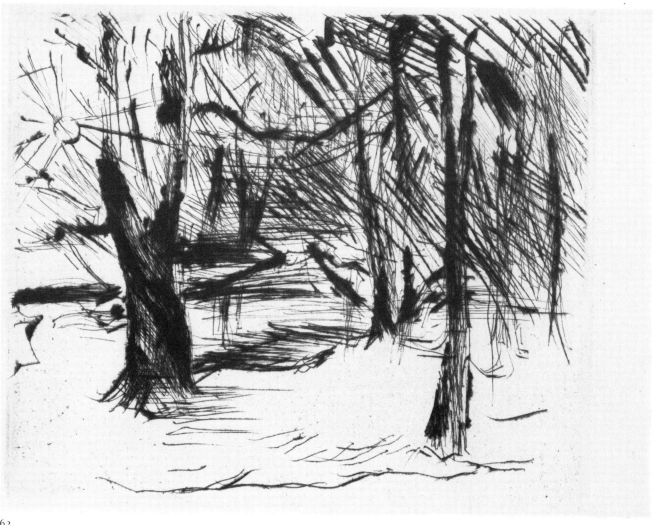

62

the preface Corinth explains that the series is a sort of journal of that year, and that the allusion to Paul's epistle to the Corinthians in the title is deliberate, in that he always felt that it was addressed directly to him. Its content curiously parallels Beckmann's 'Gesichter' which also opens and closes with a self-portrait, and which is also largely autobiographical in subject.

The portfolio was published by E.A. Seeman in Leipzig in an edition of one hundred in 1920 (cf. Thomas Corinth, 1979, pp. 253–8). Erich Goeritz, who presented to the British Museum a complete set from which this plate has been extracted, was a textile manufacturer from Chemnitz and one of Corinth's most important patrons in his later years. He owned several important paintings, and commissioned two

portraits (Berend-Corinth 841, 858) as well as several prints (Müller 488, 576, 590–1) from Corinth. He emigrated to England in the 1930s, and presented to the British Museum in 1942 seven portfolios of prints by Corinth, as well as the first two Bauhaus portfolios (see p. 199) and Kokoschka's 'O Ewigkeit – du Donnerwort' (116) among other sets of prints. He also gave to the Tate Gallery in 1936 *The Temptation of St Antony*, a large canvas of 1908, painted in Corinth's earlier manner.

60 *Part of the Tiergarten* 1920

Drypoint. Signed and numbered 61 in blue crayon. 244 × 195 mm
Schwarz 405, on wove paper. From an edition of 75 (of which 25 were on Japan paper).
1949–4–11–3841. Bequeathed by Campbell Dodgson Esq.

Another view in the Berlin Tiergarten.

61 *Two men abducting a woman* 1920

Drypoint. Signed in pencil and annotated *No. 28.* 300 × 250 mm
Schwarz 443. From an edition of 100
1981–6–20–42

This drypoint is based on a much earlier painting of 1904 (Berend-Corinth 303), which shows two men in chain-mail and plate armour carrying off a naked

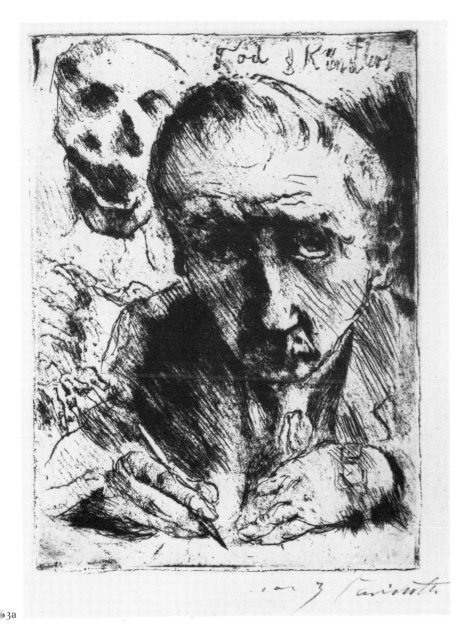

3a

woman. Similar erotic subjects, often from classical mythology, frequently recur in Corinth's earlier work and induced many to see him as a latter-day Rubens.

The reworking of earlier compositions is a curious feature of Corinth's art. In some cases he painted a new version of an earlier picture: an extreme example is the *Perseus and Andromeda*, known in versions of 1900 and 1916 (Berend-Corinth 208 and 677) which reveal very clearly the difference in his manner of painting before and after his stroke. Similarly this drypoint is not a reproduction of the painting, but almost

an experiment to see how it would come out when transformed by a new style of drawing. Even in more usual cases, when print and painting were made within a few years of each other, the same holds true: the different medium is used to bring out quite different qualities from those of the painting.

62 *Trees in the sun*
1920–1

Drypoint. Signed and numbered 45/100 in pencil. 247 × 298 mm
Müller 478
1949–4–11–3846. Bequeathed by Campbell Dodgson Esq.

This is one of a sequence of six drypoints made in the Berlin Tiergarten in the winter of 1920–1 (Müller 474–9). The prints vary considerably in size and were separately published in different editions by various publishers, although apparently originally commissioned as a series by E.A. Seeman (cf. Thomas Corinth, 1979, p.276). Like all of Corinth's landscapes, this would have been drawn directly from nature (see Charlotte Berend-Corinth's introduction to Müller's catalogue, p.13).

63 'Totentanz' (Dance of Death).
1922

Soft-ground etchings, printed on Japan paper. Each is signed and numbered 13/25 in pencil.
a. *Death and the artist.* 234 × 178 mm
Müller 546
b. *Death and the woman.* 238 × 176 mm
Müller 549
c. *Death and the couple.* 238 × 176 mm
Müller 551
d. *Death and the old man.* 240 × 178 mm
Müller 548
e. *Death and the young man.* 240 × 176 mm
Müller 547
1981–2–21–2(1–5).

The set of five soft-ground etchings of 'Totentanz' was published by the Euphorion Verlag in Berlin at the beginning of 1922. The first seven copies were on Japan paper and contained an extra set of proofs of all the plates plus a sixth plate (Müller 550); the main edition was of twenty-five copies on Japan paper, and seventy on laid paper.

The five prints of this modern 'Totentanz' relate to Corinth and his milieu. The 'artist' is a self-portrait, the 'woman' is probably his wife Charlotte, the 'couple' is the etcher Hermann Struck (1867–1944) and his wife, and the 'youth' is his son Thomas. The 'old man' has not been identified, but could be his father, to whom he was devoted. The use of soft-ground etching is unusual in Corinth's work, but is responsible for the gloomy atmospheric quality that makes these images so powerful. The fact that Struck is portrayed in the series suggests that it was he who introduced Corinth to the technique of soft-ground; his technical expertise in the techniques of etching is abundantly shown in his standard work *Die Kunst des Radierens*, first published by Paul Cassirer in 1908.

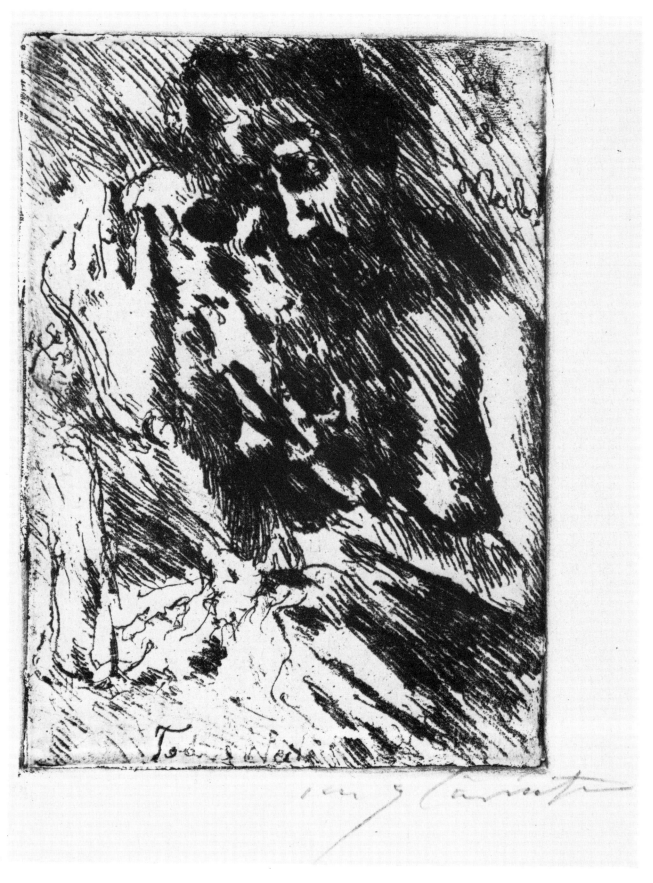

63b

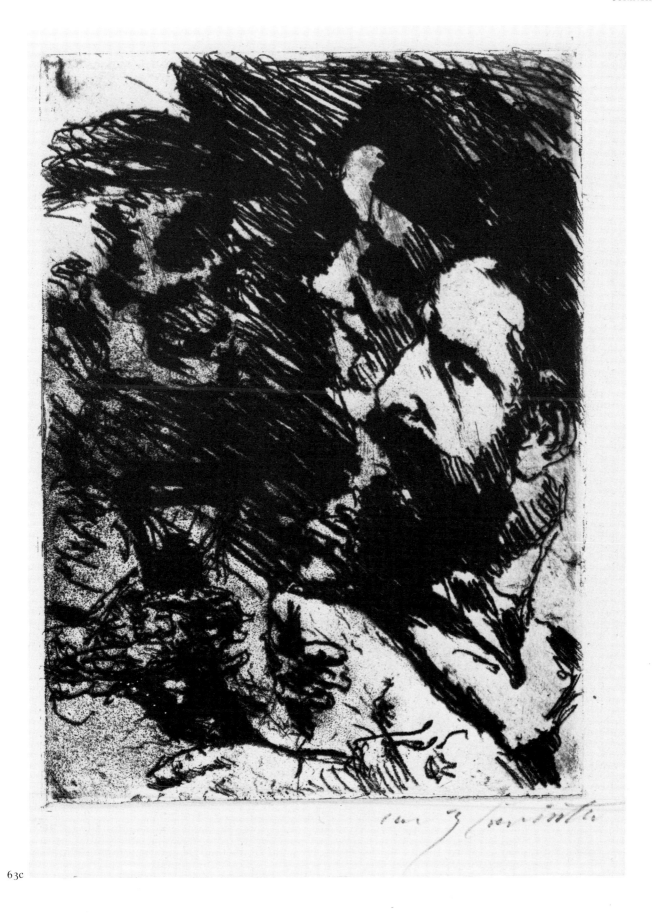

63c

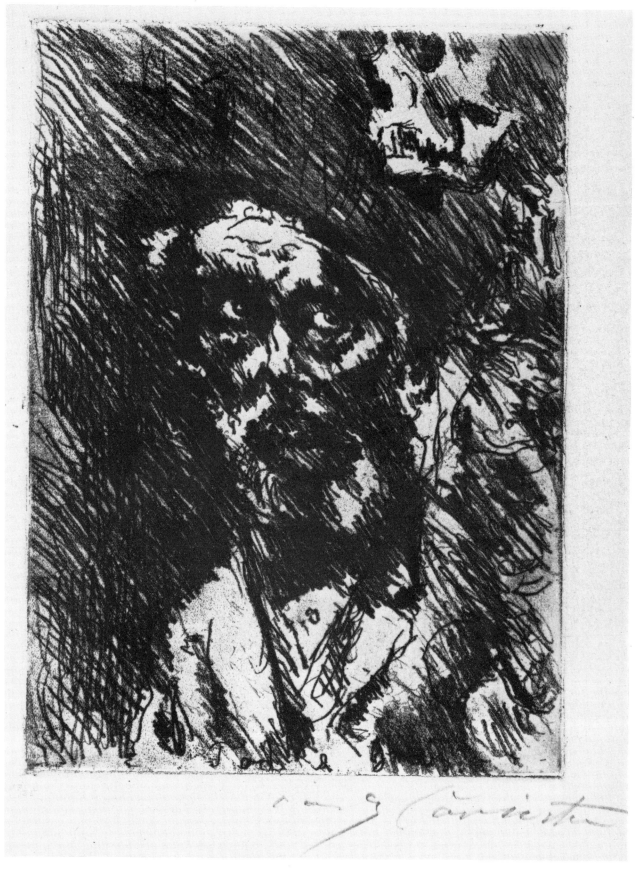

63d

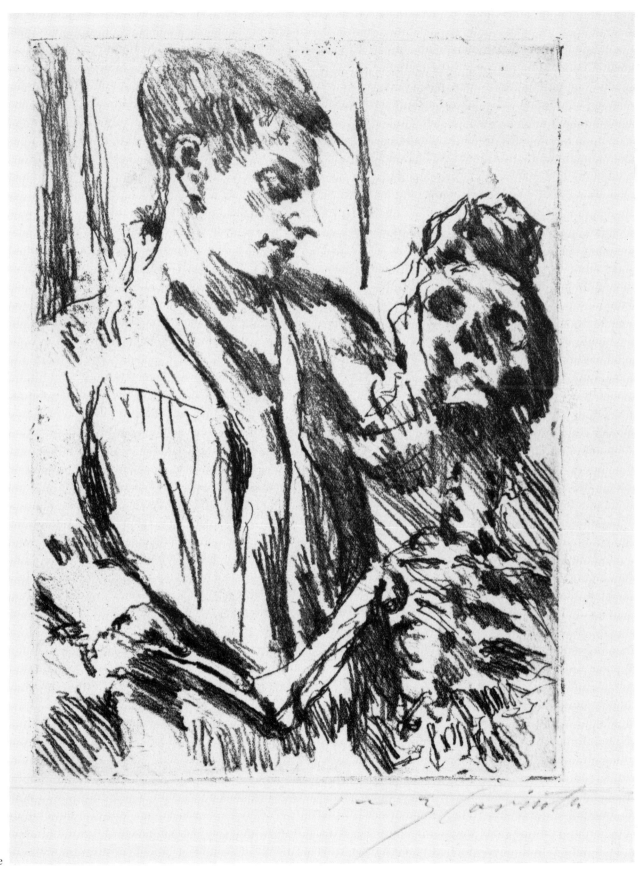

63e

ERNST BARLACH

1870–1938

Born in Wedel on the Elbe, just to the west of Hamburg. After his father, a doctor, died in 1884 he was brought up with three younger brothers by his mother in various villages in Holstein, whose flat lowlands made a great impression on him. At the age of eighteen he went to the Gewerbeschule in Hamburg, and later continued his studies in Dresden. A year spent in Paris at the Académie Julian in 1895–6 convinced him that his gifts lay in sculpture, and he later worked with a fellow student Carl Garbers on various decorative schemes in and near Hamburg. In 1899 he moved to Berlin, in 1901 returned to Wedel where he earned a living from designing ceramics for the Mutz factory, and then went back to Berlin in 1905. These were years of artistic and personal crisis: his style was a provincial derivation from Jugendstil patterning, while his illegitimate son was born in August 1906 (leading to a lawsuit with the mother over custody of the child).

To escape these pressures he went on a journey to Russia in August and September to visit his brother, who was working for an industrial company in Khar'kov in the Ukraine. The impact of the Russian peasants and the huge empty landscape changed his style radically. His sketchbooks from the journey show a new monumental simplification with pronounced elements of caricature (and indeed later, in 1907–8, he made some excellent drawings for *Simplicissimus*). On his return he took up his sculpture again, carving now directly into wood as well as modelling in clay. In order to transfer the monumentality he was seeking into his drawings, for a short time he used his own sculptured figures as models. By 1910 he had achieved the style which was to remain essentially unaltered through the rest of his life, and enjoyed considerable critical and commercial success. In Berlin in 1907 he signed a contract with the dealer Paul Cassirer to sell him his entire output in return for a fixed salary; he also became a member of the Berlin Secession. In 1909 the award of the Villa Romana prize took him to Florence for ten months; on his return he settled in Güstrow (a small town south of Rostock), where he was to remain for the rest of his life.

Barlach's earliest attempts at writing belong to the years 1901–4, when he was in Wedel. In 1907 he began work on the play *Der tote Tag*, which was completed in 1910 and published two years later, accompanied by his own lithographed illustrations. These were (with a few trivial exceptions) the first prints he made. But they stand at the head of a large subsequent output of lithographs and (from 1918–19) woodcuts, some of which were produced as illustrations to several of the six other plays he wrote (cf. 256). Barlach's distinction as author, sculptor, draughtsman and printmaker, as well as the many monuments he had made to the dead of the First World War, made him an obvious target for the Nazis; in 1937 his art was branded as 'degenerate' and 381 works were thrown out of German museums. Barlach himself was forbidden to publish or exhibit, and was forced to resign from the Berlin Akademie. He died in 1938.

Bibliography

The standard catalogue of Barlach's work was published by Friedrich Schult in three volumes: I *Das plastische Werk*, 1960; II *Das graphische Werk*, 1958; III *Werkkatalog der Zeichnungen*, 1971 (all published in Hamburg). His writings were published in Munich in three volumes: I *Die Dramen*, 1956 (ed. K. Lazarowicz); II *Die Prosa I*, 1958; III *Die Prosa II*, 1959 (both ed. F. Dross). Friedrich Dross also edited a two-volume edition of his letters: *Ernst Barlach, Die Briefe*, Munich 1968–9. Barlach wrote a short autobiography 'Ein selbsterzähltes Leben', first published in Berlin in 1928, and reprinted in *Die Prosa I*.

There is a large secondary literature on his writings and art, although there is no monograph in English. A well-illustrated introduction is C.D. Carls, *Ernst Barlach, das plastiche, graphische und dichterische Werk*, Berlin 1968 (first published 1931). The most important recent work is the three-volume catalogue of an exhibition held in East Berlin in 1981, *Ernst Barlach, Werke und Werkentwürfe aus fünf Jahrzehnten*, edited by Elmar Jansen (2nd edn 1983). This publishes much new material from the Barlach estate in Güstrow which is now administered by the East Berlin Akademie der Künste.

64-6 'Der tote Tag' (The dead day) 1912

Der tote Tag, Barlach's first completed play, was published by Paul Cassirer's Pan-Presse in Berlin in the last months of 1912. The text came in one volume, and was accompanied by a separate portfolio of twenty-seven signed lithographs; the total edition was 210 copies, 60 on Japan, 150 on laid paper. The progress of the work can be followed in the published letters (although only incompletely since Cassirer's letters to Barlach are not included). The play was begun in 1907, and by 21 January 1908 four of the five acts had been completed. Work was abandoned in 1909 during his time in Italy, but the text was finished by mid-1910. On 5 July of that year he told a correspondent that he intended to make a series of drawings to illustrate it, and it would then be published by Cassirer. By October Cassirer had persuaded him to turn his drawings into lithographs himself (presumably rather than let them be photomechanically reproduced) and this was more or less done by February 1911. That the play was only published in late 1912 seems to have been the fault of Cassirer, who was evidently unhappy about the text. The play was given its first performance in Leipzig in 1919. Although the lithographs are by far Barlach's finest prints, the play has never

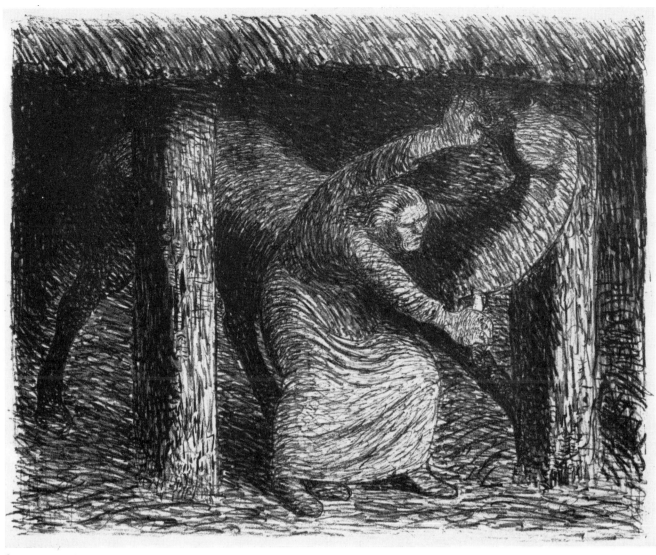

64

been highly regarded, and has apparently never been translated into English. This must be because of its deep mystical obscurity through which an underlying religious symbolism is apparent.

The plot defies intelligible summary. The protagonists are the Mother and her Son. The blind old man Kule arrives in order to rouse the son to his destiny to leave his mother to serve God; the mythical horse Herzhorn is waiting outside the cottage to take him away. That night the Mother, not wishing to lose her son, kills the horse. The sun does not rise the following day (hence the title), and the Mother confesses to the horse's murder before killing herself. The Son then kills himself as well, thus

revealing the relative weakness of his father's blood as against his mother's blood (the original working title of the play was *Blutgeschrei* – 'blood cry'). Barlach's own account of the play's meaning can be found in a letter of 28 April 1916 to Julius Cohen (published in *Die Briefe*, no. 354).

Almost all the original drawings survive, although scattered among many collections. They are very similar in size and manner to the lithographs, though most are in the reverse direction.

64 PLATE 13 *Die Mörderin* (The murderess)

Lithograph, signed in pencil. 295 × 365 mm
Schult 29. On Japan paper.
1983–10–1–30

The thirteenth plate of the published series, showing the central moment of the drama (which occurs off-stage between the second and third acts) when the Mother kills the horse Herzhorn. The original drawing, in the reverse direction to the lithograph, is in the Guggenheim Museum, New York (Schult 744).

The three plates here are the only ones from the series that are in the collection of the British Museum.

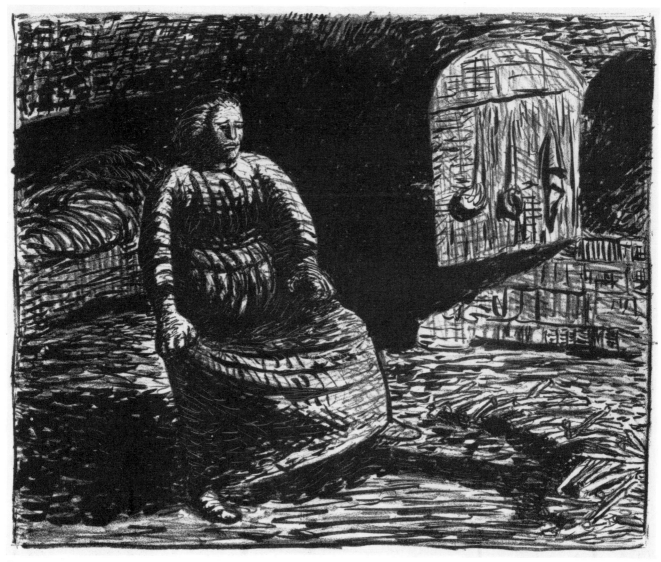

65

65 PLATE 17 *Die Frau am Herde* (The woman at the stove)

Lithograph, signed in pencil. 257 × 321 mm
Schult 35. On Japan paper
1983–10–1–29

This scene occurs at the beginning of the fourth act. The Mother starts back at the sight of the wood on the floor in front of the stove, which has been mysteriously chopped up during the night. This is one of the few plates for which the original drawing does not seem to survive.

66 *Erwachen* (Awakening)
Not in published sequence of 'Der tote Tag'

Lithograph, printed in green. Signed in pencil. 265 × 325 mm
Schult 32
1983–6–25–18

Although placed at an earlier point in Schult's catalogue, this scene follows immediately after plate 17. The Son awakes the morning after the horse's murder. The dark overall tone shows that the sun has failed to rise. The published series of lithographs only includes twenty-seven prints, although Barlach's letters of 1910 talk of thirty

drawings to illustrate the play, and thirty lithographs are known (plus an early version of plate 14). This plate, and Schult 25 and 38, must have been omitted at a fairly late stage of planning, since a letter of 7 April 1912 still refers to thirty illustrations. The original drawing is catalogued by Schult as number 747, but is not to be found at the Nelson Gallery in Kansas City, as he wrongly suggests.

This plate is a good example of Barlach's liking for compressing volumes into oval shapes, defined by drapery folds. These were much admired by Henry Moore, and had an influence on his early drawings.

CHRISTIAN ROHLFS

1849–1938

Born the youngest son of a Holstein peasant. At the age of fifteen he fell from a tree, and later had to have his leg amputated. With the help of the writer Theodor Storm and the critic Ludwig Pietsch, he was accepted as a student in the Grossherzogliche Kunstakademie in Weimar in 1870. His surviving student paintings are large figure compositions, but after establishing himself in his own studio in 1881 he turned to landscape, taking his subjects from the country round Weimar. In the next twenty years his style shifted slightly from late Naturalism to show an awareness of Impressionism, and he achieved a modest local reputation. The decisive change in his career occurred in 1901, when, on the recommendation of Henry van de Velde, he was offered the post of director of the planned art school attached to the newly founded Folkwang Museum in Hagen by Karl Ernst Osthaus in order to bring art to the inhabitants of the Ruhr. The impact of the great collection of French post-Impressionist paintings being assembled there led him first to pointillism and then to a style closely modelled on van Gogh.

In 1910 he moved for two years to Munich, where he turned to figural compositions rather than landscapes and made his first prints, but returned to Hagen in 1912, which remained his home for the rest of his life. In 1919, at the age of seventy, he first achieved national success with an exhibition in the Nationalgalerie in Berlin; he also married for the first time. There followed a remarkable late flowering of his art: he revealed unsuspected gifts as a colourist, turning increasingly to watercolour instead of oils, and to flower and landscape subjects instead of the religious themes which had dominated his work during the War.

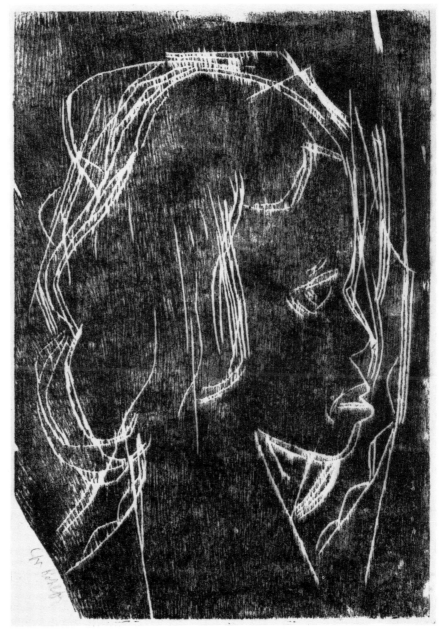

67

From 1927 he spent most of the year at Ascona on Lake Maggiore. In 1937 the Nazis declared his art 'degenerate' and had him expelled from the Berlin Akademie der Künste, and his works removed from German museums.

168 woodcuts, lino-cuts and stencil prints by him are catalogued, as well as a number of book-plates. They were all made between 1910 and 1926, and, although not of great quality or importance, present many curious and unusual features.

Bibliography

Rohlfs's work has been catalogued in three volumes published by the Verlag Aurel Bongers in Recklinghausen: *Aquarelle und Zeichnungen* appeared in 1958, *Das graphische Werk* in 1960, and the *Oeuvre-Katalog der Gemälde* in 1978. All are the work of Paul Vogt, although the catalogue in the last

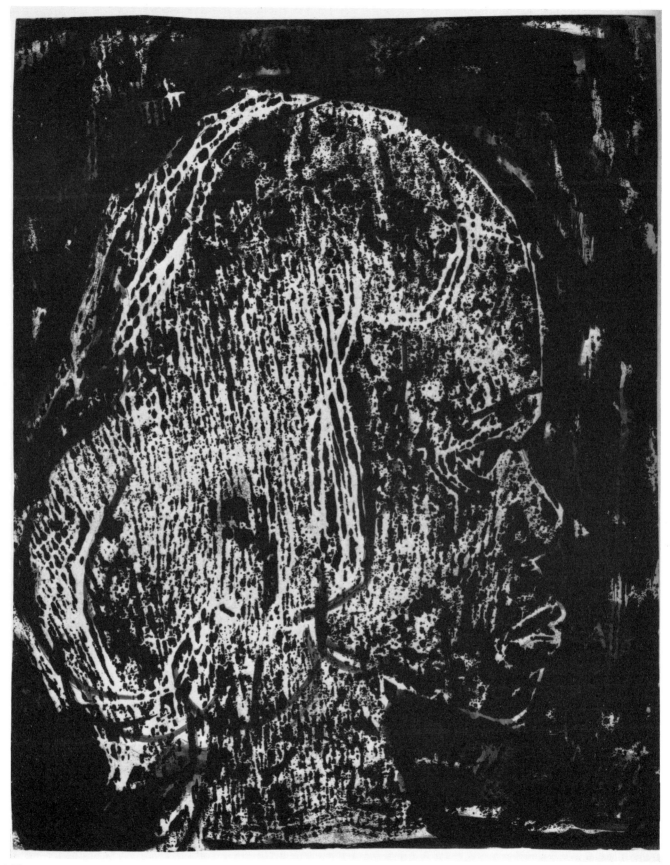

68

volume was compiled by Ulrika Köcke; Vogt has also written a number of other works on Rohlfs. The monograph by Walther Scheidig, *Christian Rohlfs*, Dresden 1965, is particularly strong on Rohlfs's Weimar years.

67 *Head of a girl in profile*
*c.*1911

Woodcut. Signed in pencil. 380 × 268 mm
Vogt 35. Printed in green on thin Japan paper.
1983-10-1-32

So far as can be judged from a letter written in 1910 (quoted by Vogt, 1960, p.15), Rohlfs began making woodcuts in 1910 while in Munich. His first attempts were on cigarette-boxes; since these were too small and tended to split, he tried lino instead, but within a few years had moved on to wood, which remained his preferred medium. As can be seen in this print, which Vogt dates *c.*1911 but which may be a bit later, Rohlfs used only the simplest means of cutting: in this case an engraving tool, in others a knife. He never used a gouge or chisel in the manner of Munch or the Brücke. His originality lay rather in the way he printed his blocks. He never used a press, but relied on the pressure from a heavy box, an iron roller or his hand. He inked his blocks in a wide range of colours and pigments (Vogt, 1960, p.60, reproduces an impression of this image in blue), often using a brush rather than a roller. He printed on a wide variety of papers, and occasionally on textiles, and frequently cut the image after printing. As a result, impressions of his prints are rarely the same, and they were never published in editions.

68 *Head of a girl in profile*
*c.*1911

Woodcut, handcoloured with blue and black-grey wash. 323 × 260 mm (irregularly cut)
Vogt 35. Printed in black on wove paper.
1980-3-22-9

According to Vogt, Rohlfs began regularly to hand-colour his prints after 1919. This procedure was extended back to his earlier blocks, from which he either used old impressions still in his possession, or reprinted new ones. This impression is taken from the same block as the previous item, but has been printed in a different blobby ink which disguises the grain of the block: this was perhaps done by mixing soap or an egg-yolk into the ink (both methods are described by Vogt, 1960, p.11). Rohlfs then went over it with watercolour, strengthening and altering the contours of the head in the process, and finally cut down the sheet to change the format. A number of similar pairs of monochrome and coloured impressions of prints are illustrated in Vogt's monograph. Rohlfs never apparently made colour woodcuts using multiple blocks, one for each colour; he did, however, frequently print successively from the single block onto one sheet of paper, either inking it in different colours, or deliberately shifting the register in order to blur the image.

EDVARD MUNCH
1863–1944

A Norwegian artist, born into a family of distinguished achievement. His father was a doctor. Munch's childhood was marked by the deaths of his mother when he was four and of his elder sister when he was fourteen. He enrolled in an engineering school, according to his father's wishes, but in 1880 gave this up to become an artist. The strongest early influence on his painting was the naturalist Christian Krohg who had the studio next to his; his intellectual formation was decisively affected by the Bohemian circle in Christiana (the former name for Oslo) around the free-thinker Hans Jaeger. His breakthrough to a distinctive subject-matter and expression came in 1886 with the first versions of the *Sick Child*, *The Day After* and *Puberty*. Between 1889 and 1892 he spent much of his time on Government scholarships in France, where he became acquainted with current post-Impressionist and early Symbolist works.

In October 1892 he was invited, almost entirely by chance, by the Verein Berliner Künstler to show in their rooms in Berlin an exhibition of his recent work which had just closed in Oslo. Violent exception was taken to the paintings by the press and many members of the Verein, and after eight days they voted by a small majority to close the exhibition. The scandal made Munch overnight one of the best-known names in German art. He therefore moved to Berlin where he spent most of the next sixteen years. He found there another Bohemian group centred around the Swedish dramatist Strindberg and the Polish novelist and satanist Przybyszewski at the tavern nicknamed 'Zum schwarzen Ferkel'. Under this stimulus he completed the series of fifteen paintings exhibited in March 1895

under the title of 'Love', which includes most of his best-known images. Many of these compositions he had begun to translate into etchings and lithographs in late 1894, and it was apparently partly in order to take advantage of the printing facilities in Paris that he moved there for a year in spring 1896–7. To this period belong his first woodcuts.

In March 1902 Munch exhibited an extended and revised version of his 1895 series – a total of twenty-two paintings to which he later gave the title 'The frieze of life'. The following years, however, saw a progressive collapse of his health as he began to suffer from paranoia and uncontrolled drinking. This came to a climax in 1908, when he admitted himself to a clinic for nervous disorders in Copenhagen. On his discharge in 1909 he returned to Norway for good, although still maintaining many connections with the German art world.

Munch's oeuvre is said to comprise 378 lithographs, 188 etchings and 148 woodcuts. Their quality is remarkably uneven, and few of the prints produced after the collapse of 1908 are of much interest or significance.

Bibliography

Most of the fundamental publications on Munch are in Norwegian, and are not mentioned here. There is still no catalogue of Munch's paintings, and the basic catalogue of his prints is very out of date: Gustav Schiefler, *Verzeichnis des graphischen Werkes Edvard Munchs*, two volumes (I up to 1906, II, 1906 to 1924), Berlin 1907 and 1927. The standard biography is Ragna Stang, *Edvard Munch, the man and the artist*, London 1979, which includes a good bibliography. See also J.H. Langaard and R. Revold, *A year by year record of Edvard Munch's life*, Oslo 1961. Among the voluminous recent literature on Munch, one exhibition catalogue is of particular importance: *Edvard Munch, symbols and images*, National Gallery of Washington

1978, which includes a number of essays. Elizabeth Prelinger, *Edvard Munch, master printmaker*, New York 1983, is the best available description of Munch's techniques of printmaking. Two other monographs on this subject, both entitled *The graphic work of Edvard Munch*, one by Werner Timm (London 1969), the other by Ole Sarvig (Copenhagen 1980), are mainly of use as collections of reproductions. Further work awaits the publication of catalogues of the holdings of the Munch Museum in Oslo, to which the artist bequeathed all the works of art remaining in his estate.

69 *The sick child*
1894

Drypoint. Signed and annotated *10* in pencil. 389 × 289 mm
Schiefler 7, fifth state. Printed on Japan paper. One of the 10 impressions before steel-facing from the Meier-Graefe portfolio.
1949-4-11-4792. Bequeathed by Campbell Dodgson Esq.

There appears to be still no documentary evidence to explain why Munch took up printmaking, in the form of drypoint, etching and lithography, in the last months of 1894, or to show who taught him the techniques. These, however, can have presented no difficulty to him, and in June 1895 he was in a position to publish a portfolio containing eight drypoints, accompanied by an introduction by his friend, the critic Julius Meier-Graefe (see p.159). The portfolio was published in a total edition of sixty-five: the first ten were on Japan paper, before steel-facing the plates (as this impression), the remainder were on ordinary paper after steel-facing. Munch later frequently had further impressions printed from the plates.

Schiefler's description of the states of this print are not adequate, as two important variations are now known. There is a new first state where the area below the design is still blank and the marked vertical striations have not been added to the plate. The empty space, however, suggests that even at this stage Munch intended to add the landscape to the bottom of the plate. This landscape appears in none of the painted versions of the composition and has always presented a puzzle to Munch's interpreters. The most commonly favoured explanation

has been to see it as pointing the contrast between the blooming life of nature and the dying of humanity. In a final state this landscape was cut off, and the plate reduced to a square. (For illustrations of these states, see the catalogue of the Bielefeld exhibition, *Munch-Liebe, Angst, Tod*, 1980, plates 101 and 99.).

The original version of the *Sick child* was painted in 1885–6, and exhibited with a very mixed reception in 1886 under the title of *Study*. In a pamphlet entitled *The Genesis of the Frieze of Life*, published in 1929, Munch gave a long description of the genesis of this painting and concluded: 'In the sick child I broke new ground – it was a breakthrough in my art. Most of what I later have done had its birth in that picture'. A photograph in the Munch Museum shows that the original painting exhibited in 1886 corresponded very closely with the first state of the drypoint. In 1895, however, Munch repainted it with long vertical strokes, and then reworked the plate in the same way. In this later form the painting survives in the National Gallery in Oslo. (For a full account, from which this is taken, see Arne Eggum's essay in the 1978 Washington catalogue, pp.143–53.)

Munch kept returning to this image throughout his career. He made five further painted versions, of which the third, of 1907, is now in the Tate Gallery (having been sold by the Nazis from the Gemäldegalerie in Dresden in 1937). There are also two other printed versions: a famous lithograph of the girl's head alone, made in Paris in Clot's printing workshop in 1896, and a similar etching of the same year (Schiefler 59 and 60).

70 *Self-portrait with skeleton arm*
1895

Lithograph. Signed *E Munch 1895 No 11*. 456 × 320 mm
Schiefler 31, first state. Printed on white paper. 1949-4-11-4872. Bequeathed by Campbell Dodgson Esq.

This is one of Munch's earliest lithographs, made when he was in Berlin in 1895 and printed there by Lassally. The present impression belongs to this early printing, of which the edition size is unknown. The plate was frequently reprinted; at a later stage (probably after

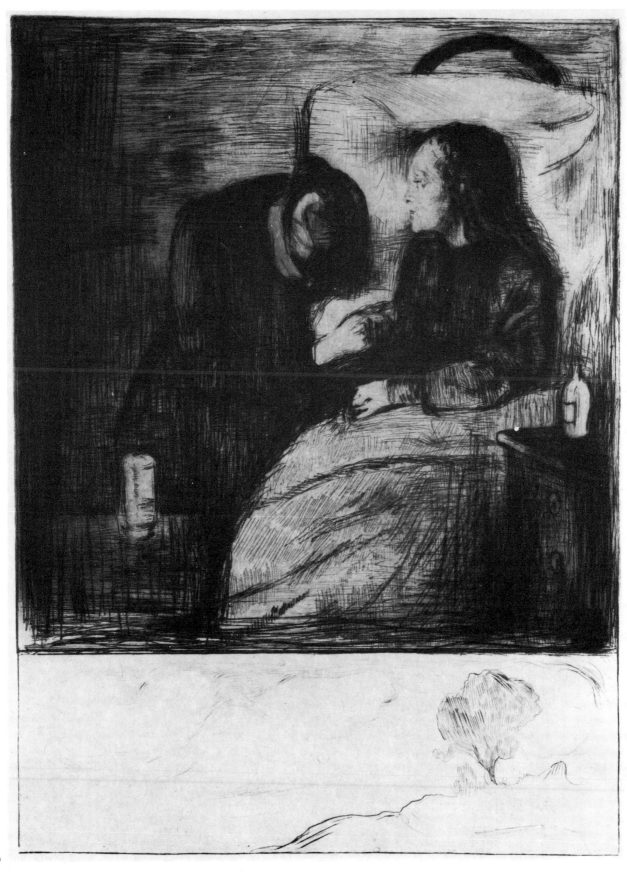

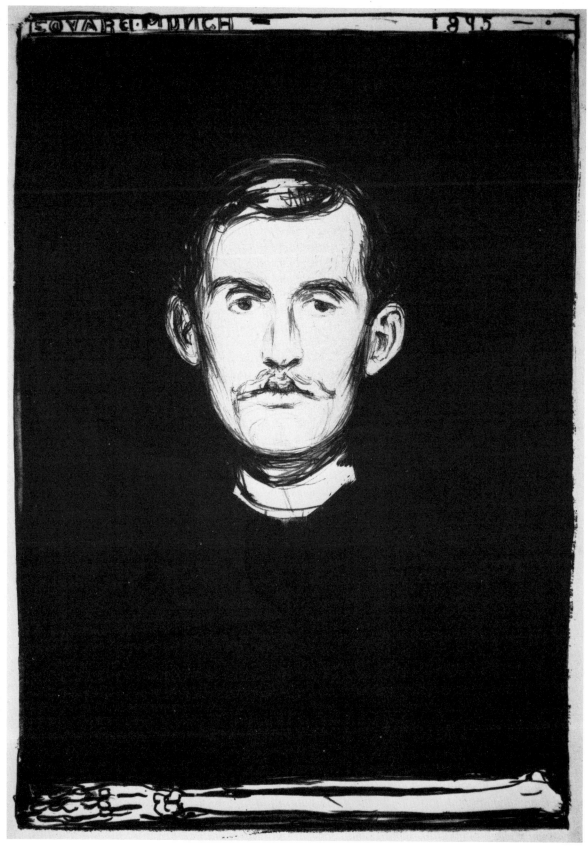

1900) Munch added a thick wash at the bottom to eliminate the skeleton arm.

This is one of only two portraits (and nine prints) made in lithography before Munch's move to Paris in early March 1896. The other one (known in two versions) is of Harry Graf Kessler, who left in his diary of April 1895 a remarkable account of his sitting for it, a sitting which was disturbed by the irruption of a shop-keeper who seized the easel on which the stone had been placed, for non-payment of a debt of 25 Marks (see Reinhold Heller in the Washington catalogue, p. 102). The print shows a remarkable mastery of the technical possibilities of lithography: the basic design is drawn in lithographic chalk, over which a thick ink wash has been brushed to create a solid black through which occasional white lines have been scratched into the stone. Such solid black areas are almost unprecedented in earlier lithography, but are common in woodcuts of the period by Vallotton and others influenced by him.

As with nearly all Munch's portrait etchings and lithographs, there is no painted version corresponding with this image. The extraordinary skeleton arm, which balances the artist's name and the date 1895 at the top of the print, has occasioned much discussion. It is clearly a *memento mori*, and the whole picture takes the form of a sepulchral tablet. (There is an essay by Arne Eggum on Munch's self-portraits in the Washington catalogue.)

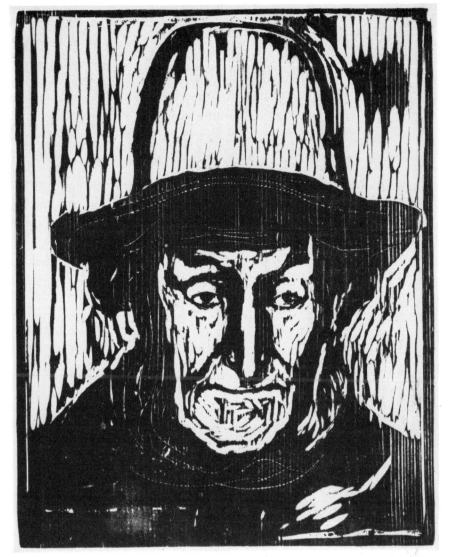

71

71 The old fisherman
1899

Woodcut. Signed in pencil. 441 × 355 mm
Schiefler 124, apparently second state. On thin Japan paper.
1984–5–12–7

Munch made his first woodcuts in 1896. Even if technical precedents, especially in the work of Gauguin, can be found for many aspects of them (the use of the gouge, or the sawing-up of the block), their sheer size and ambition and the density of the content that Munch used them to convey were radically new. Most of the earliest of his woodcuts made important use of colour (see the next item) on which they rely in some way. It was only in 1898 and 1899 that Munch

began to make woodcuts in which colour was ignored, and the entire effect was created by the cutting of the single block. These later woodcuts show some of the most pronounced sculptural work in his oeuvre. This can be clearly seen in the reproduction of the original spruce block of *The old fisherman* (now in the Munch Museum) given by Prelinger (1983, p. 65); indeed, according to Prelinger, such blocks were on occasion exhibited in their own right next to impressions of the prints. The subjects of these monochrome woodcuts often stand at some distance removed from Munch's paintings, and show motifs like this head or landscapes which are less common in

his art; thus they are less transcriptions and more independent creations made for and by the medium itself.

Schiefler states that impressions of this block (or at least those taken before publication of his catalogue in 1907) were hand-printed by the artist himself (obviously on his own press rather than by hand-rubbing). The thin Japan paper of this impression shows clearly that he was deliberately using the grain of the block itself, as well as the vigorous striations of the gouge and the dots created by dragging a point or roulette across the surface, as a determining element in his design. It was Munch's woodcuts of this type, rather than his

more pictorial colour prints, that provided a decisive impetus for later German artists. (See C. Glaser, *Die Graphik der Neuzeit*, Berlin 1922, pp. 522–4, who reproduces this actual image to make this point.)

72 *Melancholy* (also called *Evening*, *On the shore* or *Jealousy*) 1901 (first version 1896)

Woodcut printed from two blocks. Signed in pencil. 374 × 470 mm
Schiefler 144. Printed on thin Japan paper.
1980-12-13-199
See colour illustration

Melancholy, like *Vampire*, formed part of the 'Frieze of Life' and appeared in the exhibition of 1895 in this context, but with the title *Jealousy*. The original version of the composition was exhibited as a pastel in 1891, and the complicated interrelation of the later drawn and painted versions is discussed by Trygve Nergaard in the 1978 Washington catalogue, pp. 124–31. Munch's first woodcut of the subject was made in 1896 (Schiefler 82) and differs from this later version in having the head at the left, in reverse to the painted versions.

The subject is traditionally said to represent Munch's friend Jappe Nilssen, who was suffering from a hopeless love for Oda, who had just married Christian Krohg. The image, however, is not specific: there are no other persons in it; and the modern title seems to be quite accurate. As has often been pointed out, the composition derives from an aquatint by Max Klinger entitled *Night* (Singer 171), which also shows a half-length figure sunk in a reverie looking out over the sea to a cloudy sunset. Munch's scene is set on the rocky shore at Åstgårdstrand, where he spent the summer months of almost every year between 1889 and 1906.

Two blocks of wood were employed in this woodcut. First to be printed was the colour block which bears no drawing at all; this was sawn into three pieces, which were separately inked in grey (sky), blue (sea) and pale orange (shore and male figure) before being reassembled for printing. Over this was printed in black the second block, on which the design had been cut. A number of variant types of impression of this print are known. The block with the design is 559 mm

wide, while the colour block is only 470 mm wide (both survive in the Munch Museum, and are reproduced by Prelinger as figs 74–5). In some early impressions Munch experimented with masking sections along the left and right sides of the design block in order to adjust the balance of the composition. In this, the resolved final version, he left an extra 15 mm visible at the right so as to match the width of the colour block (this is Schiefler's second state; see also Christie's London auction catalogue 2 December 1981, lot 381). Furthermore, the colour block is also found in an earlier state cut into only two sections; in both states numerous different colour combinations are known. The printing was done by Lassally in Berlin, apparently in the autumn of 1901.

This impression is of some interest in that it formerly belonged to Jappe Nilssen.

ERNST LUDWIG KIRCHNER
1880–1938

Born in Aschaffenburg; his father was a distinguished chemist in the field of paper technology, and the family moved several times before settling in Chemnitz (now Karl-Marx-Stadt) in 1890. In 1901, on leaving school, he became a student of architecture at the Hochschule in Dresden, graduating in July 1905, a few weeks after the founding of the Brücke. He had had considerable training in draughtsmanship, both at school and in Dresden, but his only tuition in painting (apparently) was a winter spent in Munich in 1903–4 where he combined his architectural studies with a course at the art school.

Kirchner was always the strongest and most difficult personality of the group; it was he who seems to have been responsible for its strongly Bohemian character, and he took the lead in decorating the Dresden studios in outlandish fashion. In the summer months he usually went to a remote spot in the country or on the coast where he could paint and sketch naked models in natural movement, sometimes together with Heckel or Pechstein. From early 1910 he began to spend more of his time in Berlin, moving there permanently in October 1911. The following years saw a great advance in his art away from the shared 'Brücke style' of the Dresden years, culminating, after the dissolution of the Brücke in May 1913, in the great paintings of Berlin street scenes of 1913–14.

Early in 1915 he was called up, but the effect of military discipline on his temperament produced a nervous agitation and physical debility which led to his being given leave of absence in September. To cure his sleeplessness he turned to drugs, and a more comprehensive collapse ensued. He spent spells in asylums in Königstein

73

and Berlin, still producing works of art in a feverish way, before ending up in clinics in Switzerland in 1917. His physical recovery from partial paralysis and drug addiction (which did not prevent him making an extensive series of large woodcuts) was not complete until 1921, but he never fully regained any mental equilibrium or shook off his paranoia. He remained in Switzerland, making only a few trips to Germany, for the rest of his life, a distant figure regarded with awe by young artists. For his new subject-matter drawn from the mountain landscape and people around him, he created a bewildering new 'late' style which had little to do with his earlier work; many of the figure compositions are almost parodies of other contemporaries, especially the work of Picasso. He remained unshaken in his belief in his rightful position as the greatest German artist of his age, and the vilification of his work by the Nazis and its expulsion from German museums was more than he could stand. His suicide followed in June 1938.

Kirchner was by far the greatest printmaker of the Brücke. The foundation of his achievement was his brilliant draughtsmanship, which he continually exercised in making rapid sketches from the life; many thousands of these drawings must survive. (Drawings of similar type by Heckel are much rarer and by Schmidt-Rottluff almost unknown.) His oeuvre is the largest of the group, and consists of nearly 1,000 woodcuts, over 650 etchings and drypoints, and over 450 lithographs. They were produced in a virtually unbroken stream throughout his career, though with a marked slackening after 1927, making an average of more than one a week. Since Kirchner hardly ever allowed anyone else to print his work, impressions are almost invariably of extreme scarcity, and few collections possess more than a small percentage of his output. See also 246–9.

Bibliography

The literature on Kirchner is very extensive. The most important edition of his own writings is that of Lothar Grisebach, *E.L. Kirchners Davoser Tagebuch*, Cologne 1968. The best biographical source is E.W. Kornfeld, *E.L. Kirchner, Nachzeichnung seines Lebens*, Bern 1979.

The first catalogue of his prints was published in two volumes by Gustav Schiefler, *Die Graphik E.L. Kirchners*, Berlin 1926 and 1931. Unfortunately it suffered from being overseen by Kirchner, who supplied dates for all the prints himself. Since he antedated many of the works by three to six years (in the same way as he added wrong dates to his paintings), the result was complete chaos, which lasted until the late 1960s. The huge task of sorting out the tangled record was carried out for the paintings in a remarkable catalogue by Donald E. Gordon, *Ernst Ludwig Kirchner*, Cambridge, Mass. 1968; and for the prints by Annemarie and Wolf-Dieter Dube, *E.L. Kirchner, das graphische Werk*, 2 vols, Munich 1967 (2nd edn 1980). Gordon's article 'Kirchner in Dresden', *Art Bulletin*, XLVIII, 1966, pp. 335–66 is the fundamental investigation into Kirchner's early chronology and stylistic development. Two very good recent publications should also be noted: the large catalogue of the centenary exhibition held in the Nationalgalerie in Berlin in 1980, and the monograph *E.L. Kirchner, Zeichnungen und Pastelle*, edited by R.N. Ketterer, Stuttgart 1979 (English translation, New York 1982); this also contains a biography and a very full bibliography by Hans Bolliger. At the time of going to press Annemarie Dube-Heynig's announced edition of eighty-three postcards and letters from Kirchner to Heckel of 1909–12, now kept in the Altona museum, had not yet been published; this promises to throw much new light on Brücke history.

73 *Reclining female nude* 1905 (or perhaps 1906)

Woodcut. 90 × 151 mm
Dube 59, first state of two. On Japan paper.
1983-12-10-1

This print is the only representative in this catalogue of the style of woodcutting, derived from Jugendstil and Vallotton, which was shared by all the Brücke members in 1905–6. It relies on a sinuous contour and an opposition of areas of black or white without any use of half-tones. The draughtsmanship is already extremely accomplished and reveals the training that Kirchner brought with him to the Brücke.

Georg Reinhardt has discovered that a woodcut by Kirchner shown in the summer exhibition of the Sächsische

74

Kunstverein in 1906 was described in the catalogue as a sheet from the cycle 'The model' (see 'Die frühe Brücke 1905–1908', *Brücke-Archiv* 9/10, 1977/8, p. 25 and note 60). This enables most of the woodcuts listed by Dube as numbers 49 to 61 (probably 50, 52–3, 55–6, 58–60) to be identified as part of the cycle. Many of these contain strong art nouveau patterning in the backgrounds. At this stage in his career Kirchner seems to have thought in terms of series in his printmaking. The 1906 catalogue also refers to a set of 'Elbe landscapes' (possibly Dube 38, 62, 64–5, 76), while his best-known prints of 1905 are the cycle 'Two people' (Dube 40–8), which illustrates the cyclical epic poem of 1903 by Richard Dehmel (1863–1920). As late as 1907 he was making a series of lithographs to illustrate the Sakuntala (Dube 14–18).

When Schiefler was cataloguing Kirchner's early prints in the 1920s,

Kirchner went through the manuscript cutting out all the works which he no longer liked (cf. A. Dube-Heynig, *Kirchner, graphic work*, London 1966, p. 22). It is difficult to understand by what criteria he accepted one work and rejected another, but of the eight prints which may have comprised the 'Model' series, only four (including this one) are included. Kirchner also allocated dates to the prints in an extremely arbitrary way: this print (Schiefler 11) was dated 1898–1902, although another of the series (Dube 52, Schiefler 120) was put back to 1905–6, presumably since it appeared in the Brücke portfolio for 1906.

74 *Hospital, Dresden-Friedrichstadt* 1907

Etching. Signed in pencil and annotated *Eigendruck*. 308 × 398 mm
Dube 14, only state
1982-1-23-4

Like many other architectural and topographical subjects from the early years of the Brücke, this building lay within walking distance of Kirchner's studio in Berliner Strasse, which was a few streets south in the same suburb Friedrichstadt. It has been identified as the Marcolini Palace, where Napoleon had once stayed and which had been incorporated into the complex of buildings which formed the new Dresden hospital (see Walter Henn in the Kunstmuseum Hanover Brücke catalogue 1980, p. 23).

This is one of Kirchner's most accomplished early etchings; its density of content makes an interesting contrast

to the much sparer style of the high Brücke years, exemplified in the next item and in Heckel's *Street by the harbour* of 1910. The impression is early, and bears Kirchner's early form of signature with the *E* written in 'deutsche Schrift'; Gordon has shown that he changed this for a different 'Lateinschrift' form between July and September 1910 (*Art Bulletin*, XLVIII, 1966, p. 336).

Shortly before committing suicide Kirchner destroyed almost all the woodblocks in his possession. The metal plates however could not so easily be done away with, and most of them survive and are now in the Kunsthalle at Karlsruhe. They show that Kirchner frequently reused the backs for later etchings; the back of this plate of 1907 was used in 1916 for an etched self-portrait (Dube 218).

75 *Woman wearing a necklace in a tub*

1909

Etching. Signed in pencil and annotated *Eigendruck*. 315 × 247 mm
Dube 77, only state
1981-6-20-5

The reduction of the figure to little more than a single unbroken contour shows the influence of Matisse, whose work Kirchner had seen in Berlin in January 1909 at the Cassirer gallery, but goes beyond him in swiftness of line and directness of response which lacks the conscious poise and artistry of the French tradition. The plate has been very deeply bitten so as to give an emphatic relief to the ink as it sits on the paper. The slight textured tone of the background comes from the grain on the copper plate which is revealed by the film of ink left on the surface of the plate in the wiping. The model is almost certainly Dodo, Kirchner's companion of the Dresden years, whose real name is still unknown.

76 *Women bathing between white stones*

1912

Coloured woodcut. 286 × 272 mm
Dube 209, third state. On verso the Nachlass stamp and number H 148 III.
1980-2-23-33

The block was cut in July or August 1912, when Kirchner was on the island

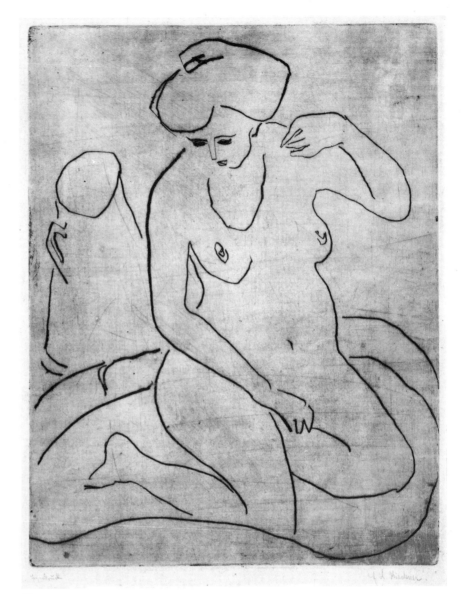

75

of Fehmarn, off the east coast of Schleswig-Holstein, with Heckel and the two Schilling sisters. As Lothar Grisebach has observed (1983–4 Essen exhibition catalogue on Heckel, pp. 20–1), it is very similar in subject, style and manner to Heckel's woodcut *Two sitting women* of 1912 (Dube 240), which may have been done at the same time. Photographs showing the rocky shore near Gut Katharinenhof are published by Karl-Heinz Gabler, *Ernst Ludwig Kirchner Dokumente*, Aschaffenburg 1980, plates 110 and 112.

According to Schiefler and the Dubes this woodcut was printed from two blocks:

one being the drawing block printed in black, the other being sawn into pieces and reassembled after inking in green, red (for the flesh) and rose (for the splashes of colour on the hat and elsewhere). But as Jacob Kainen has pointed out, this account cannot be correct. In an impression of the print in his possession the rose is printed *over* the green in the upper left corner and the same phenomenon can be seen in this impression. He further points out that many of the areas are so small, and in the case of the rose flower have such a complicated zigzag contour, as to be extremely difficult to cut out of a thick

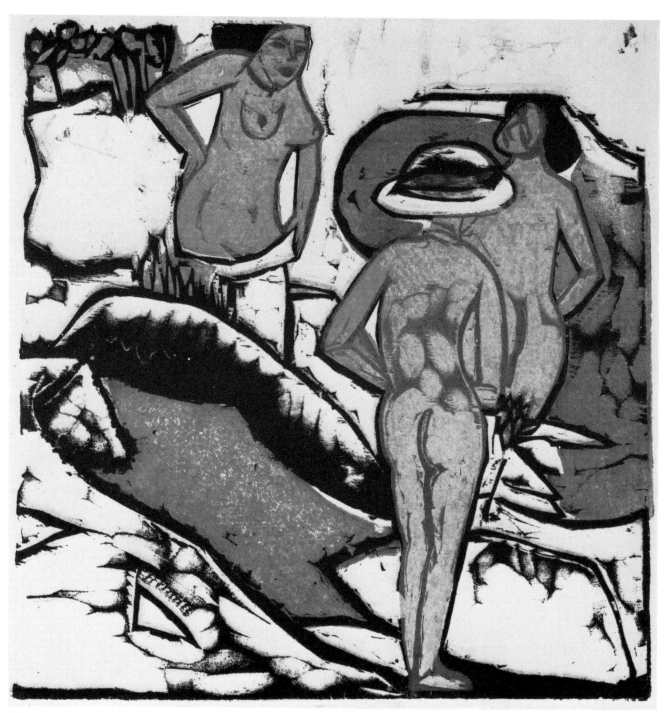

76

block with a fret saw. The answer he suggests, which must be correct, is that the rose and red colours – and possibly the green as well – were added through stencils. This explains why the ink is piled up heavily around the sharp contours of the red colour areas, and stands in relief rather than being embossed. The texture of the pigment in these areas suggests to Mr Kainen that it was applied by a small brush followed by a cloth pounce. In the case of the small rose patches it was brushed directly though without making any attempt to fill the entire area. The use of a stencil is consistent with other phenomena, such as the stray blobs of colour intruding into white areas, and the various patches of blue mixed into the green seen in the foreground of an impression of this print in the Kunsthalle in Hamburg.

The stamp found on the verso of this and many other impressions of Kirchner's prints was applied by the Kunstmuseum in Basle. Kirchner died intestate in Switzerland in 1938, leaving no direct heirs and having remained a German citizen. The position was further complicated by the post-War Washington Accord between the Allies and the Swiss Government concerning the liquidation of German assets held in Switzerland to pay for post-War reconstruction debts. In these circumstances the Basle museum was charged with the care of the entire estate, and the compilation of a proper inventory. The numbers written on the prints are Schiefler's catalogue numbers preceded by a letter to distinguish the different sequences of woodcuts, lithographs and etchings. Since these prints were never sold in Kirchner's lifetime, most of them bear no signature. The estate was only cleared up in 1953, and handed over to Kirchner's relatives (one surviving brother and the children of the second brother). See Kornfeld, 1979, pp. 327–30.

77 Bathers by stones
1913 (?1912)

Drypoint. 201 × 223 mm
Dube 164, second state of three. On verso the Nachlass stamp and number *R 151 I*.
1980–7–26–30
This drypoint is a reversed transcript of a painting which carries the date 1912, *Three bathers by the sea* (Gordon 258).

The lithograph Dube 235, like this drypoint dated by Dube to 1913, is another version of the same painting. The tendency to reduce the torso to a cylinder to which the arms and legs are appended, seen here on the left-hand bather, is a marked feature of several other paintings and prints of 1912. It derives from African wood carvings from the Cameroons, as is seen very clearly in Kirchner's own sculpture from this time. A Cameroon figure is seen in a painting (Gordon 268) of 1912, and must have been in Kirchner's own possession. In view of this, it is possible that the Dubes' dating of both drypoint and lithograph to 1913 should be brought back a year.

In this case, the drypoint would belong to the same months on Fehmarn as the woodcut in the previous entry. The stylistic divergence between the two – one showing Kirchner closer to Heckel, the other closer to African sculpture – is entirely typical of Kirchner's openness to the most varied sources in the year after his move to Berlin. It was in the following year that he found his mature style in the angular drawing and steeply raked perspective that characterises his Berlin paintings.

78 Promenade before the café
1914

Lithograph, printed in black and pink on yellow paper. Signed in pencil and annotated *Handdruck*. 510 × 598 mm (maximum dimensions)
Dube 244, third state. On verso the Nachlass stamp and the number *L 266 IV*.
1981–7–25–32
See colour illustration

The series of paintings of Berlin street scenes, which constitutes Kirchner's greatest contribution to twentieth-century art, began in the winter of 1913–14. Similar vertical compositions with elongated full-length figures appear in prints of 1914. This lithograph is one of the few which is horizontal. It shows the arched opening of a café, in which can be seen a round table with a waiter bending forward as he serves the seated customers. Before them, along the pavement which runs straight across the foreground of the composition, walk a dog and three women, identifiable by their extraordinary dresses as prostitutes. Kirchner was so pleased with this composition – one of his finest lithographs – that he printed seven impressions: it is one of the rare occasions

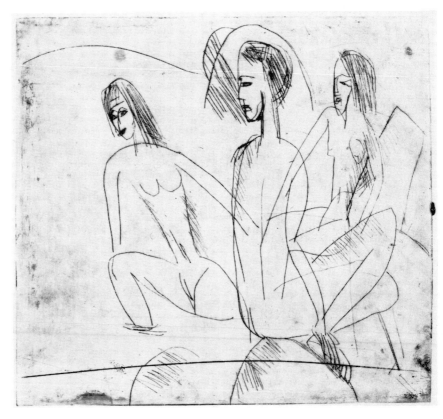

77

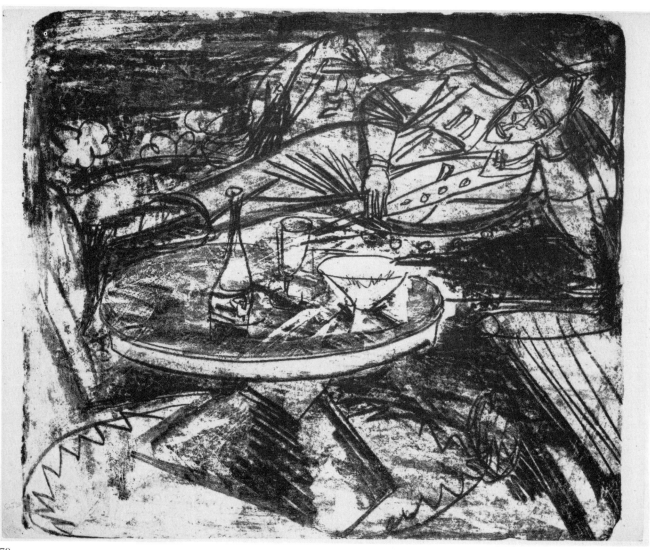

79

that Schiefler was able to discover the number he printed of any of his prints. Despite this, the print seems now to be excessively scarce; the Dubes list no impression in any public collection. Schiefler also mentions a trial proof in Kirchner's possession with hand-colouring added; this must be the same impression as that illustrated on p. 47 of the catalogue of the 1978 Hamburg Kunstverein exhibition, *Kirchner, Zeichnungen und Druckgraphik*.

This print is a good example of his completely original technique in colour lithography, which is discussed on p. 34. As can be seen along the bottom edge of the composition, the sheet went through the press twice, once for each colour

(there are two colour contours), but the same stone was used both times (the two contours exactly parallel each other).

Kirchner frequently used yellow paper in his lithographs between 1912 and 1916. It is occasionally also to be found used for woodcuts. Earlier uses of yellow paper can be found in his correspondence of 1909. The pigment used for the pink is very thick and opaque, and prints with a matt and puckered texture.

79 *Hugo lying at table*
1915

Lithograph. Signed in pencil and annotated *Handdruck*. On verso the Nachlass stamp.
502 × 590 mm (the design bleeds off along the top and bottom sides)
Dube 277, second state
1978-11-11-5

The figure lying on the couch, dressed in military uniform, is Kirchner's friend Hugo Biallowons. The print, which is printed from Kirchner's favourite large stone (used from 1908 right through to 1923), must have been made in his Berlin studio. Schiefler states that while Kirchner was undergoing his training for the artillery in Halle he often took the evening

train back to Berlin after a day's duty and painted right through the night (*Meine Graphiksammlung*, 1974, pp. 67–71). On this occasion he must have been accompanied by Biallowons. On 9 July 1916 Biallowons was killed at the Front, and Kirchner made a memorial woodcut of him (Dube 277). Biallowons had come into Kirchner's circle through Botho Graef (1857–1917), the professor of classical archaeology at the University of Jena and a great protagonist of the new young painters (see also 109 for his support of Nolde), as well as an uninhibited homosexual. A number of paintings (e.g. Gordon 425–6) show Biallowons with Graef in Kirchner's studio, and several photographs (1980 Berlin exhibition catalogue, pp. 72–3) show him dancing naked there. His features are also easily recognisable in a large number of other lithographs and etchings of 1914–15.

The paper used for this impression was not quite as wide as the stone, and four centimetres of the composition have been lost. This phenomenon is also found in a number of other impressions of lithographs of 1915, and suggests that Kirchner had been unable to obtain a stock of suitable paper, presumably because of wartime shortages.

80 *Portrait of Otto Müller*
1915

Woodcut, printed from a single block in black, blue and brown. Signed and annotated *Probedruck*. 363 × 305 (maximum dimensions)
Dube 251, fourth state
1983-4-16-3. Formerly in the collection of Gustav Schiefler.
See front cover

In the three months between mid-September and mid-December 1915 Kirchner was in Berlin with leave of absence from the army. Despite his nervous condition and weak lungs, he produced an astonishing output of paintings, drawings and prints. The most striking of the prints were colour woodcuts – a set of seven illustrations to Chamisso's story of 1814 *Peter Schlemihls wundersame Geschichte* and two portraits of Otto Müller – which are among his greatest achievements in print-making. Technically the prints show an extraordinary fertility of invention with hardly any two being quite similar. The

Schlemihl woodcuts all use two blocks, of which one or both is divided into sections (by sawing or the use of stencils) and inked either with a roller or with a brush in different colours. This portrait of Müller, however, uses only a single block, which has not been inked with a roller but coloured by hand using a brush. This method of almost painting the block in different colours stands half-way between a conventional woodcut and a monotype, and is not found in the work of any earlier artist or any other member of the Brücke. (For an illustration of two impressions of a 1917 self-portrait woodcut – Dube 327 – one printed in black, the other in colours, see the 1980 Berlin catalogue nos 272–3.) The second portrait of Müller, which shows him lying on his side, uses one or two blocks in its various versions; unlike this print, which at least in its late states is excessively rare, the second portrait is reasonably common.

This woodcut went through four states. In the first two the head is seen against an almost unworked background. It was only in the third state that Kirchner cut out the cat with a bow tie, and the two eye shapes in the bottom corners which seem to derive from Egyptian art. It is not clear what their significance might be; the cat could be suggested by Müller's own feline appearance.

Otto Müller (1874–1930) was a painter and printmaker whom Kirchner met in Berlin in May 1910 at the first Neue Secession exhibition. They soon became close friends, and Müller joined the Brücke, of which he remained a member until the group's dissolution in 1913. When compared with photographs, it can be seen that this print is a remarkably acute likeness. Kirchner's own remarks on his friendship with Müller in a letter to his patron Carl Hagemann are published in the Städel Kirchner catalogue of 1980, under no. 61. He concluded that Müller was Germany's Corot.

81 *Portrait of the wife of Professor Goldstein*
1916

Woodcut. On the verso is printed another impression taken from the same block but in its second state after additions to the white areas at the top. 457 × 239 mm
Dube 272, first state. On verso the Nachlass stamp and number H 2501.
1983-7-23-33

In December 1915 Kirchner was discharged from the army through the good offices of Hans Fehr, Nolde's close friend, on condition that he attend a sanatorium. He therefore went to Königstein in the Taunus mountains to the north-west of Frankfurt, to a clinic run by Dr Kohnstamm, a friend of Botho Graef. He spent three periods there: mid-December 1915 to mid-January 1916, mid-March to mid-April and June to mid-July, all broken by compulsive departures in order to get back to his painting in his Berlin studio. While in the clinic he made a number of woodcuts, one of inmates eating a meal and another of Otto Klemperer, the conductor (who was there recovering from one of his periodic bouts of depression), giving a piano recital. According to an autograph note by Kirchner on the verso of an impression of this print (sold at Kornfeld in Bern 1965, auction 116, lot 463), Frau Goldstein was the 'wife of the psychiatrist Goldstein'. This suggests the possibility that, despite her appearance, she was not actually a patient but the wife of a member of staff.

82 *Women at a table in a room*
1920

Drypoint and aquatint. Signed in pencil and annotated *Eigendruck*. 250 × 310 mm
Dube 294, second state of three
1982-1-23-5

From May 1917 Kirchner stayed in Switzerland, making only brief visits to Germany; indeed he was often counted as a Swiss artist by contemporary critics. Although the later Swiss prints are often and understandably discounted when compared with his earlier work, many of them are remarkable objects. In this aquatint of 1920, which is perhaps based on a photograph, the drawing of the figures, and especially the profiles, is schematic and unconvincing, but Kirchner is still capable of getting a range

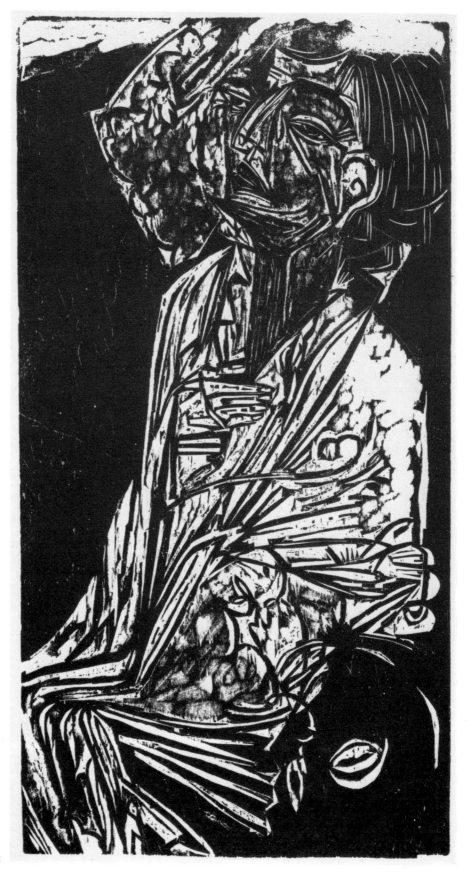

81

114

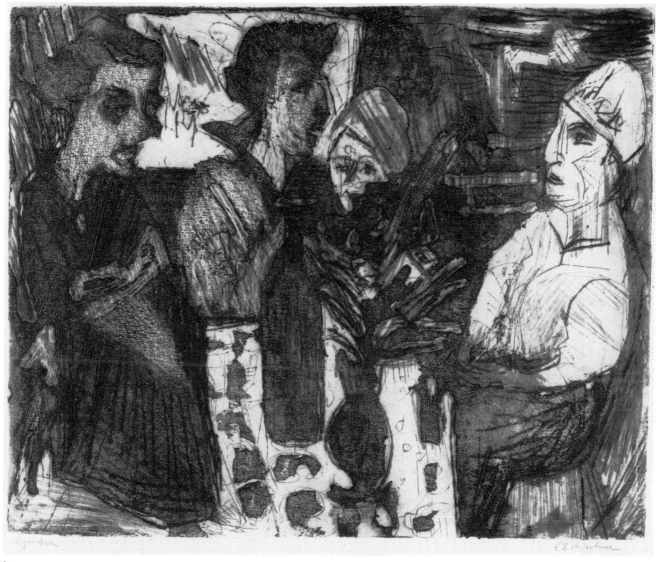

82

of tone and texture from the plate which would be envied by most printmakers.

On the verso of the print can be seen a faint offset of a pencil drawing of a lying nude. Schiefler mentions the existence of an impression printed in blue.

83 *Melancholy girl*
1922

Woodcut, printed from a single block in black, violet and red. Signed and annotated *Eigendruck 4* in red crayon within the image at the bottom. 700 × 401 mm
Dube 480, apparently second state. On Japan paper.
Lent by the Victoria and Albert Museum (inv. E 5332–1960).

This is one of the largest and finest of Kirchner's later woodcuts. It shows the artist together with Erna Schilling, whom he first met in June 1912 and who remained his companion thenceforth, although they never actually married.

During Kirchner's breakdown during the First World War she was given full power to act for him, and her signature is often seen on impressions of prints sold during those years. She only survived him by a few years, dying in 1945. The method of multi-colour inking of a single block used to print this impression is exactly the same as that used for the *Portrait of Otto Müller* (80). The number 4 on this impression is most unusual as Kirchner hardly ever numbered the editions of his prints.

ERICH HECKEL

1883–1970

Born in Döbeln in Saxony. His father
was a railway engineer, and the
family frequently moved. Between
1897 and 1904 he was at the
Chemnitz Realgymnasium and in
1901 met Schmidt-Rottluff. In 1904
he became a student of architecture
at the Technische Hochschule in
Dresden, but left after three semesters,
shortly after the foundation of the
Brücke. He maintained himself with
a job in the office of the architect
Wilhelm Kreis, resigning to become a
full-time artist in July 1907. Heckel
was the treasurer and secretary of
the Brücke, and was primarily
responsible for holding the group
together. In the summer months he
often divided his time, working first
with Kirchner and then with Schmidt-
Rottluff. Between February and May
1909 he made a long visit to Italy. In
December 1911 he moved to Berlin,
and during the course of 1912 met
most of the leading painters of the
German *avant-garde*. In 1913, after
the dissolution of the Brücke, he
began spending the summer months
at Osterholtz, near Flensburg, which
remained his favoured summer resort
until 1944.

During the First World War, having
been classified as unfit for active
service, he voluntarily joined an
ambulance unit stationed in Roeselaar
and Ostend, which was staffed mostly
by other artists, and which allowed
him some time for his art. After the
end of the War the change in his
style, which had begun in *c*. 1913,
was virtually complete; he substituted
a new 'tempera' technique for oil
painting, replacing bold colours with
more pastel tones, and introduced
new symbolic themes and
melancholy subject-matter. In 1937
his art was declared 'degenerate',
and 729 of his works were expelled
from German museums. In January
1944 his Berlin studio, containing

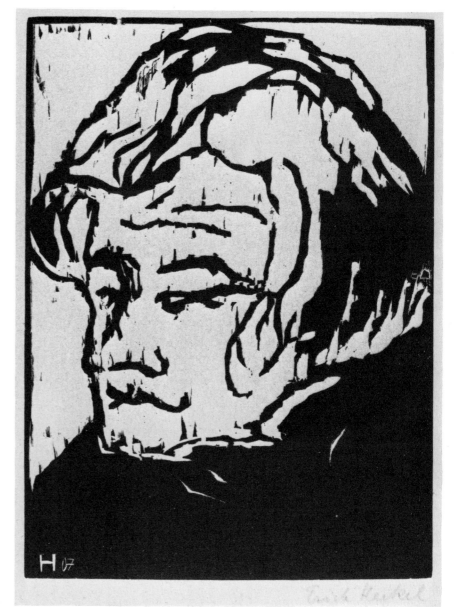

84

all his blocks and plates, was
destroyed, and he moved to
Hemmenhofen on Lake Constance.
From 1949 until his retirement in
1955 he was professor at the
Karlsruhe Akademie.

Heckel's output of prints was
second only to Kirchner's among the
artists of the Brücke: some 460
woodcuts, nearly 200 etchings and
400 lithographs are known. Nearly
three-quarters of these belong to the

years between 1903 and 1923. After
this there are only a few prints from
the late 1920s and early 1930s, and
then a larger group from the post-
Second World War years.

See also 250.

Bibliography

The standard catalogue of the paintings
is contained in Paul Vogt, *Erich Heckel*,
Recklinghausen 1965. No catalogue of
prints was compiled before Annemarie

116

and Wolf-Dieter Dube, *Erich Heckel, das graphische Werk*, 2 vols, Hamburg 1964–5; reprinted in 1974 with a third volume of supplement by Ernst Rathenau. There are also large numbers of exhibition catalogues of varying usefulness. The largest of these is that of the centenary exhibition held at the Folkwang Museum, Essen, and the Haus der Kunst, Munich, in 1983–4 which contains a good essay by Lucius Grisebach. *Erich Heckel, Zeichnungen, Aquarelle und Dokumente*, compiled by Karl-Heinz Gabler, Stuttgart 1983, was published on the occasion of an exhibition in Aschaffenburg, and is a useful assemblage of miscellaneous material. But a proper study remains to be written.

84 *The violinist's head*
1907

Woodcut. Signed in pencil. 201 × 150 mm
Dube 109, second state. On Japan paper.
A later reprint, possibly made at the same time as the edition published in the yearbook of *Das neue Pathos*, Berlin 1914–15.
1982–7–24–17

This print by Heckel is the only representative in this catalogue of an important stage in the development of the Brücke woodcut, which is discussed on p. 29. Although this head is far from being the most radical of the group made in 1907, it can be seen how Heckel has deliberately varied the direction and thickness of the line in order to avoid the flowing decorativeness of Jugendstil. The odd flecks of wood in the background, not cut away by the gouge, also emphasise the nature of the wood-block from which the image is printed; after 1906 it is never possible to mistake even a reproduction of a Brücke woodcut for a line-block reproduction of a pen and ink drawing. Heckel's paintings of 1907 (e.g. *Ziegelei, Dangast*, Vogt 167/4, in the Thyssen collection) show a marked impasto and use of pure colours laid in short lines which derive directly from van Gogh. This *facture* seems to have directly influenced his handling of the woodcut.

85 *Head in profile*
1907

Lithograph. Signed in pencil and dated *07*; annotated in lower margin with title *Kopf in Profil*. 327 × 274 mm
Dube 6, second state
1984–5–12–1

This print is one of the *incunabula* of the new techniques of lithography, introduced by Kirchner and Heckel in 1907 (see pp. 32–3). The image is drawn on the stone with a crayon, and there is as yet only a modified use of turpentine to break up the tones. From the very beginning Heckel and Kirchner left the edges of the stone inked so as to emphasise the lithographic nature of the image.

This may be a self-portrait, since Heckel wore a short fringe of beard such as seems to be visible here, but the profile view argues against this, and certainty is impossible without some documentary evidence. The tonal treatment of the face with the undifferentiated dark mass of the eye set against the white expanse of the temple continues the concerns of his earlier woodcuts of 1905–6.

85

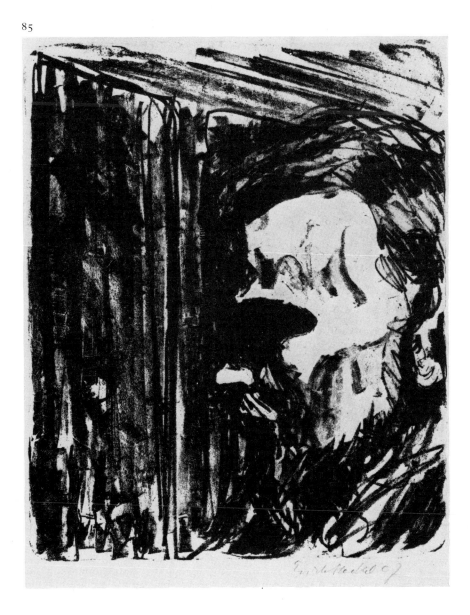

86 *Bulls*
1908

Woodcut. Signed and dated *08* in pencil.
249 × 336 mm
Dube 159, second state
1984–6–9–8

This is a fine example of the first maturity of the Brücke woodcut in 1908. The area of the field in which the two bulls (or perhaps rather a bullock and a cow) find themselves is cut by a gouge or chisel. The irregular surface is then inked so that many of the lowered areas, not just the surface, hold ink. Through the application of considerable pressure in the printing, the paper has been forced down into the lowered areas; as a result we see a mixture of solid blacks, half-tone greys and a certain amount of embossing without any inking.

The form of the signature with the flourish on the first ascender of the H shows that this is an impression printed in 1908, as Heckel seems to have changed his signature to lose the loop within a year or two (contrast the signature on the next print). It should be noted that the page of reproductions of Heckel signatures given by the Dubes (p. 11) is useless as an aid to dating, since they have made no attempt to distinguish signatures on contemporary impressions from those on later reprints.

87 *Street by the harbour*
1910

Drypoint. Signed in pencil and dated *10*.
170 × 201 mm
Dube 91. As published in the sixth Brücke portfolio of 1911 (the thick wove paper is the same as that used in the portfolio, but the sheet has been cut down to 261 × 336 mm, instead of 398 × 539 mm).
1981–10–3–22

The sixth Brücke portfolio, distributed to the sixty-eight passive members in 1911, contained three prints by Heckel inside a wrapper with a woodcut by Pechstein. Besides this drypoint, it contained a lithograph *Nudes in a wood* (Dube 153), also of 1910, and a woodcut dated (wrongly?) 1911, *Franzi standing* (Dube 204), which is a pair of sorts to the following item. The scene of this print is certainly not in Dresden, and it has been identified by Hans Bollinger as the harbour in Hamburg; presumably it is of the trees

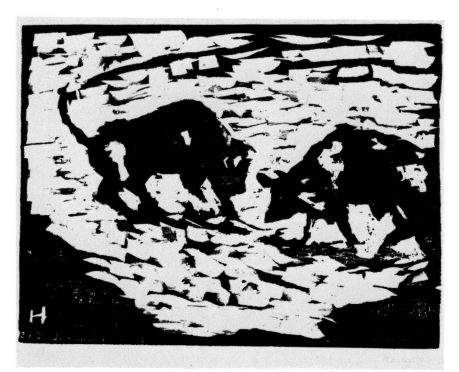

86

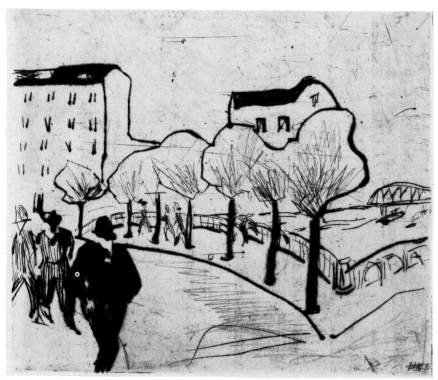

87

along the edge of the Binnenalster in the centre of the town. It was therefore probably done in October 1910, when, according to Gustav Schiefler's guest-book, Heckel and Kirchner paid him a visit. A number of drypoints and drawings by both artists showing scenes from the circus and dance-hall can be associated with this visit. The choice of this image for the portfolio was perhaps a gesture towards the very high proportion of the Brücke's passive members that lived in Hamburg.

Whereas Heckel's early intaglio prints are mainly etchings, from 1909 onwards they are almost entirely drypoints. This print is a good example of his deliberate manipulation of the burr given by the drypoint to create tone: the black of the foremost man, the tree-trunks and the two roofs is entirely defined by burr. In the two rear figures he has lightened the tone by scraping off the burr so that only the line itself prints. A slight film of ink has been left on the surface of the plate in order to give an overall tone that distinguishes the printed area from the natural colour of the paper; this seems to be standard practice in all Heckel's drypoints of the Brücke years.

The use of a single contour line to enclose the clumps of trees is a device frequently found in Heckel and Kirchner's landscape drawings: it seems to have been taken by the members of the Brücke from Munch (cf. Donald E. Gordon, 'Kirchner in Dresden', Art Bulletin, XLVIII, 1966, p. 346).

88 *Franzi lying down*
1910

Woodcut printed in red and black from one block, sawn into four pieces. Signed and dated 10, and annotated *Fränzi liegend Handdruck.*
226 × 419 mm (maximum), 203 × 408 mm (minimum)
Dube 188, second state
1983–10–1–38
See colour illustration

In general, Heckel's earliest colour woodcuts of 1905–8 were printed from two blocks, the drawing block simply being printed in black over an undifferentiated monochrome tone-plate. In his classic colour woodcuts of 1909–11 which are characterised by flat areas of unmodulated colour he used the method invented by Munch of sawing a single

block into different pieces and separately inking them before reassembling the block for printing. In this print of 1910 the uniform tone shows that the colour was added by a roller, not a brush (cf. p. 31). An impression in which the bed cover is inked in blue, rather than red, is illustrated in the Heckel exhibition catalogue, Stuttgart 1973–4, pp. 19–20. (Vogt, on p. 104 of his 1965 monograph, asserts that Heckel discovered the method of sawing up a block independently of Munch, having practised intarsia work in Kreis's studio, but this seems highly improbable.) This impression, in which the colour is remarkably fresh, is very probably a reprint made by Heckel after 1910. It is known that Heckel (unlike Kirchner) often reprinted older blocks, but the criteria for distinguishing editions have not yet been elucidated.

The model seen here and in many other works of Heckel and Kirchner dating from 1910–11 was a girl about twelve years old who, with her slightly older sister Marzella, was much employed by the Brücke, who always deliberately avoided the conventional movements and poses offered by professional models. According to Pechstein (*Max Pechstein - Erinnerungen*, ed. L. Reidemeister, Wiesbaden 1960, p. 42) they were the daughters of an artist's widow, and were found through the caretaker of the Dresden Akademie. Their discovery was announced by Heckel in a postcard to Rosa Schapire dated 18 February 1910 (Tel Aviv Museum, published by Georg Reinhardt, *Brücke-Archiv* 9/10, 1977/8, note 378); this card provides an important *terminus post quem* for all works in which the sisters appear.

89 *Woman kneeling by stones*
1913

Woodcut. Signed and dated 14 in pencil.
499 × 321 mm
Dube 258
1982–7–24–18

In 1912–13 Heckel's style of painting, like Kirchner's, changed radically under the impact of his move to Berlin and his new familiarity, acquired through seeing works in exhibitions or meeting the artists personally, with the styles derived from Cubism. The outcome was his so-called 'prismatic' manner which

reorganised light and space in a series of triangular planes. This print is a translation into woodcut of the type of composition seen in his most famous painting of this year, the *Glassy day* (Vogt 1913/21) now in the collection of modern art at Munich. As in the painting, the landscape is of the firth leading to Flensburg, near Osterholz, where he spent the summer months of 1913.

This woodcut and ten others were reprinted in an edition of forty in a portfolio published by J.B. Neumann (cf. 131) in Berlin in 1921; 90 and 92 also belong to this edition. According to the Dubes' catalogue such impressions should bear the signature of Voigt, who printed the entire edition. However, although such signatures are often seen on impressions, unsigned impressions printed on the same large sheets of deckle-edged paper are also commonly found. Moreover, what seems to be a complete set of the Neumann edition is in the Berlin Kupferstichkabinett and none of the prints has Voigt's signature.

Colour-printed impressions of this print are known. Dube mentions versions with a tone-block printed in various colours. The impression sold at Kornfeld in 1970 (auction 137, lot 354) was stated to have had blue colour added to the drawing-block.

90 *Squatting woman*
1913

Woodcut. Signed and dated 14 in pencil.
420 (at right 365) × 310 (at top 300) mm
Dube 263
1980–3–22–8

Inasmuch as it has no landscape, this woodcut lacks the 'prismatic' character of 89. The face and body are, however, firmly articulated in a manner that becomes set for the next six years: characteristic are the long sensitive fingers, and the double line that defines the bridge of the nose. Heckel frequently used irregularly shaped blocks for deliberate effect from 1908 onwards. Kirchner made much more sparing use of the device; it is only in the great series of tall vertical portraits of 1917–18 that he frequently adopts it.

It was not only Heckel's style that changed in 1912–13. There is an entirely new feeling of melancholy breathed by his figures that is far removed from the

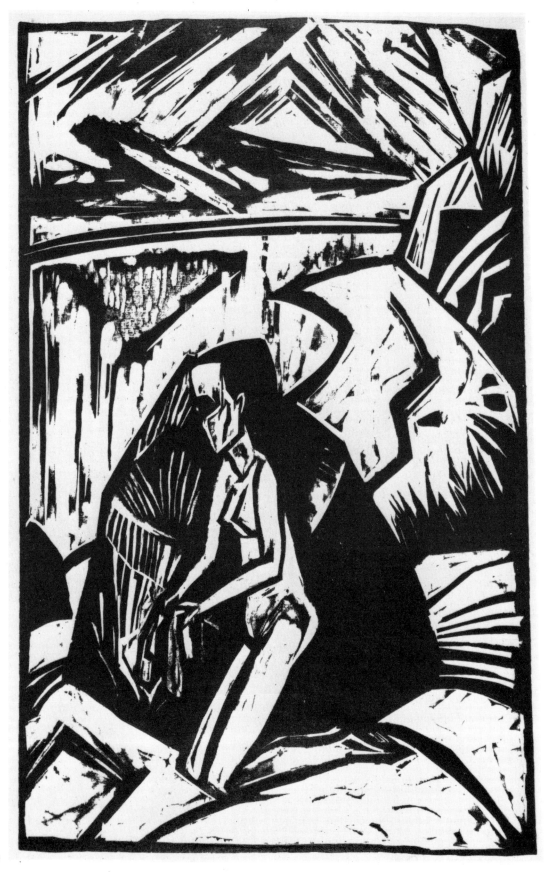

89

vitality and appetite for life that inspires the work of the Dresden years. Since there is very little published information about Heckel's own emotional history, it is impossible to say whether this can offer any explanation.

There is a preparatory black chalk drawing for this print in the Brücke Museum in Berlin, signed and dated 1913 (498 × 300 mm, illustrated Gabler, 1983, plate 51).

91 *Reading aloud*
1914

Woodcut. Signed and dated *14* in pencil. At bottom left signed by the printer *gedr. F. Voigt.*
300 × 200 mm
Dube 272, second state, on Japan paper. With the blind-stamp lower left of the Verlag der Dichtung, by whom this print was published in their first portfolio, Potsdam 1922, in an edition of 125 (of which 25 were on Japan).
1971–2–27–19

The subject of this woodcut is one of the reading evenings which Heckel held from 1912 onwards, after his move to Berlin (see 1983 Essen catalogue, p. 212). Dr Walter Kaesbach, who was Ludwig Justi's assistant at the Nationalgalerie in Berlin, and later in charge of the Red Cross unit in which Heckel served at the Western Front, is reading to Siddi Riha, the dancer with whom Heckel was then living and whom he married in 1915. Out of these evenings came a number of paintings and prints on literary subjects, particularly illustrations of scenes from Dostoyevsky, who was one of the favoured authors. The curious use of haloes to frame the heads imparts an oddly sacramental character to the scene, which is probably not accidental. A similar effect is aimed at in the painting *Woman and young girl* in the Wuppertal Museum (Vogt 1912/14, but surely to be dated 1914).

This woodcut is related to a painting of 1914 (Vogt 1914/4) which shows a similar scene with the back of Heckel's own balding head in the foreground. Its composition is even more closely linked with a watercolour of 1913–14 in the Brücke Museum which shows the two figures in the same poses but with some changes to the surroundings. (See *Brücke-Archiv* 5, 1971, plate 5; this volume shows how frequently in his later years Heckel based his paintings on

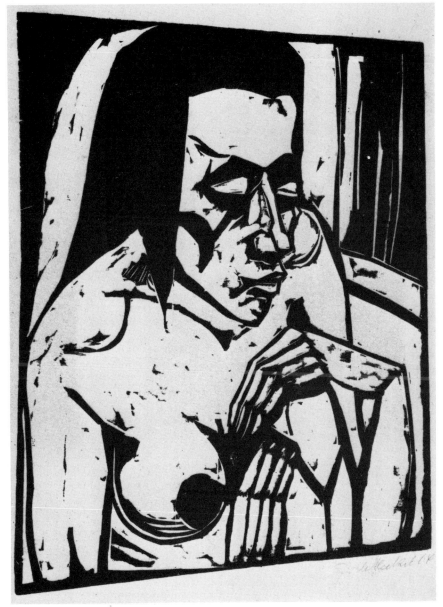

90

preliminary watercolours.) The Brücke Museum also owns a pencil study of the figure of Kaesbach alone (Gabler, 1983, plate 61).

92 *Man on a plain*
1917

Woodcut. Signed and dated *17* in pencil.
377 × 272 mm
Dube 305, second state
1982–7–24–19

While working for the ambulance unit in Ostend, Heckel made a number of paintings, drawings and prints that reflect the War in an oddly detached way. The fighting or the scene of battle is never directly portrayed. Instead there are desolate landscapes, stormy seascapes, compositions such as the 'Good Samaritan' triptych, and portraits of colleagues or their wounded patients. This self-portrait is one of the works that most successfully conveys the oppressiveness of the period. The composition reflects Munch's lithograph of 1895 *The Scream*, and the lines of the sky that run towards the head serve the same function as the parallel waves that reverberate round Munch's figure. The

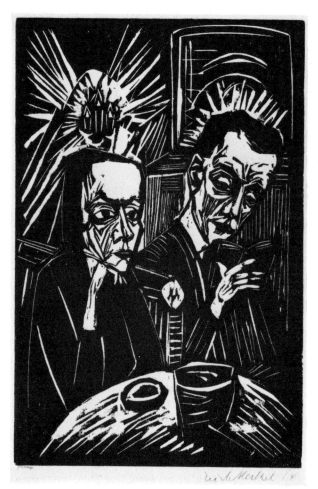

91

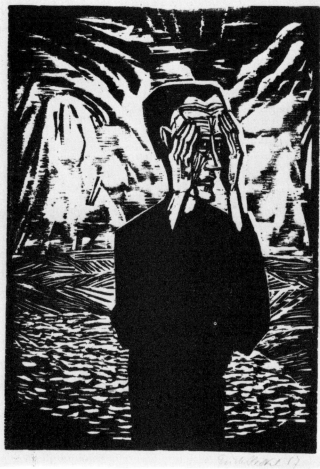

92

original block survives in a private collection in West Germany.

93 *Portrait of a man*
1919

Colour woodcut. Signed and dated *19* in pencil.
460 × 326 mm
Dube 318, probably second state, since there are white patches on the forehead. On the verso is stamped *Schlesisches Museum d. bildenden Künste*, with the inventory number *22707* in pencil.
Lent by the Arts Council of Great Britain.

This self-portrait of 1919 is one of Heckel's best-known prints. It is printed from two blocks. According to the Dubes'

catalogue, the colour block was sawn up and reassembled after separate inking (as in 88). Since in most impressions the black drawing block is printed over the colour block so as to mask the joins between the colours, this statement has been generally accepted. But in this impression, and another in the Kunsthalle in Hamburg which carries the signature of the printer Voigt, the colour block has been printed over the black. This shows that it was in fact never cut up; rather, the three colours – green, brown and blue – were brushed onto a plain block which had no design whatever cut into it. This method was regularly used by

Heckel before the War (see p. 31). In this impression the colours mask the black outlines to produce a blurred effect which is more attractive than the hard appearance of the normal printings.

Although there is little doubt that this print was cut and printed in 1919, the style of the drawing is quite dissimilar to other Heckel woodcuts of the post-War years. It fits rather into the context of the large prints of 1913–14. The obvious explanation for this is that Heckel was basing his design on an earlier drawing.

KARL SCHMIDT-ROTTLUFF

1884–1976

Born Karl Schmidt in Rottluff, a town near Chemnitz, where his father owned a mill. He was educated at the Chemnitz Humanistisches Gymnasium. After leaving school at Easter 1905 he went to Dresden to study architecture, but left after one semester after joining the Brücke, having been introduced to Kirchner and Bleyl by Heckel. In 1906 he added Rottluff to his name, and spent the summer with Nolde on Alsen. Schmidt-Rottluff was the most independent member of the Brücke, only participating in their communal activities to a limited extent. From 1907 to 1912 he spent every summer by himself at Dangast on the coast north-west of Bremen, occasionally joined by Heckel but never by Kirchner. His links with north-west Germany were strengthened by his friendships in Hamburg with Gustav Schiefler and Rosa Schapire, and in 1908 he was thinking of settling there permanently.

In December 1911, like the other Brücke members, he moved from Dresden to Berlin, and his work of the following three years shows a wide range of new influences, especially from African primitive art and Cubism. From 1915–18 he served in the army on the Eastern Front. After the War he returned to Berlin, where he remained for the rest of his life, with only a short period during the Second World War when he returned to Rottluff after his studio had been destroyed. In 1947 he was appointed professor at the Hochschule für bildende Künste in Berlin. In 1967, he founded the Brücke Museum in Berlin with a large gift of his own work.

Schmidt-Rottluff is credited with a total of 663 prints: 446 woodcuts, 121 lithographs and 96 etchings, drypoints or engravings. Almost all of them were made between 1905 and 1927. A fine collection of Schmidt-Rottluff's prints is to be found at Leicester, and some further good prints at the Victoria and Albert Museum, all bequeathed by Dr Rosa Schapire.

Bibliography

A catalogue of the paintings is included in the monograph by Will Grohmann, *Karl Schmidt-Rottluff*, Stuttgart 1956; this also contains a large bibliography. The prints were catalogued by Rosa Schapire, *Karl Schmidt-Rottluffs graphisches Werk bis 1923*, Berlin 1924. A supplementary volume of work since 1923 was published by Ernest Rathenau, New York 1964. Neither of these is illustrated. His earliest woodcuts of 1905, omitted from Schapire's catalogue, were published by Paola Viotto in *Print Collector*, XIII, 1975. A monograph by Gerhard Wietek, *Schmidt-Rottluff Graphik*, Munich 1971, has a large number of good reproductions, but an illustrated edition of Schapire is greatly needed. Professor Wietek is also the author of *Schmidt-Rottluff in Hamburg und Schleswig-Holstein*, which accompanies the large centenary exhibition in the Schleswig-Holstein Landesmuseum in late 1984.

94 Man with pipe (self-portrait) 1907

Lithograph. Signed and dated 1907, and annotated *Mann mit Pfeife* in pencil.
340 × 225 mm
Schapire 27
Lent by the Victoria and Albert Museum (inv. E 703–1955).

This is one of Schmidt-Rottluff's early lithographs, made before Kirchner and Heckel had taken up the medium, and showing none of the later technical inventions associated with Brücke lithography. Like all Schmidt-Rottluff's lithographs of 1906–7, it was printed at the Dresdner Kunstanstalt. Although nothing more complicated than a crayon and a scraper is used, the boldness and dramatic strength of the drawing puts these prints among the most remarkable early works of the Brücke.

In May 1907 Schiefler showed some of Schmidt-Rottluff's first lithographs to Munch. He recorded the artist's reaction in his diary: 'He said, "This is insane." He added. "Now I'm going to say the same about him as they have always said about me. God protect us, we're heading for bad times. But the division of black and white on the sheets is very good". The next day he returned to the subject: he had kept thinking about the works, so they must be very remarkable.' (Published by Arne Eggum, *Die Brücke – Edvard Munch*, exhibition catalogue, Munch Museum Oslo 1978, p. 19).

This lithograph is one of the collection bequeathed to the Victoria and Albert Museum by Dr Rosa Schapire. It is evidently a trial impression of sorts, and has various illegible remarks in pencil on the verso.

95 Berliner Strasse in Dresden 1909

Lithograph. Signed in pencil. 400 × 329 mm
Schapire 57
1983-10-1-37

This lithograph was one of three prints by Schmidt-Rottluff which were distributed to the passive members of the Brücke in the fourth portfolio in 1909; the woodcut cover of the portfolio was cut by Kirchner. It is therefore appropriate that its subject should be the street in Dresden where the members had their studios; Kirchner was at number 60, while Heckel's studio at number 65 served as the group's meeting place and address for correspondence. The street lay in the suburb of Friedrichstadt, and Heckel's father, as a railway employee, had a tied house at one end. It took its name from the Berliner Bahnhof on one side, which served as the station for trains to Berlin before the construction of the Grossbahnhof in 1893–8. The large houses on it were built at the end of the nineteenth century, with shops on their ground floors and flats above; but after the opening of the main station, and because the south side of the road was never built on, there was never enough trade to maintain a business. For this reason Heckel was able to rent the shop spaces very cheaply as studios for himself and his friends. (See Walter Henn in *Die Künstlergruppe Brücke . . . Verzeichnis der Bestände, Kunstmuseum Hannover mit Sammlung Sprengel*, Hanover 1982, p. 19; see also Georg Reinhardt, *Brücke-Archiv* 9/10, 1977/8, p. 34). For the other

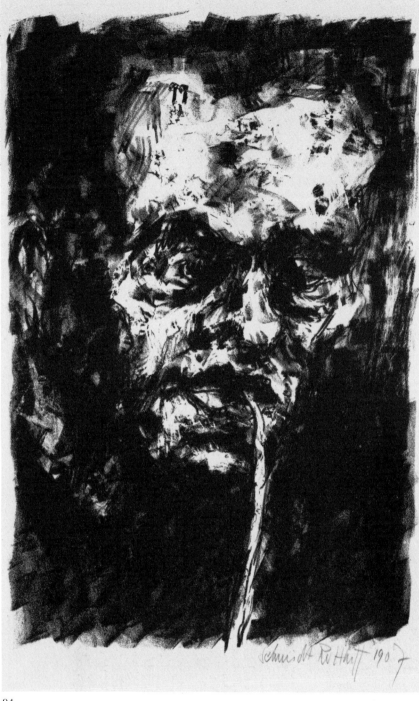

94

prints in the portfolio, see 95a.

This print is an example of the developed manner of Brücke lithography which Schmidt-Rottluff had adopted from Kirchner and Heckel (see p. 32) in which turpentine is used to break down the tones and give a more unified 'over-all' texture.

95a Portrait of Erich Heckel
1909

Lithograph. Signed in pencil. 398 × 322 mm (maximum dimensions)
Schapire 56
1984–6–9–6

This portrait of Heckel was the second print in the Brücke portfolio of 1909. The third was an etching entitled *Old houses in Dresden*. According to the 'Bericht' (report) of activities for 1908 which accompanied the prints, 'all the impressions are taken from original plates and printed on a small hand-press. Only the printing of the etching was entrusted to C. Sabo, Berlin. The two lithographs are specially drawn for this publication, and there are no impressions printed apart'.

In style this lithograph seems to be a deliberate contrast to the previous one. It is drawn with wash rather than chalk, there is no use of turpentine, and the edges are left uninked. It is therefore impossible to say whether it is printed from the same stone, although the measurements would suggest that it was. Like Pechstein's lithograph of the same year (103), the outline drawing betrays the influence of Matisse.

96 Brickworks near Varel
1909

Woodcut. Signed and dated in pencil.
297 × 389 mm
Schapire 7. Printed on grey paper.
1980–1–26–115. From the Rauert collection (sold Hauswedell, Hamburg, 7 June 1969, lot 1)

It is a curious fact that Schmidt-Rottluff, who was to become the woodcutter *par excellence* of the Brücke in terms of the dominant position the medium held in his work, made no woodcuts at all in 1907–8. His seventeen earliest woodcuts of 1905 he had excluded from Schapire's catalogue, despite their quality, since he no longer felt happy with them; the three works of 1906 are minor; and so he made

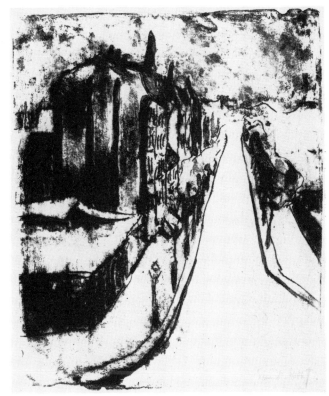

95

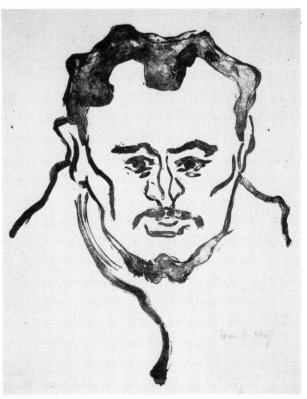

95a

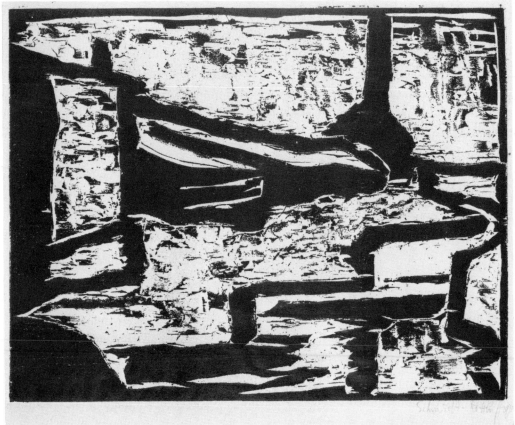

96

a fresh start in the medium in 1909. His development between 1906 and 1908 as a printmaker has therefore to be described in terms of his lithographs, with the addition of a few etchings.

The subject, a brickworks near the town of Varel just south of Dangast, is one that frequently recurs in the work of Schmidt-Rottluff and Heckel in the years 1907–9. The long low building ending in a chimney is in the background. From the left foreground running to the horizon at the right is a small stream, in which can be seen the distorted reflection of the chimney. The radical simplification of form and suppression of perspective in the interests of surface rhythm makes the group of 1909 woodcuts some of the most abstract, and interesting, images produced by any member of the Brücke. Schiefler was very struck by them and commented that 'the division of black and white in the lines and flecks was supported by a strong pressure on the block in the printing, which – by means of a scarcely perceptible creation of half-tones – appears to bring the contrasts into harmony' (*Meine Graphiksammlung*, 1974, p. 55).

Schapire records that this woodcut, like all of Schmidt-Rottluff's work between 1906 and 1912, was printed by the artist himself; she further notes that is was rare at this time for the number of impressions of the woodcuts to reach even ten. The burnishing marks on the verso made with some smooth implement show that this print was taken off the block by hand without the use of a printing press.

97 *House behind trees*
1911

Woodcut. Signed and dated 1911 in pencil in lower right corner; annotated in lower margin *Frau Dr P Rauert, S-R.* 204 × 262 mm
Schapire 54
1984–6–9–7

This print of 1911 serves as a link between the woodcuts of 1909 and 1914 in this catalogue. It shares with the 1909 print the concern for delicate hand-printing (it also has burnishing marks on the verso) and careful inking (the black areas have been only thinly inked so as to reveal the grain of the block). But it looks forward to later works in its new interest in a clearer definition of form by means of

angular cutting and broad expanses of black. A related drawing in coloured chalks was formerly in the collection of Rosa Schapire.

Martha Rauert, to whom this impression was dedicated by the artist, was with her husband Paul one of Schmidt-Rottluff's

earliest and most important Hamburg patrons, and a passive member of the Brücke. Most of their collection was sold in Hamburg, at Hauswedell's, in June 1969 (cf. 96). The impression of this print sold as lot 8 in that sale, however, was not the same as that shown here, as it

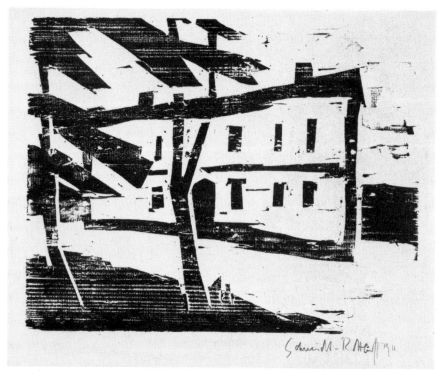

97

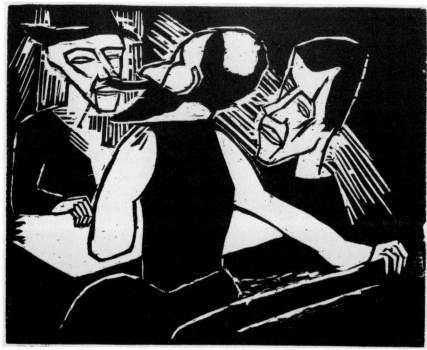

98

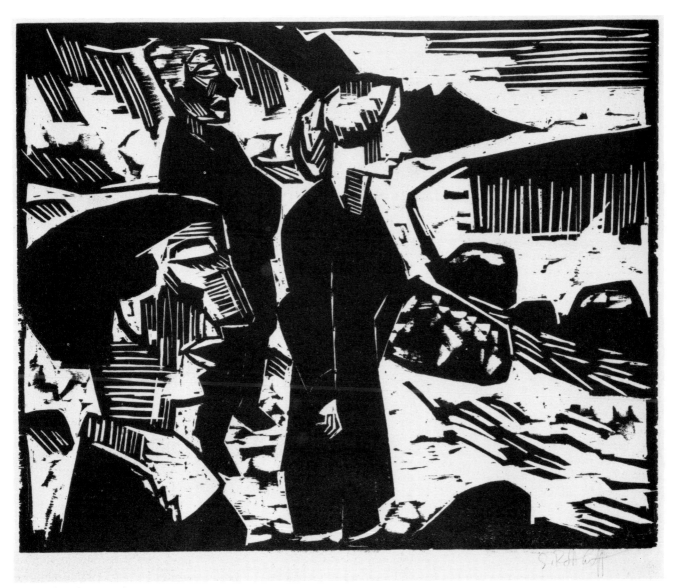

99

was signed on the left, not the right, and was undated. Frau Rauert had also been one of the first collectors of Nolde, and was one of the purchasers at his exhibition at the Commeter Gallery in 1907, an exhibition which had been warmly reviewed by Rosa Schapire.

98 *Upper Bavarian peasants*
1914

Woodcut. Signed and dated in pencil; annotated in lower margin *1421*.
393 × 500 mm
Schapire 142
1980–5–10–18

In July 1914 Schmidt-Rottluff made a visit to Munich, and this image may be connected with the journey. As is mentioned on p. 30, from 1913 Schmidt-Rottluff almost invariably had his blocks printed for him in large editions of between twenty-five and thirty. This particular block was printed by Paul Cassirer's Pan-Presse or by Voigt in Berlin. The number *1421* written on the sheet refers to the cataloguing system first adopted by Schmidt-Rottluff in 1913, coinciding with his first use of professional printers. The first two digits refer to the year, and the second two to the sequential number of the work within that year's output of prints. The print betrays an unexpected influence from Heckel's woodcuts in the structure of the face of the man at the right and the fingers of the hand at the left.

99 *People looking out to sea*
1914

Woodcut. Signed in pencil; traces of *1426* annotated in lower margin, rubbed out.
400 × 498 mm
Schapire 147
1982–7–24–22

The year 1914 was one of the high-points in Schmidt-Rottluff's activity as a woodcutter; the fifty prints he made were the largest number of any year, and the quality perhaps the most impressive.

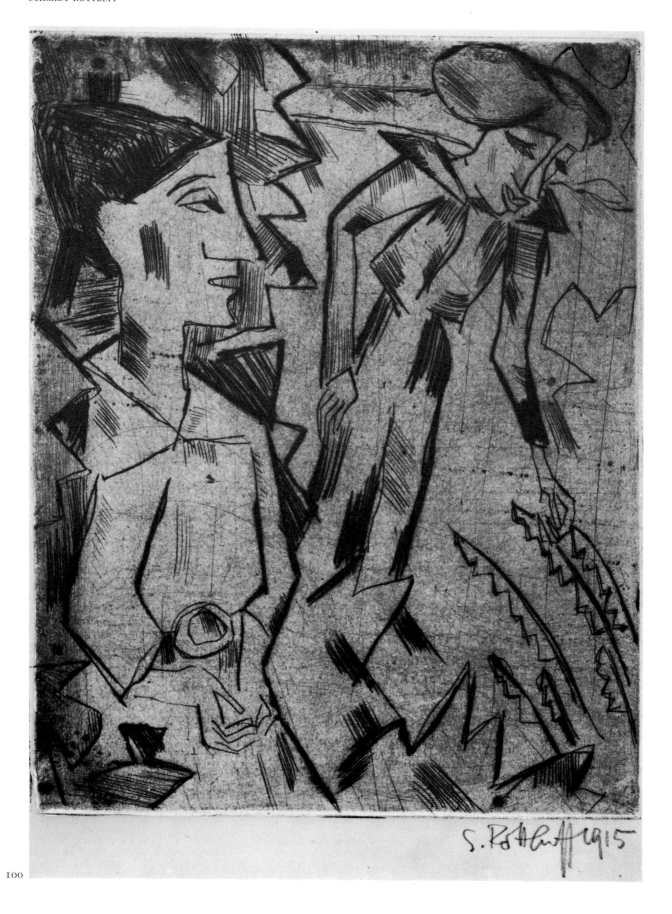

100

Among them there is a self-contained group of prints of similar subject-matter, showing clothed figures on the shore (cf. Schapire 146, 150–2, 161). Most of them are shown looking out to sea, and this places them in the centre of the tradition of German Romantic painting stemming from Caspar David Friedrich (1774–1840) and his contemporaries.

Such pensive and melancholic themes are similar to those found in the works that Heckel was making in the same years, but are far removed from the concerns of Kirchner. After the years of the First World War during which Schmidt-Rottluff hardly created any works of art, he changed course again and made a number of large woodcuts of religious subjects, many of which were published in 1919 in a portfolio by Kurt Wolff Verlag, Munich. These later prints are not included in this catalogue.

100 *Women in the garden* 1915

Drypoint. Signed and dated in pencil. Annotated in lower margin 153 (mistakenly for 158). 233 × 187 mm
Schapire 18
1983-10-1-36

Whereas Schmidt-Rottluff's woodcuts were produced fairly regularly between 1905 and 1927, the intaglio prints were made in odd groups: eleven etchings in 1907–8, eleven drypoints in 1915 and a larger number of drypoints and engravings between 1920 and 1924. According to Wietek (1971, p. 133), the eleven prints of 1915 were all made during the first months of the year while Schmidt-Rottluff was in Berlin awaiting military call-up. This drypoint of 1915 is unusual in that it reproduces in reverse the composition of a painting of 1914, now in the von der Heydt Museum, Wuppertal (Grohmann 1956, plate 260).

The two models are found in other paintings of 1914 (also illustrated Grohmann, 1956, plate 260). An undescribed first state of this print is illustrated as plate 94 of the 1974 edition of Gustav Schiefler, *Meine Graphiksammlung*.

MAX PECHSTEIN
1881–1955

Born in Zwickau into a working-class family. In 1896 he was apprenticed to a local decorative painter; in 1900 he was awarded a place at the Kunstgewerbeschule in Dresden, and in 1903 moved on to the Dresden Akademie. He graduated at Easter 1906 with the top prize, which carried with it a scholarship to Italy. A few months later, he joined the Brücke, and worked with them for most of the following sixteen months, in the process transforming his late Impressionist style. In September 1907 he went to Italy, and on his return settled in Paris for some months, where he met Kees van Dongen, who later joined the Brücke for a short time. In the summer he returned, not to Dresden but to Berlin, which remained his home for the rest of his life. His energy and charm quickly made him an important figure in Berlin artistic life: in 1910 he was elected president of the Neue Secession. However, he maintained his contacts with the other members of the Brücke, by joining their summer painting expeditions in 1910 and, more closely again, after their move to Berlin at the end of 1911.

By 1912 he was receiving important commissions for wall decorations; he broke the Brücke policy of only exhibiting together as a group by exhibiting individually at the Berlin Secession in the summer of that year, and was consequently expelled. In the spring of 1914 he went to the Palau Islands in the South Seas, only returning to Germany via Japanese internment, the USA and Holland in September 1915. He then was drafted to the Somme front, but in early 1917 was released from military service after a nervous collapse and returned to Berlin. He was thus well placed to participate in the startling events at the end of the War. He was a founder member of the Arbeiterrat für Kunst and the Novembergruppe, and his address *An alle Künstler* (see 258) received wide publicity. When Expressionism suddenly became fashionable, he, rather than Kirchner, became its best-known representative in Germany. His work, however, became repetitive and dull, and is now largely ignored. This is unjust, for during the Brücke years its quality is very high.

According to Gunther Krüger, Pechstein made a total of about 850 prints: 390 lithographs, 290 woodcuts and 170 etchings. Of these about one third were made while he was a member of the Brücke.

Bibliography

A number of monographs on Pechstein were published in the early 1920s during the height of the fashion for his work. They include Max Osborn, *Max Pechstein*, Berlin 1922, and Paul Fechter, *Das graphische Werk Max Pechsteins*, Berlin 1921, which remains the standard reference work for his prints, although it has many omissions, so many in fact as to make the book seriously misleading for the early years. No woodcut earlier than 1906 is mentioned, although Pechstein already had a significant oeuvre to his credit in the style of Lucien Pissarro. A new catalogue, with illustrations, is badly needed. Pechstein's memoirs are an important primary source on the history of the Brücke: *Max Pechstein – Erinnerungen*, edited by L. Reidemeister, Wiesbaden 1960. There are, however, no recent monographs of significance. Reference can only be made to two useful works by Gunther Krüger: an essay in the Altona Museum *Jahrbuch*, IX, 1971, pp. 9–37, and the catalogue of an exhibition of his prints held at the Altona Museum in Hamburg, 1972, which reprints Pechstein's essay about his printmaking first published in *Das graphische Jahr*, Fritz Gurlitt, Berlin 1921, p. 101. The catalogue of an exhibition of his paintings, shown at the Kunstverein Braunschweig and the Pfalzgalerie Kaiserslautern in 1982, contains a large number of reproductions.

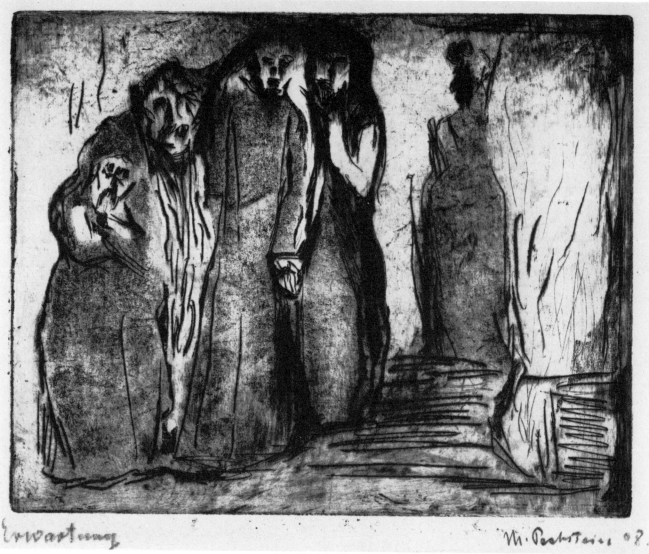

101

101 *Erwartung* (Waiting) 1908

Etching with aquatint tone. Signed, titled and dated *08* in pencil. 180 × 230 mm
Fechter 10
1980–6–28–44

An impression of this etching in the Altona Museum is inscribed *Paris*, thus proving that it was one of the group of prints made there in the early months of 1908, which is mentioned on page 28 of Pechstein's memoirs. All of these are of scenes from everyday life, and a number show prostitutes. In this print they are apparently waiting for clients. Pechstein's use of aquatint tone is most striking, and is as advanced as anything that his

Brücke colleagues (excepting of course Nolde) were producing at this time in intaglio.

102 *Sick man* 1908

Lithograph. Signed and dated *08* in pencil.
At left 4. 430 × 327 mm
Fechter 26 (most probably)
1982–7–24–23

According to Fechter's catalogue, Pechstein took up lithography in 1908, in the same year as his first etchings; but whereas the etchings were made in Paris, the lithographs were produced later in the year in Berlin. (This can be proved by

the fact that Fechter 1, of which there is an impression in Berlin, shows clear evidence of tuition by other members of the Brücke and is from the same stone as later prints, such as this one.) One would have expected him to have tried these media when he was in Dresden in the previous year, when the other members of the Brücke were devoting themselves intensively to printmaking, rather than in the year when he was for much of the time separated from them. That he did not may be evidence that Kirchner and Heckel only took up the medium after his departure for Italy in September 1907.

This print is an excellent example of early Brücke lithography. When

compared to the portrait by Heckel (85) it shows a more advanced unification of the overall tone achieved by turpentine and etching (see p. 32). As can be seen from burnishing marks on the verso, the impression was taken by rubbing the back of the paper rather than by using a press (a process specifically mentioned in his essay as being used at this time). This is the only Brücke lithograph in this catalogue that has clear signs of burnishing.

It has been suggested that this print is a portrait of Heckel, but this is impossible either to prove or disprove. Pechstein did, however, make a series of lithographic portraits of his Brücke colleagues in 1908; these must have been made in September or October when all three of them could have stopped in Berlin *en route* to Dresden after the summer months spent at Dangast or on Fehmarn.

103 *Blond young man*
1909

Lithograph. Signed and dated *09* in pencil.
At left 4. 385 × 346 mm
Fechter 55
1981–6–20–51

One of the fascinating aspects of Pechstein's work is that it reveals more clearly than that of the other Brücke members the influences that affected them. His lithographs of 1909, for instance, are the clearest example of the profound effect of the prints and drawings of Matisse (as his 1907 landscape drawings in reed pen are of the work of van Gogh, and his 1908 paintings of the work of Derain and the Fauves). In this print this is seen indirectly in the use of a single contour line to define the face, but others (e.g. Fechter 47, *Seated girl*) could almost be mistaken for the work of Matisse himself. It is remarkable that this influence is most obvious in 1909, that is after the big Matisse exhibition held in January that year in Cassirer's gallery in Berlin. When Pechstein was in Paris the previous year, he does not seem to have been so aware of Matisse's work.

Another impression of this lithograph (illustrated L.G. Buchheim, *The graphic art of German Expressionism*, Feldafing 1960, fig. 284) bears the number 5. Although he very rarely numbered his woodcuts and only occasionally the etchings, Pechstein almost invariably numbered

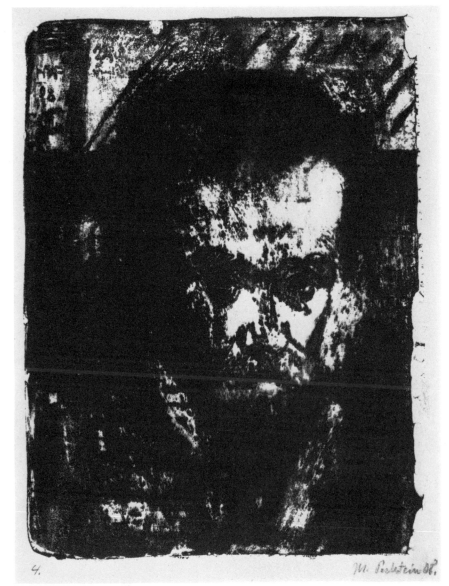

102

his lithographs, beginning with the first one in 1908; he remained (with the exception of Nolde) the only member of the Brücke to number his prints. The highest number we have seen on a lithograph is 7. In a letter of 1918 to Rosa Schapire, he answered an enquiry about the availability of impressions of an earlier print: 'At the time I made only five impressions, as in general I make few impressions of my graphics, at the most ten impressions (lithographs): then I grind off the stone. With woodcuts it is different, as with etchings'. (*German Expressionist Art, the Robert Gore Rifkind collection*, Los Angeles, 1977, no. 149).

104 *Fisherman's head* VII
1911

Woodcut. Signed and dated *11* in pencil.
Traces of the number 7 at lower left.
290 × 242 mm (maximum width; the block is irregular)
Fechter 79
1984–6–9–9

This woodcut is one of a set of eleven of heads of fishermen (Fechter 73–83) made in 1911. Pechstein also cut another set of eleven woodcuts of bathers in this year. All must have been made during the summer months he spent on Nidden on the Kurische sand-bar in East Prussia.

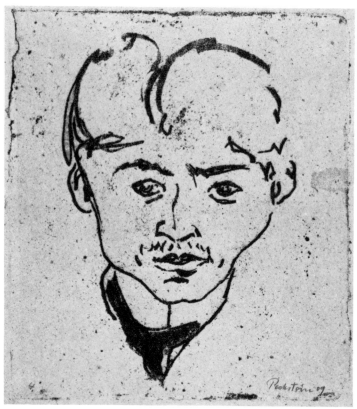

103

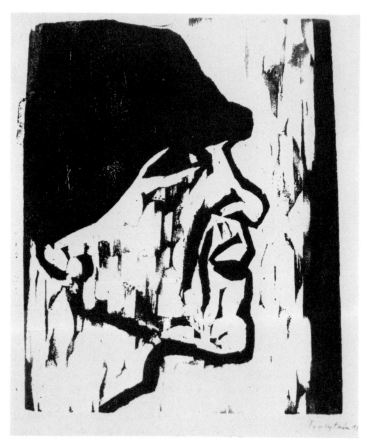

104

The set was published in an edition of twenty on Japan paper. This impression, however, comes from another edition, made only of this block, for the seventh Brücke portfolio of 1912. This was devoted to the work of Pechstein and contained, beside this woodcut, an etching of the Russian ballet and a hand-coloured lithograph of bathers; the cover was cut by Otto Müller (cf. 80) and was printed in gold on black paper. Although the entire edition of the portfolio was printed, it was apparently never distributed because of Pechstein's expulsion from the Brücke in the summer of 1912.

This print is an excellent example of the mature Brücke woodcut; the hewn character of the block enhances the man's rugged features. In his essay about his own printmaking of 1921, Pechstein commented on the development of his woodcuts: 'In 1905 in Dresden I made my first woodcut in the manner of a wood-engraving, cutting out the drawing with a burin on hard box-wood. Then I turned to the gouge and wood cut along the grain (alder, lime or poplar) which allowed an easier cutting; the preliminary design was now only sketched out on the block. Finally I took to using a short cobbler's knife and cut freely into the wood without any preparatory drawing, just as if drawing on paper with a pencil . . . My basic principle was and remains that the work must begin with the same tools as those with which it is completed, without making any preliminary drawing on the wood, stone or copper plate. The artistic intention is clarified by earlier sketches and drawings, and so prepared in the head, is brought to realization with the appropriate tools.'

EMIL NOLDE
1867–1956

Born Emil Hansen, in north Schleswig, the son of a farmer. He spent eight years as a carver and designer of furniture (1884–91), and six years as a drawing master in a school for applied arts in St Gall, Switzerland. The enormous success of the sale of postcards he had designed of Swiss mountains characterised with funny faces enabled him to afford four years at art schools in Munich, Paris and Copenhagen (1898–1901). His change of name to Nolde on the occasion of his marriage to Ada Vilstrup in 1902 marks the beginning of his career as artist at the age of thirty-five.

The following years were extremely difficult. His wife became a semi-invalid, and Nolde was dependent on the charity of friends. The turning-point came in 1906: he was invited to join the Brücke in Dresden, his painting *Erntetag* caused a sensation in the spring exhibition of the Berlin Secession, and he met his most important patrons, Karl-Ernst Osthaus, the founder of the Folkwang Museum in Hagen, and Gustav Schiefler. In these years, and for many years after, his pattern was to spend the winters in Berlin, and retire for the rest of the year to the flat country on the Danish borders, first at Alsen, then Utenwarf, and finally Seebüll (now the home of the Stiftung Ada und Emil Nolde to which he bequeathed his entire estate). Nolde's own suspicious and narrow temperament condemned him to remain a perpetual outsider in artistic circles. He resigned from the Brücke after a year and a half, and his scandalous and vicious personal attack on Max Liebermann in 1910 resulted in his expulsion from the Berlin Secession.

In 1913–14 he and his wife accompanied an expedition to the South Seas, where he found confirmation for his belief that art, like blood, can only come from the soil. As a member of the Nazi party, and a strong supporter of their call for a new German art, he was shocked to discover that he himself was one of their principal targets. Not only was he expelled from the Akademie der Künste and 1,052 of his works removed from German museums, but he was also in 1941 forbidden to exhibit, sell or even paint.

Nolde's prints were created in sporadic bursts at different points in his career. Almost 200 etchings made between 1904 and 1911 were followed by two later groups in 1918 and 1922. The woodcuts were almost all made in 1906, 1912 or 1917, and the lithographs in 1907, 1911 and 1913, with a final coda in 1926. There are hardly any prints later than 1926.

Bibliography

Nolde's autobiography has been published in four volumes: I *Das eigene Leben* (up to 1902), 1931; II *Jahre der Kämpfe* (1902–14), 1934; III *Welt und Heimat* (1913–18), 1965; IV *Reisen, Ächtung, Befreiung* (1919–46), 1967. Passages are here quoted from the collected edition published in one volume as *Mein Leben*, Cologne 1976. Also important is the anthology of letters, edited by Max Sauerlandt, *Briefe aus den Jahren 1894–1926*, Berlin 1927.

The most convenient biography is to be found in the 1963 Museum of Modern Art, New York, exhibition catalogue written by Peter Selz. Further information is to be found in many of the catalogues written by Martin Urban for exhibitions from the Nolde Foundation.

Nolde's prints were first catalogued by Gustav Schiefler in two volumes: I *Das graphische Werk bis 1910*, Berlin 1911; II *Das graphische Werk 1910–25*, Berlin 1927 (see 265). A severely abridged, though revised and illustrated, edition of this was published by Christel Mosel in 1966. This is supplemented by the 1975 exhibition catalogue, *Emil Nolde Graphik*, published by the Nolde Foundation (3rd edn 1983), which contains important new information in essays by Martin Urban and Manfred Reuther. These two authors are presently compiling the catalogue of Nolde's paintings; until this is published the Seebüll archives remain closed and much of Nolde's career remains obscure.

105 *Brutale Kraft* (Brutal strength)
Plate 8 of 'Phantasien'
1905

Etching and tonal effects. Signed in pencil and annotated *Bl.8*. 178 × 125 mm
Schiefler 12, fifth state. On laid paper; printed in blue ink.
1984-7-14-1

The set of eight prints entitled 'Phantasien' was made in a few weeks in October 1905 in a room in the pension in which Nolde was staying in Berlin. A full account of their creation is to be found in an essay by Manfred Reuther in the 1975 catalogue, *Emil Nolde Graphik*, pp. 49–53, which draws on the daily letters that Nolde wrote to his sick wife. The first proof was despatched on 17 October, and the whole series was finished by 26 October. Nolde's own account of the fury with which he worked on the plates is quoted on p. 37. He was rightly delighted with their success and showed them to Liebermann on 30 October. Liebermann was fascinated and promised to get them exhibited in the Secession, saying: 'Now you've come and stood all the established rules of etching on their head'. In early November the edition of ten sets on Japan and sixteen on ordinary paper was printed from steel-faced plates (the surfaces being so fragile) in the presence of Nolde himself, who determined the colour of ink which should be used for each plate. He then sent off thirteen sets on approval to the printrooms of Germany, only to have them all returned within a fortnight, often with rude comments attached (*Mein Leben*, p. 141).

It is clear from Nolde's autobiography that the 'Phantasien' were the prints in his oeuvre that he himself valued most highly, and indeed they show an astonishingly vivid imagination allied with an extraordinary range of tonal effects dependent as much on chance as design. The prints are, however, very little known for the simple reason that they are now excessively scarce.

105a *Young woman*
1906

Etching and tonal effects. Signed and dated *06* in pencil; printer's signature *O. Felsing Berlin gdr.* on left. 198 × 155 mm
Schiefler 22, third state. Printed in blue ink.
1909–8–7–18. Presented by the artist.

With the notable exception of the set of eight 'Phantasien', many of Nolde's earliest etchings are derived more or less closely from paintings. The source of this print, a portrait of his wife Ada, is a painting of 1904 entitled *Spring in a room* which shows her in a similar pose in a room full of flowers. The concentration on the figure at the expense of details is characteristic of the way in which Nolde reinterpreted colour in black and white. The etching is a good specimen of Nolde's unique brush technique which is discussed on p. 37. Other impressions (e.g. that in the Staatliche Graphische Sammlung in Munich) are printed in brown ink.

The print is one of a group of seven etchings acquired by the British Museum in August 1909; three were presented by Campbell Dodgson, the other four by Nolde himself. Unfortunately no further documentation of this remarkable transaction seems to survive. One can only surmise that Dodgson, who had spent some weeks in Germany in June 1909 to attend the Lanna sale, had seen Nolde's work or even met the artist himself, and had persuaded him to present some works to the Museum in return for a purchase of a comparable group. The contact must have continued subsequently, as Dodgson bequeathed to the Museum six later etchings by Nolde, including four of the famous Hamburg series of 1910 (see 110). Dodgson, however, never acquired any woodcut or lithograph by Nolde.

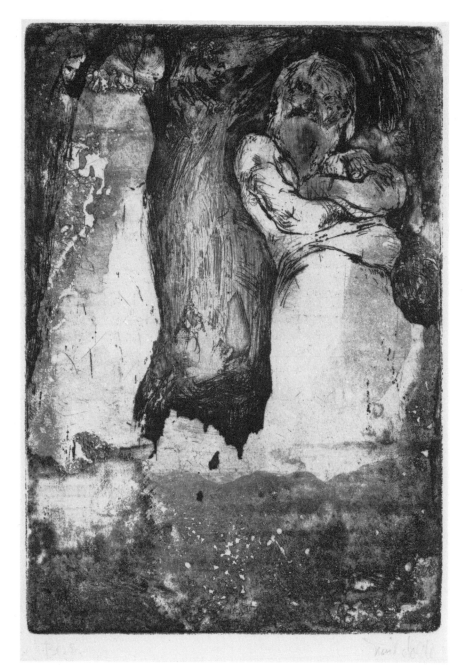

105

106 *Head lit from two sides*
1906

Woodcut. Signed and dated *06* in pencil. Annotated in lower margin with title *Kopf im Doppellicht.* 247 × 224 mm
Schiefler 23, fourth state
1969–1–11–2

Schmidt-Rottluff's letter inviting Nolde to join the Brücke is dated 4 February 1906. Nolde's earliest woodcuts belong to this year, and, according to the

'Chronik der Brücke' written by Kirchner in 1913, it was through the members of the Brücke that he learnt the technique. Since Nolde does not seem to have visited Dresden before early 1907, such instruction must have come through Schmidt-Rottluff, who stayed as Nolde's guest on Alsen in the summer of 1906. Letters published by Urban (*Emil Nolde Graphik*, pp. 19–20) show that Schmidt-Rottluff was involved in ordering a press

for him from Dresden in July of that year. Since Nolde hardly ever printed his own etchings or lithographs, but conversely always printed his woodcuts (see 113), we can safely assume that this press was intended for woodcuts.

The thirty-three woodcuts he made in 1906 fall into two groups: ten form one series of weird and fantastical subjects which were sold together, the rest are almost entirely portrait heads or half-

lengths. While Nolde's interest in facial types comes over strongly, many of the woodcuts are, like this one, as much exercises in the way that form can be defined by areas of white set against unrelieved black. This concern is equally marked in the early work of other Brücke artists.

107 *Kneeling girl*
1907

Drypoint with tonal effects. Signed in pencil and annotated *Kat Nr 76* in bottom margin; printer's signature *O. Felsing gdr* on left.
298 × 223 mm
Schiefler 76, fifth state. Printed in blue ink.
1949–4–11–3967. Bequeathed by Campbell Dodgson Esq.

The burr of the drypoint lines in this impression are very clear. The tone has been produced in the same way as in 105, using a stiff brush through an etching ground to lay bare the plate.

108 *Girl's head*
1907

Drypoint with tonal effects. Signed, dated *07* and annotated in bottom corner *IV 5*; printer's signature *O Felsing Berlin gdr* on left.
304 × 228 mm
Schiefler 77, fourth state
1949–4–11–3968. Bequeathed by Campbell Dodgson Esq.

For this print Nolde chose a brown ink which has the remarkable property of changing its shade from dark, where it is collected in the deep drypoint lines in the hair, to light, in the areas with acid wash tone around the face. This phenomenon is sometimes also found in the late etchings of Whistler.

The numbers written in the bottom left hand corners of the sheets of most of Nolde's prints were annotations added by the artist himself; the state is noted in Roman numerals, and the number of the impression in Arabic. He kept careful records in two small account books of all his prints, noting the number of states, the number of impressions and the current price he was asking (see *Emil Nolde Graphik*, p. 10). These formed the basis for the information contained in Schiefler's catalogue and the additions in Mosel's revision. Unfortunately Nolde's own archive containing, in addition to all his blocks and plates, an impression of every state of every print was destroyed

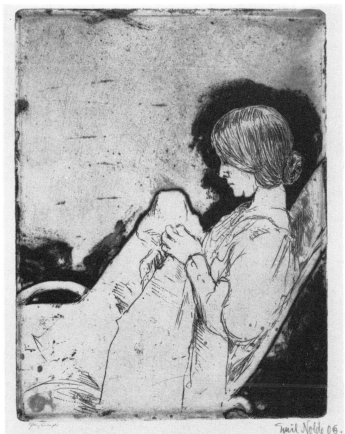

105a

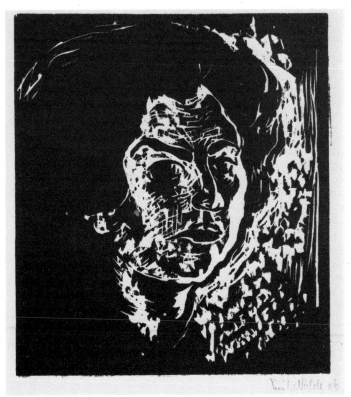

106

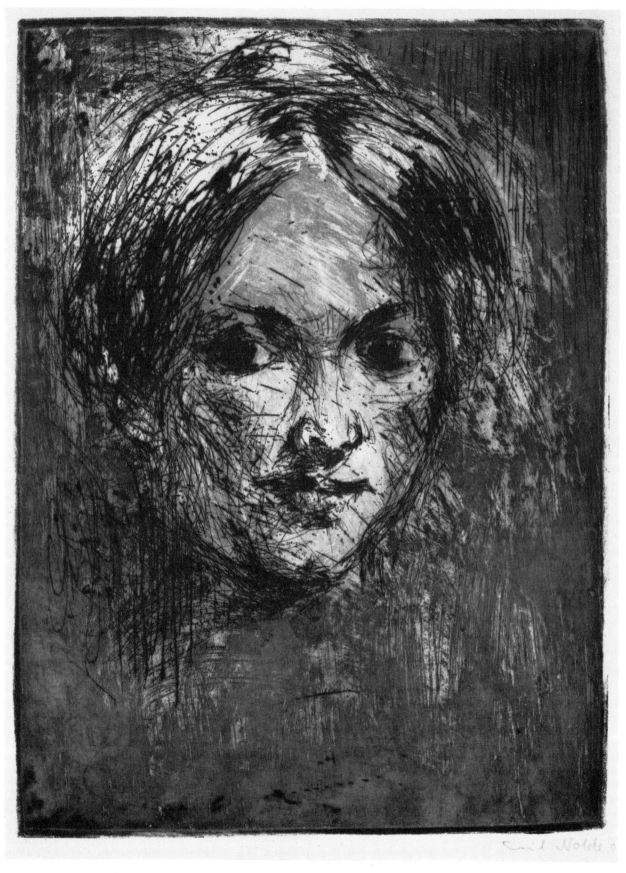

108

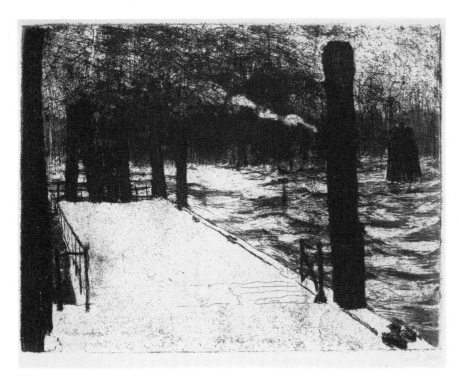

109

110 *The St Petri and St Jacobi churches, Hamburg* 1910

Etching and tonal effects. Signed in pencil, and annotated bottom left *II.13*. 412 × 312 mm
Schiefler 142, second state
1949–4–11–3971. Bequeathed by Campbell Dodgson Esq.

This etching, showing the two green copper-clad spires which are the most prominent landmarks on the east side of Hamburg, belongs to the same series as the previous print. The other two prints of the series which Dodgson bequeathed to the British Museum were *Ship and smoke* (Schiefler 141) and *Hamburg, Reiherstiegdock* (Schiefler 145). The way in which the image is built up of parallel vertical lines is not found elsewhere among Nolde's etchings.

111 *Prophet* 1912

Woodcut. Signed in pencil, and titled in bottom margin *Prophet*. 323 × 220 mm
Schiefler 110, only state
1980–10–11–45

Nolde's earliest paintings of subjects derived from the Bible were painted after he had recovered from a severe illness in the summer of 1909. They reached their peak in the huge nine-panel *Life of Christ*, which he painted in the winter of 1911–12. Although there are a number of etchings of 1910–11 on such themes, there are no woodcuts that can be linked to the group, with the exception of this one. The strong vein of fantasy in the face however links it more closely to the other woodcut heads of 1912 in which facial and racial characteristics are exaggerated almost to the point of caricature. The apparent artless spontaneity and reliance on chance in the cutting of the image are deceptive: according to Urban there are several closely related drawings in brush and black ink which may have preceded it (*Emil Nolde Graphik* p.29).

In the bottom right corner is written in pencil *9,–*; this presumably was the price in Marks when the print was first published in 1912.

by Allied bombing in his Berlin studio on 15 February 1944; since many were unique, they are now only known through Schiefler's written descriptions.

109 *Hamburg, landing-stage* 1910

Etching with stipple and tonal effects. Signed in pencil, and annotated in bottom left corner *III 22*. 311 × 411 mm
Schiefler 139, third state
1949–4–11–3972. Bequeathed by Campbell Dodgson Esq.

On 13 February 1910 a large exhibition of Nolde's work opened at the Galerie Commeter in Hamburg, arranged largely through the good offices of Gustav Schiefler, and hung by Nolde himself. The opening speech was given by Botho Graef, the professor of classical archaeology at the University of Jena, and later one of Kirchner's closest supporters (cf. 79), and, perhaps through his enthusiasm, enough paintings were sold on the opening day to secure Nolde's future for several years ahead. Nolde celebrated by disappearing without trace. Only his wife, who was in Berlin, knew that he was in a cheap sailors' lodging-house on the waterfront of the Hamburg docks. Over the next three weeks he produced, in an extraordinary frenzy of creativity, nineteen etchings (Schiefler 129–47), four woodcuts and a large number of drawings in brush and black ink of the docks and the shipping.

In his autobiography Nolde recalled in typically heightened fashion how he had made the plates: 'I travelled in the boats full of men, working; I sat by the bustling crowd on the landing stages, still working; and in the evening I laid the plates in the devouring acid – three hours was the allotted time. I slept dog tired, flat out on my bed, and then exactly at the right moment woke up to wash the plate in cold water – it was all right. Quarter of an hour more and it would have been eaten away and ruined'. (*Mein Leben*, p.154). Clearly in these circumstances Nolde would have had no proofing press, and it is notable that there are far fewer states of the Hamburg prints than is usual in his work. The early states that he did make were proofed for him by the local Hamburg printer Gente in numbers between two and five. He then reworked the images with extra layers of tone. The main edition was printed by Sabo in Berlin. (See *Emil Nolde Graphik*, pp.11–16.)

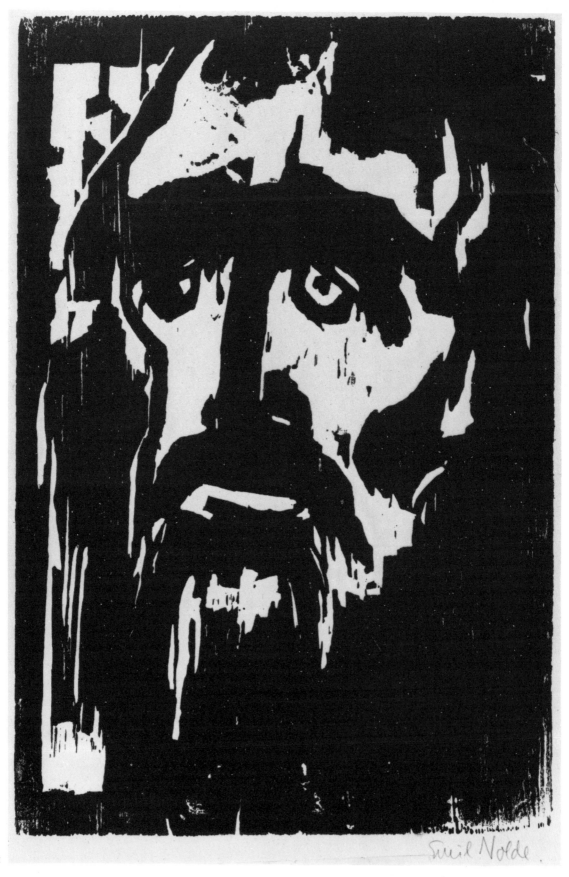

III

112 *Young couple*
1913

Lithograph, printed in three colours: black, red, and fawn. Signed in pencil and annotated *Von 5 Dr. dieser Fassung. Nr 3* and titled in lower margin *Junges Paar*. 615 × 505 mm Schiefler 52, variety C I I I; with stone A (black) in second state, stone B (red) in third state, and stone C (fawn) in first state.
1979-1-27-12

Nolde's first lithographs of 1907 were all drawn on transfer paper. It was only in a group made in 1911 (or perhaps the winter of 1912–13) that he first drew directly on the stone with a brush, prompted apparently to do so by the critical remarks that Schiefler had made in the introduction to his catalogue published in that year (see Schiefler, *Meine Graphiksammlung*, 1974, p. 52). With this limited experience of black and white lithography he suddenly decided in 1913 to take up colour lithography. For eight weeks he worked uninterruptedly in the workshop of Westphalen in Flensburg. The outcome was a series of thirteen prints, all of very large size, printed with between three and five stones in a bewildering variety of combinations of colours. In the autumn of 1913, on his departure for the South Seas, Nolde delivered the pile of over three hundred finished prints for safe-keeping to Schiefler, who then, in a *tour-de-force* of cataloguing, managed to reconstruct the entire printing history of each image; in a footnote to the catalogue of 1927 he explained that he did this in the early months of the First World War to take his mind away from its horrors.

In the case of the *Young Couple*, Schiefler's catalogue extends over four and a half pages. He described each of the four stones used, and the various states (between two and four) that it went through. He then analysed every impression to discover which stones had been used (usually three or four, with the same stone on occasion being printed twice in variant colours), in what state, and with what colour ink. His grand total was 121 impressions and 69 different combinations. This impression is annotated as being one of five of this particular combination; it is therefore the second most common variety, being capped by one other version of which eight were printed.

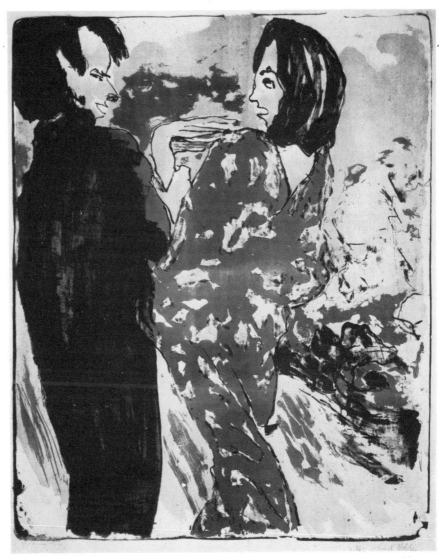

112

113 *Dancers*
1917

Woodcut. Signed in pencil. 238 × 310 mm Schiefler 132, only state. From an edition of 12
1980-3-22-26

We learn from the introduction to Schiefler's catalogue and in a letter written from Berlin on 28 December 1915 (*Briefe*, p. 119) that Nolde and his wife printed all the impressions of his woodcuts, with the exception of a few which were published in large commercial editions and those that were used as book illustrations. This impression demonstrates that it was the care needed to print these images that forced them to

do so. The block is so heavily inked as to print as a solid black in most dark areas. But in the space between the two figures it has been carefully wiped away so as to reveal the grain of the block. In the same way, the block in the area of the two dresses has been left almost completely uninked, so that the design is carried almost entirely by blind-stamping. The very considerable relief imparted to the paper can be clearly seen in a raking light and on the verso of the sheet. A consequence of such careful inking is that no two impressions of the print will be exactly similar, and in fact Nolde seems to have deliberately varied the inking of his impressions to produce a variety of effects. None of the other

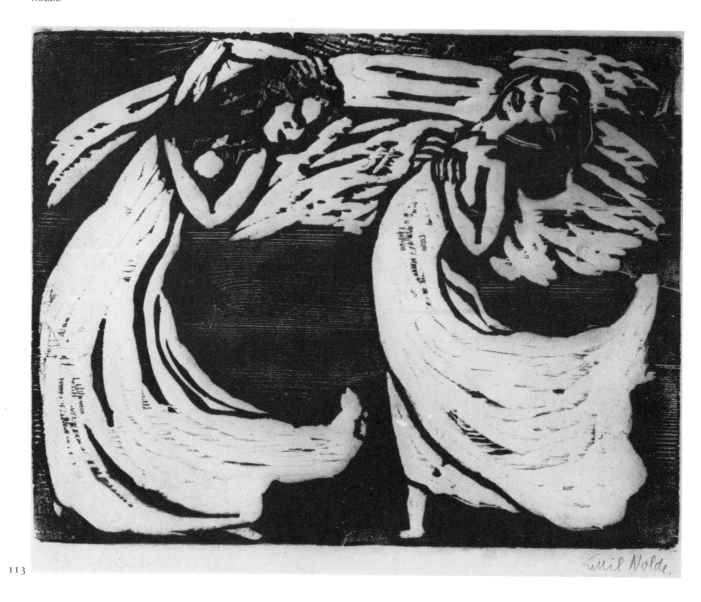

113

Emil Nolde,

printmakers of the Brücke used blind-
stamping in the same way as Nolde, and
indeed it is very rarely found in the
Western woodcut tradition, unlike the
Japanese (in which context it is usually
referred to by the French term
'gaufrage').

There does not seem to be any painting
related to this composition, which clearly
relates in a generalised way to Nolde's
interest in primitive art. Some account of
his collection, which is preserved at
Seebüll, can be found in the exhibition
catalogue, *Emil Nolde, Maske und Figuren*,
Kunsthalle Bielefeld 1971, which
includes reproductions of several
drawings Nolde made after these works.
The fullest available account of the South
Seas journey of 1913–14 is in the
catalogue of an exhibition held by the
Nationalgalerie in East Berlin in 1984.

114 *Vikings*
1922

Etching with tonal effects. Signed in pencil,
and titled in the bottom left margin *Wikinger*.
319 × 245 mm
Schiefler 212, third state. On the verso is
stamped *Museen der hansestadt Lübeck*, with an
inventory number *24/606* in pencil
1980–11–8–1

The twenty-one prints of 1922 were the
last significant etchings made by Nolde.
With the exception of a few landscapes
and portraits, all are compositions with
weird figures engaged in some kind of
activity or conversation. Most show a
curious kind of humour, which, as
Schiefler remarked, 'is only comprehen-
sible to one who possesses the same
sense of humour'. Very few, if any, seem
to bear a close relation with any
painting.

The old stamp of the Lübeck museum
in the verso shows that this is one of the
works which the Nazis forced German
museums to dispose of in 1937 as part of
the campaign against 'entartete Kunst' –
all art that they decided to call
'degenerate'. The Lübeck museum lost a
total of 210 works, according to the
figures published by P.O. Rave
(*Kunstdiktatur im Dritten Reich*, Hamburg
1949, p.91).

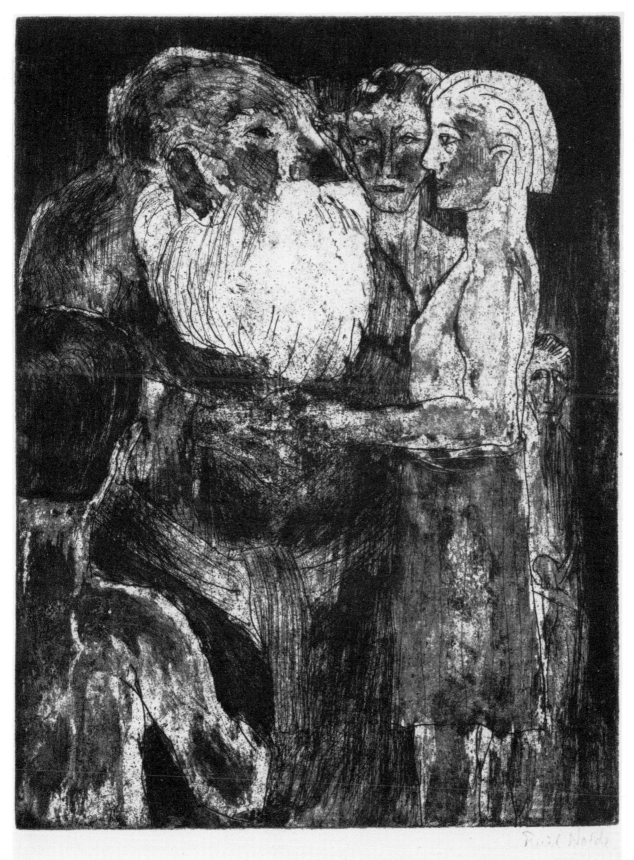

OSKAR KOKOSCHKA
1886–1980

Born in Pöchlarn on the Danube; his father was a Czech goldsmith, his mother from a Styrian peasant family. His childhood was disturbed, as his father moved from town to town looking for work. On the recommendation of a school teacher he was accepted in 1905 as a student at the Vienna Kunstgewerbeschule. His precocious brilliance was recognised by his teachers Berthold Löffler and Carl Otto Czeschka, and while still a student he was entrusted with the direction of several classes, given a number of commissions by the Wiener Werkstätte and allotted his own section at the great Kunstschau in the summer of 1908. His work there caused a great scandal, although it is now lost, with the exception of the illustrated book *Die träumenden Knaben* (see 236). It, however, won him the patronage of the architect Adolph Loos (1870–1933), who secured him a number of portrait commissions in the following years and introduced him to Herwarth Walden. Walden brought him to Berlin, where between May 1910 and January 1911 a number of his drawings were reproduced in *Der Sturm*, of which the most sensational were the illustrations to his own play, *Mörder, Hoffnung der Frauen* (Murderer, Hope of Women). He also was given his first exhibition by Paul Cassirer. In late 1911 after his return to Vienna he began a tempestuous affair with Alma Mahler (the widow of the composer, who had died in May 1911) which formed the subject for much of his work for the next four years.

At the outbreak of the First World War Kokoschka enlisted in the dragoons and was shot in the head and bayoneted in the lung on the Eastern Front; his recovery took many years. In 1917 he moved to Dresden, where he was appointed after the end of the War to a professorship at the Akademie. To this time belongs his construction of a life-size doll to be a perfect female companion. From 1924 to 1931 he travelled around Europe, supported by his now great reputation and a contract with Cassirer (which paid him an annual salary from 1910 to 1931). Financial difficulties forced him to return to Vienna in 1931, which he left again in 1934 after Dollfuss's suppression of the Socialist opposition. He settled happily in Prague, met his future wife Olda, and took Czech nationality, but fled to London in 1938 after the Munich settlement. In 1947 he became a British citizen. In 1953 he moved to Villeneuve on Lake Geneva.

The Wingler-Welz catalogue credits Kokoschka with 567 prints. They divide fairly clearly into two groups: 166 made between 1906 and 1923, and almost all the others after the Second World War. Almost all are lithographs, and almost all of these are transfers. The first prints of 1906–8 were colour lithographs made in the Wiener Werkstätte. The *Sturm* period of 1910–11 is only represented by a pair of posters. The years before the First World War in Vienna produced, in a new drawing style influenced by Ludwig Meidner, the three series in his oeuvre which are now most highly regarded: two are catalogued here, while the third is the set of eight illustrations to Karl Kraus *Die chinesische Mauer* of 1913 (see also 237). It must, however, be observed that the Wingler-Welz catalogue is a doubtful guide to the complexities of the production of Kokoschka's prints, and the problems concerning their originality. Thus it includes the Wiener Werkstätte prints while admitting that they are reproductions of his drawings, while excluding the illustrations in *Der Sturm* because they are reproductions. The larger question of how many of the later lithographs are in fact photolithographs has hardly been raised at all.

Bibliography

The task of sorting out fact from fiction in the early career of Kokoschka has only just begun, in Werner J. Schweiger's publication of the documentation assembled in the birth-place museum at Pöchlarn: *Der junge Kokoschka, Leben und Werk 1904–1914*, Vienna 1983. Anyone who looks at the careful investigation in the exhibition catalogue *Oskar Kokoschka, literary and graphic works 1906–1923* (William Benton Museum of Art, University of Connecticut, Storrs 1977) by Richard S. Field will see how much basic information about dating is still lacking. Kokoschka's own autobiography *Mein Leben*, Munich 1971 (English translation 1974) is a blend of fact and fantasy, and the lives written by admirers, of which the best is Edith Hoffmann, *Kokoschka life and work*, London 1947, do little to unravel the confusion.

The standard catalogue of the paintings is H.M. Wingler, *Oskar Kokoschka, das Werk des Malers*, Salzburg 1956; and of the prints, H.M. Wingler and F. Welz, *Oskar Kokoschka, das druckgraphische Werk*, Salzburg 1975 (supplemented by a second volume for the prints of 1975–80, published in 1981). Ernst Rathenau has published five volumes of reproductions with commentary on his drawings, Berlin 1935, and New York 1961, 1966, 1971 and 1977. The standard edition of the writings, *Oskar Kokoschka, das schriftliche Werk*, is edited by Heinz Spielmann in four volumes published in Hamburg 1973–6. Of these the first is devoted to the *Dichtungen und Dramen*. Spielmann is now preparing a companion edition of the letters in collaboration with the artist's widow.

115 *The road into the grave*
Plate 4 of *Der gefesselte Kolumbus*
1913

Lithograph. Signed and annotated *Columbus Von Zanter [for 'Zander'], bütten probe* in pencil.
280 × 288 mm
Wingler-Welz 46
1967-10-14-23. Presented by Lord Croft.

The text of *The fettered Columbus* was written by Kokoschka himself, and is virtually identical with an earlier work by him entitled *Der weisse Tiertöter* (The white slayer of animals) written in 1908–9; it was envisaged as a sort of sequel to *Die träumenden Knaben* and

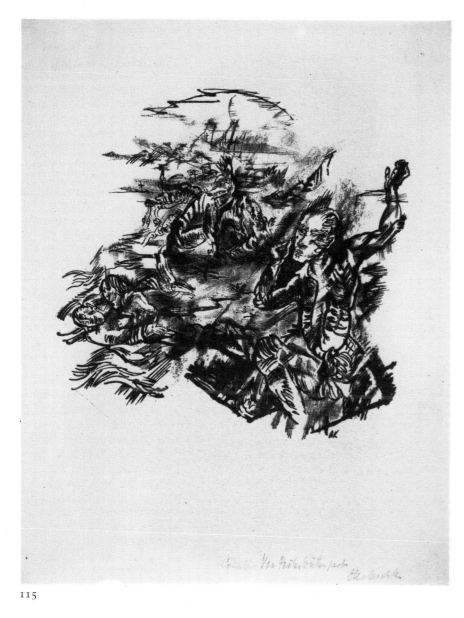

115

Franz Werfel, with whom she emigrated to America in 1940; she died in New York in 1964.

According to the standard reference works the set of twelve illustrations was drawn by Kokoschka in 1913 on transfer paper (although only published in 1916). Neither of these statements seems to be documented and both are open to doubt. The drawings could be later, while the prints might be photolithographs rather than transfer lithographs. Four of the original drawings for the series were sold at Ketterer in Munich in 1979 (auction 36 lots 954, 956–8; all formerly in the National Gallery in Prague, whence presumably looted). They correspond exactly to the published illustrations.

The prints were first published by the Fritz Gurlitt Verlag in a portfolio without text in 1916 in two editions, the first of fifty on Japan, the second of one hundred and fifty on laid paper (Zanders Bütten, as in this trial proof). A second edition in 1921 included the text as well. The British Museum possesses two proofs from the series (the other being of Wingler-Welz 51). Both prints were included in the exhibition held at the British Museum in 1967, *Kokoschka, Word and Vision*, on loan from Lord Croft. After its close, he generously presented them, with a number of other works by Kokoschka, to the Museum. Lord Croft was one of Kokoschka's first (and few) patrons in Britain after he fled here in 1938 with little more than a suitcase, an unfinished painting and £10.

Kokoschka made a few illustrations to it in 1909 in the same manner as in that work. The change of name came at the same time as he made a new sequence of twelve illustrations (of which this print is one) which all bear the strong impress of the affair with Alma Mahler. In an interview in 1966 Kokoschka admitted that the images were autobiographical: 'Columbus Bound is me again, of course, and in this sense the title is symbolic – bound by a woman, whose features I have depicted on the title page. My Columbus ventures out not to discover America but to recognise a woman who binds him in chains. At the end she appears to him as a love-ghost, moon woman.' (See the 1966 Arts Council Kokoschka exhibition catalogue, pp. 12–13.) In this print Kokoschka seems to be both the man stepping into the grave in the foreground, and possibly one of the pair of lovers in the middle distance on the left. An account of the affair is given in Alma Mahler's autobiography entitled *And the bridge is love*, New York 1958. She states that the series began with a film about Columbus that they had seen together in Munich in 1912. Alma Mahler's succession of lovers was extraordinary; after the affair with Kokoschka she married first Walter Gropius, the director of the Bauhaus, and in 1929 the Viennese poet and novelist

116 *Self-portrait with brush* Frontispiece to 'O Ewigkeit – du Donnerwort' 1914

Lithograph. 456 × 305 mm
Wingler-Welz 58
1942–10–10–25(1). Presented by Mr Erich Goeritz.

The series consists of eleven prints, a self-portrait as frontispiece, a title-vignette and nine illustrations to the text of J.S. Bach's Cantata 60 (of 1723), 'O Eternity, thou word of thunder'. The text consists of a dialogue between Hope and Fear, serving as a meditation on Revelations XIV, verse 13, and the plates show two figures, clearly recognisable as

Kokoschka himself and Alma Mahler taking the parts of Fear and Hope respectively. In an interview Kokoschka stated that 'it was the text rather than the score of the Bach cantata which gave me my starting point. The text suggested a certain train of thought which I then pursued quite subjectively and independently and expressed in the pictures. Certainly it's hope and fear that I'm depicting, but this wasn't thought out and laid down beforehand' (1966 Arts Council, Kokoschka catalogue, p. 13).

The prints were first published in a portfolio in 1916 (or 1917). A second edition in 1918 came out both as a portfolio, and as a bound book with the text included. It is this latter variation which is catalogued here, open at the frontispiece. It bears the number 44 of the total edition of 125, and is signed by the artist. The Wingler-Welz catalogue suggests, without giving reasons, that the 1916–17 edition was printed from transferred drawings, whereas the 1918 edition consists of photolithographs. Without a copy of the earlier edition to hand no comment is possible on the first assertion, but the second seems to be very likely to be correct.

In the case of this *Self-portrait*, the original drawing has been published (in Rathenau 1, 1935, pl. 71: we have not seen a copy of this book) and is in reverse to the print, so that the artist's monogram is the wrong way round. The reversal of the design in the book could only have been done by photomechanical means. Since there is no difference in quality between this plate and the others in the book, it follows that they are almost certainly photolithographs as well.

This portrait is very similar to a painting (Wingler 102) which is dated 24 December 1914. It would tend to support the traditional dating of the drawings in 1914.

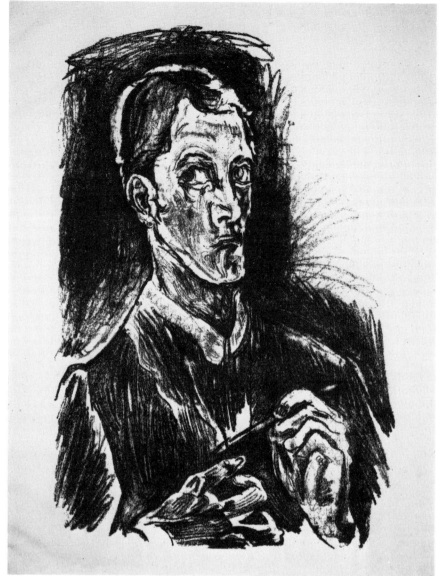

116

FRANZ MARC
1880–1916

Born in Munich, he first studied philosophy and theology at the University but changed to painting in 1900, when he enrolled as a pupil at the Munich Akademie. Two visits to Paris and Brittany in 1903 and to Paris again in 1907 exposed him to the work of Gauguin and van Gogh. During a severe bout of depression in 1907 after the death of his father Marc began seriously to explore the notion of a pantheistic rhythm between animals and nature, as suggested by his oil study for a tapestry, *Orpheus and the Animals* (Lenbachhaus, Munich). In the same year he made daily visits to the zoo in Berlin for several weeks, then returned to Munich, where he gave lessons in animal anatomy in order to earn money. His animal sculptures date from 1908; after his first one-man exhibition at the Brackl Gallery in Munich, Marc's reputation in this genre, already popular in Munich, was established, and he was included in Reinhard Piper's publication *Das Tier in der Kunst (The Animal in Art)*, Munich 1910. Marc's decisive encounter with Kandinsky, whose painting and theories of colour were to exert such a powerful influence upon him, occurred in 1910 after the opening in December 1909 of the first Neue Künstlervereinigung München exhibition at the Thannhauser Gallery. In January 1910 he met August Macke, his closest friend and correspondent, who introduced him to the collector Bernhard Koehler. Koehler immediately bought Marc's work and by the summer of 1910 had become his main financial support. Another important experience for Marc in 1910 was his first contact with Matisse's paintings when they were exhibited in Munich. At the beginning of 1911 he joined the Neue Künstlervereinigung until

December, when Kandinsky, Marc, Gabriele Münter and Kubin, formed a breakaway splinter group in order to prepare the 'exhibition of the editors of *Der Blaue Reiter*'. During this period he finally rejected the human figure entirely in favour of the animal, principally the horse, and his correspondence with Macke dwells upon the concept of the regeneration of art through a return to the primitive world. The first *Blauer Reiter* (the name expressed Kandinsky and Marc's common interests) exhibition opened on 18 December 1912 at the Thannhauser Gallery and included paintings by the composer Arnold Schönberg and Robert Delaunay among others. The second exhibition in February 1912 at the Hans Goltz Gallery was limited to prints, drawings and watercolours, for which Marc brought a large selection of work from Berlin by Nolde, Kirchner and Heckel. In May 1912 followed the publication of the almanac (cf. 239) containing Marc's important statements 'Spiritual Treasures' and 'The German Fauves'. His work in 1912 became more overtly Futurist in style, reflecting the influence of the Futurist exhibition he saw at the Sturm Gallery in Berlin. He made an important contribution to Herwarth Walden's *Erster Deutscher Herbstsalon* in 1913, which included his major painting, *Fate of the Animals*. The apocalyptic imagery of *Fate of the Animals* captured the spirit of the pre-War period in Germany. Marc was initially elated by his call-up in 1914, but his mood changed after the death of August Macke in action in September 1914; by late March 1915 he was completely appalled by his experiences: his *Letters and Sketchbook from a Battlefield* form one of the most significant records of active service during the First World War. He was killed at Verdun on 4 March 1916.

Marc's achievement as a painter and watercolourist surpasses his efforts as a printmaker. He had

already produced some small scale decorative designs of animal motifs for a book on handicraft design in 1908 (cf. 238) before he met Kandinsky; however, it was the latter who provided the real impetus for Marc's work in a graphic medium, at the time of their collaboration over the illustrations to *Der Blaue Reiter*. Marc described how the woodcut technique helped him to clarify his own artistic style. Of the forty-six known prints by him a number were first printed in *Der Sturm*, but others were only published after his death.

Bibliography

The three basic works on Marc have been written by Klaus Lankheit. *Franz Marc, Katalog der Werke*, Cologne 1970, is complemented by the collection of his writings, *Franz Marc Schriften*, Cologne 1978. *Franz Marc, sein Leben und seine Kunst*, Cologne 1976, is a general introduction. Also of use is the catalogue of the large exhibition held in 1980 in the Lenbachhaus in Munich. Frederick S. Levine, *The apocalyptic vision, the art of Franz Marc as German Expressionism*, New York 1979, is the only monograph in English.

117 *Schöpfungsgeschichte I* (Creation I)
1914

Woodcut on Japanese paper. Signed on the verso by Maria Marc (the artist's widow).
289 × 199 mm
Lankheit 842, second state. Published in the third Bauhaus portfolio.
1942-10-10-31(9). Presented by Mr Erich Goeritz.

118 *Schöpfungsgeschichte II* (Creation II)
1914

Woodcut printed in three colours, black, green and yellow. Annotated in pencil *gedr. F. Voigt*.
237 × 200 mm
Lankheit 843, fifth state
1982-11-6-8

Creation I and II, together with two slightly earlier woodcuts, *Birth of the Horses*, printed in four colours, and *Birth of the Wolves*, printed in black and white (Lankheit 840, 841) represent the first

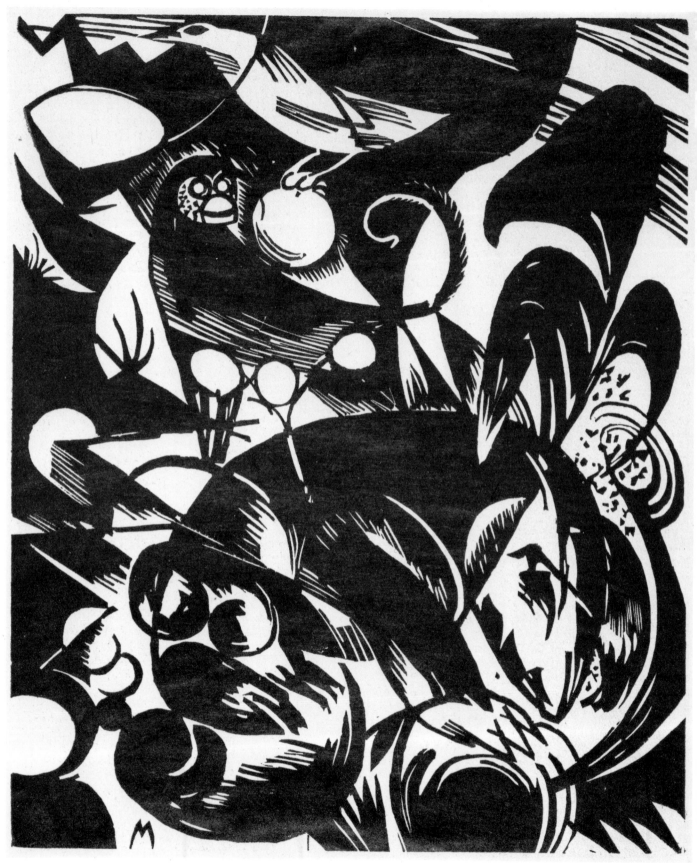

117

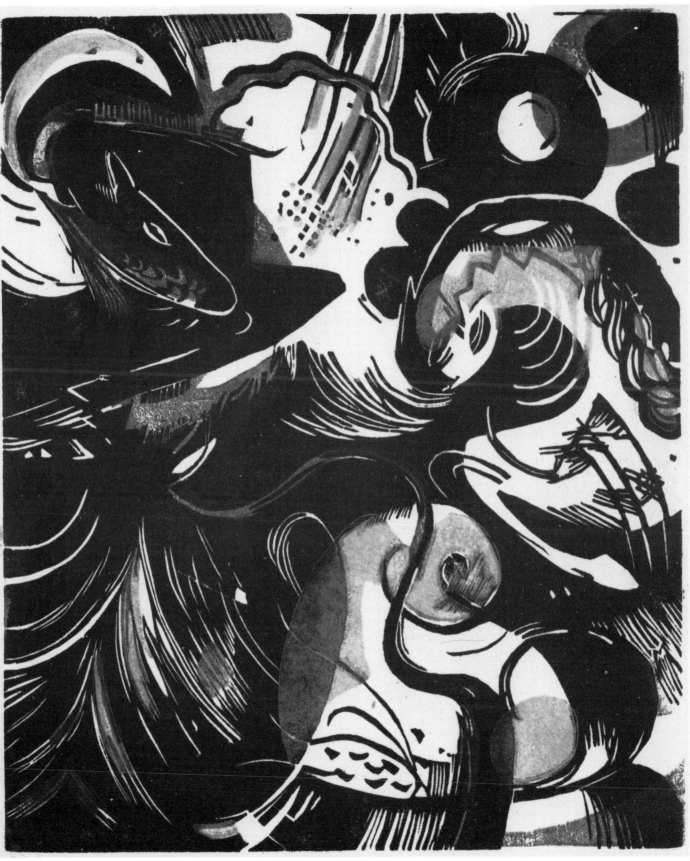

stage of a project for a series of illustrations to the different books of the Bible. Marc outlined the scheme in a letter to Alfred Kubin of March 1913 (quoted in Lankheit, 1976, p. 151): 'Would you like to illustrate something from the Bible? Large format, very sumptuous; collaborators: Kandinsky, Klee, Heckel, Kokoschka and myself. Each according to his choice. They will appear in separate issues. Kandinsky takes the Apocalypse, I the first book of Moses . . . we've already found a means of publishing it! What do you think of it? I tremble with joy, as the idea really begins to take shape.' Reinhard Piper was supposed to publish it in separate numbers and then as a complete Bible, but the War intervened, forcing Marc to abandon the project. On the back of the original woodblock for *Creation I* was a stamp acknowledging receipt and the signature of the artist's widow, Maria Marc, who made it available to the Bauhaus, and who signed each impression on the verso.

For further bibliographical details about the third Bauhaus portfolio see 191 and introduction p. 25.

AUGUST MACKE
1883–1914

Born in Meschede in Sauerland. He studied in Düsseldorf at the Akademie and Kunstgewerbeschule between 1904 and 1905, and under Lovis Corinth in Berlin from 1907 to 1908. From 1905 he travelled extensively in Western Europe; in 1907 through his fiancée Elizabeth Gerhardt, he met her uncle, Bernhard Koehler, the Berlin manufacturer who became an important patron for all *Der Blaue Reiter* artists. Koehler accompanied Macke on his second visit to Paris in 1908 when the latter first came into contact with the paintings of Cézanne at Ambrose Vollard's gallery. In 1910 Macke moved to Tegernsee near Munich, where he met Franz Marc, with whom he joined the Neue Künstler-vereinigung and then *Der Blaue Reiter*. He returned to live in Bonn in 1911. From 1911 to 1914 he exhibited extensively in Munich, Cologne, Dresden, the Sturm Gallery in Berlin, and Moscow; his use of colour betrayed the powerful influence of the School of Paris, a characteristic which was enhanced by his exposure to Matisse's painting in 1910 and confirmed by his pilgrimage, together with Marc and Klee, to visit Delaunay in Paris in 1912. In 1913 he participated in the Bonn exhibition entitled *Die rheinischen Expressionisten*. In 1914 he visited Tunis with Paul Klee, producing a series of vivid watercolours. He was killed in action on 26 September 1914.

Macke's most distinguished work belongs to the period 1912–14, when he had synthesised the French influences on his formal construction and use of colour with *Der Blaue Reiter*'s Expressionist style. As with so many of his colleagues among the Munich *avant-garde* his creativity was not confined to the fine arts; he designed wall-hangings, carpets, tapestries, and embroideries which were often executed by Elizabeth Macke, and wood-carvings, pottery and glass-paintings which he made himself. Printmaking occupied a very minor position among all these activities; his complete oeuvre apparently contains only two lino-cuts: 119 and *Drei Akte* (Three nudes) of 1913, and one woodcut made in 1907.

Bibliography

The basic monograph is Gustav Vriesen, *August Macke*, Stuttgart 1953 (enlarged edition 1957), which includes a catalogue of the paintings and watercolours. More recent studies are in the catalogue of the 1976 Münster exhibition of his watercolours and drawings, and in the 1979 Bonn exhibition *Die rheinischen Expressionisten*. Source material is published by Elizabeth Erdmann-Macke, *Erinnerung an August Macke*, Stuttgart 1962, and in the *August Macke – Franz Marc Briefwechsel*, edited by Wolfgang Macke, Cologne 1964. Dominik Bartmann, *August Macke Kunsthandwerk*, Berlin 1979, provides an interesting visual survey of his work in the decorative arts.

119 *Begrüssung* (Greeting) 1912

Lino-cut. Annotated in pencil on verso *Begrüssung . Bestätigt Elizabeth Macke*. 245 × 195 mm
Published in the third Bauhaus portfolio 1942–10–10–30(8). Presented by Mr Erich Goeritz.

The print was originally published in *Der Sturm* (III Jg., p. 221) in 1912. The artist's widow subsequently made the block available to the Bauhaus printing workshop for another edition in the third Bauhaus portfolio in 1921.

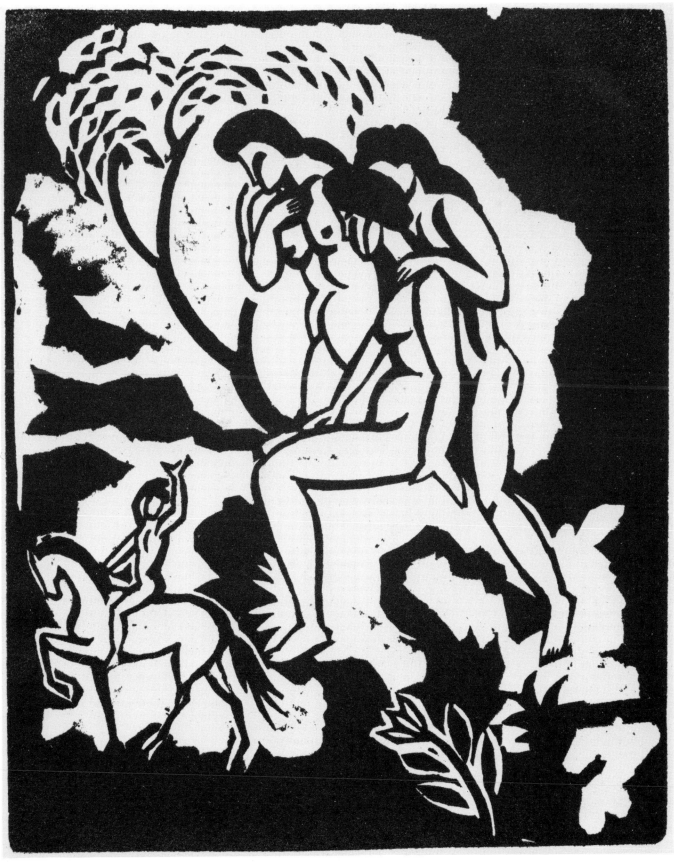

119

VASILY KANDINSKY
1866–1944

Born in Moscow, he entered university to study law and economics, cultivating an interest in fine art as a hobby. After completing his legal studies in 1895, he briefly joined a printing firm in Moscow as art director, then rejected the offer of a professorship in Estonia in order to study painting in Munich in 1896. The choice of Munich was decisive for the subsequent development of Kandinsky's interest in the whole range of art forms; in 1930 he recalled: 'Everyone painted – or wrote poems, or made music, or took up dancing – in every house one found at least two ateliers under the roof...' In 1900 Kandinsky transferred from Anton Ažbé's art school at Schwabing to the Munich Akademie to study under Franz von Stuck, the president of the Munich Secession. In 1901–4 Kandinsky founded and organised Phalanx, an exhibiting society with its own art school which became a forum for the arts and crafts movement. The ninth Phalanx show, early in 1904, included three woodcuts by Kandinsky and ten colour drawings, many of which were translated into woodcut compositions and exhibited at the eleventh Phalanx show, which was devoted entirely to graphic art. In 1904 he published the portfolio of woodcuts 'Gedichte ohne Worte' (Poems without Words) anticipating 'Klänge' (Harmonies) of 1913 and demonstrating the mixture of Jugendstil and Symbolist influences which helped to shape his style.

Between 1903 and 1909 Kandinsky established his reputation internationally, exhibiting in Paris, Moscow, Berlin, Dresden, Warsaw, Vienna and elsewhere. During this period he moved further and further towards abstraction, using colour in his paintings as the main vehicle for the communication of his synaesthetic theory of art, which achieved its most notable expression in his treatise 'Über das Geistige in der Kunst' (On the Spiritual in Art), completed in 1910 and published in 1912. In 1909 he founded his second artistic society, the Neue Künstlervereinigung, through which he met Franz Marc, with whom he founded the group *Der Blaue Reiter*, in 1911. He spent the years from 1916 to 1921 in Russia, where he played a key role in post-Revolutionary cultural reorganisation as a teacher, administrator and museum curator. The impact of Constructivism on his own style was quite apparent when he returned to Germany and joined Paul Klee at the Bauhaus in 1922. There he developed the basic design course, in addition to directing the mural-painting workshop. He retained his central interest in the psychology of colour, which was now expressed by geometric forms of a wholly abstract nature. Although painting became an increasingly marginal aspect of the Bauhaus programme from 1923 onwards, Kandinsky remained an important influence. He survived the internal political changes until the final closure of the Bauhaus in 1933, when he moved to Paris, eventually becoming a French citizen in 1939.

Kandinsky's printmaking, most notably in the medium of woodcut, played a more integrated role within the context of his many artistic activities than was the case with almost any other comparable figure. He was initially influenced by the international style of black and white woodcut illustration deriving from William Nicholson and Felix Vallotton, the tradition of East European popular illustration and Munich's own considerable graphic tradition. Between 1902 and 1904 Kandinsky completed nearly fifty woodcuts and his prints had begun to receive critical acclaim. Compositions executed in one medium were often translated into another. The woodcuts imposed a degree of simplification which forced the artist to analyse carefully the essential elements of his design, and played a vital role in the development of his style, serving as the link between ornament and abstraction (cf. Weiss 1979, chapter XII).

After the publication of 'Klänge' in 1913 Kandinsky's involvement with the woodcut diminished. From 1913 to 1916 his most notable achievement as a printmaker was an impressive group of drypoints (see 122). The Bauhaus published his most important work of the early 1920s, including the portfolio, 'Kleine Welten' (see 123 and 124). Once the Bauhaus had moved to Dessau the printing workshop became wholly absorbed in typography and Kandinsky's subsequent work had to be printed elsewhere. Otto Ralfs, a Braunschweig merchant, founded the Kandinsky Society in 1925, a companion to the one he had formed for Klee a year earlier, for whose members both artists created small editions of prints until the early thirties. During the last period of his life in Paris Kandinsky's printed output dwindled to a mere six images.

Bibliography

His important theoretical writings on art have now been collected and translated in two volumes by Kenneth Lindsay and Peter Vergo: *Kandinsky: Complete Writings on Art*, Boston and London, 1982. Kandinsky's book in the Bauhaus series, *Punkt und Linie zu Fläche*, Dessau 1926, had been previously translated as *Point and Line to Plane* in 1926 (reprint New York 1979).

The secondary literature is vast. The standard introduction is H.K. Roethel and J.K. Benjamin, *Kandinsky*, Oxford 1979. Peg Weiss, *Kandinsky in Munich, The Formative Jugendstil Years*, Princeton 1979, is a good study of a vital period in Kandinsky's career. The exhibition and permanent collection catalogues from the two major public holdings of his work, the Lenbachhaus in Munich and

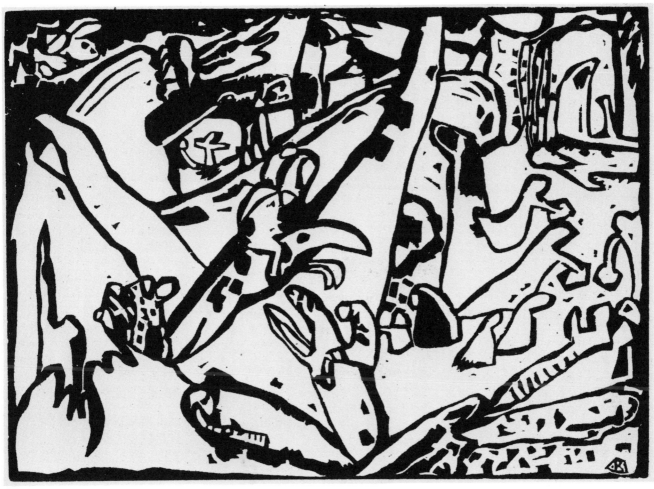

121

the Guggenheim Museum in New York are also important: the most recent Guggenheim catalogues are *Kandinsky in Munich*, 1982, and *Kandinsky: Russian and Bauhaus Years 1915–1933*, 1984.

The prints are fully described in H.K. Roethel's monumental catalogue *Kandinsky: Das graphische Werk*, Cologne 1970, which is abridged in his exhibition catalogue for the Guggenheim, *The Graphic Work of Kandinsky*, International Exhibitions Foundation, 1974–5. The paintings have been catalogued by H.K. Roethel and J.K. Benjamin in 2 volumes: I 1900–15 (London 1982), II 1916–44 (London 1984).

120 *The Mirror*
1907

Lino-cut printed in five colours from two blocks on Japan paper. 320 × 158 mm
Roethel 49; only state
1983-7-23-24
See colour illustration

The date of 1907 was originally agreed with Kandinsky by W. Grohmann when preparing a preliminary list of the artist's graphic work in 1933. Roethel accepts it on stylistic grounds but, as he makes plain in the introduction to his catalogue, there are problems surrounding any attempt to establish the chronology of the early woodcuts in the absence of dates on the prints themselves or accurate records made by Kandinsky. Stylistically *The Mirror* is closely related to other woodcuts dated by Roethel in 1903. Most of Kandinsky's early colour

woodcuts, like this one, were printed from only two blocks, either of wood or of linoleum. The colour block was inked with watercolour pigments applied (probably) through a stencil in five colours; the line block was printed in black. The watercolour pigment often created particularly subtle, evanescent effects that prompted one reviewer of Kandinsky's woodcuts in the eleventh Phalanx exhibition of 1904, to comment that his 'light-blooming colours in all gradations . . . recall Whistler in fineness of tone' (Weiss, 1979, p. 71). *The Mirror*, however, has a mosaic, jewel-like quality in the application of the colour, which characterises several of Kandinsky's compositions of 1903–7. Wilhelm Michel, who reviewed Kandinsky's graphic work in *Deutsche Kunst und Dekoration* in 1905, saw this aspect in the context of Kandinsky revealing his Russian heritage 'in the

stylisation and adventurous, almost stained glass quality of colour in his prints' (Weiss, 1979, p. 77). The subject of this print is reminiscent of the figure in *The Night* (Roethel 6) and recalls Kandinsky's interest in popular fairy tales; its style, however, is not specifically Russian but shows more generalised Central European Jugendstil influences.

121 *Composition II*
1911

Woodcut. 148 × 208 mm
Roethel 97. Proof before publication in 'Klänge', Munich, 1913, p. 11 (cf. 240).
1980-6-28-25

This impression is a proof of one of the illustrations of 'Klänge'. The chronology of the twelve colour and forty-four black and white woodcuts contained in the book is difficult to determine, and for this reason Roethel dates them all in 1911 or 1912 with the exception of four made in 1907. Kandinsky intended them to show the development of his work from the figurative to the abstract, a development which was also to be found in the poems themselves (cf. Roethel, 1970, p. 448; his appendix 9 contains a full account of the publication). Some of the designs were exhibited between 1910 and 1912 in Paris, Munich, London and Berlin; in Berlin six woodcuts for the album were included in the fifth exhibition of the Neue Secession, where fifty Marks were asked for the one coloured image and twenty Marks for the black and white prints. 'Klänge' was of great importance to Kandinsky, who regarded its role in his work as decisive. Reinhard Piper, his publisher, was initially sceptical of the venture and demanded that Kandinsky guarantee half the costs of publication.

This impression of *Composition II* was one of five proofs for 'Klänge', formerly in the collection of Sir Michael Sadleir, which were auctioned at Sotheby's in 1980 (16/17 May, lots 525–9). They were purchased by him at the Salon of the Allied Artists' Association at the Royal Albert Hall in 1911, to which they had been submitted via the shippers Chenil and Co. Ltd of the King's Road (the original labels were on the back of the frame). The catalogue listed them as 'Six Woodcuts and Album with text £1',

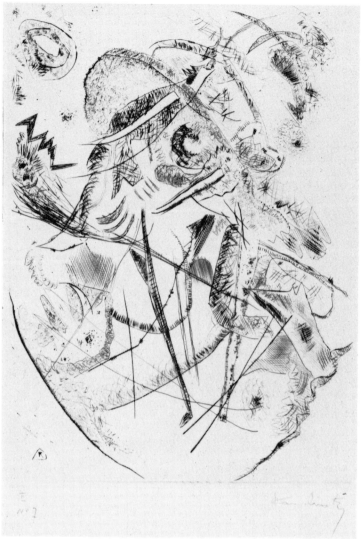

122

although only five prints were in fact received. Michael Sadler (1861–1943) was a distinguished academic and educationalist whose varied interests in primitive art and post-Impressionism were reflected in his private collection, which impressed the young Henry Moore when Sadleir was Vice-Chancellor of Leeds University from 1911 to 1923. Sadleir had a particular interest in the Prussian educational system prior to the First World War; it was, no doubt, this involvement with German culture, combined with his general didactic and artistic inclinations which prompted the translation he undertook of Kandinsky's 'Über das Geistige in der Kunst' (1913) which was published as 'The Art of Spiritual Harmony' in 1914.

122 *Etching II*
1913–14

Drypoint. Signed in pencil lower right and inscribed lower left *'II/No. 7'*. 241 × 179 mm
Roethel 148. From the edition of 7.
1983-1-27-4

Kandinsky executed six drypoint compositions which Roethel assigns to the years 1913–14 on the basis of their affinity with paintings of the same date. Each one exists in only seven impressions and they were presumably executed in Munich prior to the artist's departure for Switzerland in 1914. A second series of drypoints appeared in 1916; these were printed in editions of ten in Stockholm, where Kandinsky spent the winter of 1915–16.

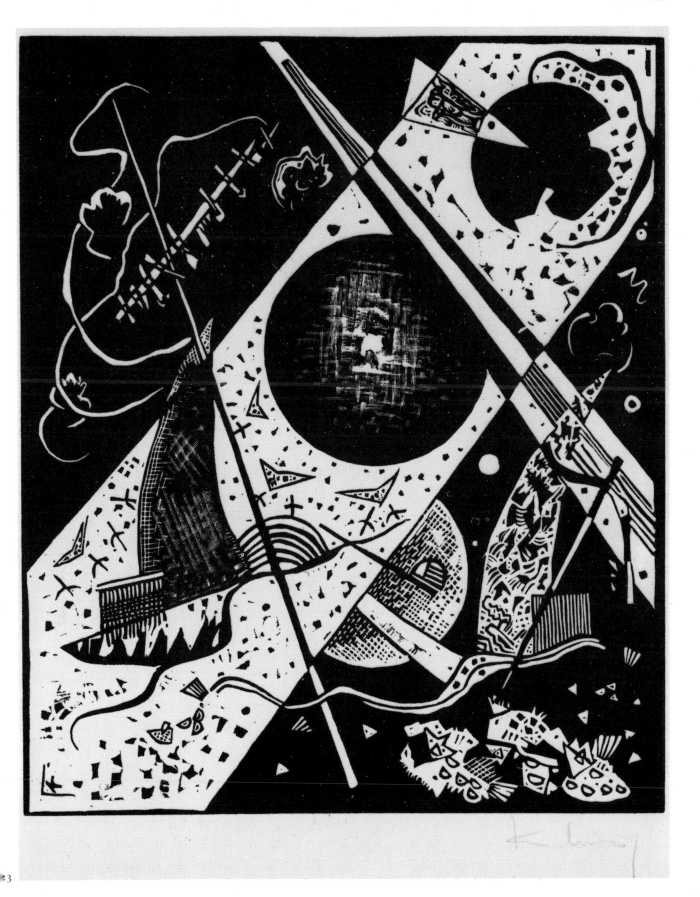

123 *Kleine Welten* VI
(Small Worlds VI)
1922

Woodcut. Signed in pencil lower right.
273 × 233 mm
Roethel 169. Published in the 'Kleine Welten'
portfolio, 1922
1984–7–14–15

'Kleine Welten' was one of the most
important productions of the Bauhaus
printing workshop, and undoubtedly
Kandinsky's most significant statement
as a printmaker during the second half of
his career. It was issued as a publication
of the Propyläen Press in Berlin in a total
edition of 230. It contained twelve prints:
four drypoints, two black and white
woodcuts and a further two in colour
(which were described as woodcuts but
were actually printed from lithographic
stones to which they had been transferred
from woodcut impressions), together
with four straightforward colour
lithographs. Stylistically the twelve
compositions document Kandinsky's
development during the previous decade,
from his 'abstract Impressionism' of
1912–13 to the greater geometric
precision of his Bauhaus period, while
the three techniques employed illustrate
the theoretical discussion in *Punkt und
Linie zu Fläche*, 1926, which attributes
specific characteristics, both formal and
sociological, to the different media of
intaglio, woodcut and lithography.
(Christian Geelhaar in 'The Graphic
Legacy of Paul Klee', Bard College 1983,
pp. 49–62, provides a good synopsis of
Kandinsky's argument.)

 In a preface written in Weimar in
1923 to the published edition, Kandinsky
described how the main body of his
material for *Punkt und Linie* had been
assembled during his brief sojourn on
Lake Constance at the beginning of the
First World War, but then remained
untouched for nearly ten years. His
analytical course at the Bauhaus created
the opportunity to refine his ideas which
must be understood as having a wider
application to his own work than just to
the period when the book was published.
Composition is described thus: 'the action
of the force on the given material brings
life into the material, which expresses
itself in tensions. The tensions, for their
part, permit the inner nature of the

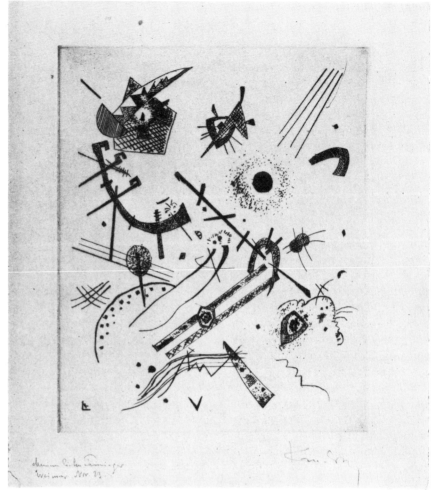

124

element to be expressed'. It is within this
context that the techniques of woodcut,
etching and lithography are categorised;
the woodcut is the most planar of the
three, etching the most linear, whereas
lithography with 'its particular speed in
creation, combined with an almost
indestructible hardness of the block,
completely suits the spirit of our time'.

124 *Kleine Welten* XI
(Small Worlds XI)
1922

Drypoint. Signed in pencil and inscribed
bottom left *Meinem lieben Feininger Weimar
Nov. 23*. 239 × 207 mm
Roethel 174. A proof apart from the edition
published in 'Kleine Welten'.
1984–2–25–1

This proof was dedicated to Feininger,
who was the Master in charge of the
printing workshop at the time that the
portfolio was printed.

LUDWIG MEIDNER
1884–1966

Born in Bernstadt in Silesia. Originally intended by his parents to enter the building trade, he got himself into the Kunstschule in Breslau in 1903. In 1905 he moved to Berlin and worked as a fashion illustrator, until a relative gave him enough money to spend a year in Paris in 1906–7; there he studied at the Académies Julian and Cormon and met Modigliani. The next five years in Berlin he himself described as a 'blind alley'. The few surviving paintings are in a style influenced by Marquet and the Fauves. It was only in 1912 that he suddenly found his own style, almost certainly after seeing the Futurist exhibition in the Sturm Gallery in April. With two other fellow countrymen from Silesia, Richard Janthur (1883–1956) and Jakob Steinhardt (1884–1968) he founded the group Die Pathetiker, which held an exhibition in the Sturm Gallery in October. The style of their paintings derived from the crazy perspectives of Robert Delaunay and the Futurists, but what was startling were the apocalyptic subjects, dominated by earthquakes, burning cities, floods and revolutions. This was something new in painting, but is closely paralleled in contemporary Expressionist poetry. According to Groschowiak, Meidner knew Jakob van Hoddis (1887–1942), the author of 'Weltende', published in 1911, and Alfred Lichtenstein (1889–1914), whose 'Die Dämmerung' also came out in 1911; he also painted portraits of two other minor contemporary poets, Alfred Mombert (1872–1942) and Max Herrmann-Neisse (1886–1941). Moreover, during his service in the army between 1916 and 1918 Meidner himself composed two prose poems, 'Im Nacken das Sternenmeer' and 'Septemberschrei', which were published in 1918 and 1920 respectively (see 257).

After the end of the War he seems to have been fairly successful for a time, and was supported by Paul Cassirer and J.B. Neumann, but his style and subject-matter began to look increasingly dated. In 1935 he moved to Cologne, and in 1938, being a Jew, fled to England with his wife, whom he had married in 1927. But he never managed to re-establish himself as an artist in London, and in 1952 returned to Germany, and died in Darmstadt fourteen years later; his widow remained in London until her death in 1977.

No catalogue or study of Meidner's prints has ever been written, nor is it easy to find the material on which to base judgements, but it seems that he only made drypoints or, in later years, etchings. The earliest drypoints seem to have been made in 1913 and the best (as with the paintings) belong to the two years before the First World War. His production increased enormously after the War, and he must have made several hundreds of etchings in the early 1920s. Prints by him from the 1930s or later are rarely seen.

Bibliography

The earliest monograph on Meidner by Lothar Brieger, published in Leipzig in 1919, retains its importance because it contains a three-page autobiography by the artist. This is reprinted by Diether Schmidt in the two-volume collection he edited of *Schriften deutscher Künstler des zwanzigsten Jahrhunderts* (1905–45), Dresden 1963–4, along with others of Meidner's many tracts and essays, including his 1914 'Anleitung zum Malen von Grossstadtbildern'. Thomas Groschowiak, *Ludwig Meidner*, Recklinghausen 1966, is the only modern monograph; it is well illustrated, but contains no catalogue or list of paintings and is less informative than might be wished. J.P. Hodin has published a volume, *Ludwig Meidner, seine Kunst, seine Persönlichkeit, seine Zeit*, Darmstadt 1973, which records a number of conversations with Meidner, and has also edited the reminiscences of his widow, *Aus den Erinnerungen von Else Meidner*, Darmstadt 1979.

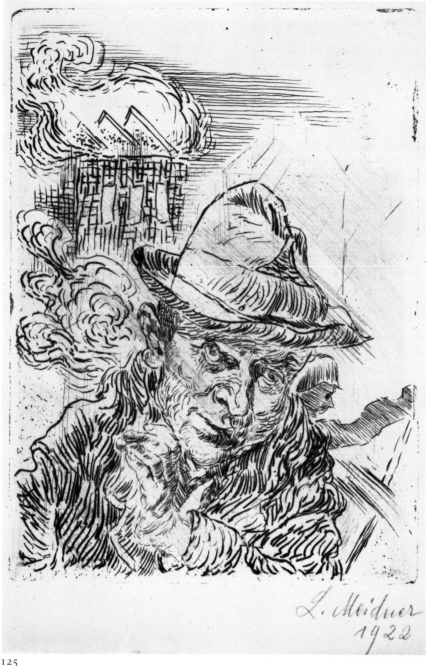

125

125 *Self-portrait*
1922

Etching. Signed and dated *1922* in pencil.
175 × 130 mm
1969–11–1–11. Presented by Lord Croft.

Among Meidner's numerous portraits is a very large number of self-portraits, made throughout his career.

In George Grosz's autobiography is an account of Meidner in Berlin: 'Another interesting character in my portrait gallery of this period was Ludwig Meidner, the painter. He was a strange little spirit who came to life only at night . . . He was like a character out of a short story by E.T.A. Hoffmann. Meidner lived in a hole of a garret, dark as a cave . . . Right next to the door as one entered was an old iron, pot-bellied stove. Beside it was a high mound covered neatly with newspapers and cardboard. The mound was concealed in semi-obscurity because the sole source of illumination in the cave came from a single gas jet suspended from the ceiling. The other jet did not function. Everything lay in semi-darkness and the room had a fantastic, ghostlike, gloomy effect. Upon closer inspection, the mysterious mound revealed itself to be a heap of ashes and slag. It had been years since any of this refuse had been removed and carried down the five flights of stairs. It was just piled into a corner until it eventually formed a curious landscape. Whenever Meidner gesticulated, which he did frequently and passionately, or when he raised his sharp, shrill bass voice in argument, the paper and cardboard would flutter and a cloud of dust would rise from the hill and swirl around the smoke-filled room. The dust would settle in our hair, make our eyes tear and tickle our noses until we were forced to sneeze. This violent disturbance would agitate the dust some more, and the cycle would continue. We called this rain of ashes "The Destruction of Pompeii".' (*A Little Yes and a Big No*, 1946, p.212: this passage was not reprinted in the German edition).

MAX BECKMANN
1884–1950

Born in Leipzig, the youngest of three children of a flour merchant. After his father's death in 1894 the family moved to Braunschweig, where Beckmann was educated. Between 1900 and 1903 he was a student in the Kunstakademie in Weimar, and after graduating spent five months in Paris before settling in Berlin. His painting *Young man by the sea*, exhibited at Weimar in 1906, won him the Villa Romana prize; he therefore spent the winter of 1906–7 in Florence with his wife Minna Tube, whom he married in September. In the following years Beckmann rapidly established a considerable reputation as one of the most promising talents of the Berlin Secession with a number of large paintings on themes such as the *Battle of the Amazons* and *The Sinking of the Titanic*, all extremely accomplished works in a late Impressionist manner.

The experience of the First World War, in which Beckmann volunteered as a medical orderly, radically changed the direction of his work. After a nervous breakdown in 1915, he was given leave to go to Frankfurt where he was to remain for eighteen years. His wife was meanwhile pursuing her own career as an opera-singer in Graz. The principal works of the early Frankfurt years are drypoints and drawings; the number of paintings only becomes significant again after 1919. Beckmann's style in the War years is often called Expressionist, while the paintings of the early 1920s are frequently regarded as examples of the Neue Sachlichkeit. But no label can comprehend adequately the original blend of the real and the visionary to create a dense and impenetrable personal language which is the hallmark of all his later work.

In 1925 he divorced his first wife and married Mathilde ('Quappi') von Kaulbach, and was given a teaching appointment in the art school attached to the Städel Kunstinstitut. From 1929 he began to spend each winter in Paris. After the Nazi seizure of power in 1933, he moved to Berlin before his dismissal from the Städel. To this time belongs *Departure*, the first of the nine great triptychs on which he worked in his later years. The day after hearing Hitler's speech at the opening of the Haus der deutschen Kunst in Munich in July 1937, he emigrated to Holland, intending at first to settle in Paris, but later, after the outbreak of war, to go to America. This plan was frustrated by the German invasion of Holland, and he spent the war years in Amsterdam. He only left for the United States in 1947, where he taught in several art schools, mainly in St Louis and New York – the third time he had had to reconstruct his professional career.

Beckmann made some 370 prints. The earliest were some lithographs made between 1909 and 1912. Then he turned to drypoint, to which transfer lithography was added in 1919. The quantity of Beckmann's production increased enormously in the years immediately after the First World War, and almost one third of his entire output was made in 1922–3. After 1923 he abandoned printmaking almost completely; the only significant later works are two series of lithographs made in the 1940s. For his illustrated books, see 243–5.

Bibliography

The literature on Beckmann is huge. To begin with, there is a large number of editions of the artist's own writings and of reminiscences about him by his family and friends. The most important for the period covered in this catalogue is the edition of his *Briefe im Kriege* by Minna Tube, Berlin 1916 (reprinted Munich 1955). The basic works of modern scholarship are the two-volume *Katalog der Gemälde* by Erhard and Barbara Göpel, Bern 1976 (with a huge bibliography), and, for the drawings, Stephan von Wiese, *Max Beckmanns zeichnerisches Werk 1903–25*, Düsseldorf 1978. The catalogue of the prints which has been prepared by James Hofmaier is still unpublished; for this reason references are also given here to the obsolete listing in the exhibition catalogue, *Max Beckmann die Druckgraphik* by Klaus Gallwitz (Karlsruhe Kunstverein 1962).

A good introduction is Friedhelm W. Fischer, *Der Maler Max Beckmann*, Cologne 1972 (English translation 1973). The same author's study of Beckmann's symbolism, *Max Beckmann, Symbol und Weltbild*, Munich 1972, is highly regarded. The past few years have seen the publication of a clutch of excellent exhibition catalogues: the Bielefeld/Frankfurt *Max Beckmann, die frühen Bilder* of 1982–3 was followed by the Berlin Kupferstichkabinett, *Max Beckmann, Die Hölle* in 1983 (by Alexander Dückers). The centenary of Beckmann's birth has been marked in 1984 by two large (and many smaller) exhibitions: *Max Beckmann, Frankfurt 1915–1933* held in the Städel Kunstinstitut in Frankfurt, and the huge *Max Beckmann Retrospektive* in Munich, Berlin, St Louis and Los Angeles. Both catalogues include numerous introductory essays; the second also has a biography and full bibliography. (At the time of writing the English language edition of the latter had not been published.)

126 *Hell*
1911

Lithograph. Signed in pencil. 322 × 270 mm Hofmaier 24; Gallwitz 13. On Japan paper. 1981-7-25-43. From the collection of Reinhard Piper.

Beckmann's first prints are almost all lithographs; it was only in 1912 that he abruptly turned to drypoint, virtually abandoning lithography until 1919. Most of the early lithographs are transfers. This print is unusual in that it is drawn directly on the stone and the composition is extended up to the very edge, so that the irregular contour prints

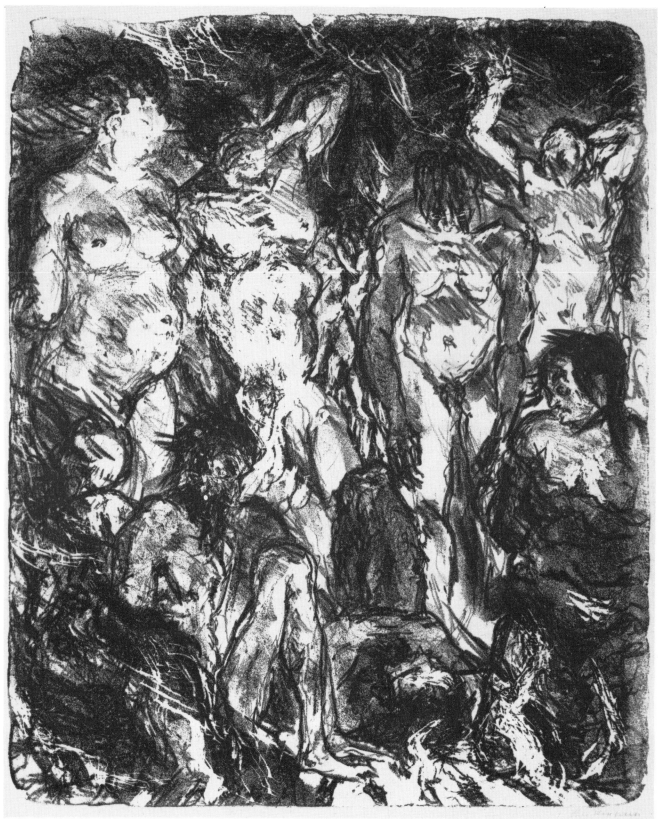

126

clearly. The only printmakers regularly using this device were the members of the Brücke, which suggests that Beckmann was looking at their work attentively even at this early date.

Although the title is the same as that of Beckmann's series of 1919 (149), the connection is purely accidental as there is no link between them. 'Hell' here is purely a place of torment, and no allegorical or extended meaning is intended. The 1911 print is one of a large number of works on biblical themes made between 1908 and 1912; some are prints (such as the series of 'Six lithographs on the New Testament' of 1911), others are paintings (among them, a *Crucifixion*, a *Resurrection* and *Pentecost*). The fashion for such large-scale reworkings of biblical themes seems to have been introduced to German painting by Klinger, and was embraced by Corinth, who exercised a great influence on Beckmann's early style, as can clearly be seen in this print. Religious subjects surface again in Beckmann's work in the years 1916–18.

This and various other prints by Beckmann catalogued here were purchased at the sale of the collection of Reinhard Piper held in Munich (Karl & Faber) on 29 June 1981; all have his collector's mark on the verso. Piper (1879–1953) founded his own publishing house in Munich in 1904. He first met Beckmann in 1912, when he bought his painting *Samson and Delilah*. He also commissioned various works from him, and this marked the beginning of a collaboration which was second in importance only to that with J.B. Neumann (131). Piper bought all his prints directly from Beckmann and amassed a collection of great importance and quality. A number of his letters from his correspondence with Beckmann have been published (*Reinhard Piper, Briefwechsel mit Autoren und Künstlern 1903–53* edited by U. Buergel-Goodwin and W. Göbel, Munich 1979) and others survive in the Piper archives. See also the collected edition of his memoirs *Mein Leben als Verleger*, Munich 1964.

127 *Drunken cripple*
1914

Drypoint. Titled *Der besoffene Einarm (2 Zustand)* and signed and dated *14* in pencil.
269 × 210 mm
Hofmaier 66, third state; Gallwitz 46
1981–7–25–44. From the collection of Reinhard Piper.

This is one of the small group of some ten drypoints made between Beckmann's taking up the medium in 1912 and the outbreak of the First World War in August 1914. Although clearly different to the later prints, they are evidence that his style was already fast changing before the War began. The low subjects from the street or the brothel are unthinkable in his early prints of 1909 or 1911, and look forward to the post-War works. It seems that it was the pressure of the new subject-matter and the new linear style he was creating for it that led him to reject lithography, which he only knew as a tonal graphic medium. His first experiments in intaglio were in etching, but after a few attempts (Gallwitz 40–43) he gave this up for good and turned to drypoint, which provided everything he wanted in directness of record of his lines and a relatively straightforward possibility of making corrections.

128–48 'Gesichter' (Faces)
1919

In 1919 Reinhard Piper published a portfolio containing nineteen drypoints by Beckmann, made over the five years of the War from 1914 to 1918. The plates had not been made with the portfolio in mind; it contained simply a selection made by Beckmann and Meier-Graefe (so Sarah O'Brien-Twohig in the 1984 Munich/Berlin Retrospective, p.103, note 69, referring to an unpublished letter in the Piper archive) from those still in the artist's possession, after several other plates (such as 130–1) had been creamed off and individually published in the previous years by J.B. Neumann and Paul Cassirer in Berlin. It seems therefore unlikely that there can be any particular significance in the order of the plates. In the exhibition the series is shown complete in the order of publication; in this catalogue, however, they are listed in chronological order of creation (which means that the sequence is interrupted

by several independent plates) in order to reveal more clearly the stylistic development.

The prints were published in a handsome portfolio accompanied by a booklet of sixteen pages; the typography and layout were in the hands of E.R. Weiss. The plates were printed by Franz Hanfstaengel in Munich and the text by W. Drugulin in Leipzig. The portfolio was published in an edition of a hundred by the Marées-Gesellschaft; the first forty were printed on Japan paper before the plates were steel-faced, while the remaining sixty were on ordinary laid paper after steel-facing. This set is number XVI of those on Japan and bears the name of the subscriber Alfred Weiske. Comparison with sets of the ordinary edition shows that the steel-facing leads to surprisingly little loss of quality in the image, but that the rough texture of the laid paper produces an unfortunate mottling, which is completely avoided by the smooth Japan paper.

In the accompanying booklet is printed an essay by Julius Meier-Graefe (1867–1935), the outstanding critic of modern art of the time and the founder of the Marées-Gesellschaft (see Kenworth Moffett, *Meier-Graefe as art critic*, Munich 1973, pp.121–3). Meier-Graefe was one of Beckmann's most constant supporters, as he had earlier helped Munch (69). In 1903 when Beckmann was only nineteen, he had raised 3000 Marks to send him to Paris, and later bought a number of important paintings. Meier-Graefe was also closely associated with Piper, who was responsible for publishing the productions of the Marées-Gesellschaft. The first publication of the society had been Meier-Graefe's own monograph on Hans van Marées (1837–87), the artist whom he wished to set up as representing the alternative tradition in German art to the dead-end he saw represented by Arnold Böcklin (1827–1901). 'Gesichter' came out as the society's thirteenth publication, and each sheet bears in the bottom right-hand corner its blind-stamp taken from a drawing by von Marées of Ganymed being borne off by the eagle.

The titles given to the plates in the booklet occasionally differ from those written on the prints themselves. Since the series includes a landscape, it is at first sight surprising that it was given the

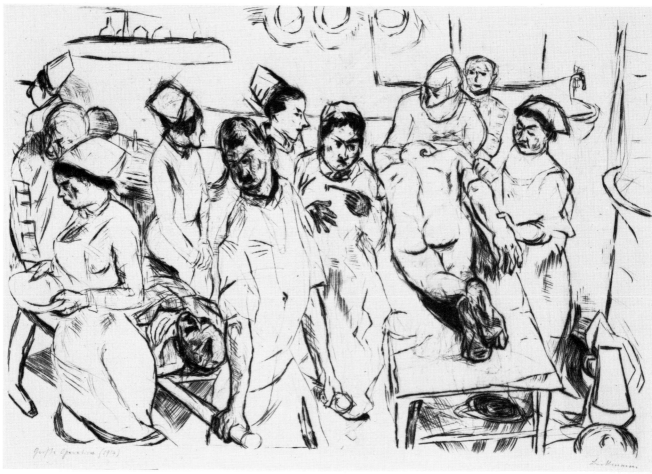

128

title 'Gesichter', and in fact Beckmann had at an earlier point intended to call the series 'Welttheater' (Theatre of the World), but changed it at Meier-Graefe's suggestion (see von Wiese, 1978, p. 113). But it points to the central feature of the prints: all are strongly autobiographical in character, and are dominated by Beckmann himself, his family and friends, on whom he relied for support in a world that he regarded as unpredictable and hostile.

128 PLATE 18 *Operation (large plate)* 1914

Drypoint. Titled *Grosse Operation (1914)* and signed in pencil. 298 × 434 mm
Hofmaier 78, sixth state; Gallwitz 55
1982–7–24–27(18)

The plate is connected with another half the size (Hofmaier 79) entitled *Kleine Operation*, which had been published by Paul Cassirer. Since the operations in both plates seem to be equally serious, the adjectives must refer to the size of the plate.

This is the earliest of the plates in 'Gesichter', and the only one that directly refers to Beckmann's war service as a medical orderly in an operating theatre in Courtrai. He described this fully in his letters to his wife, published under the title *Briefe im Kriege*. The tone of the first of these (as one would expect) is factual and reasonably cheerful, matching the character of near-reportage in this print. But after he was sent into the front-line trenches he wrote: 'I suffer with every shot and have the wildest visions. My plans for plates that I want to make swell like a victory in Galicia' (p. 60). In fact, the only print he made with such a visionary and fearful quality is *The Grenade* (130). There are indeed barely ten plates in all which actually record scenes from Beckmann's time with the army.

129 PLATE 15 *Two officers of the motor corps* 1915

Drypoint. Titled *2 Autooffiziere (15)* and signed in pencil. 113 × 177 mm
Hofmaier 82, only state; Gallwitz 60
1982–7–24–27(15)

130 *The grenade* Not part of 'Gesichter' 1915

Drypoint. Inscribed *Handprobedruck 1. Zustand* and signed in pencil. 431 × 287 mm
Hofmaier 83, second state; Gallwitz 62
1982–7–24–14

130a

Another impression. Inscribed *Granate (3. Zustand)* and signed and dated *16* in pencil. In bottom margin annotated *Einziger Druck der noch in meinem Besitz. 120M.* 435 × 288 mm
Hofmaier 83, third state
1981-7-25-45. From the collection of Reinhard Piper.

This is the most remarkable print related to Beckmann's wartime experiences in the gas attacks at Ypres. He had considerable difficulty with the composition and five states of the plate are known. In the first three the plate is 435 mm high, and the states are distinguished by additional drypoint work. In the fourth state (illustrated in the catalogue *Neuerwerbungen 1982* of the Staatliche Graphische Sammlung, Munich, no. 82), the top 55 mm of the plate were cut off; a remark in the hand of Reinhard Piper in the margin of our impression of the third state, 'Platte später oben abgeschnitten' refers to this. In the fifth state the standing soldier in the right foreground was taken out of the plate and the leg of the rushing man behind him extended to fill the gap. This final state was published in an edition of twenty. Beckmann's inscription on our impression of the second state, identifying it as an impression of the first state, is incorrect, as is the dating 1916 on the impression of the third state. Another impression of the third state (illustrated in the 1983 Berlin *Die Hölle*, no. 39) is annotated *1 Zustand*, while a third (in Frankfurt, no. 228 in the 1984 Munich/Berlin catalogue) is annotated *2 Zustand*. These inaccuracies might be explained by the fact that Beckmann added the inscriptions after March 1917, the date on which he deliberately changed the 'Latin' form of his signature (seen in 126) for a new form in so-called 'deutsche Schrift' (see von Wiese, 1978, p. 110 and note 293).

Von Wiese (1978, pp. 96–8) gives a lengthy analysis of the composition of this print. He compares two drawings of 1914 by Ludwig Meidner, who greatly influenced Beckmann at this period; but a more unexpected source is in Bernard von Orley's 1521 *Job altar*, which Beckmann must have seen in the museum at Brussels. This also shows figures falling out and away from the centre of the composition, driven by fear of a collapsing roof, as the figures here flee from the poison gas.

This and the following print did not form part of 'Gesichter', since they had been previously separately published by other publishers. Paul Cassirer, the publisher of this plate, was the greatest Berlin dealer in modern paintings of the day, and the driving force behind the Berlin Secession (cf. introduction p. 16). He seems to have published all the Beckmann plates that he handled in numbered editions of twenty; Neumann preferred fifty and presumably lower prices, while the edition size of the much obscurer Karl Lang is unknown. Neither Neumann, Lang nor Piper ever had editions numbered.

131 *Society*
Not part of 'Gesichter'
1915

Drypoint. Signed in pencil. 263 × 320 mm
Hofmaier 84, fourth state; Gallwitz 63. From the edition of 50.
1982-7-24-16

In late May 1915 Beckmann suffered a nervous breakdown; nothing is known of his whereabouts for the next three months. In September he was in Strasbourg making medical drawings at an institute of hygiene. It was not until October that a friendly doctor had him released from service. Instead of returning to his wife and son in Berlin, he went to Frankfurt where he was put up by his old friend from the days at art school in Weimar, Ugi Battenberg (1879–1957) and his wife Fridel (1880–1965). Ugi, who had stopped painting, handed over his studio on the top floor above their flat to Beckmann, who used it until his departure from Frankfurt in 1933. Their portraits frequently recur in Beckmann's work of the following years (e.g. 134), with those of other friends and relations. This print shows an evening at their home. The participants have been identified as (left to right) their maid Klara, Major von Braunbehrens, Fridel Battenburg, Lili von Braunbehrens, Ugi Battenburg and Wanda von Braunbehrens (see the 1984 Munich/Berlin catalogue no. 229). Major von Braunbehrens was responsible for getting Beckmann discharged from military service in 1917; the book of poems *Stadtnacht* written by Lili, his daughter (see 245) was later illustrated by Beckmann.

This print was published by Israel Ber Neumann (1887–1961), who from

131

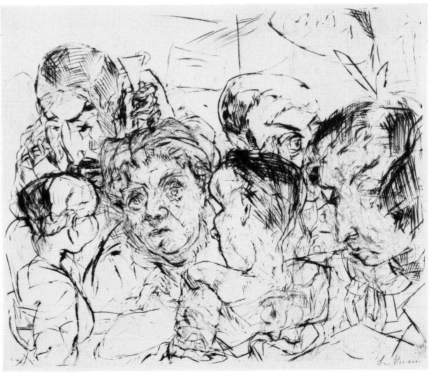

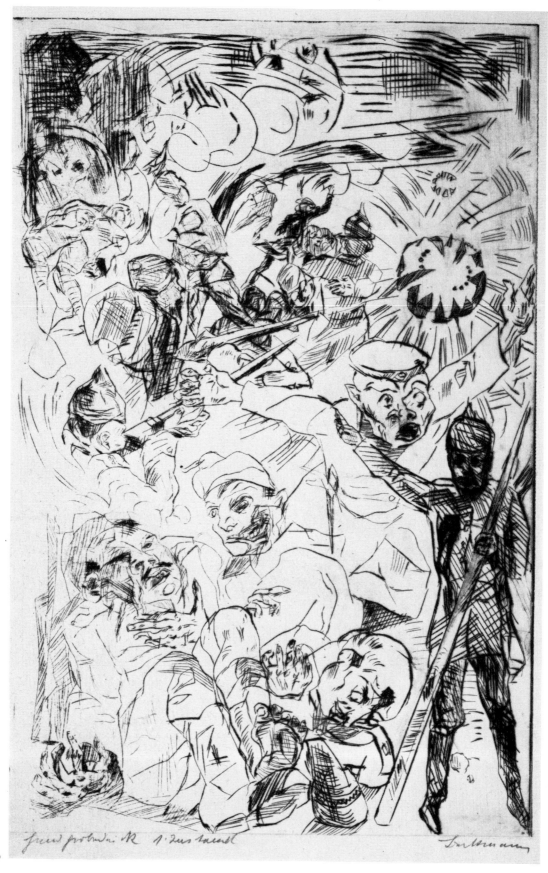

Freud problen(?) Nr. 1. Zustand Beckmann

130a

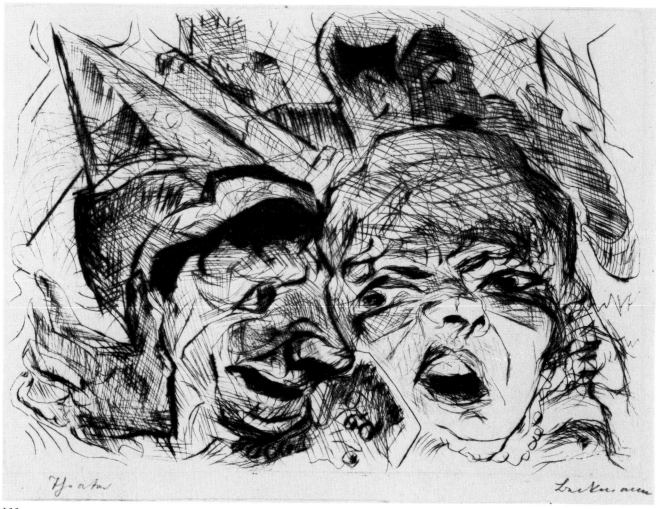

133

1920 was Beckmann's sole dealer, selling his paintings against a monthly salary. He had previously published many of his early lithographs, and later commissioned 'Die Hölle' and 'Berliner Reise'. Viennese by origin, he went to Berlin in 1911. In 1923 he emigrated to New York, where he remained active as a dealer until his death, giving Beckmann his first American showing in 1926. The letters Beckmann wrote to him between 1920 and 1939 (published in the 1984 Frankfurt catalogue, pp. 265–89) show how highly he valued him as one of the very few who really understood his painting. He turns up with Fridel Battenburg in the painting of 1920, *Fastnacht*, now in the Tate Gallery.

132 PLATE 4 *Lovers* 1916

Drypoint. Titled *Liebespaar I (16)* and signed in pencil. 224 × 294 mm
Hofmaier 86, third state; Gallwitz 65
1982–7–24–27(4)

The plate has such a mass of erasures and reworkings that it is difficult to decipher. Three different positions of the left leg of the man are visible. Such pentimenti are particularly common in the drypoints of the early War years. Beckmann seems to have liked leaving such traces visible in the plate so as to create an agitated surface from which the figures emerge. The erasures prove that Beckmann regularly composed directly onto the plate, and this is

confirmed by the almost complete absence of preparatory drawings for the prints. One of the rare exceptions to this pattern is 139; the few prints after paintings are a separate case.

133 PLATE 8 *Theatre* 1916

Drypoint. Titled *Theater* and signed in pencil. 129 × 173 mm
Hofmaier 87, third state; Gallwitz 66
1982–7–24–27(8)

This must be a scene from amateur theatricals. The man in the background must be Ugi Battenberg, while Fridel is recognisable in the right foreground. The third figure (possibly Beckmann himself) wears a mask. In the Munich/Berlin

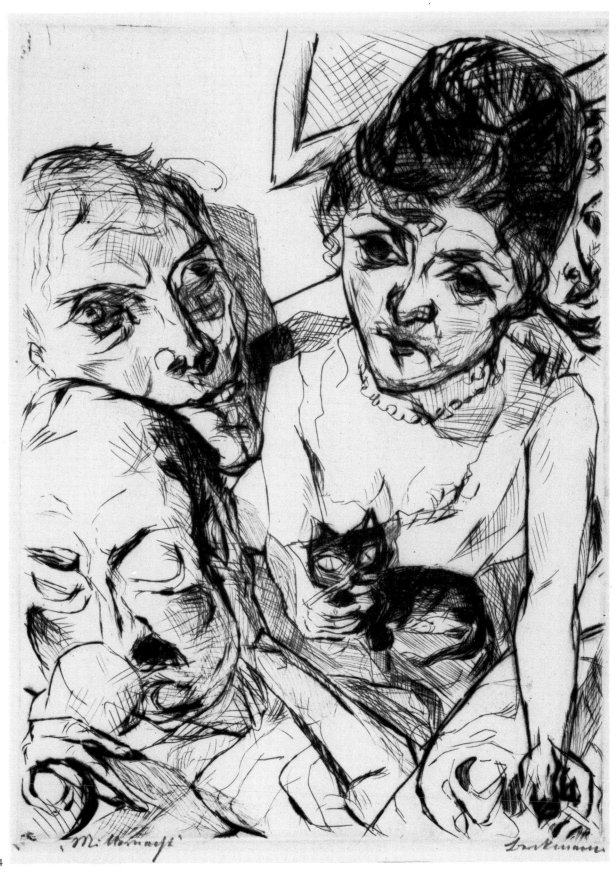

„Mitternacht" Beckmann

catalogue of 1984 the protagonists are identified as taking the parts of Rigoletto and his daughter Gilda (from Verdi's opera), but no evidence or reason for this assertion is given. In the list of contents this print is given the title *Mitternacht* (midnight).

134 PLATE 10 *Midnight*
1916

Drypoint. Titled *Mitternacht* and signed in pencil. 238 × 177 mm
Hofmaier 88, third state; Gallwitz 67
1982-7-24-27(10)

A self-portrait with the Battenbergs: Fridel has her favourite cat (seen in many other prints and paintings), while Ugi is immediately recognisable from his thick moustache and bald head. Although the print bears the autograph title *Mitternacht* (midnight), it is listed in the contents sheet of 'Gesichter' as *Der Abend* (the evening). It is also often known as the *Self-portrait with the Battenbergs*.

135 PLATE 1 *Self-portrait*
1917

Drypoint. Titled *Selbstporträt 1917* and signed in pencil. 296 × 236 mm
Hofmaier 103, third state; Gallwitz 82
1982-7-24-27(1)

The cycle 'Gesichter' opens with this self-portrait, in which Beckmann is holding a drypoint needle, and closes with another self-portrait (148). Other self-portraits open (and occasionally close) his other major sets of prints ('Die Hölle', 'Der Jahrmarkt' and 'Berliner Reise'); and there are also large numbers of individual self-portraits and plates in which Beckmann's features are to be found. Only Kollwitz among the other artists in this exhibition made such a sequence.

136 PLATE 17 *Happy New Year*
1917

Drypoint. Titled *Prosit Neujahr 1917* and signed in pencil. 237 × 296 mm
Hofmaier 106, seventh state; Gallwitz 86
1982-7-24-17(17)

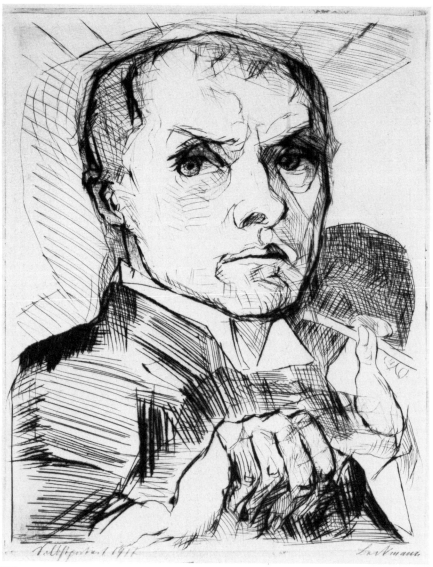

135

137 PLATE 5 *Brothel scene*
1918

Drypoint. Titled *Liebespaar (18)* and signed in pencil. 215 × 256 mm
Hofmaier 124, second state; Gallwitz 97
1982-7-24-27(5)

The plate bears the same title as the *Lovers* of 1916 (132). The stylistic advance over the two-year period is remarkable.

138 PLATE 2 *Family scene*
1918

Drypoint. Titled *Familienszene* and signed in pencil. 302 × 260 mm
Hofmaier 125, second state; Gallwitz 98
1982-7-24-27(2)

The participants are Beckmann's wife Minna, with their ten-year-old son Peter, her mother, Frau Tube (1843–1922), and Beckmann himself in the background. Beckmann clearly had a close rapport with his mother-in-law, who appears in his work more frequently than does his wife.

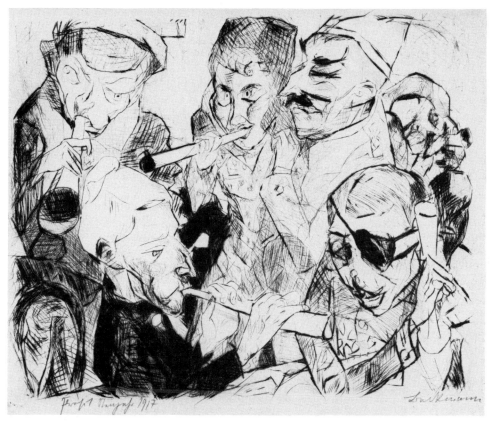

136

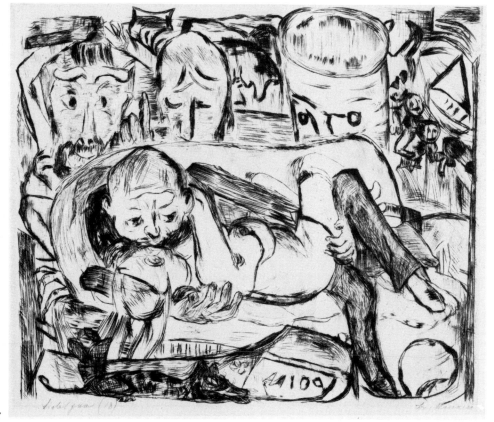

137

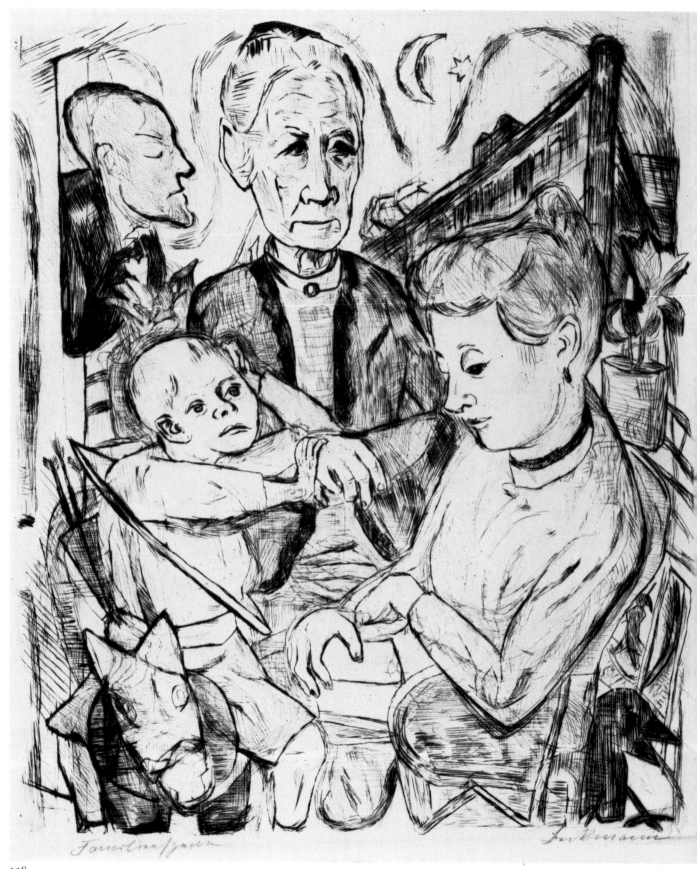

Familienszene Beckmann

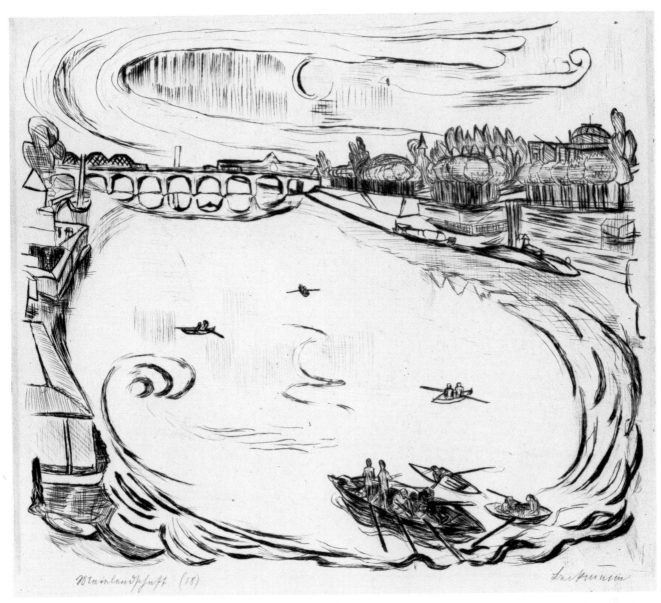

139

139 PLATE 6 *Landscape on the Main*
1918

Drypoint. Titled *Mainlandschaft (18)* and
signed in pencil. 248 × 291 mm
Hofmaier 126, fourth state; Gallwitz 99
1982–7–24–27(6)

The print shows, in reverse, a view in
Frankfurt looking west along the Main
away from the Untermainbrücke. In the
distance is the Friedensbrücke, and on
the right the Schaumainkai with the
cupola of the Städel Art Institute. On the
opposite bank are bathing establishments.
The worked-up preparatory pencil

drawing for this print (von Wiese 409),
and an earlier drawing, apparently taken
on the spot (von Wiese 408), were both
sold with the Piper collection of 1981;
both are dated 1918. The curious circular
eddy in the river and the matching
curved cloud formation in the sky are
only to be found in rudimentary form in
the drawings.

140 PLATE 7 *Yawning*
1918

Drypoint. Titled *Siesta (18)* and signed in
pencil. 292 × 253 mm
Hofmaier 127, fifth state; Gallwitz 100
1982–7–24–27(7)

At the top left of the plate, reversed in the
printing, is written *Beckmann Sommer
Hermsdorf 1918*. Beckmann himself is in
the background, the Battenbergs on the
right, and another unidentified couple on
the left. Hermsdorf is the district of Berlin
where Beckmann had his pre-War house
and studio.

141 PLATE 9 *Café-music*
1918

Drypoint. Titled *Konzertkaffee (Handdruck)* and annotated *Zweiter* [crossed out] *erster Zustand*; signed and dated *18* in pencil. 310 × 226 mm
Hofmaier 128, second state; Gallwitz 101
1981–7–25–46. From the collection of Reinhard Piper.

141a

Another impression. Titled *Concertkaffee* and signed in pencil.
314 × 231 mm
Hofmaier 128, fourth state
1982–7–24–27(9)

The unique impression of the second state from the Piper collection is extensively overdrawn in pencil.

142 PLATE 11 *The Deposition from the Cross*
1918

Drypoint. Signed in pencil. 306 × 253 mm
Hofmaier 129, second state; Gallwitz 102
1982–7–24–27(11)

This is a reversed version of a painting dated 1917, now in the Museum of Modern Art, New York (Göpel 192, formerly Städtische Galerie, Frankfurt, whence sold in 1937). The painting is one of a number of religious subjects painted in that year which form a self-contained group in Beckmann's work: besides the great *Resurrection* there is an *Adam and Eve* and a *Christ and the woman taken in adultery*, which is exactly the same size as this painting. The standing figure at the right in the black tunic is identified as Major von Braunbehrens, who also appears in 131. The kneeling figure on the right is perhaps Klara, the Battenberg's maid (so the Göpels).

The Göpels publish an interesting account of the genesis of the painting. Beckmann was in the Leipzig-Haus in Frankfurt with Georg Hartmann, one of his Frankfurt patrons and the owner of a foundry, looking at a Gothic wooden Pietà of *c.* 1400. Hartmann challenged him to produce as strong a work of art in the spirit of the modern age; Beckmann accepted the challenge and produced this painting. The Gothic sculpture has been identified and is illustrated in Göpel 1976, I, p. 577. Another Gothic work which is known to have impressed Beckmann deeply at this time are the panels of the great altar-piece of the Passion by Hans Holbein the Elder in the Städel.

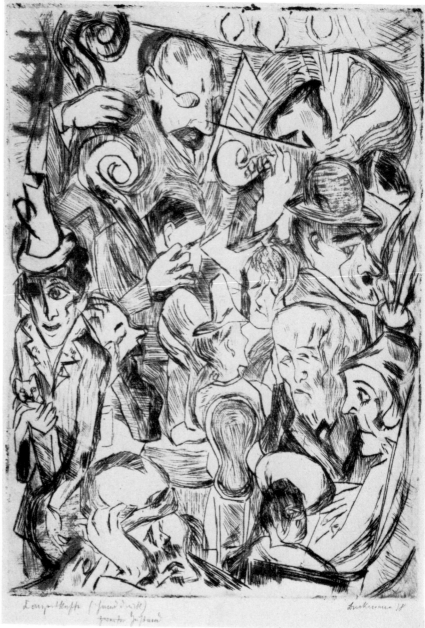

141

143 PLATE 12 *Resurrection*
1918

Drypoint. Titled *Auferstehung (18)* and signed in pencil. 242 × 334 mm
Hofmaier 130, third state; Gallwitz 103
1982–7–24–27(12)

This drypoint is a reversed version of Beckmann's largest and most ambitious painting of the war years – the huge (3.5 × 5 m) *Resurrection* now in the Staatsgalerie in Stuttgart (Göpel 190). The first drawing of the subject is dated

1914, and in a letter to his wife of May 1915 Beckmann talks of his recurring dreams of world destruction. Work on the painting in Frankfurt began in 1916 and seems to have taken up much of the year, and perhaps continued into 1917 and 1918. It was in fact never finished, but hung on the wall of the Frankfurt studio until Beckmann rolled it up in 1933 to take with him to Berlin. From there it accompanied him to Amsterdam and St Louis, never once being exhibited in his lifetime. In a letter to Reinhard

Piper Beckmann informed him that he intended to paint four paintings of this size which would form a modern hall of devotion; nothing came of this idea.

The print follows the composition of the painting fairly closely, though of course completing the passages left unfinished. A drawing (von Wiese 390) also dated 1918 goes beyond the print in revising significant elements of the composition, but this is probably to be explained by the fact that it was commissioned by Piper. The painting is the clearest example of Beckmann's intensive study of German late medieval painting, apparent not only in the choice of subject and the introduction of portraits of himself, his wife and son and the Battenbergs in the position of praying donors positioned at the open mouth of hell, but in the Gothic forms. Dückers (Berlin catalogue, 1983, p. 82) illustrates a medieval sculpture of a morris dancer which is a source for the extravagant poses for the upper figures.

In its handling of space and perspective, and in the bizarre distortion of the figures, *Resurrection* signified a complete break with Beckmann's earlier paintings. This is clearly seen by comparing it with his earlier large (4 × 2.5 m) *Resurrection*, painted in 1909 (also now in Stuttgart, Göpel 104), which is inspired by El Greco, and which also contains portraits of contemporaries. It is an aggregation of individual forms and disparate ideas, and so perhaps could never result in a finished painting. But its wealth of invention allowed Beckmann to make a fresh start, and he quarried ideas from it for years afterwards (e.g. in the second plate illustrating Kasimir Edschmid, *Die Fürstin*, 1917: see 244).

144 PLATE 13 *Street in Frankfurt*
1918

Drypoint. Titled *Frühling (18)* and signed in pencil. 293 × 195 mm
Hofmaier 131, second state; Gallwitz 104
1982-7-24-27(13)

Leaning out of the window to welcome the spring are Beckmann and his wife.

145 PLATE 14 *Landscape with balloon*
1918

Drypoint. Titled *Strasse (18)* and signed in pencil. 234 × 288 mm
Hofmaier 132, second state; Gallwitz 105
1982-7-24-27(14)

This is a reversed version of a painting dated 1917, now in the Museum Ludwig, Cologne (Göpel 195). The scene has been identified as the Darmstädter Landstrasse in the suburbs of Frankfurt. The sight of balloons would not have been unusual at this date, but the balloon obviously was a symbol of significance to Beckmann. It appears already in a painting of 1908 (Göpel 100). The flag-poles in the windows and the sun or moon in the sky were only added to the plate in the second state; neither appear in the painting.

146 PLATE 3 *Madhouse*
1918

Drypoint. Signed in pencil. 254 × 299 mm
Hofmaier 133, fourth state; Gallwitz 106
1982-7-24-27(3)

No-one seems to have been able to elucidate this alarming image.

141a

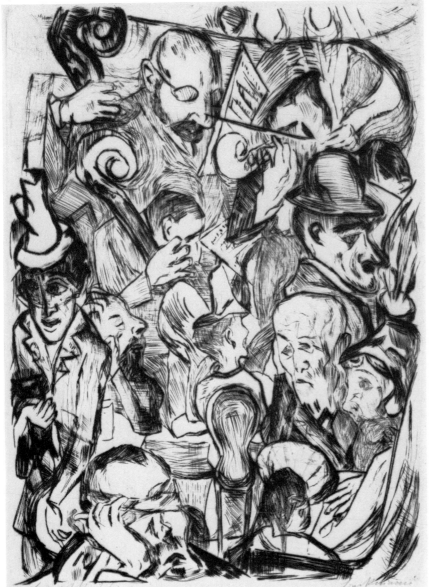

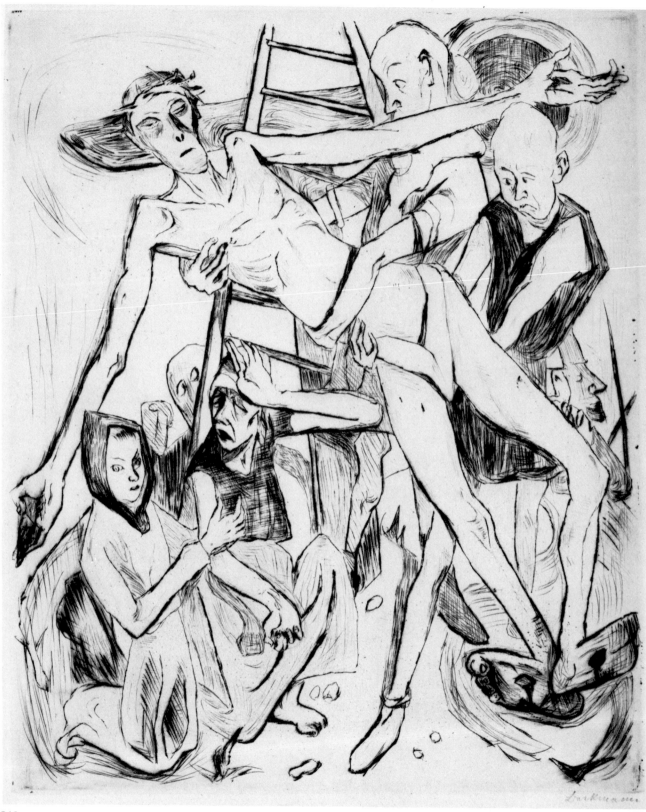

142

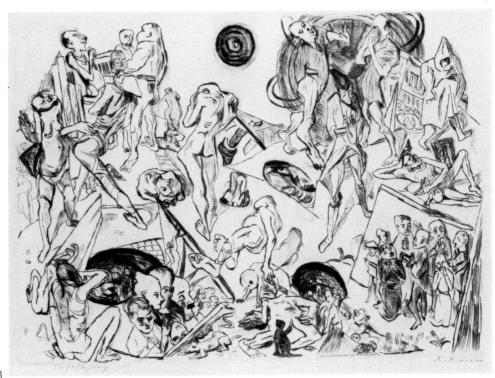

143

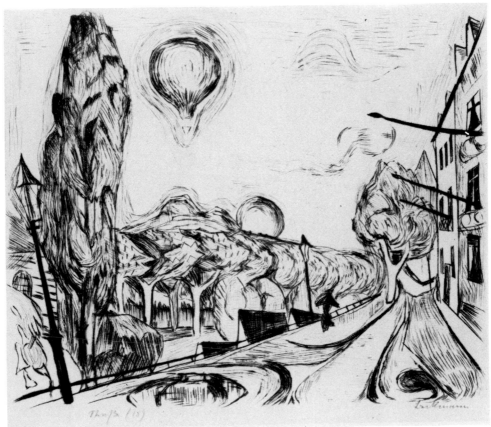

145

147 PLATE 16 *Children playing*
1918

Drypoint. Titled *Spielende Kinder (18)* and
signed in pencil. 251 × 295 mm
Hofmaier 134, third state; Gallwitz 107
1982–7–24–27(16)

The most famous painting of this subject
is Pieter Bruegel's canvas of 1560 in
Vienna. But whereas that is in essence an
anthology of over sixty children's games,
Beckmann's children are only playing
one game, mock warfare.

148 PLATE 19 *Self-portrait*
1918

Drypoint. Signed in pencil. 277 × 256 mm
Hofmaier 135, third state; Gallwitz 108
1982–7–24–27(19)

This self-portrait closes the series which
was opened by another self-portrait (135).
There is some disagreement in the
literature on Beckmann as to which
comes at the beginning and which at the
end. The list of contents of 'Gesichter'
states that plate 1 is *Selbstbildnis 1917*
while plate 19 is *Selbstbildnis 1918*. This
plate is undated, but the other one carries
the pencil date *1917* – whence the
order adopted here, which differs from
Hofmaier's.

149 *The Street*
Plate 2 of 'Die Hölle'
1919

Lithograph. Signed, titled *Die Strasse* and
numbered 4/75 in pencil. 672 × 535 mm
Hofmaier 139; Gallwitz 115
Lent by the Scottish National Gallery of
Modern Art, Edinburgh (inv. GMA 2465).

This print comes from a set of ten very
large transfer lithographs plus a title-page
published by J.B. Neumann in Berlin in
1919 under the title 'Die Hölle' (Hell).
Seven of the original drawings for the
transfers survive, and of these that for
Die Strasse (von Wiese 411) is now in
the collection of the British Museum
(1983–3–5–55). The print is borrowed
from the complete set of 'Die Hölle'
acquired by Edinburgh in 1981.

'Die Hölle' is Beckmann's most ambitious
and sustained achievement in narrative
printmaking. On the title-page is a self-
portrait with the text: 'Hell. A great
spectacle in 10 pictures by Beckmann',

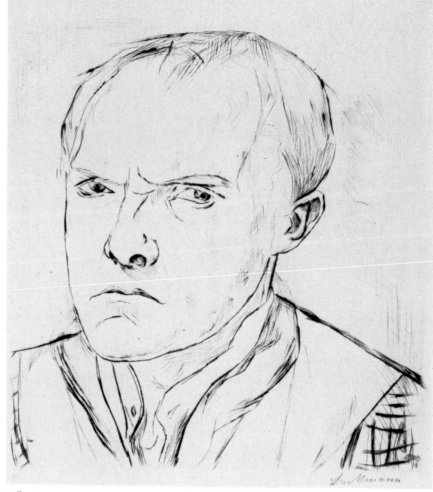

148

and below: 'We beg our esteemed public
to step forward. You have the pleasant
prospect that perhaps for ten minutes
you won't be bored. Anyone who is not
delighted will get his money back.' The
following prints present an appalling
picture of a society in collapse. They
begin with the artist himself starting back
in horror at meeting a deformed cripple
on his way home, and end with him at
home with his mother-in-law and son,
who is dressed up as a soldier and
brandishes a pair of hand-grenades.
Between comes a panorama of Berlin
during the Revolution of 1919. *The Street*
shows the public aspect with chaos and
lawlessness. In *The Martyrdom* a woman,
clearly Rosa Luxemburg, is murdered by
soldiers of the Freikorps. Next *The
Ideologues* of all persuasions talk and
yawn, while in *Hunger* a starving family

contemplates an empty table. The centre-
piece of the sequence is *The Night* (the
same composition as the famous painting
now in the Nordrhein-Westfalen collection
in Düsseldorf, Göpel 200), in which a
family is horribly tortured by a gang of
housebreakers. Meanwhile, in *Malepartus*,
wealthy revellers (the war-profiteers)
dance wildly to the music of a band. To
the sound of *The patriotic song*
representatives of the armed forces yawn
and fall asleep. In the penultimate plate,
The last ones (of the Spartacus rising) keep
up their fight with machine-guns and
rifles against unseen opponents. (This
account is based on the excellent
catalogue by Alexander Dückers of the
exhibition of the series in Berlin in 1983.)

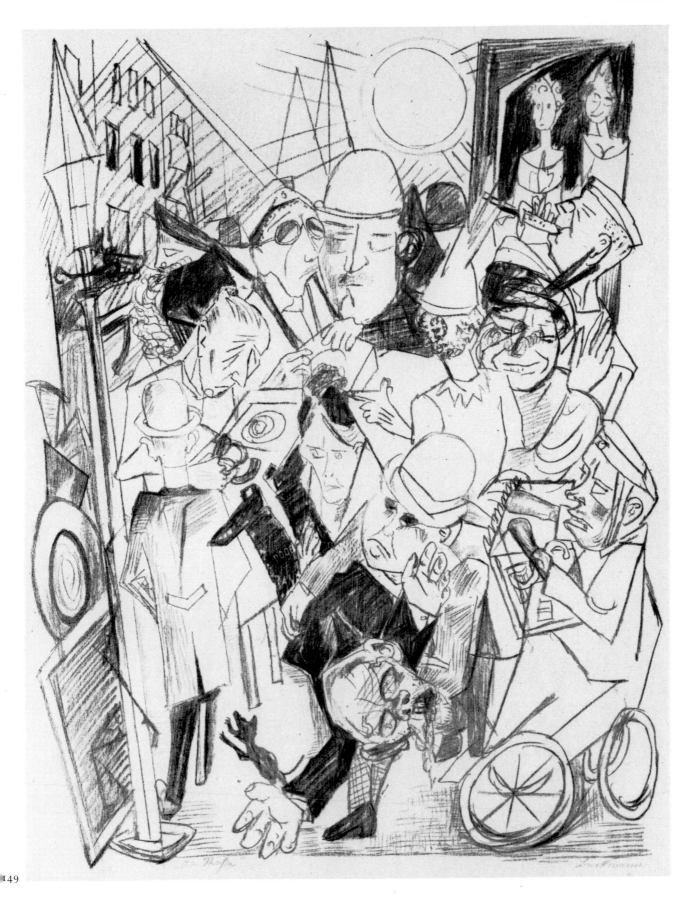

150 *Christmas*
1919

Drypoint. Inscribed *Probedruck (Weihnachten 1920)* and *Modelldruck* and signed in pencil (title *Weihnachten 1919* in reverse on plate).
175 × 238 mm
Hofmaier 153, second state; Gallwitz 126
1981–7–25–47. From the collection of Reinhard Piper.

Like 'Die Hölle', this print reflects Beckmann's impressions of post-war Berlin. The annotation *Modelldruck* shows that this impression was to be used by the printer as the standard on which to base the printing of the main edition. The French equivalent is the remark *bon à tirer*, a term which is often used in Britain and America as well.

151 *Sent M'Ahesa*
1921

Lithograph. Signed in pencil. 565 × 410 mm
Hofmaier 182; Gallwitz 155
1981–3–28–4

An early proof (illustrated by Gallwitz) carries an inscription, *20.4.21 bei Weidner von Beckmann* (21 April 1921 at Weidner's, by Beckmann), which is not to be seen on the impression from the ordinary edition published by J.B. Neumann. This portrait forms a pair with one of Dr Weidner (Gallwitz 154). Sent M'Ahesa was a dancer; a portrait bust of her was made by Bernhard Hoetger (1874–1949) in 1917, based on the famous head of Queen Nefertiti in Berlin.

The pair stands at the beginning of a number of similar portrait lithographs made in the following two years.

152 *Self-portrait*
Plate 1 of 'Jahrmarkt'
1921

Drypoint. Signed in pencil. 340 × 256 mm
Hofmaier 190, third state; Gallwitz 163. On laid paper.
1979–5–12–1. Presented by the British Museum Society.

'Der Jahrmarkt' (The Fair) is a set of ten drypoints made in 1921, commissioned and published by Maier-Graefe and Reinhard Piper in 1922 in a large edition as the 36th publication of the Marées-Gesellschaft. Seventy-five sets were on Japan, and 125 on ordinary laid paper. The plates all show scenes set in a fairground, which is seen in an allusive symbolic sense as a microcosm of society.

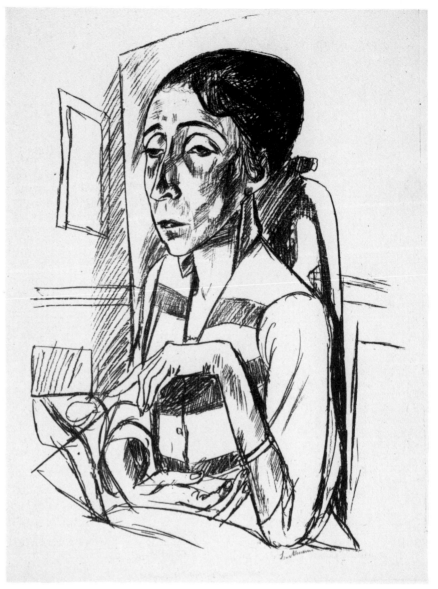

151

By the early 1920s Beckmann's bafflingly complex private system of allegory was already highly developed, and this series is probably its most striking manifestation in his prints.

In this introductory first plate to the series Beckmann shows a self-portrait as a crier with a bell summoning custom to his fair, the 'Circus Beckmann' which is advertised on the placard behind. The same idea is found on the title-page of 'Die Hölle', and derives from Wedekind, who uses the device of the animal-tamer introducing the cast in his 'Lulu' plays. Such a parallel with Wedekind is actually made in the prospectus advertising the series issued by the Marées-Gesellschaft

in 1922 (presumably written by Meier-Graefe). Dix also made a set of prints entitled 'Zirkus' in 1922 (Karsch 32–41).

153 *The disappointed I*
Plate 2 of 'Berliner Reise'
1922

Lithograph. 490 × 375 mm
Hofmaier 213; Gallwitz 183
1983–10–1–33

The portfolio 'Berliner Reise' (Journey to Berlin) consisting of ten large transfer lithographs, can be seen as a sort of sequel to 'Die Hölle'. Compared with the earlier series the approach is more dispassionate, and the artist presents himself in the first

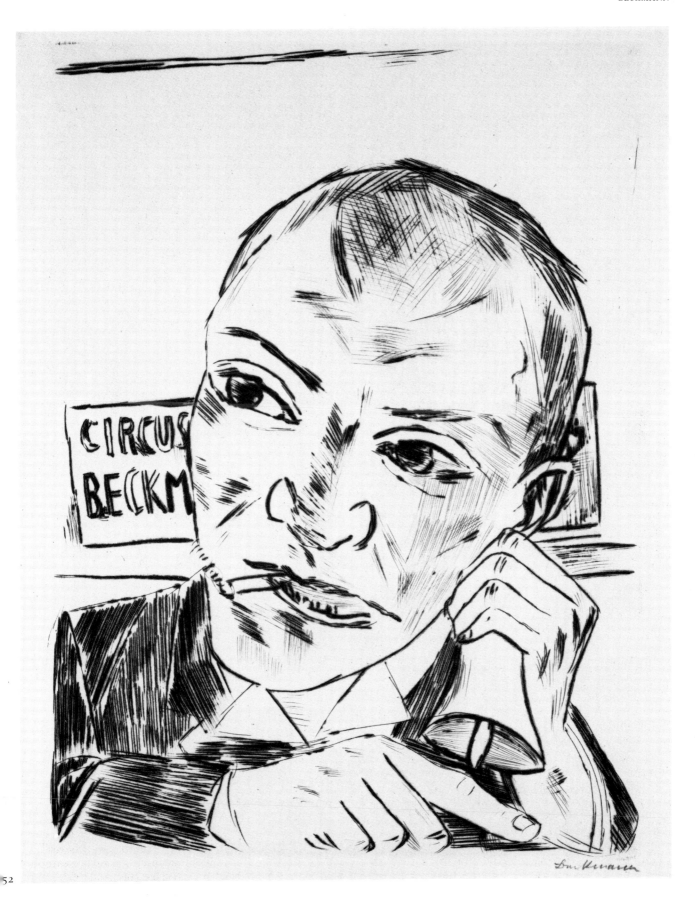

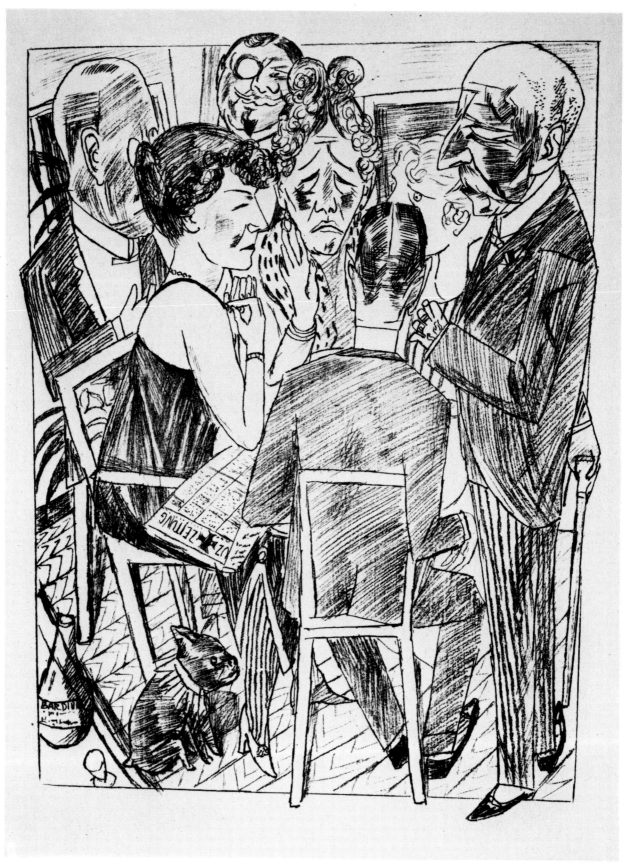

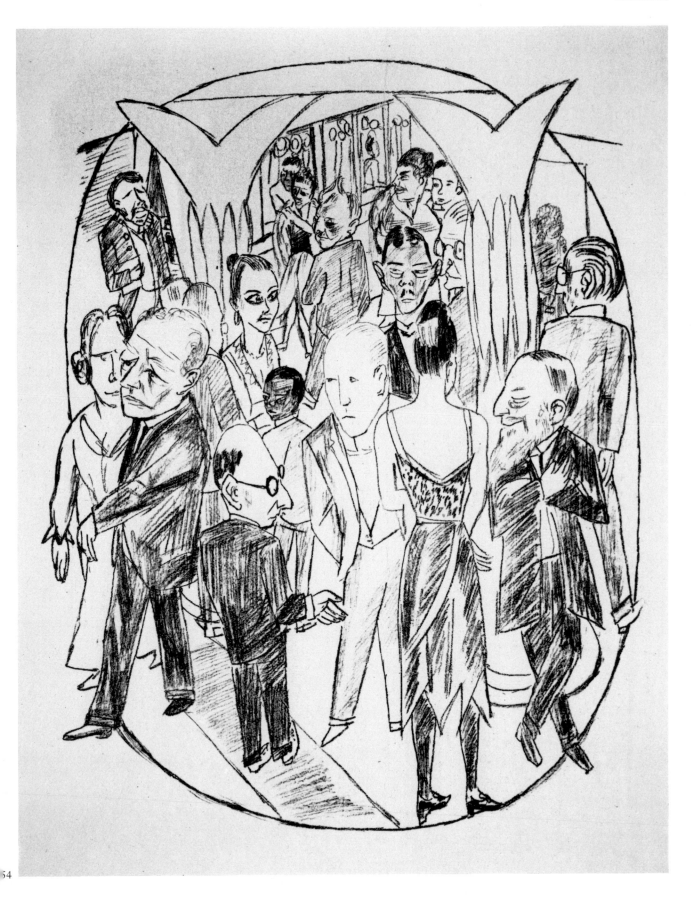

introductory plate more as the neutral observer, pen in hand, than the critic and appalled participant. The plates are organised in a series of contrasts or parallels. *The disappointed I* is the second plate, and shows a group of seven well-to-do people discussing in a circle the news brought to them by their conservative newspaper, the *Kreuz-Zeitung*. Their discontent, evident in their gestures and expressions, must be with the end of the German Reich and the establishment of Weimar democracy. The contrasting third plate, *Night*, portrays a poor family sleeping in exhaustion in a mean tenement block; the baby is given Beckmann's own features. The sixth plate is also entitled *The disappointed*, but the four people yawning as they conduct a desultory conversation are now identified as Communist ideologues by the publications they carry, which are speeches and addresses by Rosa Luxemburg and Karl Liebknecht; the failure of the Spartacus rising has left them as disappointed as the monarchists.

'Berliner Reise' was drawn in the early months of 1922 and published by J.B. Neumann in April that year in a signed and numbered edition of one hundred. The two plates catalogued here, being neither signed nor numbered, must be a few spare sheets printed above the stated number in case of accident and thus left unsigned when they were not needed. None of the original transfer drawings seems to survive, though von Wiese catalogues several related pencil studies from a sketchbook (nos 498 ff.).

154 The Theatre foyer
Plate 8 of 'Berliner Reise'
1922

Lithograph. 490 × 400 mm
Hofmaier 219; Gallwitz 189
1983–10–1–34

In the eighth plate of 'Berliner Reise' we are taken into the lobby of a theatre of up-to-date neo-Egyptian style. This form of middle-class entertainment finds its counterpart in the ninth plate (which has an identical oval frame) in a couple of workers dancing in a back-street bar. The final plate of the series shows a blackened chimney-sweep at work letting his brush down a chimney. This is usually taken as a disguised self-portrait; the artist is

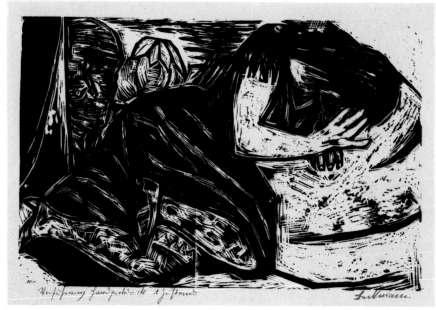

155

besmirched by his contact with the world, although a rising sun on the horizon offers a hope for better things to come.

155 Seduction
1923

Woodcut. Titled *Verführung. Handprobedruck l. Zustand* and signed in pencil.
159 × 243 mm
Hofmaier 256, first state; Gallwitz 222
1981–7–25–48. From the collection of Reinhard Piper.

Beckmann's first woodcuts were made in 1920, and he made a number of others in 1922–3 (eighteen prints in total) without the technique ever becoming as important to him as drypoint or lithography. He seems never to have been happy using a knife or gouge, and almost all his woodblocks were worked by a process of attrition, cutting away at the surface with a graving tool. In this print, one of his finest woodcuts, the tone is created by a network of hatched lines, thus leaving a disconcerting number of black flecks in white areas. Perhaps unhappy about the crack running down the centre of the block, Beckmann never published the print and only a few impressions survive; according to Hofmaier this is the unique impression of the first state, while only four of the second are known.

The subject looks back to a number of earlier prints in which a woman is observed through a window by a man (e.g. *Frau in der Nacht*, Gallwitz 147, of 1920). In this print the theme and title are directly related to Beckmann himself by making the head an obvious self-portrait. It is perhaps not unreasonable to connect this with his meeting in 1923 Mathilde von Kaulbach in Vienna; he subsequently divorced his first wife Minna, and married Mathilde in September 1925. A later drypoint of the same year entitled *Siesta* (Gallwitz 238) shows Beckmann seated contemplating a half-naked woman lying on a bed. (See Fischer, *Max Beckmann, Symbol und Weltbild*, 1972, 136–53 on the theme of temptation in his work.)

GEORGE GROSZ
1893–1959

Born in Berlin, but brought up in the provincial town of Stolp in Pomerania. From 1909 to 1911 he studied drawing at the Dresden Akademie under the autocratic and conservative Richard Müller. From 1912 to 1917 he was a part-time student at the Art School in Berlin under Emil Orlik, but it was a visit to Paris in 1913 which introduced him to drawing from rapid observation, of vital importance for his subsequent career as a satirist. After his release from a brief period of military service in 1915, Grosz met the Communist writer, Wieland Herzfelde, whose publishing ventures, first the provocative, anti-establishment journal *Neue Jugend* and then the prolific Malik Verlag, founded in 1916, were to provide Grosz with his main outlet for more than a decade. Wieland and his brother Helmut (John Heartfield from 1916 onwards: cf. 273) immediately perceived the potential in harnessing the mordant quality of Grosz's work to their own political views. In spring 1917 they published his first portfolio of drawings, the *Erste George Grosz-Mappe*, followed by the *Kleine Grosz-Mappe* in the autumn, which immediately brought him to public attention. After his readmission to the army in early 1917, he underwent psychiatric treatment. After his discharge he began to explore the medium of collage and photomontage and continued to paint the apocalyptic, Futurist scenes of urban collapse which culminated in *Dedicated to Oscar Panizza* (Staatsgalerie, Stuttgart) of 1918–19. In 1918 he joined the Communist party, and in 1919 became a leading participant in the Berlin Dada movement. The period 1919–23 saw the production of his most caustic interpretations of contemporary society. *Gott mit uns* (God is on our side), a portfolio of anti-militarist drawings of 1919, was confiscated by the police from the first Dada-Messe; *Ecce Homo* another portfolio of 1923, led to a trial for obscenity which resulted in a fine of 6,000 Marks. In 1925 he was included as one of the main painters in the Neue Sachlichkeit exhibition in Mannheim. By this time he was under contract to the fashionable dealer, Alfred Flechtheim, and his watercolours began to betray a softer, more gently derisive attitude reminiscent of Pascin, although he continued his left-wing political associations, drawing regularly from 1924 to 1927 for the Communist weekly, *Der Knüppel* (The Cudgel). In 1927 Malik published Grosz's set designs for Erwin Piscator's production of *The Good Soldier Schweik* as *Hintergrund* (Background), which provoked yet another criminal charge on the grounds of blasphemy. By 1930, however, Grosz had become less and less committed to the role of a left-wing political satirist, cherishing, among his ambitions, a desire to become a modern German history painter equivalent to Hogarth. He moved to America in 1933, and his work became the subject of wholesale vilification and destruction by the Nazis. But Grosz never succeeded in becoming the kind of illustrator who could appeal to American popular taste. He completely rejected his left-wing past and subsided into a nihilistic and drunken melancholia. Disillusioned with his failure to adjust successfully to America, Grosz began to revisit Germany in 1954. He died in Berlin in 1959 shortly after returning for the third time.

The impact of Grosz's published drawings was enormous; *Das Gesicht der herrschenden Klasse* of 1921 (cf. 272) sold out its first edition instantly and Malik reprinted a second 25,000. His admirers included Count Kessler, the distinguished diplomat and patron of the arts, and the young novelist, Elias Canetti, who travelled to Berlin from Vienna in 1928, largely in the hope of meeting him. Grosz presented the younger man with a copy of *Ecce Homo* which made a great impression on Canetti: 'it inserted itself between me and Berlin, and from then on it coloured most things for me, especially all the things I saw at night.' Canetti has provided a vivid picture of the ambiguities of Grosz's character: on the one hand a revered (from his point of view) political and social satirist, who dressed like a nautical American and behaved with open-handed generosity; on the other hand a drunken, lecherous dandy and an abusive guest at a party who was transformed into one of the loathsome characters in his drawings (cf. Elias Canetti, 'Berlin 1928' in *The New Criterion*, September 1982, pp. 16–35). Despite his affiliations, Grosz's political views lacked the sharp focus of the Herzfelde brothers; it was they who to some extent determined the public's understanding of the drawings by carefully selecting the anthologies and supplying the captions.

Apart from a few early etchings of 1912–14 and another later group from 1939 and 1949, the vast majority of the considerable number of prints Grosz produced were photolithographic facsimiles of drawings. It is for this reason that he is only represented by a single item in a catalogue which is devoted to original printmaking. From Grosz's point of view the distinction was meaningless. He had no intrinsic interest in print techniques but was proud to be a journalistic draughtsman whose concern was to reach the widest possible audience.

Bibliography

His autobiography, *A Little Yes and a Big No*, was first published in English in New York in 1946. A revised German edition appeared in Hamburg in 1955, from which a new translation was published in London in 1982. It is easily the most compelling account of his work. Herbert Knust has edited a selection of letters,

George Grosz, Briefe 1913–59, Reinbek 1979.

Hans Hess, *George Grosz*, London 1974, is the best biographical introduction, while Uwe M. Schneede, *George Grosz, his life and work*, London 1979 (German edn 1975), has a wealth of illustrations. Beth Irwin Lewis, *George Grosz, art and politics in the Weimar Republic*, London 1971, is an attempt to unravel the complexities of Grosz's psychology and intentions. Alexander Dückers, *George Grosz: Das druckgraphische Werk*, Berlin 1979, is an immensely thorough catalogue raisonné of the prints, and contains a wealth of information of relevance to all aspects of Grosz's art.

156 *Vollkommene Menschen* (Perfect people) 1920

Transfer lithograph. Signed in pencil bottom right. 268 × 220 mm
Dückers E62. Published in *Die Schaffenden*, year 2, 4th portfolio, pl. 1, 1926
1920–6–28–26

Vollkommene Menschen appeared as a separate sheet and was never included in any of the published sets of Grosz's drawings. It appeared in *Die Schaffenden* (cf. 194) together with another lithograph, *Kein Hahn kräht nach ihnen* (No cock crows for them). His compositions after 1920 moved away from 'the terrible adjacency and chaos' (Canetti, 'Berlin 1928', *The New Criterion*, Sept. 1982), of the previous years, towards a more 'rational' space and a sharply defined realism.

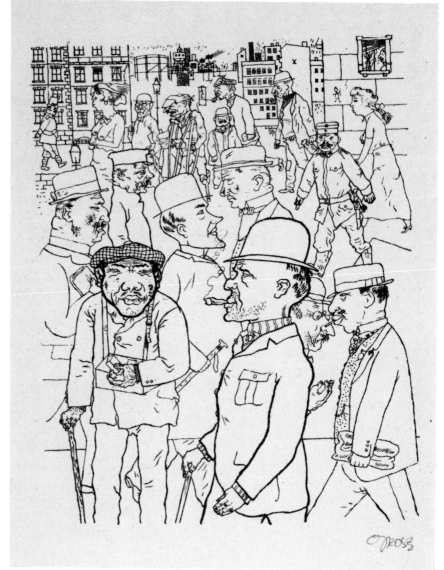

156

OTTO DIX
1891–1969

Born near Gera, he worked locally as a decorator before moving to Dresden in 1909, where he studied at the Kunstgewerbeschule until 1914. His first group of self-portraits from 1912–13 revealed both his debt to German Renaissance and Nazarene painting and looked forward to the sharply focused *Verismus* which characterised his work of the 1920s. Two important influences of this period in Dresden were the van Gogh exhibition of 1912 and the lectures he attended on Nietzsche. Dix volunteered for military service in 1914 and the ensuing years proved to be of vital importance for his outlook as an artist; he experienced the full horrors of trench warfare, including gas attacks, from Flanders to the Somme. More than six hundred drawings belong to this period.

He returned to Dresden at the beginning of 1919, to become a student at the Akademie; immediately he identified with the left-wing political milieu of the city, helping to found in the Dresden Secession an offshoot of the radical Novembergruppe in Berlin (cf. 258), of which he was also a member. Dix's Expressionist style of the War years gave way in 1920, first to an attempt at large-scale collages, which he exhibited at the Dada-Messe in Berlin, and then to *Verismus*, the new naturalism which *Das Kunstblatt* in 1922 described as arising from 'the ashes of Expressionism'. A series of savagely delineated subjects ensued: *War Cripples*, *The Butcher's Shop*, and *Prager Street*. To these years belong his first portrait of his parents, his first drypoints and the beginning of the definitive composition of *The Trench*.

Dix moved to Düsseldorf in 1922, partly at the prompting of the dealer, Johanna ('Mutter') Ey and partly to study intaglio techniques with the

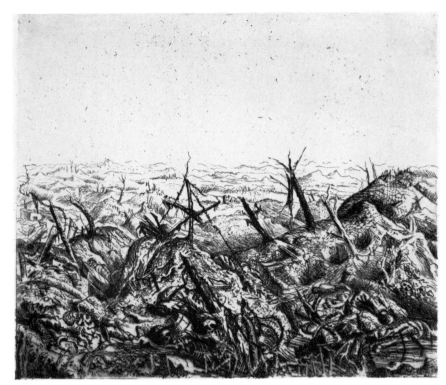

160

master printer, Wilhelm Heberholz, in order to produce his graphic cycle 'Der Krieg' (1924). *The Trench*, a triptych, was finished in 1923 and exhibited in the Academy in Berlin in 1924, where it was purchased for 10,000 Marks by the Wallraf-Richartz Museum in Cologne. Its horrific imagery provoked an immediate furore and its purchase by the Cologne Museum was revoked after a press agitation led by Meier-Graefe, despite Liebermann's and Corinth's attempt, among others, to defend the painting. Dix survived the inflationary years through sales of his watercolours. Five of his paintings were included in the Neue Sachlichkeit exhibition in Mannheim of 1925, where Dix emerged as the dominant personality, among figures like Grosz, Schlichter and Hubbuch. In Berlin, where he moved in 1925, he associated with the far-left Rote Gruppe and received a series of important portrait commissions.

From 1927 to 1933, he lived in Dresden, where he had been appointed a professor at the Akademie. During this period he painted his lurid vision of city life, the triptych *Grossstadt* (The Big City), 1927–8. The imagery of 'The Trench' resurfaced, albeit in a slightly more muted form, in another triptych *Der Krieg*, painted from 1929 to 1932; the subject continued to fascinate him throughout the 1930s as demonstrated by *Battlefield in Flanders* (1934–6), his last major war painting. In 1933 Dix was dismissed from the Düsseldorf Akademie, and in the following year forbidden to exhibit. In 1937, 260 of his works were confiscated; the centre-pieces of *Entartete Kunst* in Munich in 1938 were Dix's paintings *The Trench* and *War Cripples*; the former was toured through Germany as 'a witness to the attempt to undermine the German people's attempt to defend itself'. Both pictures were burnt in 1939. In 1936 Dix

had moved to Hemmenhofen on Lake Constance where he painted *The Seven Deadly Sins*, with Hitler cast as Envy, in 1937. In 1949 he resumed his close association with the city of Dresden, which he often visited until his death.

Dix, together with Beckmann, is the dominant figure in the field of original printmaking in Germany after the First World War. His first post-War prints were various woodcuts made in 1919–20 in an Expressionist style. But he quickly abandoned woodcut in favour of drypoint, using its harsh directness to reproduce a number of his savage paintings of those years. His series 'Circus' of 1922 was also in drypoint, but for 'Der Krieg' of 1924 he learnt etching and aquatint. In 1923 Karl Nierendorf had published a series of large colour lithographs by him, and his exhibition of 1926 included a complete retrospective of all Dix's prints. At this point, however, Dix abandoned printmaking until 1948 when he returned to working almost exclusively in lithography. The mordancy of his earlier work is entirely lacking from these post-War prints.

Bibliography

The basic general books are Fritz Löffler, *Otto Dix, Leben und Werk*, Dresden 1960, 4th edn 1977 (English trans. New York and London 1982); Fritz Löffler, *Otto Dix, Oeuvrekatalog der Gemälde*, Recklinghausen 1981; Otto Conzelmann, *Otto Dix, Handzeichnungen*, Hanover 1968; and Florian Karsh and Hans Kinkel, *Otto Dix, das graphische Werk*, Hanover 1970 (the catalogue raisonné of Dix's prints). Lothar Fischer, *Otto Dix, Ein Malerleben in Deutschland*, Berlin 1981, is an illustrated chronology of the artist's life, while Dietrich Schubert's *Otto Dix in Selbstzeugnissen und Bilddokumenten*, Reinbek 1980, is a useful condensed account of Dix in the small Rowohlt monograph series. A certain amount of primary source material has been published in *Dokumente und Werk des Malers Otto Dix 1891–1969*, Archiv für Bildende Kunst, Materialen 2, Germanisches Nationalmuseum, Nuremberg 1977. A recent book which specifically deals with 'Der Krieg' and related paintings, together with their art-historical sources, is Otto Conzelmann, *Der andere Dix: Sein Bild vom Menschen und von Krieg*, Stuttgart 1983.

157–186 'Der Krieg' (War) 1924

The fifty etchings of this cycle represent Dix's central achievement as a graphic artist. Their foundation lay in the hundreds of drawings he had executed while serving as a front-line gunner and the apocalyptic imagery which had been so prevalent in German poetry and the graphic arts since 1912.

Stylistically his wartime sketches were far removed from the actual prints, although there are one or two exceptions: the *Ruins of Langemark* (Karsch 94) is closely allied to a pastel of 1917 entitled *Ruins by Night*. The studies he made for 'The Trench' from 1920 to 1923 evidently inspired some of the etchings: 161 and 162 for example derive from the left-hand side of the central panel. A visit to the catacombs in Palermo in the winter of 1923–4 was also to prove a fruitful source of macabre images. In all, twenty rough sketches in black wash have been identified by Conzelmann as preparatory studies executed specifically for the etchings.

Dix was one of several artists who produced graphic cycles designed to counteract the empty chauvinism and vain self-delusion which had been the features of official wartime propaganda. Käthe Kollwitz produced her own series (1923) and Frans Masereel published his 'Political Drawings against the War' in the tenth volume of *Tribüne der Kunst und Zeit*, 1924. The range of Dix's imagery, however, extends far beyond that of his contemporaries; nihilistic landscapes, brutalised soldiery, obscene prostitutes and decaying corpses transmuted into figures of Death, are portrayed with a merciless candour. One print, *Soldat und Nonne* (Karsch 120), depicting a nun endeavouring to repel a soldier intent on raping her, was evidently too disturbing and had to be withdrawn from the published edition.

Although Dix had produced several drypoints prior to 'Der Krieg', he realised that his command of intaglio methods was unequal to the project he had in mind. After a period of intensive study with Herberholz in Düsseldorf he felt sufficient confidence to embark upon the plates for 'Der Krieg' which indeed demonstrate an extraordinary ability to marry technique to expression. The corrosive qualities of aquatint were exploited to suggest physical and moral decay (see 159, 165, 175). A spare, linear treatment was used to convey stark terror or madness (see 172 and 174) or a more straightforward, narrative style when appropriate (see 167, 177). Etching printed in relief to produce white lines against a black background was reserved for the depiction of ghostly, ravaged landscapes (see 158).

When 'Der Krieg' appeared the critics immediately invoked the comparison with Goya's 'Disasters of War', a precedent of which Dix was only too well aware, although the only direct quotation he makes is in 176 (cf. *Disasters*, plate 30). Other quotations are from Dix's favourite German artists, such as Grünewald (159) and Urs Graf (the white line technique of 158 recalls some of his woodcuts which Dix had seen in Basle); 175 belongs to a long tradition of lascivious allegorical women, luring mankind to destruction; the skull (171) is yet another *memento mori* and symbol of decay with a long art-historical provenance. Dix was a deeply traditional artist in many ways, but was capable of creating startlingly original images; 173 and 181 are two examples of his instantly recognisable personal style.

'Der Krieg' was published in five portfolios, each containing ten prints numbered 1–10 in pencil in roman numerals within each portfolio, but consecutively in the printed table of contents. The plates were printed by Otto Felsing in Berlin and published by Karl Nierendorf in an edition of seventy. The individual portfolios cost 300 Marks but a book edition was published at the same time, containing twenty-four offset reproductions and an introduction by Henri Barbusse, the author of the famous anti-war novel, *Le Feu*, of 1916; this sold for 2,50 Marks and had an immediate success. Critical acclaim for the prints was enormous, and the portfolios were

exhibited in Berlin, Vienna, Breslau, Wiesbaden and elsewhere. More than any other comparable publication, it was regarded as capturing the traumatic experiences of the First World War, which had been horrific, bitter, revolting and occasionally wryly humorous, but never glorious. Erich Maria Remarque, author of the celebrated novel, *All Quiet on the Western Front*, 1929, recalled in 1952 in a letter to Dix, how closely the imagery of 'Der Krieg' anticipated many passages in his book.

The following thirty plates have been selected from the complete set acquired by the British Museum in 1982.

157 PLATE 3 *Men killed by gas (Templeux-la-Fosse, August 1916)*

Etching. 194 × 287 mm

158 PLATE 4 *Field of shell craters near Dontrein lit up by flares*

Etching printed in relief. 193 × 254 mm

159 PLATE 6 *Wounded (Autumn 1916, Bapaume)*

Etching and aquatint. 193 × 289 mm

160 PLATE 7 *Near Langemark (February 1918)*

Etching. 247 × 293 mm

161 PLATE 9 *Destroyed trenches*

Etching, aquatint and roulette. 298 × 244 mm

162 PLATE 11 *Abandoned position near Neuville*

Etching. 198 × 145 mm

163 PLATE 12 *Stormtroops advance under gas*

Etching and aquatint. 193 × 288 mm

164 PLATE 13 *Meal-time in the ditch (Loretto heights)*

Etching and aquatint. 191 × 288 mm

165 PLATE 16 *Corpse in barbed wire (Flanders)*

Etching and aquatint. 293 × 247 mm

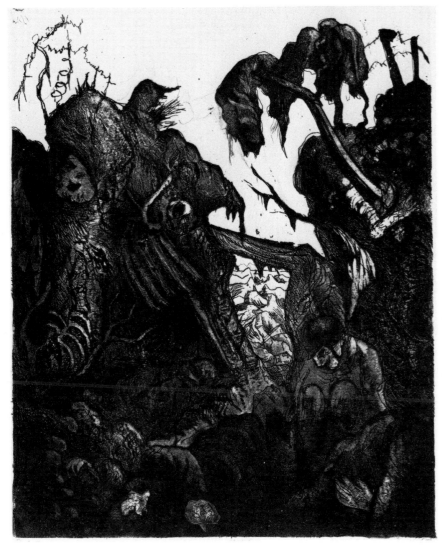

161

166 PLATE 19 *Dance of death, 1917 (the dead man's mound)*

Etching and aquatint. 244 × 299 mm

167 PLATE 21 *Exhausted troops retreat (Battle of the Somme)*

Etching. 196 × 287 mm

168 PLATE 22 *Nocturnal meeting with a madman*

Etching and aquatint. 258 × 194 mm

169 PLATE 26 *Dying soldier*

Etching and aquatint. 195 × 144 mm

170 PLATE 28 *Seen at the steep slope at Cléry-sur-Somme*

Etching and aquatint. 257 × 190 mm

171 PLATE 31 *Skull*

Etching. 255 × 195 mm

172 PLATE 33 *Lens is attacked with bombs*

Etching. 297 × 244 mm

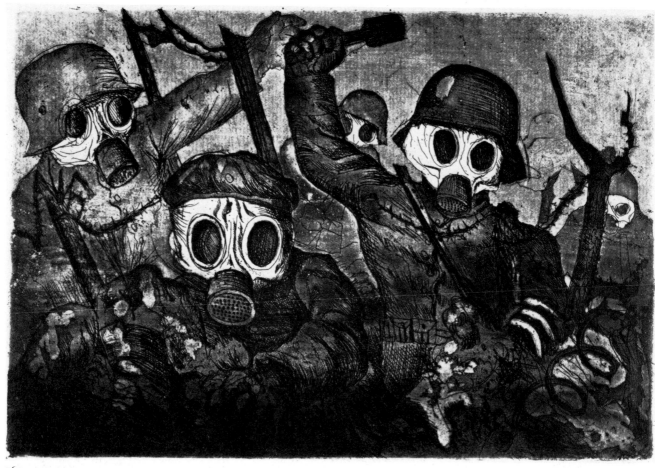

163

173 PLATE 34 *Front-line soldier in Brussels*

Etching and aquatint. 288 × 196 mm

174 PLATE 35 *The mad woman of St Marie-à-Py*

Etching and engraving. 286 × 192 mm

175 PLATE 36 *Visit to Madame Germaine at Méricourt*

Etching and aquatint. 257 × 193 mm

176 PLATE 39 *House destroyed by bombs (Tournai)*

Etching, engraving and aquatint. 297 × 244 mm

177 PLATE 41 *Machine-gun party advances (Somme, November 1916)*

Etching and aquatint. 243 × 298 mm

178 PLATE 42 *Dead man (St Clément)*

Etching and aquatint. 298 × 256 mm

179 PLATE 43 *Ration carriers at Pilkem*

Etching and aquatint. 245 × 297 mm

180 PLATE 44 *Surprise attack of a raiding party on a look-out position*

Etching and aquatint. 199 × 148 mm

181 PLATE 45 *Dug-out*

Etching and aquatint. 195 × 287 mm

182 PLATE 46 *The sleepers of Fort Vaux (gas victims)*

Etching and aquatint. 242 × 293 mm

183 PLATE 47 *Carrying the wounded in Houthulster Wood*

Etching and aquatint. 195 × 257 mm

184 PLATE 48 *The outposts have to maintain their fire at night*

Etching and aquatint. 244 × 298 mm

185 PLATE 49 *Roll-call of the returned*

Etching and aquatint. 196 × 286 mm

186 PLATE 50 *Dead men before the position at Tahure*

Etching and aquatint. 194 × 258 mm

Each plate is signed, numbered 31/70 and annotated with a roman numeral in pencil. 1982-7-24-28(1-50) (the complete series)

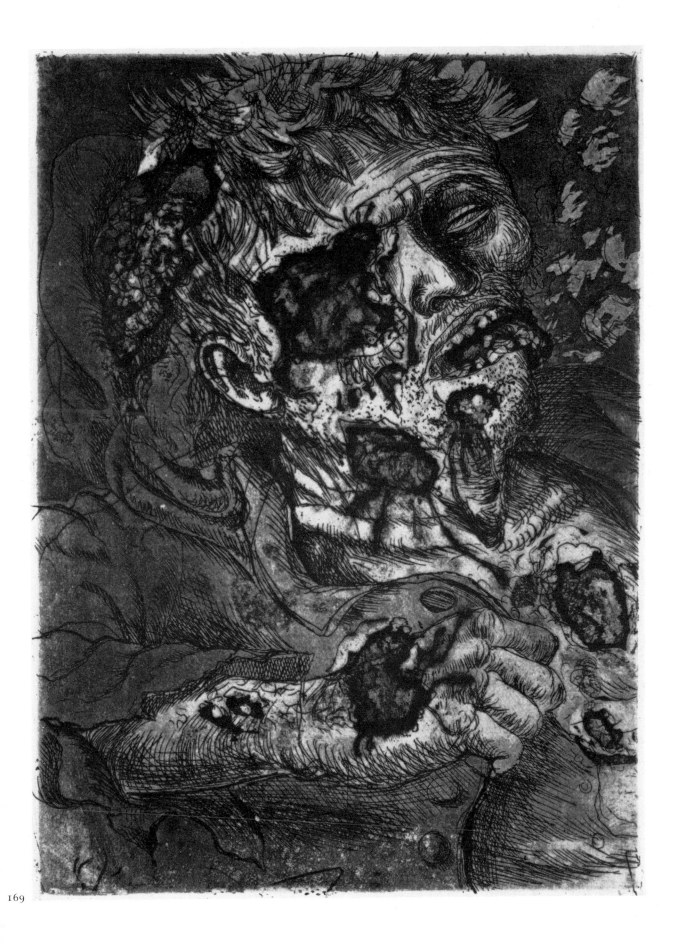

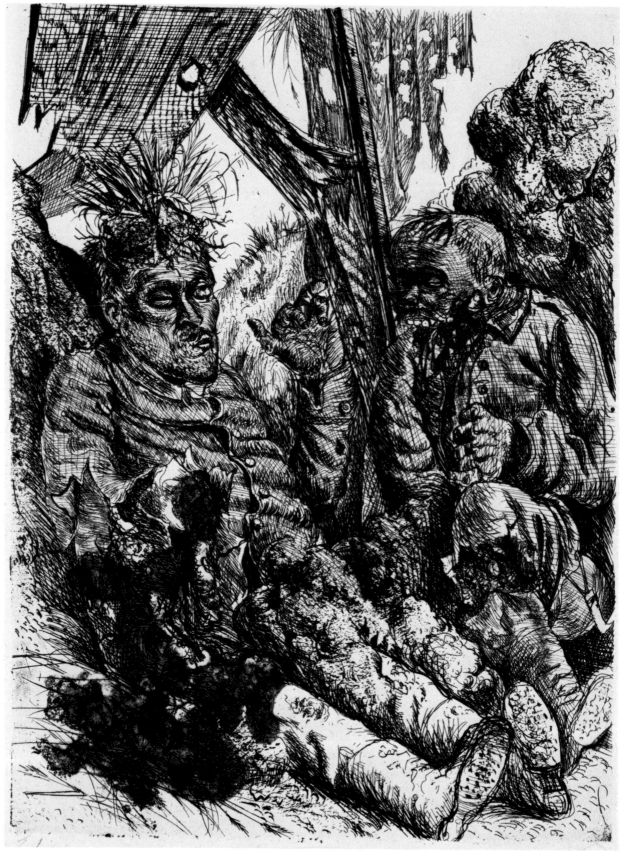

170

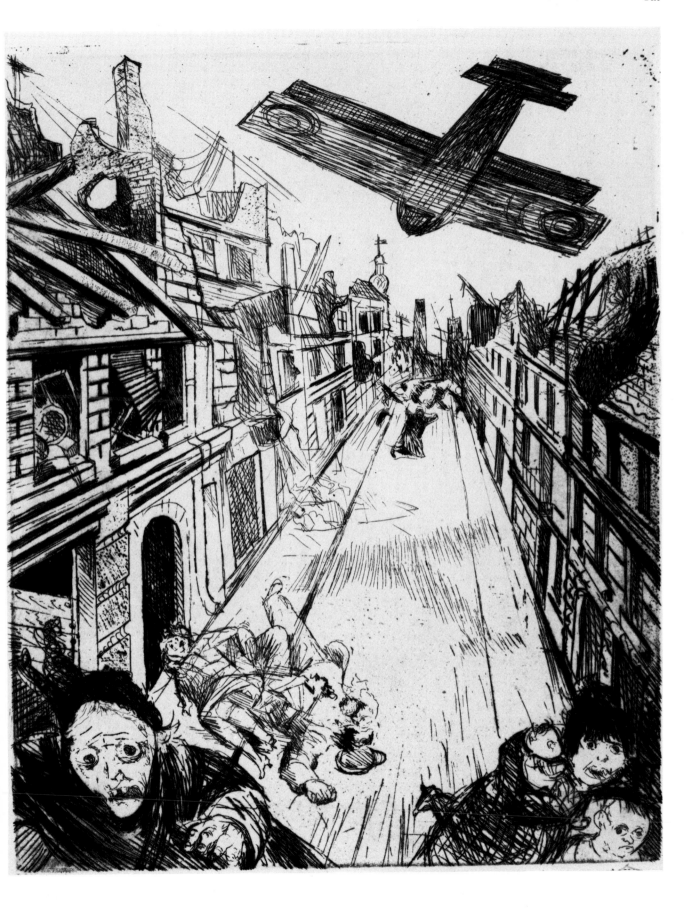

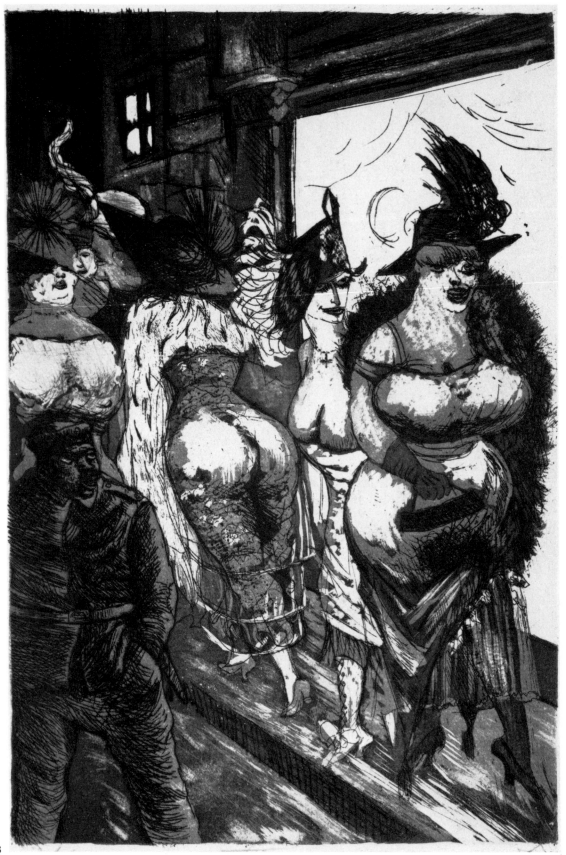

173

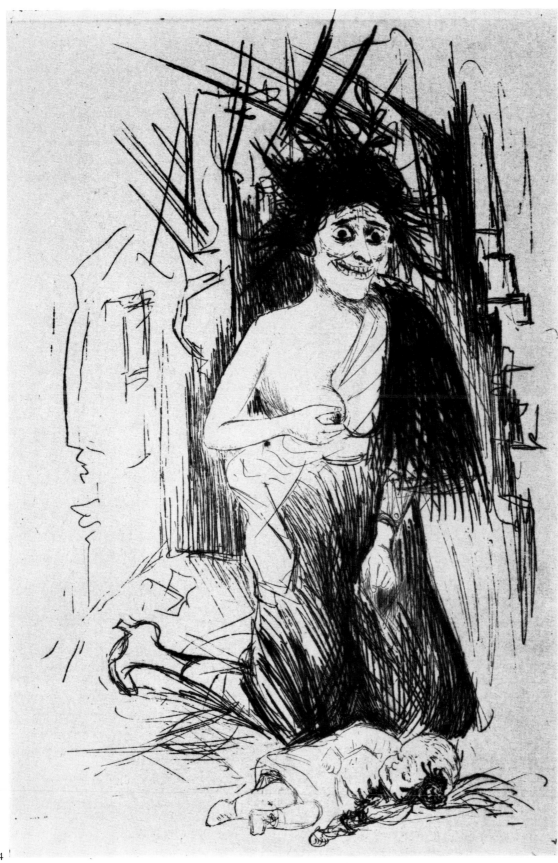

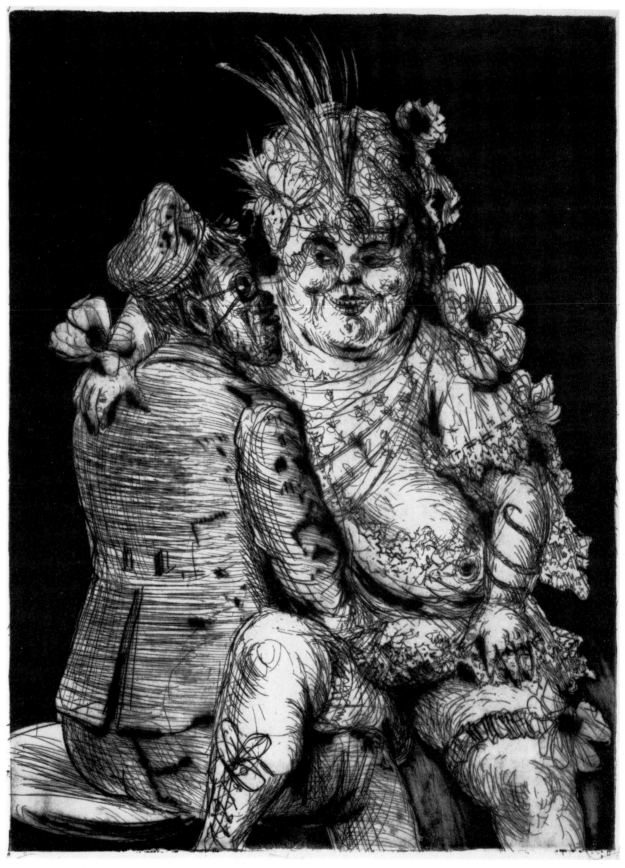

175

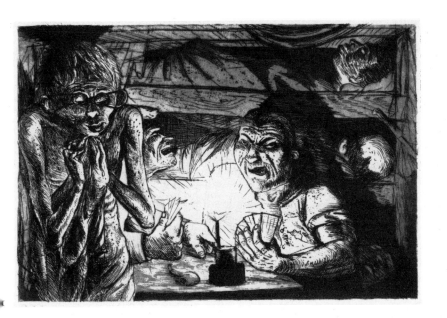

187 *Mutzli* (Frau Dix)
1924

Drypoint. Signed and dated in pencil bottom right. Numbered VII/XXV bottom left.
245 × 192 mm
Karsch 123
1984–2–25–4

Dix married Martha Lindner in Düsseldorf in 1923, commemorating the union with a double portrait in oils. It was as a portraitist that Dix earned much of his reputation as the leading exponent of Neue Sachlichkeit, even, at a later date, exciting the dubious admiration of Ribbentrop. Self-portraiture held a particular fascination for him and this drypoint of his wife should be compared with a glowering self-portrait in the same medium, of 1922 (Karsch 17).

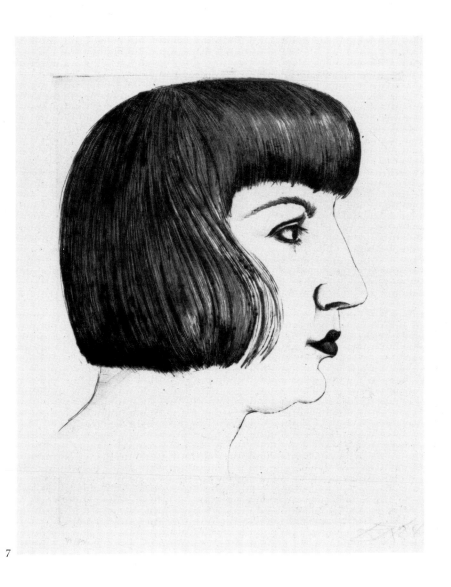

7

BERNARD KRETZSCHMAR
1889–1972

Born in Döbeln in Saxony; his father was a tailor. At the age of fifteen he was apprenticed as a decorative painter. By 1909 he had saved enough to enroll at the Dresden Kunstgewerbeschule, from where he moved to the Kunstakademie in 1911. His studies there lasted until 1920, with the exception of two years spent in the army medical corps in 1917–18. In 1920 he destroyed most of his work and started afresh, now basing his paintings and prints on the life of Dresden and the small suburban town of Gostritz where he lived. His speciality in the 1920s and 1930s (to which most of his best work belongs) remained the life of the petty bourgeoisie and artisans, depicted with a meticulous accumulation of detail and affectionate irony. It is this sympathy that distinguishes him most clearly from the better-known realists of the period such as Grosz and Dix, whose observations are always critical in intention. In 1945 his studio and its contents were destroyed in the bombing of Dresden. However, he remained there and was made a professor at the Dresden Akademie. In post-War years he devoted himself mainly to painting portraits and landscapes and does not seem to have received more than a general acknowledgement in East Germany, while in West Germany he has been completely ignored. He remains the only artist of those included here who has not yet received proper recognition.

Bibliography

The only monograph on Kretzschmar, published by Diether Schmidt in Leipzig in 1970, includes a catalogue of the prints. Unfortunately we have at the time of writing failed to locate a copy to consult. The information given here is drawn from the catalogue of the memorial exhibition held by the Akademie der Künste in the Nationalgalerie in East Berlin in 1974, supplemented by the informative notice published in Thieme-Becker's *Allgemeines Lexikon der bildenden Künstler* in 1927.

188 *In the butcher's shop*
1921

Drypoint and aquatint. Signed and dated *21* in pencil. 265 × 294 mm
Schmidt 64. With the Ganymed blind-stamp of the Marées-Gesellschaft in the bottom right corner
1982–7–24–20

This was one of Kretzschmar's first prints to become well known. Otto Hettner, one of the teachers at the Dresden Akademie, had recommended Kretzschmar to Julius Meier-Graefe, who gave him much help and included this print as plate 6 in the first of the Ganymed portfolios published by the Marées-Gesellschaft in an edition of 200 (cf. p. 159). The sign above the door can be translated: 'No credit – I have found that it loses me both my goods and my customers'. Compared with the next print, made in the following year, it shows a looser, more 'Expressionist' line, and a steeper perspective. It was probably influenced by Dix's drypoint *Butcher's Shop* of 1920 (Karsch 7) which was based on an earlier painting.

188

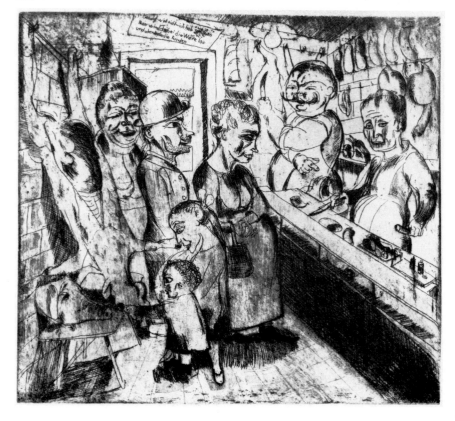

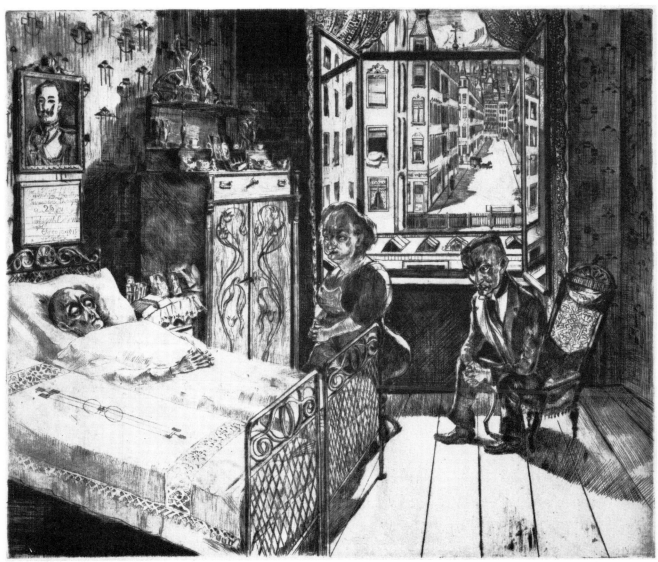

189

189 *The death of Secretary K*
1922

Drypoint and burnished aquatint. Signed,
dated *22* and titled *Tod des Sekretärs K* in
pencil. 323 × 394 mm
Schmidt number unknown
1983–6–25–21

This is one of Kretzschmar's finest prints,
and apparently the first he made on such
a scale. The full title given by Löffler (in
the introduction to the 1974 catalogue,
p. 9), is *The death of Secretary Krüger*;
whether Krüger was an actual individual
or just a type is not clear. The
characterising of the turn-of-the-century
bedroom in which the deceased lies is
careful in every detail, from the wallpaper,
cabinet and trinkets to the portrait of
Kaiser Wilhelm II and the certificate
recording twenty-five years' service
behind the bed. In later years Kretzschmar
added three further prints to make a
cycle entitled 'About a man': in 1930 he
made *The burial*, in 1932 *The Heirs*,
and in 1933 *Lost hours* (illustrated as
plates 22, 24 and 25 of the 1974
catalogue). Related to the series, though
not apparently part of it, are two further
prints, *God seeker* (1932) and *Secretary
sought – or Much ado about nothing* (1938,
ill. plate 29).

KARL HUBBUCH

1891–1979

Born in Karlsruhe, where he was to remain for most of his life. His studies at the Karlsruhe Akademie (1908–12) and then in Emil Orlik's class at the school attached to the Berlin Kunstgewerbemuseum, were interrupted by the First World War, in which he served in the army. At the end of the War he fell seriously ill with malaria and spent two years recovering at his parents' home in Neuenburg. Only in 1920 did he resume his training with a year spent in Walter Conz's etching class in Karlsruhe. By 1921 he had developed his own unique mixture of phantasy and realism (see 190) and found a patron who paid for two years spent in Berlin, in 1922 and again in 1924. Here his compositions adopted a less personal and more social and political note. In 1925 he was appointed to a teaching position at the Landeskunstschule in Karlsruhe, which he held until dismissed by the Nazis in 1933. He supported himself during the following years by piece-work, painting clock faces and ceramics, until in 1947 he was again appointed to a teaching post; he retired in 1957.

Even in the 1920s Hubbuch was hardly a well-known artist, partly because he devoted himself to drawing and printmaking and made few paintings, and partly because of his strange and inscrutable compositions. In the Nazi years he was completely forgotten and was only 'rediscovered' in the late 1960s and 1970s. He made his first prints in 1919, and produced his best works between 1921 and 1924. After 1930 there is a gap of nearly twenty years in his printmaking; when he took up the medium again in 1949 he adopted a late Expressionist style which had nothing in common with his hard-edge Neue Sachlichkeit manner of the 1920s.

190

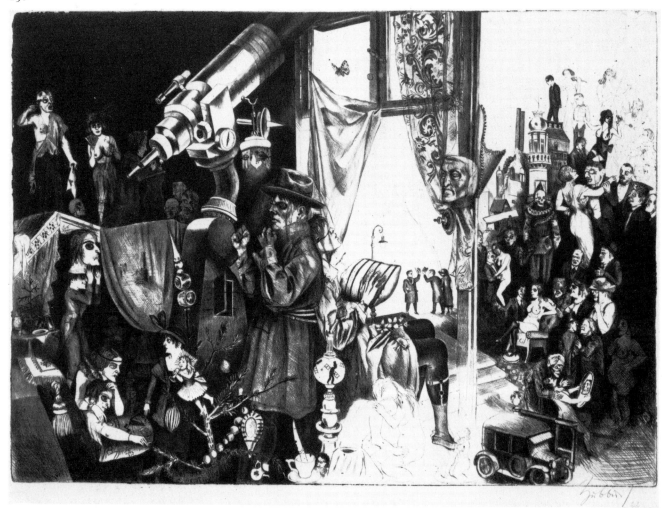

Bibliography

The only full study of Hubbuch's work is the catalogue of the memorial exhibition held in Karlsruhe in 1981. This large volume includes an excellent study of his life and work by Wolfgang Hartmann among a number of other essays, as well as numerous reproductions. A first attempt at producing a catalogue of his prints was made by Rudolf Riester in the catalogue of the exhibition *Karl Hubbuch, das graphische Werk* held in Freiburg in Breisgau in 1969. According to Hartmann in the Karlsruhe catalogue (p. 35, note 1) the 198 prints described comprise only about half his work, and the chronology is confused. Another significant catalogue, *Der frühe Hubbuch, Zeichnungen und Druckgraphik 1911–25* by Hans Kinkel, was published on the occasion of an exhibition held in the Kunsthalle in Bremen in 1973.

190 *Wissend und Blind* (The knowing and the blind: self-portrait)

1922

Drypoint. Signed and dated 22 in pencil
324 × 458 mm
Riester 54, an impression printed in the late 1960s
1982–11–6–10

This is one of Hubbuch's most ambitious prints, and a typical example of his method of composition by juxtaposing in illogical groupings and on arbitrary scales quite unrelated elements, some autobiographical, others erotic, yet others political in character. A clue to its meaning is given by Hubbuch in a letter of February 1973 quoted by Hans Kinkel in the last paragraph of his introduction to the 1973 Bremen catalogue: 'The two main figures when added together give one person – half energetic and purposeful, half sentimental and suffering, bound together with uncompassionate ropes . . . The telescope: in order to see things better, more clearly, even those lying far off. Instrument, tool for Verismus'. This suggests that it shows the two sides of Hubbuch himself: one part of him fighting against the tribulations of the world armed with his telescope, which brings knowledge, the other blind to its charms and apparent delights.

An early state of this print, reproduced on page 130 of the 1981 Karlsruhe catalogue, shows how Hubbuch built up his compositions by adding and subtracting elements: in the finished state (the sketchy and unfinished appearance of certain areas is typical of all of his prints) the head of Dante by the curtain has been added, while a group of figures at the right in the centre has been obscured by a mass of lines.

According to Riester, only four of Hubbuch's prints of the 1920s were published in formal editions. Most, like the plate, were printed as occasion demanded. Since Hubbuch was little known, demand was not large and so early impressions are now very scarce. Most of the plates however survived to be reprinted from the 1960s onwards as interest in Hubbuch's work revived. This impression is such a restrike.

JOHANNES ITTEN

1888–1967

Born in the Bernese Oberland. He trained as a primary school teacher in the Froebel method from 1904 to 1908; during his course he encountered Paul Klee's father Hans, who encouraged his musical gifts and introduced him to philosophy. In 1912, after studying natural sciences and mathematics at the University of Berne for two years, he decided to become a painter, inspired by visits to Paris and Munich. He enrolled at the Stuttgart Akademie in 1913, where he joined the circle of students around Adolf Hoelzel (1853–1934), an important colour theorist and a pioneer of abstraction. In 1916 Herwarth Walden exhibited Itten's work at the Sturm Gallery. From 1916 to 1919 Itten ran a private art school in Vienna where he developed his radical methods of instruction. Alma Mahler introduced him to a distinguished intellectual and artistic circle which included the composers Arnold Schönberg and Alban Berg and the architects Adolf Loos and Walter Gropius. Her recommendation of him to Gropius, to whom she was married, secured Itten an invitation to become one of the first Masters of Form at the Bauhaus in 1919. At first he was in charge of the workshops for carving, metalwork, stained glass and mural-painting; however, his greatest contribution was the design of the preliminary course which dominated the Bauhaus teaching programme thereafter. By 1923 Gropius could no longer tolerate Itten's eccentric individualism and the latter returned to Switzerland to work near Zürich. He opened another school of his own in Berlin in 1926. From 1934 to 1935 he directed the school of Textile Design in Krefeld; he was included in the exhibition *Entartete Kunst* of 1937, and in the following year the school in Krefeld closed. Itten continued his interest in

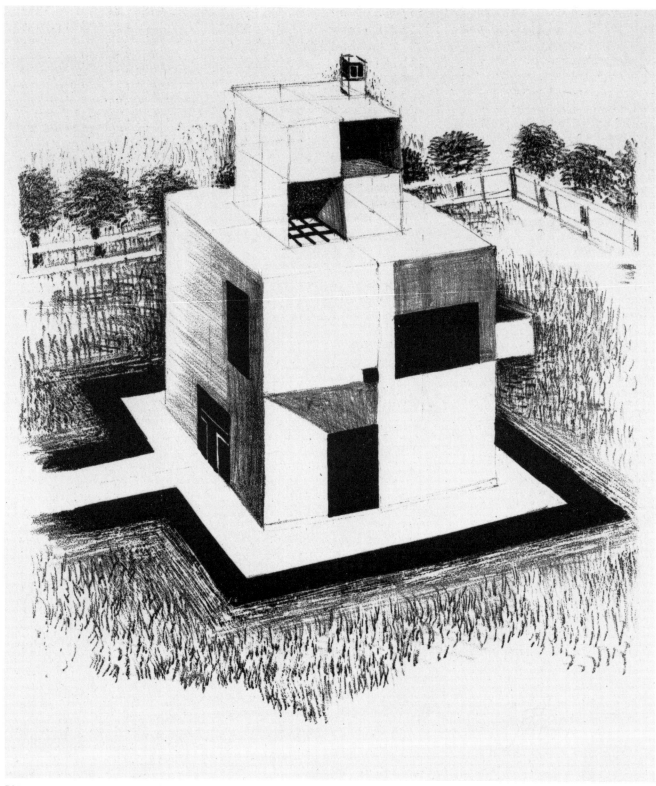

191

textile design after his return to Zürich in 1938, where he held the positions of Director of the Kunstgewerbe School and Museum, and later, of the School of Textile Design and the Rietberg Museum. His pedagogical influence remained considerable within Switzerland, and the latter part of his life was largely devoted to working on his theory of colour. The basic course he had created for the Bauhaus was eventually published as *Mein Vorkurs am Bauhaus, Gestaltungs- und Formenlehre* (Ravensburg 1963).

Itten was one of the most extraordinary personalities associated with the Weimar Bauhaus; he adopted a quasi-monastic attire in keeping with his mystical beliefs in Mazdaznan, an obscure cult whose practical consequences for the Bauhaus entailed a rigorous vegetarian diet, which was forced on the canteen menu to the consternation of some of the students. He fiercely resisted any suggestion that the Bauhaus be made more responsive to the needs of industry, unlike his successor, Moholy-Nagy, whose approach was the very antithesis of Itten's. Oskar Schlemmer provides an amusing glimpse of Itten's highly idiosyncratic teaching methods: 'Itten gives analyses at Weimar. He shows slides from which the students are supposed to draw this or that essential element; usually the movement, the main line, the curve. Then he refers to a Gothic figure. After that he shows the weeping Mary Magdalene from Grünewald's altarpiece; the students strive to separate some essential feature from the very complex configuration. Itten sees their attempts and thunders: "If you had any artistic sensibility you would not draw in the presence of this sublime image of weeping, which could be the weeping of the world, you would sit there and burst into tears". So saying he slams the door'. (*The Letter and Diaries of Oskar Schlemmer*, ed. Tut Schlemmer, 1972, Letter to Otto Meyer, 16 May 1921.) Nevertheless, his influence, with that of Klee and Kandinsky, on art education, extended far beyond the confines of the Bauhaus. The emotional content of his theory of form and colour did not prevent the development of a rigorous course of study, designed to inspire a new visual language.

Itten was only an occasional printmaker. He used lithography simply as another means for disseminating his pedagogical principles, as exemplified by his portfolio of 1921, 'Utopia, Dokumente der Wirklichkeit', a series of rythmic designs entitled 'Analyses of Old Masters'.

Bibliography

Mein Vorkurs am Bauhaus appeared in an English translation as *Design and Form, the basic course at the Bauhaus*, Toronto and London 1964. Itten's own diary of his teaching materials and methods with numerous illustrations was published in a limited edition in 1930 by the Itten School in Berlin as *Tagebuch: Beiträge zu einem Kontrapunkt der bildenden Kunst* (a copy is in the British Museum). *Johannes Itten, Werke und Schriften*, edited by Willy Rotzler and with a Werkverzeichnis by Annaliese Itten, Zurich 1978, is the only complete study, and contains a full biography. Frank Whitford provides a particularly vivid account of Itten in his recent book on the Bauhaus (*Bauhaus*, London 1984).

191 *Das Haus des weissen Mannes* (House of the white man) 1920

Lithograph. Signed in pencil. 253 × 242 mm
Werkverzeichnis 222. From the first Bauhaus portfolio.
1942–10–10–30(4). Presented by Mr Erich Goeritz.

This print comes from the first of the four published Bauhaus portfolios; their composition and significance are discussed in the introduction (pp. 24–5). Each portfolio was published in an edition of 110 copies. The first 10 were on Japan paper, and the remainder (of which our copy is number 35) on ordinary paper. As the caption states: 'All the prints are printed by hand in the printing shop of the State Bauhaus. Each sheet is signed by the artist himself. The portfolio cover is hand-made in the book bindery of the State Bauhaus'. The cover of this first portfolio was designed by Feininger, who also designed the title-page and list of contents. It contains a total of fourteen prints, two by each of the Bauhaus masters. They are numbered in this catalogue as follows: Itten, 191–2; Feininger, 195–6; Marcks, 197–8; Klee, 200–1; Muche, 203–4; Schreyer, 206–7; Schlemmer, 208–9.

The contents sheet of the portfolio identifies *Das Haus des weissen Mannes* as an architectural study; it relates to the idealised architectural compositions, mainly in the form of models, which Itten was producing in 1919 and 1920.

192 *Spruch* (Dictum) 1921

Lithograph printed in five colours, yellow, red, green, blue and black. Signed in pencil below.
295 × 228 mm
Werkverzeichnis 223. From the first Bauhaus portfolio.
1942–10–10–30(3). Presented by Mr Erich Goeritz.

This is one of a number of similar calligraphic dicta made by Itten in 1921. Four of them appeared as lithographs (Werkverzeichnis 242, 244, 246, 248); another with a text of Jacob Boehme is a watercolour (Werkverzeichnis 225). The text of this print is taken from Dr Otoman Zar-Adusht Hanish (1848–1936), the founder of the Mazdaznan movement, and the author of *How to fast scientifically* and the *Mazdaznan dietetics and cookery book*, among numerous other titles. Itten's own account of Mazdaznan is published by Rotzler (1978, pp. 228–9); his connection with it lasted from 1920 to Hanish's death in 1936.

The text of the dictum can be translated: 'Greeting and salutation to hearts which live illumined by the light of love, and are not led astray either by hopes of a heaven or fear of a hell'.

LYONEL FEININGER

1871–1956

Born in New York. His parents were
both German, and were distinguished
concert musicians. Feininger was
something of an infant prodigy on
the violin, and in 1887 was sent to
Hamburg for further study. He quickly
decided, however, that music was
not to be his career, and enrolled in
the Kunstgewerbeschule in Hamburg,
moving on to the Berlin Akademie in
1888, and spending six months in
Paris in 1892–3. On his return to
Berlin he took up the profession of
cartoonist and political caricaturist,
which he was to follow for fourteen
years, working for different illustrated
papers. In 1906 a lucrative contract
from the *Chicago Sunday Tribune* for
his comic strips enabled him to move
to Paris for two years. There he
decided to give up cartoons and
devote himself to painting. His early
canvases, however, are still very
much in the caricaturist mould, and
it was not until 1911 when he saw
Cubist paintings for the first time
during a brief visit to Paris that he
transformed his style, adopting the
dislocated planar surfaces that were
to be such a consistent feature of all
his future work. In 1919 he was
appointed to the Bauhaus, and
remained associated with it until it
was closed down in 1933; between
1919 and 1925 he was in charge of
the graphic printing shop, where he
exercised a powerful influence on his
students and colleagues, particularly
in introducing them to the technique
of woodcut. The *Entartete Kunst*
exhibition of 1937 persuaded him to
return to America (he had retained
his American citizenship), where he
lived in New York during the winter
months, while spending the summers
in the country.

Feininger made 65 intaglio prints,
20 lithographs and 320 woodcuts.
Most of the etchings and drypoints
were made between 1910 and 1912,
and he virtually abandoned the

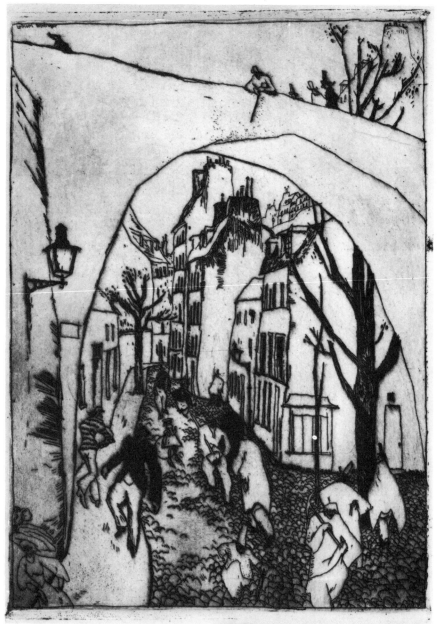

193

medium after 1917 in favour of
woodcut. He made his first woodcut
in 1918, and produced over two-
thirds of his complete oeuvre in the
three years 1918–20; a diminished
output in the 1920s and 1930s
ceased entirely after his move to
America.

See also 259.

Bibliography

The standard monograph is Hans Hess,
Lyonel Feininger, Stuttgart 1959 (English
trans. 1961) which contains an oeuvre
catalogue of the paintings compiled by
Julia Feininger, the artist's widow. The
prints were catalogued by L.E. Prasse,
*Feininger, a definitive catalogue of his
graphic work*, Cleveland 1972. Ernst
Schleyer, *Lyonel Feininger, caricature and
fantasy*, Detroit 1964, has much
information on Feininger's early work as
a cartoonist. June L. Ness, *Lyonel Feininger*,

New York 1974, in the 'Documentary
Monographs on Modern Art' series,
publishes in translation a large number
of the artist's letters.

193 *The green bridge*
1910–11

Etching. Signed and titled *Die grüne Brücke* in
pencil. 286 × 196 mm
Prasse 22
1969–12–13–5. Presented by Lord Croft.

This is a typical example of Feininger's
early style; the drawing of the figures
betrays the hand of the expert cartoonist.
The etching reproduces in reverse the
composition of a painting of the same
title, finished on 6 May 1909, and
exhibited in the Salon des Indépendants
in Paris in 1911 (oeuvre cat. 44). To
judge from a comparison with a painting
of 1907 (oeuvre cat. 24), the bridge may
have been in Arcueil.

The plate was apparently etched a few
years after the painting, but was only
published in 1922, in a portfolio
distributed to members of the Kreis
graphischer Künstler und Sammler in
Leipzig. A possibly autograph annotation
on the bottom margin of this impression
states that it was printed before this
edition.

194 *The Gate*
1912

Drypoint. Signed in pencil. 271 × 198 mm
Prasse 52. On thick Japan paper. With the
blindstamp of *Die Schaffenden* in the bottom left
corner.
1983–1–27–5

The contrast with the previous print
shows the effect of the visit Feininger had
made to Paris in May 1911, when he had
seen Cubist paintings for the first time.
The plate is inscribed with a signature,
the title *The Gate* in English, and the date
Wednesday, Sept.4. 1912. Prasse illustrates
an almost identical preparatory drawing
in reverse, which is dated *Saturday,
Nov. 4. 1911*. To judge from a woodcut
of 1918 (Prasse 10) and a painting of
1943 (oeuvre cat. 432) which show a
very similar structure identified as the
town gate of Ribnitz, this must also be a
view of that gate. It is certainly not, as
may be thought, fanciful. Ribnitz is on
the Baltic coast in Mecklenburg, north-
east of Rostock, in a region where

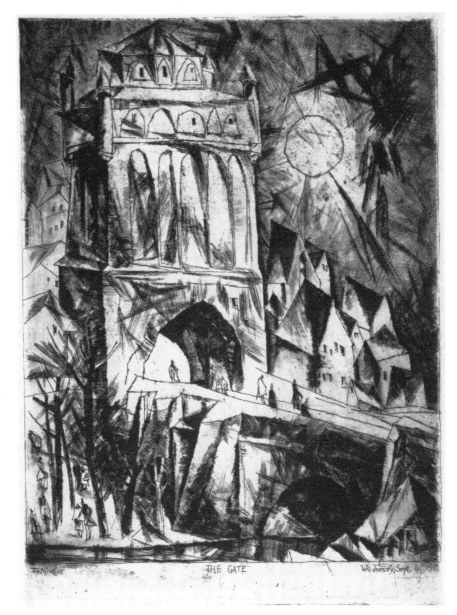

194

Feininger often spent his summers. There
is also a view of the gate in a woodcut by
Schmidt-Rottluff of 1912 (Schapire 81).
Feininger's love of Gothic buildings is
well attested in his correspondence.

The print was only published seven
years later, in *Die Schaffenden*, the most
important of the collections of original
prints published in post-War Germany.
It was produced in three volumes in
1919–22, each volume containing four
portfolios with ten prints in each; the
editor was Paul Westheim and the
publisher the Gustav Kiepenheuer Verlag

in Weimar. For a complete listing of the
contents of the first three volumes, see
Kornfeld auction 116 (1965) lot 1044,
supplemented by auction 132 (1969)
lot 1146. The publication was then
taken over by the Euphorion Verlag in
Berlin, and continued for five further
volumes until it expired in 1932 (cf.
Prasse, 1972, pp. 11, 33, 258–9).

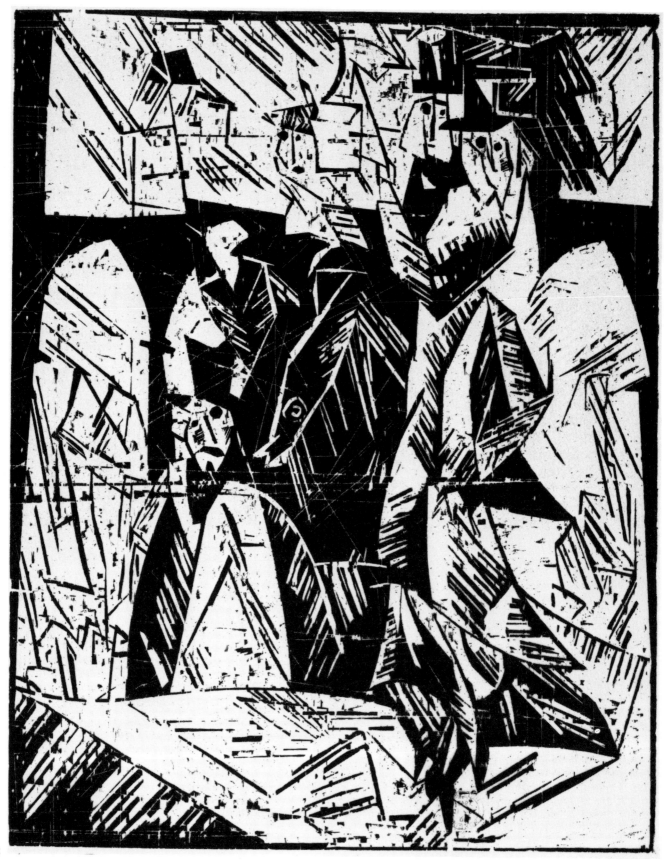

195

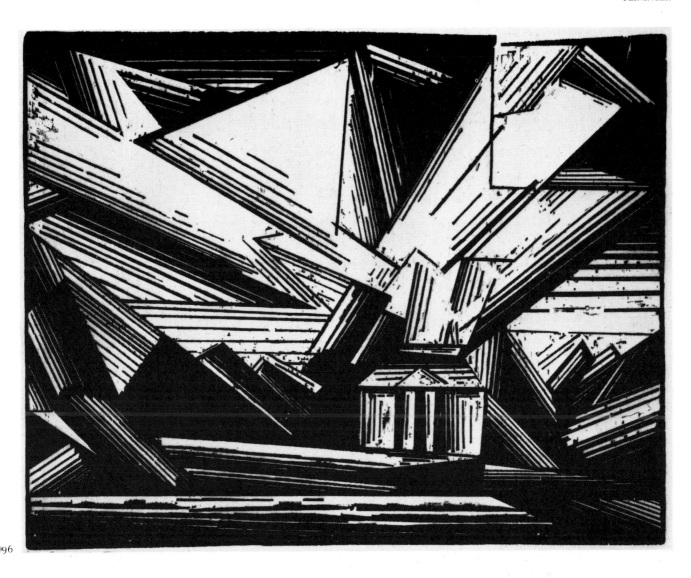

96

195 *Promenaders*
1918

Woodcut. Signed in pencil bottom left.
369 × 295 mm
Prasse 113. On tissue paper, published in the
first Bauhaus portfolio.
1942–10–10–30(2). Presented by
Mr Erich Goeritz.

According to Gerhard Wietek (*Schmidt-Rottluff Graphik*, Munich 1971, p. 59), Feininger was introduced to woodcut by Schmidt-Rottluff's friend Emma Ritter. Many of his early woodcuts, like his etchings, are related to earlier paintings. This one is a version, in reverse, of a painting made in 1915 entitled *Promenade, Arcueil* (oeuvre cat. 144).

196 *Villa on the shore*
1920

Woodcut. Signed in pencil bottom left.
268 × 342 mm
Prasse 226. On thin Japan paper, published in
the first Bauhaus portfolio.
1942–10–10–30(1). Presented by
Mr Erich Goeritz.

The villa portrayed is the Villa Staudt at Heringsdorf at which Kaiser Wilhelm II often stayed during fleet manoeuvres in the summer. It would have been well known to Feininger, who spent his summers at Heringsdorf, a Baltic seaside village, between 1909 and 1911. Although there seem to be no paintings of this subject, there are three earlier woodcut versions of the composition (Prasse 2, 3 and 80, of 1918). Such repeated reworkings of a subject in different media and styles is a pronounced characteristic of Feininger's work. For example, woodcut versions of *The Gate* were produced in 1918 (Prasse 10) and 1920 (Prasse 227), and a painted version in 1943 (oeuvre cat. 432).

GERHARD MARCKS

1889–1981

Born in Berlin. In 1907 he entered
the atelier of the painter Richard
Scheibe, but was directed towards
sculpture by Georg Kolbe and August
Gaul, who helped to inspire his
interest in animal motifs. He served
as a soldier at the beginning of the
First World War until invalided out
of the army. He encountered Gropius
at the Cologne Werkbund exhibition
of 1914, to which they both
contributed. In 1918–19 he taught
sculpture at the Kunstgewerbeschule
in Berlin under the directorship of
the architect Bruno Paul. In 1919 he
was one of the first Masters, together
with Itten and Feininger, to be
appointed by Gropius to the Bauhaus.
Marcks was put in charge of the
Ceramic Workshop at Dornburg, a
pottery centre not far from Weimar,
which became one of the most
successful manifestations of the early
Bauhaus concern for 'organic
creations to be developed from
craftsmanship' (Programme of the
State Bauhaus in Weimar 1919).
The years 1919–24 were crucial to
Marcks's development as a graphic
artist and sculptor; he was deeply
influenced by traditional forms of
German art which he sought to
assimilate to the Expressionist
sculptural style represented most
notably by Barlach. By 1925 his
divergence from the increasingly
technological orientation of the
Bauhaus had become quite apparent
and he did not move with it to
Dessau, taking instead a position at
the Kunstgewerbeschule at Burg
Giebichenstein near Halle, where he
became director in 1928. In 1933 he
was dismissed, and retreated to the
Baltic coast; as a 'degenerate' artist,
from 1937 he was barred from
participation in all forms of cultural
activity. After the war in 1946–50
he became Professor at the State
School of Art in Hamburg, during
which period he executed one of his

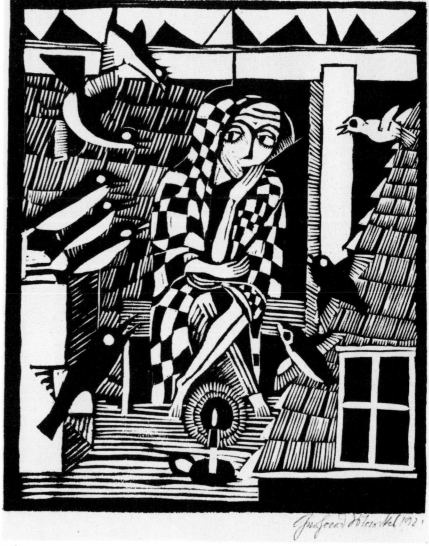

198

most important commissions, the
completion of the sculptural
decoration, begun by Barlach, for the
façade of St Catherine's Church,
Lübeck. In 1950 he retired to Cologne
where he resided until his death.

Bibliography

Günter Busch and Martina Rudloff,
Gerhard Marcks, das plastiche Werk,
Frankfurt-am-Main 1977, provides the
most complete picture of Marcks as an
artist with a catalogue of his sculpture.
A general survey is in the exhibition
catalogue, *Gerhard Marcks*, University of
California, Los Angeles 1969. A catalogue
raisonné of his prints was being prepared
initially by his dealer in Hamburg, Rudolf
Hoffmann, and then continued by
Hoffmann's widow, but no publication
has yet appeared. *Gerhard Marcks, Frühe
Holzschnitte 1901–27*, Ernest Rathenau,
New York 1972, is a picture-book which
makes no claim to completeness.

197 *Die Katzen* (The cats)
1921

Woodcut. Signed and dated in pencil bottom left. 237 × 387 mm
On coarse-grained paper, published in the first Bauhaus portfolio.
1942-10-10-30(7). Presented by Mr Erich Goeritz.

It was Feininger who revealed to Marcks the expressive possibilities of woodcut composition; this discovery was to have a decisive effect upon his printmaking and sculpture. 'I made friends with Feininger at Weimar in 1920. The miracles he wrought with a straight edge and penknife on the pine blocks were naturally inimitable as far as I was concerned. But the woodcut appealed to me. I cautiously began to make a picture. Abstraction was the keyword at the Bauhaus. I only resorted to this in the organisation of the plane surface, that is to say, the woodblock: black, grey, white marks were made in the appropriate places and a network of lines duly emerged, but this was all for a representational purpose, not an end in itself' (Busch and Rudolf, 1977, p.46).

One outcome of Marcks's experimentation with woodblock cutting and printing was his increasing use of wood as a sculptural material. By 1927 he had produced over fifty woodcuts. He contributed to the portfolio of the Masters of the State Bauhaus published in 1923, and in the same year the Bauhaus issued *Das Wielandslied der Edda* (The Wieland Saga in the Edda), containing ten woodcuts by Marcks.

198 *Die Eule* (The owl)
1921

Woodcut. Signed and dated in pencil bottom right. 282 × 238 mm
Published in the first Bauhaus portfolio.
1942-10-10-30(8). Presented by Mr Erich Goeritz.

This particular image demonstrates Marcks's interest in the German popular woodcut tradition.

PAUL KLEE
1879–1940

Born in Münchenbuchsee, near Berne; his father, a music teacher, was German and Klee had German nationality. In 1898 he entered Knirr's private academy in Munich, and in 1900 moved to Franz Stuck's class at the Akademie for a year. This completed his formal training. After seven months spent in Italy, he returned to Berne in 1902, where he lived with his parents until 1906. The chief product of these four years was a group of etchings (see 199); Klee was to remain primarily a graphic artist until 1914. In 1906 he married and moved to Munich, but remained isolated until the *Blaue Reiter* exhibition of 1911–12 introduced him to many of the leading figures in contemporary art, and led to a visit to Paris where he was decisively influenced by Cubist paintings. A visit to Tunis in 1914 in the company of August Macke was equally important in turning him first to watercolour and then to painting. He was in the German army from 1916 to the end of the War.

In 1919 he was rejected as a successor to Adolf Hoelzel at the Stuttgart Akademie on the grounds that his 'past and recent work revealed his work to be playful in character and lacking the firm commitment to structure and composition which is rightly demanded by the Moderns' (Oskar Schlemmer in a letter of 28 December 1919; *Letters and Diaries of Oskar Schlemmer*, 1972, p. 77). In late 1920 he was appointed to the staff of the Bauhaus, where he remained for eleven years. His most important contribution, like Itten's, was in teaching the preliminary course in basic principles of design. Other specific areas of responsibility were the bookbinding shop in 1920–2, and later the glass-painting section;

subsequently in Dessau he taught in the weaving shop. In 1931 he took another appointment at the Akademie in Düsseldorf, but after his dismissal by the Nazis in 1933 retired to Berne, where he applied for Swiss citizenship and remained for the rest of his life.

Klee was a curious mixture of a highly imaginative artist who was yet very deliberate and premeditated in all his work. He habitually committed his thoughts self-consciously to paper: besides numerous notebooks, letters, essays and pedagogical treatises, a number of poems are known. Another aspect of his almost programmatic development of his art is the self-compiled 'Werk-verzeichnis' of everything he produced; he began this in 1911, extending it back to 1884, and continued it to his death. The manuscript is now kept with much else in the Klee Foundation established in the Kunstmuseum in Berne.

Klee's 109 catalogued prints fall in general into four groups: the early Berne etchings of 1903–5; a group of linear landscapes in an 'impressionist' manner of 1911–12; the 'cubist' etchings of 1913 and the Cubist-derived works of the years before the War; and finally the prints made in Munich after the end of the War and at the Bauhaus, firstly a number of lithographs in 1921–5 and then some etchings in 1928–32.

Bibliography

The basic editions of Klee's own non-theoretical writings are the following: *Tagebücher 1898–1918*, ed. Felix Klee, Cologne 1957 (English trans. 1964); *Briefe an die Familie*, ed. Felix Klee, 2 vols, Cologne 1979; *Schriften: Rezensionen und Aufsätze*, ed. Christian Geelhaar, Cologne 1976. Klee's 'Werkverzeichnis' has not been published, but the catalogue of the works in the Klee Foundation in the Kunstmuseum in Berne being published by Jürgen Glaesemer will contain a quarter of his oeuvre. So far two volumes have been published, on the coloured

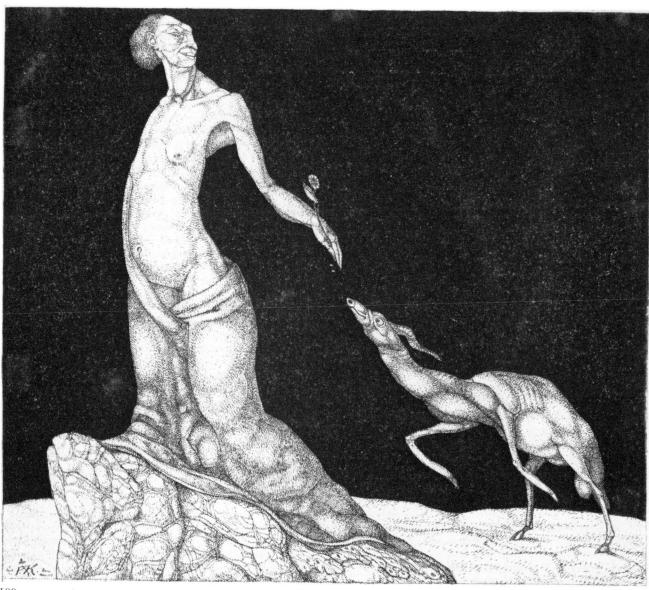

199

works (in 1976) and the drawings made
before 1920 (in 1973). E.W. Kornfeld,
*Verzeichnis des graphischen Werkes von
Paul Klee*, Bern 1963, is the standard
catalogue raisonné of the prints, which
can be supplemented by the excellent
essays in two exhibition catalogues: *Paul
Klee, das graphische und plastische Werk*,
Lehmbruck-Museum, Duisburg 1974, and
The Graphic Legacy of Paul Klee, Bard
College, Annandale-on-Hudson, New
York 1983.

The secondary literature on Klee is
huge. A brief introduction is Norbert
Lynton, *Klee*, London 1964 (2nd edn

1975), as is Christian Geelhaar, *Paul
Klee, Leben und Werk*, Cologne 1974
(English trans. 1982). Geelhaar has also
written a monograph *Paul Klee und das
Bauhaus*, Cologne 1972 (English trans.
1973). There are also numerous
exhibition catalogues on all aspects
of Klee's art.

199 *Woman and animal*
1904

Etching and aquatint. 183 × 199 mm
(trimmed within the platemark and laid down)
Kornfeld 13, apparently a proof apart from the
signed and numbered edition of 20.
1945–12–8–214. Presented by the
Contemporary Art Society.

The series of eleven etchings which
together form Klee's 'Opus 1' under the
title 'Inventions' was made in Berne
between July 1903 and March 1905;
they are the strangest and most perplexing
works in Klee's oeuvre. They share a

bizarre mixture of freakish satirical distortion, incomprehensible iconography and strong eroticism. Commentators have seen them as a deliberate assault on the classical tradition of figure drawing, then fresh in his consciousness after the months spent in Italy in 1901–2, and an attempt to create a style which was quite original and independent. But he soon realised that this was a dead end, and started off in a new direction with a study of light and tonal gradations.

This etching was intended by Klee as the first of the series. It derives from two drawings *Whippet-like beast* and *Doll-like lady* (Glaesemer 269, 270) made in Rome in 1902, and Klee had made a first, rejected etched version in 1903 (Kornfeld 3). In a diary entry of July 1903 (*Tagebücher*, no. 513) Klee commented on the image thus: 'The beast in man pursues the woman, who is not entirely averse to it. Affinities of the lady with the bestial. A bit of unveiling of the female psyche. Recognition of a truth that one likes to mask.'

200 *Die Heilige vom inneren Licht* (The saint of the inner light) 1921

Lithograph printed in black and two shades of brown. Signed and annotated with the work-number *1921/122* in pencil. 311 × 175 mm Kornfeld 81 II c. From the first Bauhaus portfolio.
1942–10–10–30(6). Presented by Mr Erich Goeritz.

This and the following lithograph were made for publication in the first of the Bauhaus portfolios, devoted to the work of the masters teaching there. Both were printed in the Bauhaus printing workshop, and both were produced by a curious tracing technique that Klee had first devised in 1919. It enabled him to reuse his drawings for prints by tracing them through a sort of hand-made 'carbon' paper onto ordinary lithographic transfer paper; from this the design was transferred to the stone for printing in the usual way. This tracing process is responsible for the blurred line and random background grain that distinguishes these prints; in this they are somewhat reminiscent of Gauguin's traced monotypes. Klee later extended his use of this technique to make drawings and watercolours (sometimes referred to

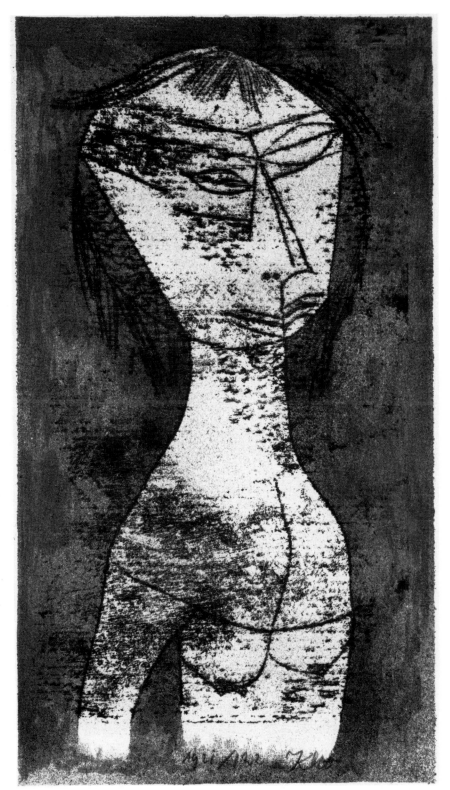

200

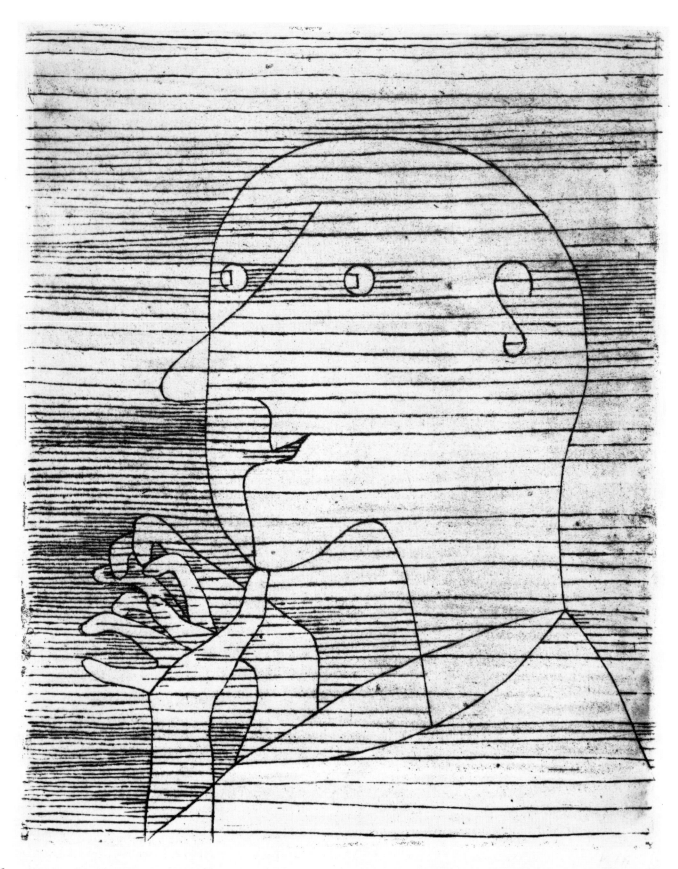

202

in the Klee literature as 'oil-transfer paintings'). An interesting discussion of the subject by Jim M. Jordon is published in the 1983 Bard College exhibition catalogue, pp. 87–105. The original drawing (work number 1921/158) is in the collection of E.W. Kornfeld in Bern (no. 82c of the 1974 Duisburg catalogue).

201 Hoffmanneske Szene (Hoffmannesque scene)
1921

Lithograph, printed in black, yellow and violet. Signed and annotated with the work number 1921/123 in pencil. 317 × 230 mm Kornfeld 82 IIc, from the first Bauhaus portfolio.
1942-10-10-30(5). Presented by Mr Erich Goeritz.
See colour illustration

The title, alludes to E.T.A. Hoffmann (1776–1822), who is famous for his often macabre short stories.

202 Old man counting
1929

Etching. Signed and numbered 77/125 in the bottom left-hand corner in pencil
297 × 238 mm
Kornfeld 104 b, from the edition of 125 for the Schweizerische Graphische Gesellschaft.
1930-1-18-13. Presented by Campbell Dodgson Esq.

This etching was distributed to the members of the Swiss Graphic Society; it was apparently much disliked and several members destroyed their copies (so Felix Klee, p. 20 of the 1983 Bard College catalogue). Dodgson, a member of the Society, fortunately decided to present the work to the British Museum instead. The etching is based on an almost identical drawing (so Felix Klee, *op. cit.*).

GEORG MUCHE
b. 1895

Born in Querfurt, Saxony. In 1913–14 he studied painting in Munich at the private academy formerly run by Anton Ažbè, where Kandinsky had also enrolled. The style of *Der Blaue Reiter* had an immediate impact upon Muche; in 1915 he was introduced to the *Sturm* circle in Berlin; his work was exhibited there on several occasions, in conjunction with that of artists like Max Ernst, Paul Klee and Archipenko. Herwarth Walden even gave him a five-year contract in 1917 whereby Muche received a monthly stipend in return for supplying a fixed number of paintings. He taught at the *Sturm* art school from 1917 to 1920 with a brief interruption for military service on the Western Front. In 1919 Gropius invited Muche to join the Bauhaus; after some initial reservations he was persuaded by Feininger's enthusiasm and arrived in Weimar in 1920 as the most junior 'Master of Form'. He immediately assumed considerable responsibilities, principally in connection with Itten's preliminary course, then from 1921 to 1927 as the Master in charge of the weaving workshop. His mystical leanings led him to identify closely with Itten, whom he had met at the *Sturm*, and the Mazdaznan cult; however, by 1923, after Itten's departure, he had apparently undergone a complete volte-face and remained to become a staunch supporter of Itten's successor in charge of the 'Vorkurs', Moholy-Nagy. Muche was head of the organising committee for the first Bauhaus exhibition in 1923, for which he designed the important experimental house, 'Haus am Horn'; together with Marcel Breuer he became the driving-force in the Bauhaus architectural study group, formed in 1924, and produced a highly original 'Stahlhaus' (steel

house) at Dessau-Törten in 1926–7. In 1927 he, like so many of his colleagues, became disillusioned with the Bauhaus under Hannes Meyer's direction, and joined Itten's private school in Berlin. In 1931–3 Muche taught with Schlemmer at the Breslau Akademie, and after the Akademie's closure returned to Berlin to teach at Hugo Häring's school Kunst und Werk for four years. Thirteen of his paintings were removed from public collections in 1937 and two of his prints included in *Entartete Kunst*. From 1939 to 1958 he resumed his interest in textiles, running a master class on design at the Textile-Engineering School in Krefeld; in addition he collaborated with Schlemmer at Dr Kurt Herbert's paint factory in Wuppertal. In his private work he concentrated upon research into the techniques of fresco painting, and in 1965 began to explore an electro-mechanical method of printmaking, 'Vario-Klischography'.

Muche's most interesting prints and drawings belong to the decade from 1913 to 1923, when he was strongly influenced by Chagall and Klee. His particular debt to the latter emerges quite clearly in the two portfolios of etchings and one lino-cut from 1920–1, 'Ypsilon – von den kleinen Maschinen und ihren Ketten – Satire auf den Materialisten N' and 'Cogito ergo credo'. His entire production of prints amounted to only thirty-one items by 1934; thereafter ensued a prolonged caesura until his post-War experimentation with new techniques.

Bibliography

Muche's personal reminiscences in *Blickpunkt: Sturm, Dada, Bauhaus, Gegenwart*, Munich 1961, are interesting, but not always reliable as historical evidence. A complete catalogue of his early paintings and drawings, as well as much documentary material, is contained in the Bauhaus-Archiv catalogue *Georg*

Muche, das künstlerische Werk 1912–1927, edited by Magdalena Droste, Berlin 1980. The prints have been catalogued in another Bauhaus-Archiv publication: *Georg Muche, das druckgraphische Werk*, Berlin 1970, by Peter H. Schiller.

203 *Tierkopf* (Animal head)
1921

Etching. Signed in pencil. 148 × 100 mm
Schiller 12. Published in the first Bauhaus portfolio.
1942–10–10–30(9). Presented by Mr Erich Goeritz.

A pen and ink drawing of 1916 by Muche (Droste 252) entitled *Marc Chagall gewidmet* (Dedicated to Marc Chagall), which was reproduced on the cover of the December 1917 issue of *Der Sturm*, demonstrates the full extent of his debt to the Russian artist, which is again apparent in this etching.

204 *Radierung* (Etching)
1921

Etching. Signed in pencil. 150 × 134 mm
Schiller 13. Published in the first Bauhaus portfolio.
1942–10–10–30(10). Presented by Mr Erich Goeritz.

Although the title of this print is simply given as *Radierung* in the table of contents to the portfolio, Muche refers to it variously as *Hand and Heart* and *The Hand of Fatima* in his reminiscences. The motif of the hand occurs, in reverse, in a painting of 1920–1, *Picture with the green hand and candle shadows* (Droste M62). *Der Hand der Fatme* was a title apparently conferred by Josef Strzgowski when visiting the Bauhaus, after he had prompted Muche to search his memory for an explanation of the imagery. In April 1938 Muche had occasion to repeat this exercise in response to an official letter demanding an elucidation of the ambiguous nature of the print, which had been included in one of the *Entartete Kunst* exhibitions in 1937. 'The idea for the print in question originated in the trenches in 1917. On a reconnaissance trip I was hit by a shell explosion and lay unconscious during the night. At dawn, as I recovered consciousness in the grey devastated area, a brightly coloured patch attracted my attention. It was a

205

tattered cloth, a flag, with a hand depicted in the centre. I reached out across the ground and pulled it towards myself . . . This wartime experience made such an impression upon me that during the years 1919 to 1920 I sought to incorporate it into my paintings and drawings'. The flag had been the standard of a North African cavalry regiment. Muche's explanation must have been accepted as he alludes to the divine power of the symbol when he states: 'The Hand of Fatima preserved me from being denied the right to work' (*Blickpunkt*, pp. 137–8).

205 *Kleines romantisches Formenalphabet* (A little romantic alphabet of forms)
1922

Etching, signed, titled (as above) in centre margin below, and numbered 5/15 in pencil.
245 × 157 mm
Schiller 19
1981–7–25–22

Another impression of this print is inscribed by the artist with the title *Formenalphabet für die Weberei* (Alphabet of forms for weaving), making Muche's intention quite explicit. Muche recalled: 'My alphabet of forms from abstract painting transformed itself into a fantasy which, in the hands of the weaving women, became tapestries, carpets and fabrics'. Certain aspects of Itten's preliminary course, in particular the naturalistic texture studies and the exercises in ornamental abstraction, provided a special inspiration for the weaving workshop. Gunta Stözl, who assumed control after Muche's departure, described in 1931 the ideas prevalent in 1922–3 by way of contrast with those of the late twenties in Dessau: 'Our textiles were still permitted then to be poems heavy with ideas, flowery embellishment, and individual experience . . . they were the most easily understandable and, by virtue of their subject matter, the most ingratiating articles of those wildly revolutionary Bauhaus products! Gradually there was a shift . . . We made an effort to become simpler, to discipline our means and to achieve a greater unity between material and function' (Hans Wingler, *The Bauhaus*, 1969, p.465).

LOTHAR SCHREYER
1886–1966

Born in Dresden, he trained as a lawyer before deciding to devote himself to painting and the Expressionist theatre. In 1916 he joined the *Sturm* circle, helping to found its drama school which he directed from 1918 to 1920; at the same time he ran the Hamburg Kampfbühne which was formed with a group of two to three hundred 'friends of Expressionism' as an audience. His dramaturgical theories acknowledged a debt to the early plays of Kokoschka and Kandinsky's wholly abstract dramatic composition *The Yellow Sound* among other sources; he sought to create 'a single organism in which word, sound, colour and movement were united' (*Erinnerungen*, p.23). He was appointed to run the theatre workshop at the Bauhaus in 1921, after Gropius had been impressed by his work in Hamburg. Originally Gropius hoped Schreyer's dramatic talents would complement Schlemmer's, but his arcane approach became increasingly incompatible with the direction Gropius sought for the Bauhaus. Schreyer eventually left in 1923 after scathing criticism of a rehearsal of his own composition *Moon-play*, which he was preparing for the Bauhaus exhibition. From 1924–7 he taught at the Wegschule in Berlin and Dresden, and then settled in Hamburg where he continued to write liturgical drama for the stage and to publish numerous essays on religion and art.

Bibliography

Schreyer's own *Erinnerungen an Sturm und Bauhaus*, Munich 1956, gives the best picture of Schreyer himself and the *avant-garde* productions of the *Sturm*. Other reminiscences appear in the volume he edited with Nell Walden, *Der Sturm, Ein Erinnerungsbuch an Herwarth*

Walden und die Künstler aus dem Sturmkreis, Baden-Baden, 1954.

Otherwise, apart from brief discussions in the general literature on the Bauhaus, information about him can be found among discussions of early twentieth-century German theatre. His own work on the subject is *Expressionistiches Theater*, Hamburg 1948.

206 Colour design from the stage play *Kindsterben*
1921

Lithograph, hand-coloured in white, yellow, red and blue on Japan paper, signed and dated 1921 in pencil bottom right. 225 × 167 mm
Published in the first Bauhaus portfolio.
1942–10–10–30(13). Presented by Mr Erich Goeritz.

The text of the play *Kindsterben (Child-Dying)* was printed in the journal *Der Sturm* (XIth year, 1921, vol. 11–12, p.148). It formed one of a group of three dramas written by Schreyer, the other two being *Man* and *Crucifixion* which were first performed by his *avant-garde* theatre in Hamburg (cf. 260). They were conceived as modern Mystery plays in which the actors wore elaborate masks, often larger than life-size; from behind these masks they would declaim the text in a sonorous rhythm for which Schreyer would arrange an appropriate musical accompaniment. That for *Kindsterben* consisted of a glass harmonica combined with a gong, which in his opinion, achieved 'an overwhelmingly powerful transcendental effect' (*Erinnerungen*, p.28). For the same play, in addition to the masks, painted figures, both large and small, were built which became the visual focus of the performance: 'each of these figures was a non-objective, sculptural, coloured work of art' (*Erinnerungen*, p.27). The 'Colour design 2' from the Bauhaus portfolio may reflect one of these figures.

207 Colour design 2 from the stage-play *Kindsterben*
1921

Lithograph, hand-coloured in white, red and blue, on Japan paper, signed and dated 1921 in pencil bottom right. 293 × 172 mm
Published in the first Bauhaus portfolio.
1942–10–10–30(14). Presented by Mr Erich Goeritz.

206

OSKAR SCHLEMMER

1888–1943

Born in Stuttgart; in 1906 he entered the Akademie where, like Itten, he became one of Adolf Hoelzel's pupils and formed two important friendships – with Otto Meyer-Amden (1885–1933), a source of much intellectual stimulation, and Willy Baumeister (1889–1955), whose treatment of the human figure closely resembled Schlemmer's. In 1910 he worked in Berlin, embarking upon his first experiments with dance and a passionate involvement with *avant-garde* theatre. He volunteered for military service in 1914 and was wounded on both Fronts. 1916 witnessed the genesis of his most famous production, the 'Triadic Ballet', whose stylised choreography and costumes, reminiscent of marionette performances, was ultimately to bring Schlemmer considerable renown, earning the admiration of Fernand Léger among many others. He continued to paint during the War years, exhibiting at the Cologne Werkbund in 1914, the Galerie Arnold in Dresden and the Sturm Gallery in Berlin; by 1919 a remarkable mature style had emerged, characterised by a schematic rendering of impersonal human figures in space. In 1921 he designed and choreographed a production of Kokoschka's *Mörder, Hoffnung der Frauen* for the Stuttgart Landestheater, where the fully realised 'Triadic Ballet', with music by Paul Hindemith, was performed in 1923. He joined the Bauhaus in 1921, and rapidly became one of the most influential teachers until his resignation in 1929 over Hannes Meyer's attempt to politicise the theatre. During the Weimar phase he was involved in teaching life drawing and directing the sculpture, mural-painting and, after Schreyer's resignation in 1923, theatre workshops, the last appointment

being the most significant (see 266). His paintings and reliefs for the entrance hall and staircase of the workshop building, executed for the Bauhaus exhibition of 1923, were removed or obliterated in 1930 at the behest of the National Socialist Director of the Weimar Art Akademie. In Dessau he concentrated upon the experimental theatre and developed his course on 'Man' in 1928–9, the most complete expression of his attitude to figure drawing. After leaving the Bauhaus

he taught at the Breslau Akademie and worked on murals for the Folkwang Museum, Essen. The Akademie's enforced closure led him to seek employment in Berlin at the Vereinigte Staatsschulen, which, however, only lasted for one year before his dismissal in 1933. For part of the remaining decade of his life he, together with Muche and Baumeister, was dependent upon work as a consultant for Dr Herberts, the paint manufacturer in Wuppertal.

208

Schlemmer's printed oeuvre was tiny; with the exception of one etching and a few lino-cuts, it was entirely confined to lithography, and petered out in 1931. However, the formal content of the work reflects his analytical concern with the use of pure line to convey, objectively, the rhythm of the human figure. Lithography clearly appealed to him insofar as its mechanical aspects offered the promise of accurate reproduction, rather than as an experimental medium in its own right.

Bibliography

The Letters and Diaries of Oskar Schlemmer, selected and edited by Tut Schlemmer, Middletown, Conn. 1972 (German edn 1958) contains the best biography as well as being an indispensable source of information about the Bauhaus and its major personalities. Schlemmer's essay on the Bauhaus stage, *Die Bühne im Bauhaus* appeared as the fourth of the Bauhaus Books in 1925 (266) (trans. Middletown 1961). *Oskar Schlemmer Man. Teaching notes from the Bauhaus*, edited by Heimo Kuchling, London 1971, is a translation of *Der Mensch*, posthumously published in the Neue Bauhausbücher series in 1970. The standard monograph in two volumes is Karin von Maur, *Oskar Schlemmer: Monographie und Oeuvrekatalog der Gemälde, Aquarelle, Pastelle und Plastiken*, Munich 1979. The graphic work is catalogued in *Oskar Schlemmer Zeichnungen und Graphik, Oeuvrekatalog*, introduced by Will Grohmann, Stuttgart 1965. The best discussion of his work as a printmaker, however, appears in the exhibition catalogue, *Oskar Schlemmer*, Staatsgalerie Stuttgart 1977, by Karin von Maur.

208 *Figur H2*
1921

Lithograph on pink paper. Signed in pencil lower right. 358 × 235 mm
Grohmann GL 7. Published in the first Bauhaus portfolio.
1942–10–10–30(11). Presented by Mr Erich Goeritz.

Precise preparatory drawings in wash on transfer paper were made for all Schlemmer's lithographs; he did not

209

execute the design on the stone, preferring to avail himself of the technical expertise in transfer in the printing workshop. The process was, however, supervised by the artist, as explained in the announcement accompanying Schlemmer's most important print portfolio 'Spiel mit Köpfen' (Game with Heads) published in 1923. 'These sheets – variations on a formal and technical theme – were transferred by R. Baschant to the stone in the printing workshop of the State Bauhaus in Weimar under the supervision of Oskar Schlemmer.'

Schlemmer's formal schema for constructing the human figure was intended to rescue figure drawing from 'the odium of academicism'. 'The greatest variety of attitudes are possible, I would wish for the most objective. Matisse: to be able to draw like Dürer before expressions are composed. Therefore set expressions aside, and so work towards objectivity.' (*Letters and Diaries*, letter to Tut Schlemmer, 16 May 1921.)

209 *Figurenplan K1*
(Figure Design K1)
1921

Lithograph on yellow paper. Signed in pencil lower right. 398 × 185 mm
Grohmann GL 8. Published in the first Bauhaus portfolio.
1942–10–10–30(12). Presented by Mr Erich Goeritz.

KURT SCHWITTERS
1887–1948

Born in Hanover. He attended the
Kunstgewerbeschule from 1908 to
1909; from 1909 to 1914, like so
many of his contemporaries, he
studied at the Dresden Akademie. In
1916 the Kestner-Gesellschaft was
founded in Hanover, where it became
the focus of *avant-garde* art; Schwitters
himself exhibited there from 1917.
In that year he was conscripted as a
mechanical engineer at the Wülfel
iron works. His close friendship with
Hans Arp and the Zurich Dadaists led
to the development of his own
version of Dada, 'Merz', in 1919; this
took the form of poetry, published
under the title *Anna Blume* (cf. 254)
by Paul Steegemann, an *avant-garde*
publisher in Hanover, public recitals
of nonsense in Hanover and Berlin,
an attempt to construct a Merz stage
as part of the *Sturm* theatre school,
and the execution of his first Merz
picture. The fragmentary verbal
juxtapositions of his poems had their
visual equivalent in the ephemeral,
collaged materials which became the
hallmark of his Merz pictorial style.
Among the Berlin Dadaists Schwitters
had close connections with Raoul
Hausmann and Hannah Höch, but
was excluded from the first Dada-
Messe in 1920 because of his refusal
to accept the politicisation sought
by other members of the group.
Schwitters's style became increasingly
Constructivist in 1922–3, after he
had met Lissitzky and van Doesburg
at the Dada-Congress in Hanover
and spent six months in Holland
where he was greatly impressed by
De Stijl. Lissitzky collaborated with
Schwitters throughout the 1920s,
encouraging him in his typographical
experimentation. The results were to
be seen in the journal *Merz*, of which
Schwitters produced twenty-four
issues intermittently between 1923
and 1932; in the children's stories
which he composed with Käte Steinitz;

and in his work as a freelance
consultant and graphic artist which
burgeoned into an independent
advertising agency, Merz-
Werbezentrale.

In 1923 he began his most
ambitious project, an attempt to
create a complete environment out
of random materials and detritus, the
'Merzbau'. When he was forced to
take refuge in Norway in 1937, he
embarked upon a second construction.
In 1940 he had to flee again, this
time to England, where he was
interned on the Isle of Man until
1941, when he went to live in
London, moving in 1945 to the Lake
District. With the aid of a grant from
the Museum of Modern Art in New
York, Schwitters began a third
'Merzbau' in a barn at Little Langdale
in 1947, shortly before his death; it is
now in the Hatton Gallery in the
University of Newcastle-upon-Tyne.

'Merz' was Schwitters's highly
individual contribution to the
iconoclasm of the *avant-garde* in
Germany after the First World War.
As he explained, it was 'the second
syllable of "Kommerz" [Commerce]
. . . It was cut out and glued on from
an advertisement for the KOMMERZ
UND PRIVATBANK . . . When I first
exhibited these pasted and nailed
pictures with the Sturm in Berlin, I
searched for a collective noun for
this new kind of picture, because I
could not define them with older
conceptions like Expressionism,
Futurism or whatever . . . Later on I
expanded this name "Merz" to include
my poetry . . . and finally all my
relevant activities. Now I call myself
Merz' (quoted from Merz 20, 1927,
in Steinitz, 1972, pp. xviii–xix). His
eccentricity was often scarcely
distinguishable from madness. Kate
Steinitz remembered him as a petit-
bourgeois Hanoverian who 'travelled
a lot, always with a second suitcase
filled with Hanover potatoes and
carrots. These he cooked over a
portable coal-oil burner so as not
to spend any money in restaurants.

Sticking out of his pants pocket was
a much used notebook containing
addresses of all progressive publishers,
artists, dealers, and collectors
everywhere. In it he also kept track
of auctions, and sales prices, and
thus he spun an international network
of Dada threads from country to
country around the whole world'
(Steinitz, 1972, p. 18).

Bibliography

The fundamental study of Schwitters by
the main authority on the artist is
Werner Schmalenbach's *Kurt Schwitters*,
Cologne 1967 (English trans. London
1970), which includes a bibliography by
Hans Bolliger. References are here given
to the German original as the translation
is often inaccurate. Another general
work is Friedhelm Lach, *Der Merzkünstler
Kurt Schwitters*, Cologne 1971. Hans
Richter, *Dada, art and anti-art*, London
1965, discusses Schwitters's role in Dada.
Friedhelm Lach has edited the complete
literary writings of Schwitters, *Das
literarische Werk*, 5 vols, Cologne
1973–81, and Ernst Nündel has edited a
selection of his letters, *Kurt Schwitters,
Briefe aus fünf Jahrzehnten*, Frankfurt
1975. A personal portrait of the artist
has been published by his lifelong friend,
Käte Steinitz, *Kurt Schwitters, A Portrait
from Life*, Berkeley 1968 (an expanded
version of *Erinnerungen aus den Jahren
1918 bis 1930*, Zurich 1963).

210 Untitled
1923

Lithograph, printed in black, signed in pencil
and numbered 15/6. 556 × 445 mm (sheet
size)
Published in the Merzmappe (Merz portfolio),
1923.
1983-5-21-2

211 Untitled
1923

Lithograph, printed in orange, signed in pencil
and numbered 48/2. 556 × 445 mm (sheet
size)
Published in the Merzmappe, 1923.
1983-5-21-3

The Merzmappe consisted of six
lithographs 'auf den Stein gemerzt'
('Merzed' onto the stone), published as

the third issue of Schwitters's series *Merz* in a numbered edition of fifty. It was the only portfolio he ever produced of his own prints and concluded his limited activities as an original printmaker. His only other published prints were two woodcuts (cf. 255) and two lithographs, and the eight lithographs which came out under the title 'Die Kathedrale' (The Cathedral) in 1920 in Steegemann's 'Silbergäule' series. These prints were executed in a highly original manner which reflected Schwitters's interest in collage. In the case of 'Die Kathedrale', he seems to have glued or nailed materials such as shoe leather and embossed papers to wooden blocks; impressions were taken from these on transfer paper and thence transferred to lithographic stones for publication (cf. Schmalenbach, 1967, p. 91).

The Merzmappe is a work of Schwitters's Constructivist phase, exactly contemporary with Moholy-Nagy's Kestnermappe (cf. 215–20). The individual prints were printed in a single but variable colour and present the appearance of lithographed collages; in some copies of the portfolio actual collage has been applied in the form of small rectangles of coloured paper. There is some confusion about the way in which the prints were made and they are frequently described as photolithographs. Schmalenbach, however, gives an entirely convincing account of the autographic nature of their production, which is quite consistent with both the visual evidence and the original advertisement in *Merz* 6, 1923, which described the prints as having been 'Merzed by hand onto the stone'.

The lithographs were apparently made in the Molling printing plant, from which Schwitters was wont to salvage material for reuse in his art, and these circumstances may have determined some of their distinctive features. 'Schwitters apparently made use of freshly printed papers of all kinds, which in their wet and oily state he transferred to the lithographic stone, so that he could print off his composition "Merzed" directly on to the stone . . . Schwitters used rectangular cut-out pieces of paper, parts of illustrations, parts of cigarette wrappers and advertisements, and single letters . . . In the fragments of illustrations, he often chose a colour separation from a four-colour reproduction. The small marginal

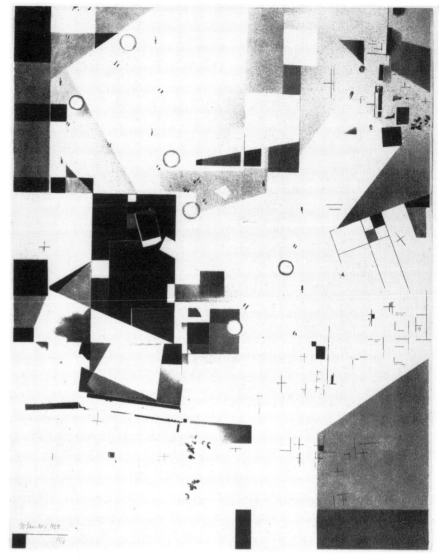

210

crosses necessary for alignment in colour printing he often incorporated as self-sufficient elements into his compositions. Once he had made offsets of these various elements on the stone, he made minor adjustments here and there with chalk and needle' (Schmalenbach, 1967, pp. 155–6).

The fifth issue of *Merz* was a companion portfolio of lithographs by Hans Arp entitled '7 Arpaden'. The two portfolios, *Merz* 3 and *Merz* 5, were initially sold for 60 and 30 Marks respectively.

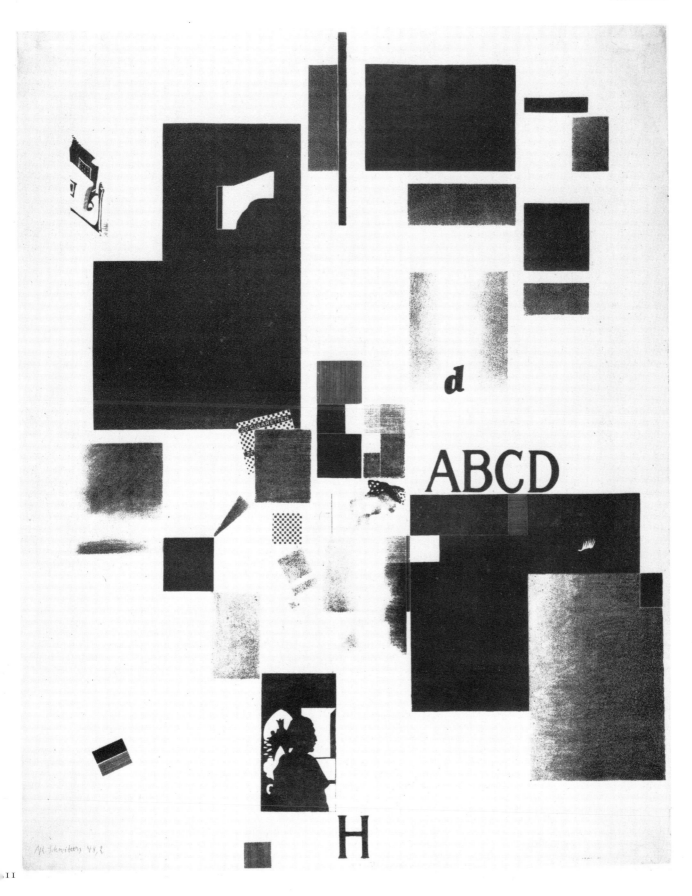

EL LISSITZKY

1890–1941

Born Lazar Markovich Lissitsky in the district of Smolensk in Russia. He studied as an architectural engineer in the Technische Hochschule in Darmstadt (1909–14), but received his diploma in architecture in 1916 in Russia after returning at the outbreak of the First World War. He embraced the Revolution enthusiastically and became one of the foremost protagonists and publicists for the new Soviet culture. From 1917 Lissitzky concentrated on illustrations for a number of Jewish picture-books published in Kiev, the style of which is quite plainly derived from Chagall. In 1919 Chagall invited him to join his Vitebsk Art Labour Co-operative as a teacher of architecture and the graphic arts. This was a crucial appointment for the development of his Constructivist style, for at Vitebsk he met Malevich and almost immediately assimilated the latter's revolutionary 'Suprematist' syntax of abstract, geometrical forms floating in space. Lissitzky's first 'Proun' compositions (drawings, watercolours, paintings and relief constructions) date from the Vitebsk period. The term, which he invented, is an abbreviation of the Russian 'Project for the affirmation of the new', and they were meant to represent 'the interchange station between painting and architecture' (Lissitzky-Küppers, 1968, p. 21), creating a new visual language for a new society. Their theoretical basis was set out by Lissitzky in a lecture read to the General Meeting of Inkhuk (Institute for Artistic Culture) in Moscow in 1921 after his move there to teach architecture. Kandinsky had formulated the original programme for this body after the Revolution, but Lissitzky lacked any sympathy for the older artist's work, censuring it in an article of 1922 for having ' no cohesion, no clarity, no object' (quoted in John Boult's essay in the 1976 Gmurzynska catalogue, p. 47).

In 1922 he participated in the creation of the first Soviet Art Exhibition in Berlin, which introduced Russian Suprematism/Constructivism to the mainstream of European art. In Berlin Lissitzky met the two artists with whom his work was to be most closely associated, Moholy-Nagy and Schwitters; their common interests in typographical design, photomontage and architectonic effects were to exercise many reciprocal influences. Schwitters was particularly attracted to Lissitzky's work, readily perceiving the analogy between his 'Merzbau' and the latter's 'Proun' compositions. He was instrumental in introducing Lissitzky in 1922 to the Kestner-Gesellschaft in Hanover which was run by Sophie Küppers, the former artistic director's widow, whom Lissitzky was to marry in 1927. After the success of an exhibition of his work there Lissitzky was commissioned in 1923 to produce a portfolio of lithographs. At the end of 1923 Lissitzky was diagnosed as suffering from tuberculosis and spent two years in Swiss sanatoria without making a full recovery. In 1925 he returned to Moscow to an appointment on the faculty of woodwork and metalwork at the State Art Schools. Between then and 1931 he moved between Moscow and Germany in his capacity as designer of various official Soviet displays at international exhibitions; he came to regard this as his most important artistic activity. He continued to work throughout the Stalinist era, principally as a poster and graphic designer when his deteriorating health prevented him from undertaking large-scale projects.

Lissitzky's main contribution to twentieth-century graphic art lies in the realm of book design and typography, where, together with Schwitters and Moholy-Nagy he revolutionised conventional ideas of layout and illustration. His work as an original printmaker is centred around three portfolios, the first Proun portfolio produced in Moscow in 1921, the second Proun portfolio made for the Kestner-Gesellschaft in 1923, and the set of prints related to the play *Victory over the sun*, also made in Hanover (the last set is in the Tate Gallery). After 1923 his interest in autographic techniques, whether in printmaking or painting, began to wane and he turned his attention increasingly to the expressive possibilities of photography and typography, which could claim to be a more democratic process.

Although the three Proun lithographs described here were made before he went to Germany, they are closely related to his 1923 prints, which were to exercise such an influence on his contemporaries.

Bibliography

The memoir by the artist's widow Sophie Lissitzky-Küppers, *El Lissitzky, life, letters, texts*, London 1968 (German edn Leipzig 1967), is the only monograph, and publishes many of the very informative letters he wrote to her. The most useful exhibition catalogue is that of the Galerie Gmurzynska, Cologne 1976, which contains an essay on Lissitzky's lithographs by Donald Karshan.

212 *Proun 1A*
1919–21

Lithograph on white paper, signed in pencil lower left. 170 × 310 mm
1979-6-23-26

This and 213 belong to a group of eight proofs for Lissitzky's first 'Proun' portfolio, auctioned in 1979. In January 1923, while Lissitzky was in Berlin, he was invited to send some lino-cuts and woodcuts to an exhibition organised by the Belgian *avant-garde* periodical, *Ça Ira*. Lissitzky proposed to the editor, Maurice van Essche, that he should send a series of lithographs as he had no work in the other media available. When the suggestion was accepted, he enclosed the prints with a letter explaining: 'I am sending you eight lithographs for the exhibition in an unsealed envelope . . . They are the last few hand-printed proofs

that I have left, and I must ask 20 francs each'. The lithographs remained unsold at the end of the exhibition but van Essche suggested that Lissitzky might care to leave them with him, in exchange for some of his publications. The proofs remained in his family in Antwerp until sold in 1979 (see Sotheby's sale catalogue 17 May 1979, lots 121A–121H).

The first Proun portfolio is stated to have included ten lithographs and a title-page, but no proper edition was issued (the most complete discussion of these and related compositions is to be found in *Russian Avant-Garde Art. The George Costakis Collection*, London 1981, pp. 246–8). Sophie Lissitzky-Küppers (1968, p. 26) stated that 'The Prouns produced in Lissitzky's attic studio in Berlin [in 1922] are for the most part variations on lithographs printed in Vitebsk, which Lissitzky recreated on wood panels or canvases'; despite this statement, it is also possible that the lithographs were printed in Moscow. It is, however, certain that Vitebsk is where he executed the many watercolours, paintings and reliefs on which the lithographs were based. A photograph of him in his studio in 1919 shows a composition on the wall behind him which corresponds to *Proun 1A* and may be the gouache now in the collection of E. Estorick, London (Lissitzky-Küppers, 1968, plate 22).

213 *Proun 1C*
1919–21

Lithograph on grey paper. Signed in pencil lower right. 233 × 233 mm
1979–6–23–27

Proun 1C was also based on a watercolour which Lissitzky may have exhibited at the first Russian exhibition in Berlin in 1922. It was one of the watercolours purchased by Sophie Küppers at the prompting of Kurt Schwitters and was reproduced on the cover of the invitation to the exhibition of Lissitzky's *Prouns* in Hanover in 1923. 'The large design with the floating body, which had to be illustrated on the invitation card, was acquired by Dr Dorner. It was a variation of the first Proun study of 1919' (Lissitzky-Küppers, 1968, p. 34; Alexander Dorner was the director of the Hanover Landesmuseum). The lithograph is reproduced in Lissitzky-Küppers, 1968, plate 25, and a painted version of the

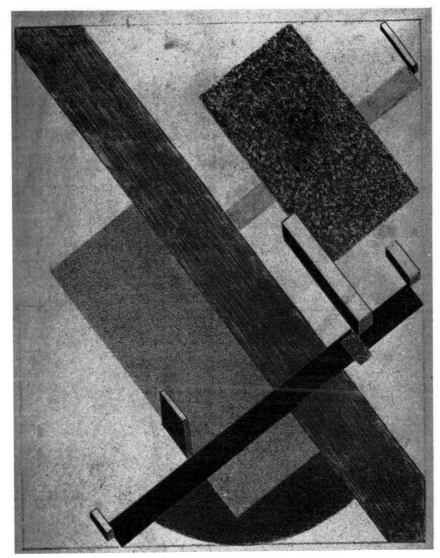

214

composition (in reverse) is illustrated in *The George Costakis Collection, Russian Avant-Garde Art*, ed. A.Z. Rudenstine, London 1981.

214 *Proun, unnumbered*
1919–21

Lithograph on grey-brown paper.
310 × 239 mm
1982–7–24–13

This Proun composition is printed on paper similar to 212–13 and its appearance suggests that it was connected with the Proun portfolio, although it was not included in the 1921 issue.

The experimental nature of the first Proun lithographs renders them more appealing, in some ways, than the immaculate productions of Lounis and Campe, the printers of the Kestner Proun portfolio. Lissitzky, however, was more pleased with the printing in Hanover, precisely because it imparted a new technical perfection to his drawing. It was an easy transition to make from this attitude to a complete acceptance of the superiority of photomechanical reproduction; the artist's intervention in the manufacture of the work would no longer be necessary beyond supplying the initial idea.

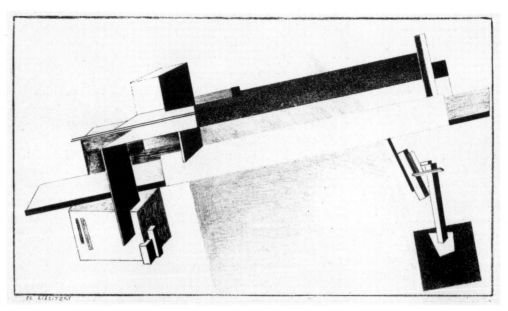

212

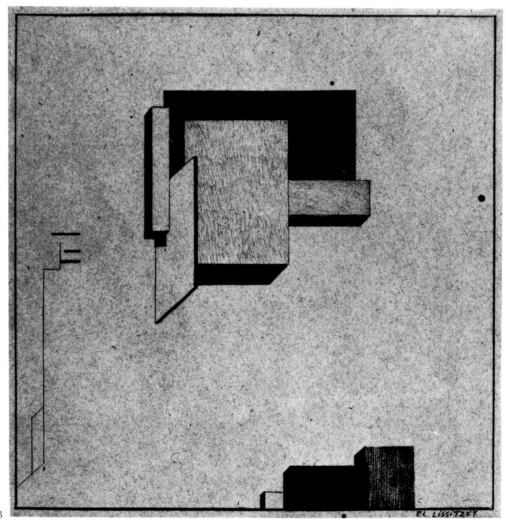

213

LASZLO MOHOLY-NAGY
1895–1946

Born in Báesborsod in Hungary as Lászlo Nagy, to which he subsequently added Moholy, the name of the neighbouring village. His legal studies at the University of Budapest were interrupted after one year by the outbreak of the First World War and he was drafted into the Austro-Hungarian army as an artillery officer. His wartime experiences prompted a series of Expressionist drawings; after his discharge he abandoned law in favour of an intensive self-taught course on painting. He was an enthusiastic supporter in 1919 of Bela Kun's short-lived Hungarian Soviet, and became a member of a group of *avant-garde* artists who organised exhibitions and published an influential periodical *MA* (Today) which introduced Moholy to Russian Constructivism. After the Counter-Revolution in late 1919 publication of the journal continued in Vienna. Here Moholy went, but left for Berlin at the end of 1920, where he met Schwitters who became a close friend. After his arrival Moholy did purely non-objective work, devoting almost a year to collages and 'fotograms' (camera-less photographs); he signed the 'Manifesto of Elemental Art' published in *De Stijl* in October 1921, and became closely associated with El Lissitzky, who strengthened his interest in Constructivist ideas. In 1922 the Sturm Gallery held Moholy's first one-man show. Later in the year he attended the Dadaist-Constructivist congress in Weimar, organised by the Dutch artist Theo van Doesburg as part of a campaign to redirect the Bauhaus along more progressive, industrialised lines. In 1922–3 Moholy exhibited with Lissitzky at the Kestner-Gesellschaft in Hanover and shared a studio with Schwitters in Berlin.

Partly prompted by the pressure of van Doesburg's campaign, Gropius invited Moholy to run the *Vorkurs* and the Metal Workshop at the Bauhaus after the resignation of Itten in 1923. Moholy injected quite a different approach, which was more closely identified with Gropius' than any of his colleagues; indeed he was known as Gropius' 'prime minister'. The Bauhaus moved towards an integrated programme of theory and the practical solution of the problems of mass-produced design. Moholy's influence was far-reaching on future education and industrial design. The most complete expression of the unified values of the Bauhaus was the series of fourteen Bauhaus books, published in Dessau, of which Moholy was both editor and typographical designer (cf. 266, 267). He continued his experiments in photography, increasingly abandoning painting in its favour. After his resignation from the Bauhaus in 1928, together with Gropius, Breuer and Herbert Bayer, Moholy ran a commercial design office in Berlin and also turned to stage design, initially for the Kroll Opera and Erwin Piscator's political theatre.

He established contact with the English abstract artists through Ben Nicholson, whom he met in Paris after joining 'Abstraction-Création' in 1932. From 1935–1937 he lived in London, responding with characteristic versatility to his new environment. He acted as a design consultant to Simpson (Piccadilly) Ltd, produced three books of specially commissioned photographs and a film 'The new architecture at London Zoo' among many other activities. In 1937 he moved to Chicago to run the 'New Bauhaus', established under the influence of Gropius, who had moved to the School of Architecture at Harvard. It went bankrupt in 1938, but in the following year Moholy opened his own School of Design, which, despite wartime difficulties, had begun to achieve considerable success at the time of his death in 1946. His final theoretical work, which he described as his 'visual testament' was *Vision in Motion*, published in 1947.

In the field of graphic art Moholy himself would certainly have regarded his photographic and typographical work (cf. 267) as his major achievement. His original prints are few in number, and were all made during a short period in the first half of the 1920s. Nevertheless his wood-engravings, lino-cuts, drypoints and lithographs from the period 1919–25 are remarkably beautiful; a reviewer of Moholy's exhibition at the Sturm Gallery in 1922 commented: 'Don't talk about coldness, mechanisation; this is sensuality refined to its most sublimated expression' (Sibyl Moholy-Nagy, 1969, p. 32).

Bibliography

Moholy-Nagy was a prolific publicist for his own theories; perhaps the most complete statement of his views is contained in *Von Material zu Architektur*, Bauhausbuch No. 14, Munich 1929, of which an English edition appeared in New York in 1930 as *The new vision: from material to architecture*, Sibyl Moholy-Nagy published a retrospective assessment of his work, *Moholy-Nagy: Experiment in totality*, New York 1950 (revised edn 1969). To this can be added the documents contained in Lucia Moholy-Nagy, *Moholy-Nagy marginal notes*, Krefeld 1972, and in the collection edited by Richard Kostelanetz, *Moholy-Nagy*, London 1971. *Moholy-Nagy*, Centre Georges Pompidou, Paris 1974, is the best exhibition catalogue. A monograph by Krisztina Passuth is due to be published by Thames and Hudson, London, before the end of 1984. Very little information has been compiled on his prints. Wieland Schmied's *Wegbereiter zur modernen Kunst: 50 Jahre Kestner-Gesellschaft*, reproduces the Kestner portfolio, while the catalogue for the Moholy-Nagy exhibition at the Art Institute, Chicago in 1947 contains the only attempt to list his lino-cuts and drypoints as well as the lithographs.

215–20 'Konstruktionen'
(Kestnermappe 6)
1923

The 'Proun' lithographs by Lissitzky in
the first Kestner portfolio and Moholy's
'Constructions' in the sixth, represent the
most complete statement of Constructivist
values in the field of original printmaking.
In 1922 Moholy-Nagy had articulated his
own view of this form of abstraction in a
series of articles published by *MA*:
'Constructivism is neither proletarian nor
capitalistic. Constructivism is primordial,
without class or ancestor. It expresses the
pure form of nature – the direct colour,
the spatial rhythm, the equilibrium of
form. The new world of the masses needs
Constructivism because it needs
fundamentals that are without deceit . . .
Constructivism is the socialism of vision'
(Sibyl Moholy-Nagy, 1969, pp. 19–20).
Moholy had been deeply influenced by
Malevich's precise analysis of visual
elements, although he rejected the
spiritual dimension to the latter's work,
which he regarded as wholly extraneous
to a revolutionary art form.

Lissitzky, who lectured in 1923 on
'The New Russian Art' to the Kestner-
Gesellschaft, the focus of the *avant-garde*
in Hanover (cf. 255), was responsible for
bringing Moholy's work to the attention
of Sophie Küppers, who, with Eckard von
Sydow, the artistic director, was
responsible for publishing the six Kestner
portfolios, all of which appeared in 1923.
As a necessary precaution, in view of the
spiralling inflation, von Sydow made the
publication a joint venture with the
Hanover bookseller, Ludwig Ey. The
portfolios were all of identical composition
and format, each sheet measuring
600 × 440 mm, containing six lithographs
and a colophon, and were published in
editions of fifty. Those by Lissitzky and
Moholy-Nagy were easily the most
important; Schmidt-Rottluff and Max
Kaus (1891–1977) contributed II and
III, while two very minor figures, Martel
Schwichtenberg (1896–1945) and Willy
Robert Huth (b. 1890) appeared in IV
and V.

The British Museum's copy of
'Konstruktionen' is no. 29 from the
edition of fifty and is an unrecorded
variant. Cat. 217 does not appear in other
copies, while 215 is inscribed *Probedruck*.
The print normally found instead of 217

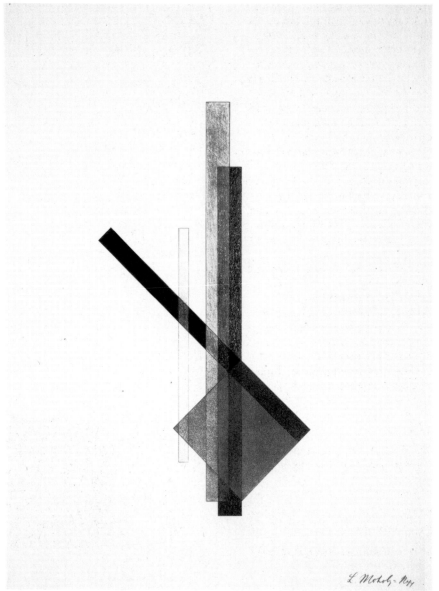

216

is reproduced as no. 6 in Schmied (*op. cit.*); the print in the British Museum's portfolio is presumably a rejected design. There can be no question that the Museum's copy has always existed in this form, as is proved by its provenance from the artist's widow Sibyl Moholy-Nagy and the identical pinholes in the upper corners. An ink drawing, dated 1922, corresponding to 220, was exhibited at the Moholy-Nagy Memorial exhibition at the Guggenheim Museum in 1947; it suggests that Moholy supplied very precise drawings for all the prints to the lithographers at Leunis and Chapman, who would have redrawn the designs on the stones under the artist's supervision, in some cases using commercial techniques like mechanical ruling and prepared tonal screens. This, however, cannot be called a process of 'photomechanical' reproduction; despite Riva Castleman's statement (*Prints of the twentieth century*, London 1976, p. 66) there is no evidence in the prints themselves of the employment of any photographic process.

215 PLATE 1

Lithograph in red. Inscribed in pencil *Probedruck* bottom left, signed bottom right. 600 × 440 mm
See colour illustration

216 PLATE 2

Lithograph. Signed in pencil bottom right. 600 × 440 mm

217 PLATE 3 (variant)

Lithograph. Signed in pencil bottom right. 600 × 440 mm

218 PLATE 4

Lithograph. Signed in pencil bottom right. 600 × 440 mm

219 PLATE 5

Lithograph, printed on black. Signed in pencil bottom right. 600 × 440 mm

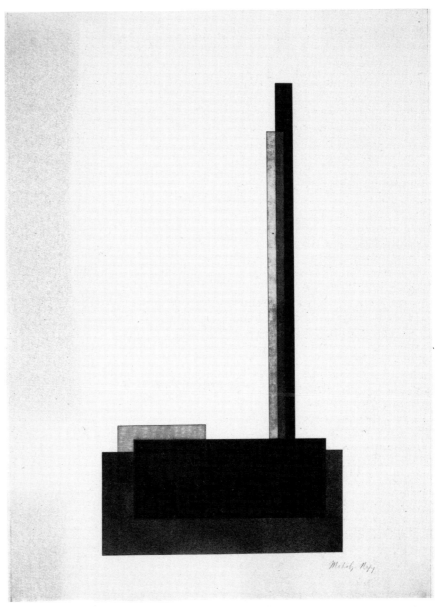

217

220 PLATE 6

Lithograph, printed on grey paper. Signed in **pencil bott**om right. 600 × 440 mm
1983–3–5–56(1–6)

221 *Untitled*
1924

Wood-engraving, signed in pencil lower right. 119 × 82 mm
1981–6–20–4. From the collection of Sibyl Moholy-Nagy, the artist's widow.

This impression is a proof for the cover of the issue of *Der Sturm* of December 1924, where it appears with the lettering *Moholy-Nagy Holzschnitt vom Stock gedruckt* (woodcut printed from the block). Most of his wood-engravings and lino-cuts were made as cover designs for *MA* and *Der Sturm* (see 1974 Centre Georges Pompidou catalogue, nos 42–44).

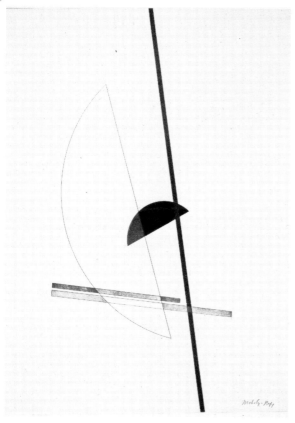

218

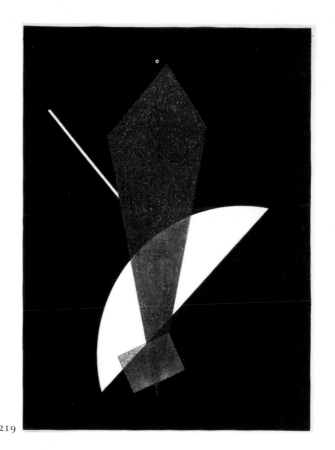

219

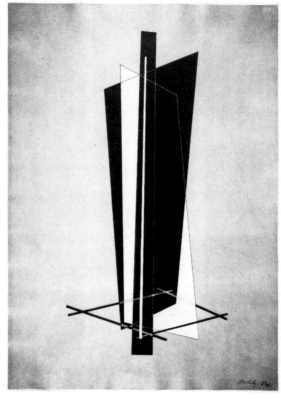

220

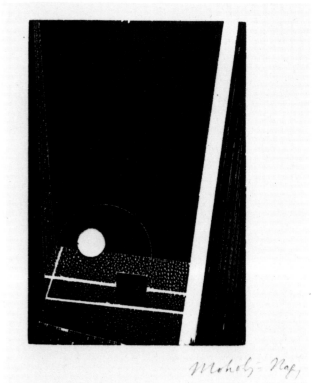

221

ROLF NESCH

1893–1975

Born in Oberesslingen in Württemberg. At the age of fourteen he was apprenticed to a decorative painter in Heidenheim and completed his pupillage in Stuttgart in 1912. After working for some time as a journeyman he decided to train as an artist and entered the Kunstakademie in Dresden in 1913. The First World War interrupted his studies, which he was only able to resume in 1919 after being released from a British prisoner-of-war camp. In about 1922 he seems to have taken up printmaking and made the first of many visits to Hamburg. It seems to have been Gustav Schiefler, Nesch's strongest supporter and 'almost a parent' to him, who arranged for him to visit Kirchner in Davos for six weeks in 1924. After moving between various German cities, he settled in Hamburg in 1929 where he began to build a reputation for his remarkably original prints. In 1933 local Nazis had some of his works rejected from an exhibition, and he at once destroyed almost all his paintings and emigrated to Norway – the choice of country apparently being determined by his admiration for Munch. His first years there were spent in dire poverty; it was only in 1946 that he was granted Norwegian citizenship and became increasingly successful, and indeed one of the most influential of contemporary printmakers.

The list of Nesch's innovations is long. In 1925–6 he first began to etch right through plates (cf. 230); in the years to 1931 he concentrated on developing his facility with aquatint and experimented with colour printing (223 and 225). In 1932 he invented the so-called 'metal print' which involves collaging pieces of metal onto the plate (see 229). The experiments continued in Norway. In 1934 he made his first 'material

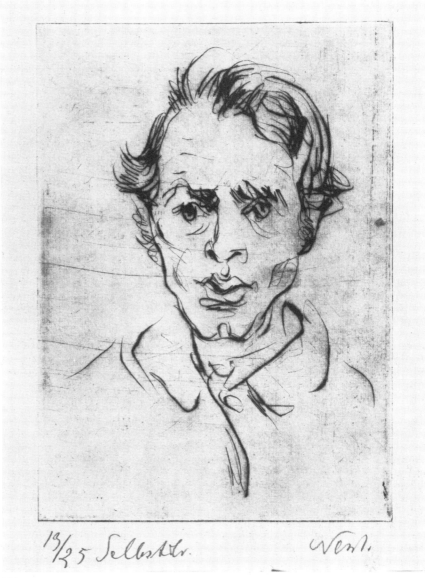

222

picture' by collaging elements onto a backing sheet – a development from the plates made for the 'metal prints' but no longer intended for printing – and in the later 1930s began to make sculpture in copper or stone. The late 1930s are something of a watershed in his work; he began to make long prints composed of two to six sheets, and turned away from his predominantly monochrome approach to become the most striking colourist in the printmaking of his time. According to Hentzen's calculations made in 1958, Nesch made some

175 intaglio prints and 6 woodcuts up to 1931, and 270 'metal prints' between 1932 and 1958, along with the two more conventional series made in 1946–7.

Bibliography

The standard monograph on Nesch is Alfred Hentzen, *Rolf Nesch*, Stuttgart 1960 (English trans. 1964). Hentzen has also published an essay in *Prints*, edited by Carl Zigrosser, New York 1962, pp. 40–54. The most important autobiographical source, from which later writers draw heavily, is Nesch's speech of acceptance when awarded the Lichtwark

prize in Hamburg in 1958; it was first published in *Neues Hamburg*, XII, 1958, pp. 15–17, and often reprinted thereafter (for example in the West Berlin Akademie der Künste exhibition catalogue of 1966). Of a number of exhibition catalogues, the most useful is that from Detroit in 1969, *The graphic art of Rolf Nesch*, which includes an essay on Nesch's technique by Jan Askeland and an illustrated catalogue of the three Hamburg series (cf. 228) and the first two Norwegian series, 'Snow' of 1933–4 and 'Lofoten' of 1936. These are of great help, given the absence of any published catalogue of Nesch's prints. A large volume with introductory essays by Alfred Hentzen and Wolf Stubbe, *Rolf Nesch Drucke*, Frankfurt 1973, has numerous excellent reproductions, especially of the later prints.

222 *Self-portrait*
1922

Drypoint. Signed, titled and numbered 13/25 in pencil. Annotated in bottom margin *Selbstb. 1922*. 230 × 169 mm
1983-6-25-43

This is one of Nesch's earliest prints, and a typical example of his straightforward use of the drypoint line and burr at this stage in his work. Most of the early prints were published in numbered editions of twenty-five or thirty-five. As his techniques became more complicated and the time needed for printing longer, Nesch ceased to produce regular editions. The later plates rarely had more than ten impressions taken from them.

Eight of the nine prints by Nesch catalogued here were purchased in 1983 from Mr Eivind Otto Hjelle in Norway, the artist's son-in-law. Included in the purchase was a ninth print, not described here because it falls outside the chronological limits of this catalogue. It is the famous six-part *Herring Catch* made in 1938 (inv. 1983-6-25-51(1–6)).

223 *Black chorus line*
1930

Etching and aquatint with monotype colouring. Signed, titled *Negerrevue* and annotated *Selbstdruck* in pencil. 334 × 448 mm Printed on thick Japan paper.
1981-11-7-9
See colour illustration

This plate shows the benefit of Nesch's experiments in deeply etching the plate. The main areas of the dancers' dresses have been etched down and some thick grain used to create the pitted areas, while the swirling bands on the dresses have been stopped out so that the original surface of the plate has been preserved. The effects thus created on the plate have been enhanced by very careful wiping. The black ink has been wiped almost clean on the women's dresses, while a heavy surface-tone has been left on the flesh areas; this gives the contrast of the black skin against the cotton of the dresses. The coloured inks have been wiped onto the raised surface areas of the plate by hand; the marks of the rag used to do so are clearly visible. Small patches of yellow are applied to define an ear-ring and a hat. Such hand-colouring is perhaps the most important purely technical device that Nesch learnt from Kirchner (cf. 83 and p. 36).

The importance of the inking is shown by comparison with an illustration of another impression (in the 1969 Detroit catalogue, p. 16) now in Los Angeles. In this the upper part of the dress of the right-hand dancer is the same tone as the lower part, and the traces of an arm visible between the right-hand figures is entirely obscured by the red ink.

224 *Head of Rosa Schapire*
1931

Drypoint. Signed, titled *Rosa Schapire* and annotated *Probedruck* in pencil. 494 × 331 mm
1983-6-25-44

This print is composed of nothing more than a few deeply incised drypoint lines. The surface texture is that of the rough metal plate employed, which is brought out by leaving a film of ink on the surface in the wiping.

Rosa Schapire (1874–1954) has already been mentioned many times in this catalogue (p. 7). Born into a Jewish family on the then Austrian-Polish border, she studied art history in Zurich and Leipzig, financing her studies by translating from Polish and French into German; translating and occasional journalism were to remain the basis of her livelihood. She earned her doctorate in 1904 with a thesis on J.L.E. Morgenstern, the eighteenth-century Frankfurt painter; she then spent several years moving

round Europe, and by 1908 had settled in Hamburg. Through Gustav Schiefler she had met Nolde in 1907 and became a passive member of the Brücke. Although she knew all the members, her closest friendship was with Schmidt-Rottluff in the years from 1909; she published a catalogue of his prints in 1924 and in 1921 had him design and paint all the furniture in her flat. She maintained her interest in contemporary art in the post-First World War years, and published a number of essays on young artists, as well as jointly editing two famous Expressionist periodicals, *Die rote Erde* and *Kündung*. She emigrated to London just two weeks before the beginning of the Second World War, with nothing but ten Marks and her Schmidt-Rottluff collection. In England she was to help Pevsner on the *Buildings of England*, and later acted as the London correspondent for *Weltkunst*. A very full account of her life and collection, as well as a complete bibliography of her writings is given by Gerhard Wietek in the *Jahrbuch der Hamburger Kunstsammlungen*, IX, 1964, pp. 114–60. This portrait by Nesch is the last of twenty recorded portraits of her, made by no less than fourteen different artists. Nesch's reminiscences of her are published on p. 131 of Wietek's article; her patronage of him had extended to buying a complete set of the Karl Muck series (*ibid.*, p. 141).

225 *Head of Karl Muck*
Plate 17 of 'Karl Muck and his orchestra'
1931

Etching and aquatint. Signed and annotated *II. Zustand* in pencil. Traces of an old dedication *Druck für* [?] erased. 448 × 355 mm
1983-6-25-45

Karl Muck (1859–1940) was one of the most distinguished conductors of his day, with a reputation founded on his performances of Wagner and Bruckner. Between 1922 and 1933 he was the principal conductor of the Hamburg Philharmonic Orchestra, and the city

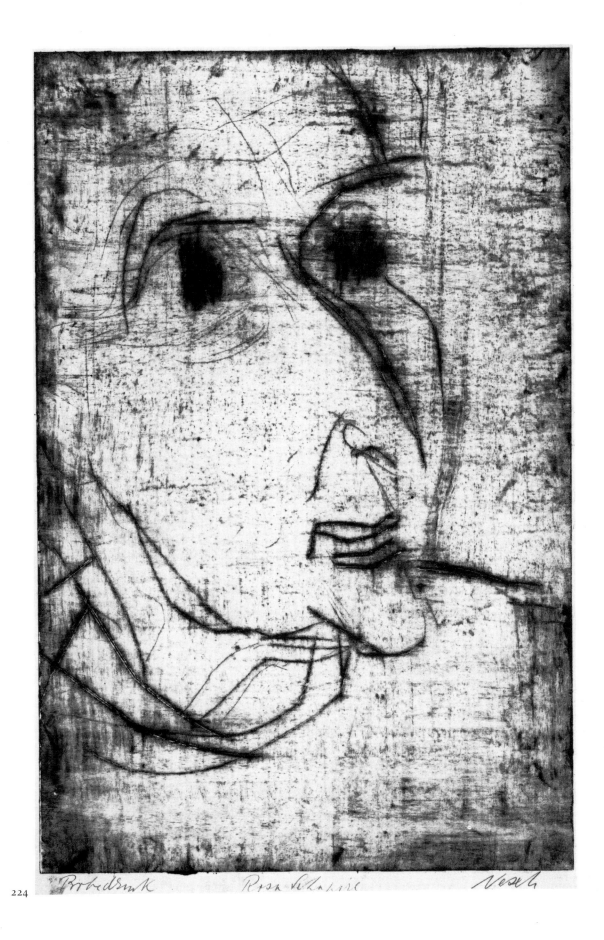

Probedruck Rosa Schacht Nesch

commissioned a portrait to honour his seventieth birthday. Max Sauerlandt, the Director of the Hamburg Museum für Kunst und Gewerbe, was responsible for getting the commission assigned to the relatively unknown Nesch who decided to make a series of prints rather than a painting. In an interview in 1971 Nesch gave an amusing account of how Muck not only refused to sit, but would not let him get nearer than the upper balcony during rehearsals; since Muck was so short-sighted that he continually bent over the score, Nesch could do nothing but draw the musicians of the orchestra instead. It was only in performances that he could get anywhere near the front to see Muck. A daring attempt to get closer led to a confrontation in which Muck stuck out his tongue at Nesch as far as it would go. (See *Kunsten Idag*, edited by Per Rom, Heft 102, 1972, pp. 58–9.) In these circumstances developed the series of twenty-four prints made between February and April, 1931, and published in an edition of six, showing either Muck himself, with his goatee beard, or sections of the orchestra.

Technically the plates are most remarkable for their use of brushed and burnished aquatint, the effect of which is furthered by careful inking and wiping. Nesch managed to keep the spontaneous and improvisory character of a sketch, despite the labour needed to prepare the plate, only by using up to six plates for each image before getting the right result. Nesch gave all the plates to the Museum für Kunst und Gewerbe in Hamburg, but they were doubtless destroyed in the Nazis' action against 'degenerate' art.

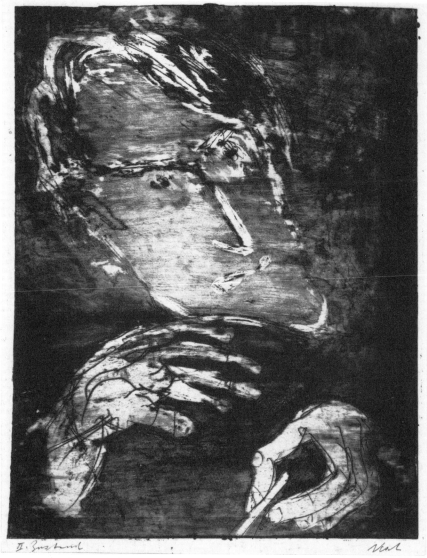

225

226 *Bassoonists*
Plate 21 of 'Karl Muck and his Orchestra'
1931

Etching and aquatint. Signed and annotated *Selbstdruck* in pencil. 451 × 294 mm
1983-6-25-46

The twenty-four prints of the Muck series, of very varying shape and size, were organised by Nesch in a deliberate order, explained in a letter to Schiefler of April 1931. At the beginning was a triptych of three prints of the strings, balanced by a triptych of woodwind at the end (of which the plate of the bassoonists is the last). In

the centre were seven prints of the same size, of the brass, percussion and double-basses. These three sequences were separated by groups of portraits (eleven in all) of Muck himself. (See the full account of the series in the short monograph *Rolf Nesch, Karl Muck und sein Orchester*, edited by Eivind Otto Hjelle, Hamburg 1978.)

The circular mouths of the bassoons in this print were stopped out during the etching process, and then clean-wiped in the printing.

227 *Wrestlers*
Plate 7 of the Series 'St Pauli'
1931

Etching and aquatint, printed in colour. Signed, titled *Ringer* and annotated *Selbstdruck* in pencil. In bottom left corner 4 in pen, and *ED. 8* in pencil. 540 × 380 mm
1983-6-25-47

While completing the Muck series, Nesch made a second set of twelve prints entitled 'St Pauli', showing characteristic figures and scenes from the famous entertainment and red-light district by the port of Hamburg. Whereas the plates of the Muck series were all monochrome, a number of the 'St Pauli' plates

were printed in colour by a most unconventional process involving the double-inking and printing of a single plate. In the case of the *Wrestlers* the plate was first inked on the surface in blue and printed in relief as if a woodcut, and then re-inked in black and over-printed in intaglio. The 1969 Detroit catalogue (p. 23) illustrates in colour another impression in the Kunsthalle in Hamburg which is printed in blue over orange. Other plates of the series are said to involve three such printings. An essay on the cycle by Wolf Stubbe has been published in the *Jahrbuch der Hamburger Kunstsammlungen*, x, 1965, pp. 97–112.

The annotation in the bottom corner shows that this is the fourth impression from the total edition of eight.

228 *Farewell*
Plate 1 of the 'Hamburg Bridges'
1932

Aquatint, printed in colour. Signed, titled *Abschied* and annotated *Selbstdruck* in pencil.
444 × 594 mm
1983–6–25–49
See colour illustration

The third great series of prints that Nesch made in Hamburg was the twenty plates of 'Hamburg Bridges', published in 1932 in an edition of eight. His emigration to Norway interrupted work on a fourth cycle 'Hagenbeck', devoted to the famous Hamburg zoo, which was supposed to complement the impressions of the city given in the 'St Pauli' and 'Bridges' cycles.

Like the 'St Pauli' cycle, it comprises colour and monochrome works, but it goes far beyond those prints in artistic and technical originality. This print is reasonably straightforward, being printed once from a single plate which has been inked in blue and black, possibly using a stencil or other masking device for the application of the ink. The main complexity lies in the extraordinary patterns created in the aquatint grain. An interesting feature of the print is the direct derivation from Munch of the two couples saying their goodbyes. The woman on the extreme left is almost a direct quotation from Munch's *Die Einsamen* (the lonely ones).

The complete set of the original metal plates of the 'Hamburg Bridges' series is now in the Kunsthalle in Hamburg, presented by the artist.

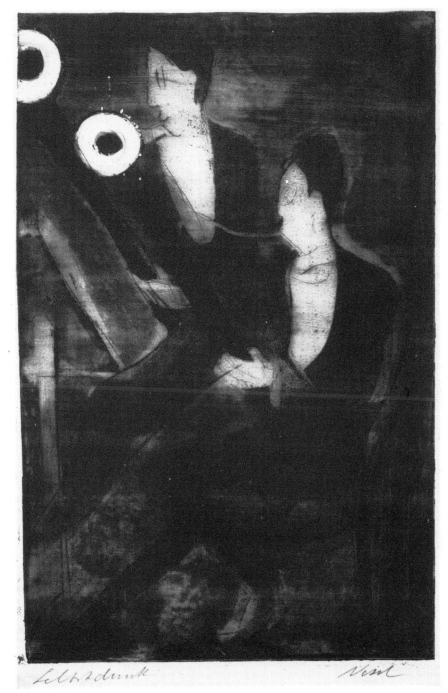

226

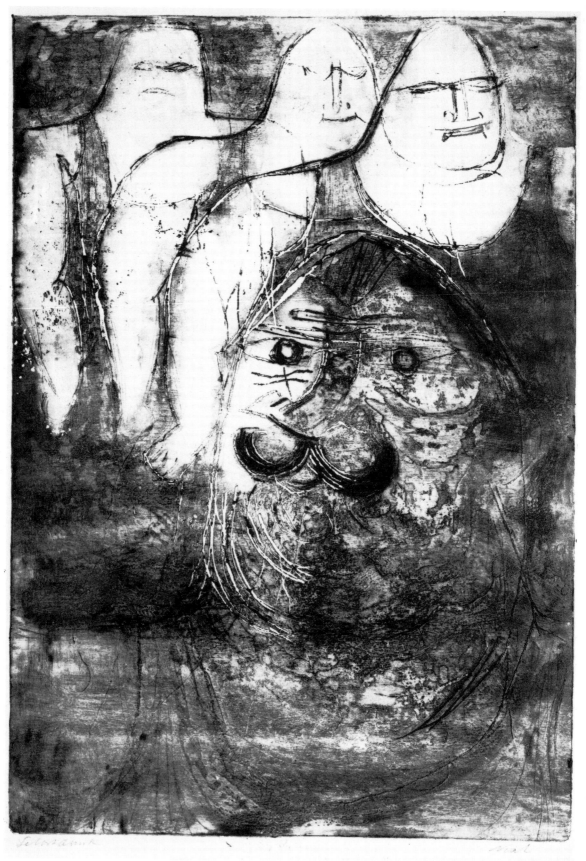

227

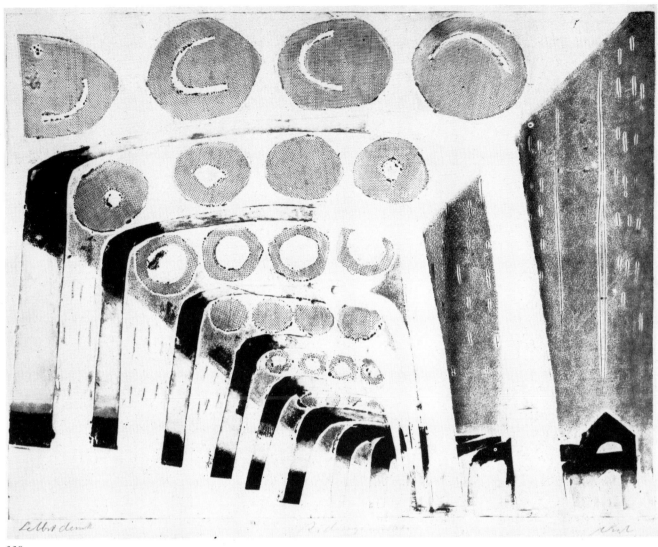

229

229 Elevated bridge, Rödingsmarkt
Plate 10 of the 'Hamburg Bridges'
1932

Metal print. Signed, titled *Rödingsmarkt* and annotated *Selbstdruck* in pencil. 444 × 590 mm
1983-6-25-48

The technical innovation that was invented by Nesch and first used on certain plates of the 'Hamburg Bridges' series consists of placing or welding metal elements onto the surface of the plate, thus creating a new class of work now known as 'metal prints'. Nesch described in his speech of 1958 how the idea came to him by chance one afternoon as he passed a shop containing a soldering iron and metal wire: if metal could be taken out of a plate, it could equally well be added to it. To wire thread he later added pieces of wire netting and scraps of metal. This print shows all three in use.

Firstly, circular pieces of wire mesh have been cut out and soldered to the plate to represent the lights in the ceiling of the covered bridge. Then, at the right, the vertical lines set apart in the grey of the aquatint that forms the background were made by drilling holes in the plate and threading pieces of wire through to the back; the fore-edge of the wire held ink, but its relief prevented the area alongside it from being inked, hence the white 'shadow'. Finally, the ribs of the bridge itself were printed from cut-out elements of sheet metal; these may have been welded to the plate, or they could have been inked separately and merely placed loosely in position for printing. Needless to say, such printing could only have been done by the artist himself, and would have required exceptionally strong pressure in the press and unusually tough paper. The strong embossing thus created is an important part of the final design.

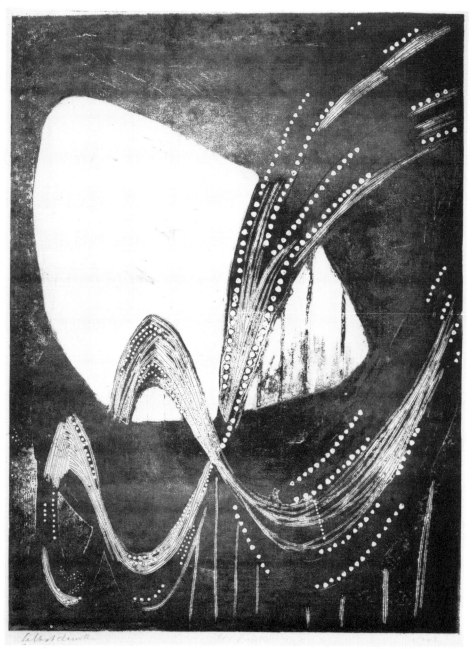

230

230 *Elbe bridge III*
Plate 19 of the 'Hamburg Bridges'
1932

Metal print. Signed, titled *Elbbrücke* and
annotated *Selbstdruck* in pencil. 595 × 444 mm
1983-6-25-50

The only elements added to the surface of
this plate are the copper wires that define
the girders of the bridge. Otherwise the
design is created by the grain of the
aquatint and the circular dots. As can be
seen from their marked embossing, these
dots are not created simply by stopping
out circles in the aquatint; rather, they
are holes punched right into, or possibly
right through, the plate. Nesch had first
discovered this possibility by accident in
1925 in the print entitled *Die steinernen
Jungfrauen* (The stone maidens), and had
used it deliberately in several prints
during the following years.

A bridge of the kind here portrayed
can be seen on the left-hand side when
travelling by train from the Hamburg
Hauptbahnhof on the line to Bremen; a
photograph is reproduced on p. 25 of the
1979 Detroit catalogue. The technological
beauties of the iron bridges that are still a
dominant feature of the dock areas in
Hamburg were the ideal subject for the
technical innovations of these prints.

The Illustrated Books

Introduction

The supplementary selection of German illustrated books which follows is undogmatic, and is intended to suggest something of the great variety of artists' involvement with books and to broaden the background of the printmakers' work. It is not, however, an attempt to present a segment from a balanced history of the illustrated book, which would have to take systematic account, firstly, of foreign influences which combined with the German nineteenth-century tradition the modern concept of visual and intellectual integration of text and illustration; then of a much wider range of literary genres, from the instructional and scientific manual to popular literature and children's books; and finally of technical matters such as typography and layout, photographic reproduction, and the hand-press revival. It is merely a fairly eclectic choice of books from the British Library with illustrations and prints by some of the better-known artists of the period.

As such it is naturally limited by the Library's holdings, which may now be representative but were not always so. From the 1890s until well after the Second World War a reduction in the purchase grant for foreign books meant that, while a satisfactory level of acquisition of scholarly books and periodicals could be maintained, unfortunately some other areas of German publishing, notably *avant-garde* writing and art, had to be neglected. Strenuous efforts have been made recently to fill the gaps, and indeed most of the books included here were purchased in the last few years. One important genre sadly almost totally lacking from this catalogue (though modern reprints are in the collection for study purposes) is that of Expressionist literary and artistic periodicals, such as *Die Aktion* and *Der Sturm*, which played so vital a role in the propagation of the new movements.

Static exhibitions of books cannot do them justice, for books require to be read, to reveal their complex messages to the single reader turning their pages in his or her hand. That is the paradox of the, by nature, multiple printed book, as it is the central problem of a national library whose duty it is to collect the literary products of its own and foreign cultures, to make them freely available for use, and yet to preserve them for future generations. Thus the Library's copy of the Munich satirical journal *Simplicissimus* (founded in 1896), which like its coeval *Jugend* (the source of the name Jugendstil) did so much to popularise new styles in art around the turn of the century, cannot be shown because its wood-pulp-based paper is now disintegrating after almost a century of use.

It goes without saying that books with illustrations are different in kind from prints, and demand to be considered from the point of view of their texts as well, indeed as unities where that ideal is achieved. In both art and literature the first three decades of the twentieth century saw a veritable explosion of talent, experiment and enthusiasm, if naturally of variable quality, which seems to have encompassed most of the styles the later century has exploited: if there was a common factor in the new movements it was energy. Cultural progress was not simply linear, however, and the variety of books shown may help to exemplify the coexistence of radically different styles, of older traditions and new reactions against them.

The close association of art and imaginative literature in the *avant-garde* is not fortuitous, and new aesthetics were embodied in a variety of media, indeed a number of artists were also writers and poets, and vice versa. Common to both, of course, was a leisured audience: this was not then, and is not now, a popular culture. Limited editions and expensive production methods put up prices and

narrow the market, not only to the middle class, but to a particularly cultured and privileged stratum of collectors. Edition sizes and original selling prices have therefore been recorded where readily available as an objective indication of these books' various audiences.

Prices are not self-explanatory, unfortunately, since they need to be set against fluctuating wages and salaries, and cost of living. However, to permit at least a very crude comparison, here are the average weekly wage-rates of city printers (producers of this particular commodity, and towards the lower end of skilled workers' remuneration) for the years from which there are exhibits, excepting the years of the First World War when rates nearly doubled, and the succeeding period of hyperinflation, for which meaningful figures are not available:

1880–1	21.99 Marks	1924	32.56 Marks	1927	50.86 Marks
1900	25.03 Marks	1925	45 Marks	1929	57.88 Marks
1907–9	29.79 Marks	1926	48 Marks	1930	58.50 Marks
1912–13	33 Marks				

(Rates from Gerhard Bry, *Wages in Germany 1871–1945*, Princeton 1960, pp. 333f.)

Popularity is certainly an economic function, but also an effect of subject-matter and style. While the schematisations of Jugendstil and Constructivism readily lent themselves to commercial and applied art and design, so that the styles, if not individual works of 'high' art, could gain a wider currency, the formal displacements of Expressionism did not. Yet for a brief period in the early 1920s a derivative of Expressionist style figured in that new art-form, the cinema, which was to become both a bourgeois and a working-class favourite. While films remained silent their audience could even be international, and *Das Cabinet des Dr Caligari* (1920), with its Expressionist sets, had a world-wide success.

For all their tendency to localised groupings, the German artists of our period were mostly very conscious of the international context of their work. The books they illustrated, however, had by reason of their language a more restricted audience. Germany had but recently become a unitary state, and though language was hardly used to define the nation outside Nazi ideology, all books in German, being both a multiple and a nation-wide commodity, had the potential to reinforce national feeling. Books in German from the non-German countries (principally Austria and German-speaking Switzerland, both represented here, as is Prague), by extension, pointed again towards a possible breaking down of national boundaries

The literary and artistic movements of the early twentieth century did not follow the periodicity of political developments – Expressionism began well before the war – but 1933 was both a political and a cultural turning-point. The coming to power of National Socialism brutally ended cultural internationalism and its leftward political direction, and steam-rollered with the *Anschluss* and plans for a Greater Germany any chance that the language itself might ward off chauvinism. After 1933 it was left to exiles publishing in German all over the world to maintain the ideals of a non-aggressive nation. Inside Germany books were burned, as Heine had warned, as a prelude to the burning of people, and national collections were purged of 'degenerate art'. The catalogue of the Munich exhibition of 1937 appropriately sets a period to our books. An authoritarian aesthetic had taken the field, and not until after the defeat of Nazism were Germans able to rediscover and rehabilitate the artistic riches of their recent but buried past.

Supplementary Bibliography

Georg Kurt Schauer, *Deutsche Buchkunst 1890 bis 1960*, 2 vols, Hamburg 1963. (Vol. 2 contains a good bibliography, as well as many illustrations.)

Expressionismus, Literatur und Kunst 1910–1923, exhibition catalogue, Deutsches Literaturarchiv Marbach 1960 (by Paul Raabe and H.L. Greve)

Paul Raabe, *Die Zeitschriften und Sammlungen des literarischen Expressionismus*, Stuttgart 1964

Lothar Lang, *Expressionist Book Illustration in Germany 1907–1927*, London 1976 (German edn 1975)

Hans H. Hofstätter, *Jugendstil Druckkunst*, Baden-Baden 1968

The artist and the book 1860–1960 in Western Europe and the United States, exhibition catalogue, Museum of Fine Arts, Boston, 1961

Julius Rodenberg, *Deutsche Pressen: Eine Bibliographie*, Zurich 1925 (Nachtrag 1925–30, published 1931). (A new bibliography of German private presses 1907–40 by Heribert Tenschert is promised for 1984.)

Vom Jugendstil zum Bauhaus, Deutsche Buchkunst 1895–1930, exhibition catalogue, Münster, Westfälisches Landesmuseum 1981.

A few more references will be found at the end of individual descriptions.

List of Artists included

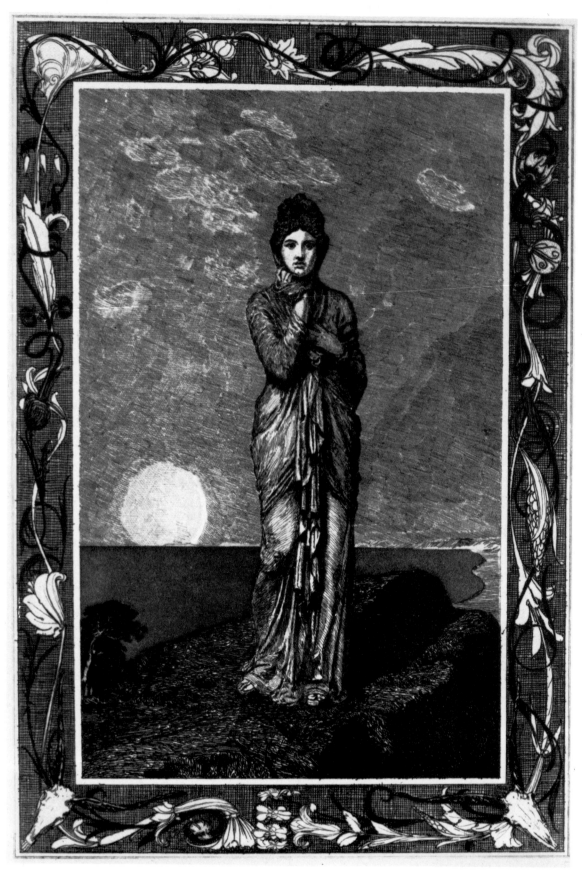

231

MAX KLINGER

See also 1–20

231

Apuleius: Amor und Psyche. Aus dem
 Lateinischen von Reinhold Jachmann.
 Illustrirt in 46 Original-Radirungen und
 ornamentirt von Max Klinger. München:
 Theo Stroefer's Kunstverlag, [1881].
 pp. lxvii: plates. 36 cm. C.103.i.23.

This extraordinarily beautiful book looks
forward to later developments in its unity
of design, text and illustration. The young
Klinger, his reputation as a painter not
yet established, lavished great care on his
only essay in book-illustration, for which
he provided engravings, line-drawn page
borders and a binding design in black,
silver and gold on cream. He dedicated
it to Brahms, whose music finds a
harmonious counterpart in the heavy
sensuality of the engravings. These are
true illustrations, growing from the text
but extending it into a rich world of the
imagination. The mythological figures
have so startlingly vivid a presence, and
their landscapes such depth, that, with
hindsight, we may sense Surrealism just
around the corner. Meanwhile, some of
the decorative page borders with their
botanical motifs prefigure the language
of Jugendstil. However, for all its organic
place in Klinger's own development and
the illustrations' affinities with the
contemporary work of the painter Arnold
Böcklin, as a book it remains an isolated
achievement somewhat ahead of its time.

Naturally an expensive book, at 65
Marks it seems not to have sold well.
Though first published in 1880, copies
were probably issued later on demand:
this one is in a decorated publisher's
binding with the date 1881 on the spine.

HEINRICH VOGELER

See also 50–1

232

Hugo von Hofmannsthal: Der Kaiser und die
 Hexe. Mit Zeichnungen von Heinrich
 Vogeler-Worpswede. Berlin: im Verlage der
 Insel bei Schuster & Löffler, May 1900.
 pp. 58. 24 cm. no. 124 of 200 copies,
 bound in vellum. C.108.aaaa.10.
See colour illustration

This fairy-tale verse drama, written in
1897, was first published in January 1900
in the monthly literary journal *Die Insel*,
with black-and-white decorations by
Vogeler, who was responsible for the
Jugendstil design which is so much a
feature of many early products of the
Insel Verlag. This major literary publishing
house, then just beginning, has for the
whole century represented a rather
conservative tradition in German writing.
The rule is only proved by exceptions
such as Frank Wedekind's *Die Büchse der
Pandora* (*Pandora's Box*), published in *Die
Insel* in July 1902, and one of the two
Lulu-dramas by this 'dramatist, erotomane
and forerunner of expressionism', as
George Grosz later described him, or the
poems which the Insel Verlag published
after the First World War by the politically
radical Expressionist Johannes Becher,
who in his old age was to become
Minister of Culture of the German
Democratic Republic. The poets Rilke
and Hofmannsthal, two major house
authors of the early twentieth century,
are far more typical of the Insel Verlag's
undemanding aesthetic.

The Austrian poet Hofmannsthal
(1874–1929) here presents symbolic
events in beautiful and fluent verse,
conflicts of control and erotic abandon-
ment, of illusion and reality, the realities
being those of his own psyche, for in
this self-absorbed and aristocratic art
there is no place for contemporary
society and social relations. Vogeler's
wonderfully decorative double-page title
design catches the element of picturesque
control but cannot match the passion of
the text. Rilke rhapsodically praised it as
an example of how Vogeler's 'calm and
compact, yet inwardly so rich, linear art
is uniquely suited to accompany like a
song the movement of noble type'. By
contrast, Grosz was to characterise the
whole of Jugendstil, not this particular
example, as 'a real spaghetti-orgy of lines'.
While that description may fairly be
applied to Vogeler's first design for *Der
Kaiser und die Hexe* in *Die Insel*, we must
allow his second thoughts here their
beauty, however derivative from
Beardsley and Burne-Jones. The text,
printed in red and black, is otherwise
undecorated and unillustrated. The book
sold at 30 Marks.

It is ironic that in their later years
Hofmannsthal and Vogeler moved in
opposite directions, the poet towards
control and the decorative, the artist
away from his thoroughly bourgeois art
to the committed life of a Communist.

Heinz Sarkowski, *Der Insel-Verlag, eine
Bibliographie 1899–1969*, Frankfurt-am-
Main 1970

MELCHIOR LECHTER

233

Stefan George: Maximin. Ein Gedenkbuch.
 Herausgegeben von Stefan George.
 (Ausschmueckung von Melchior Lechter.)
 Berlin: Blaetter fuer die Kunst, 1907.
 pp. [56]. 35 cm. no. 174 of 200 copies,
 bound in gold-tooled vellum. C.107.h.15.

'Maximin' was Maximilian Kronberger,
who had died in April 1904, just sixteen
years old, and the book comprises prose
and verse in his memory by Stefan George
(1868–1933) and members of his circle,
as well as poems by Kronberger himself.
George had met the boy two years before
his death, which affected him deeply and
which he regarded as the central
experience of his life. He saw the boy as
the incarnation of his extremely exclusive
aesthetic ideals, but, for all the austere
beauty of his verse, his vatic pose and
assembly of 'disciples' are now very hard to
approve, a feeling intensified rather than
mitigated by a large body of over-respectful
critical literature. Eroticism sublimated in
a pretentious form can be both ridiculous
and chilling: we regret the waste of spirit.
Kronberger's verse shows astonishing
talent for a young teenager, but it is
difficult to discern an individual voice
behind its George-like vocabulary and
hieratic classical settings.

Melchior Lechter (1865–1937) designed
a number of George's publications,
starting with *Das Jahr der Seele* in 1897,
but, though he was a type-designer too,
was not responsible for the characteristic
type (Stefan George-Schrift) with its
severely simplified letter-forms in which
George had most of his poetry printed.
Lechter's preferences were not so severe,
and we can see in the proliferation of
neo-Gothic ornament in his books both
his early apprenticeship as a stained-glass
artist and the strong influence of William
Morris with his ideal of a book's organic
unity as a work of art. He did not,
however, share Morris's socialism, and
like George had a small, exclusive

233

audience in view. The photograph of
Maximin, supplied by George against
Lechter's reluctance to accommodate
half-tones, has nevertheless been skilfully
integrated into the design. The book was
printed in November 1906 in two hundred
copies at a subscription price of 25
Marks, and immediately sold out to the
subscribers. One copy was printed on
vellum, still since the days of the earliest
printed books the traditional way to
bestow the cachet of exclusivity on a
product by nature multiple.

Wolfhard Raub, *Melchior Lechter als
Buchkünstler*, Cologne 1969

CARL OTTO CZESCHKA

234

Franz Keim: Die Nibelungen, dem deutschen
Volke wiedererzählt. Bilder und
Ausstattung von C.O. Czeschka. Wien,
Leipzig: Verlag Gerlach & Wiedling, [1909].
pp. 67. 14 cm. (Gerlachs Jugendbücherei.
No. 22.) C.107.df.43.

This is a children's book, an extremely

compressed prose outline of the
wonderfully exciting medieval epic,
intended not as a picture-book, but to be
read. The publisher began the series, of
which this is no. 22, in 1902 with the
deliberate aim of improving the quality of
books for children, perhaps influenced by
the English *Banbury Cross* series (begun
1894) and by other German and Austrian
examples. 'Only the best for children' was
his motto, and in trying to provide
educational material 'in the modern spirit'
he was part of a reforming pedagogic
movement. The series ran to thirty-four
numbers, the last in 1920. How far books
such as this reached children on a wide
scale may be doubted, despite a moderate
price of 3 Marks (slightly more than other
volumes in the series), though it is said
that the republishing of some volumes
after the War did bring copies into a
number of school libraries.

The painter and graphic artist Carl Otto
Czeschka (1878–1960) designed and
illustrated nos 14 and 22 of the series,
the latter being probably its artistic high-

point. Born in Vienna, he taught at the
Kunstgewerbeschule there from 1902
until 1908, when he moved to the
equivalent institution in Hamburg.
Though not a member of the Vienna
Secession, he did take part in the work of
the Wiener Werkstätte, one of the most
important sources of Jugendstil design.
His eight extremely striking double-page
illustrations here are in line engraving
with colour printing, the particularly
lustrous gold being achieved by applying
bronze powder over yellow or red printed
areas. It may not be fanciful to see their
influence in the precisely composed visual
grandeur of Fritz Lang's two silent
Nibelungen films of 1924.

F.C. Heller, 'Gerlachs Jugendbücherei' in
Die Schiefertafel 4, Hamburg 1981,
pp. 138–62

234

235

236

EPHRAIM MOSE LILIEN

235

Die Bücher der Bibel. Herausgegeben von
F. Rahlwes. Zeichnungen von E.M. Lilien.
Braunschweig: Verlag von Georg
Westermann, 1908,09,12. Bd.1,6,7.
25 cm. C.106.f.21.

With this illustrated Bible we can be
certain that it is the text which has
overwhelmingly primary importance.
The new version by Rahlwes, substantially
a reworking of the 1891–4 translation

by Eduard Reuss, attempts a non-archaic
German in a regrouping of the texts.

The designer and illustrator Ephraim
Mose Lilien (1874–1925) was born in
Galicia, tried but failed to study in Vienna
because he was too poor, moved first to
Munich in 1896, where he supplied
work for various socialist papers as well
as the weekly *Jugend*, and then to Berlin
in 1899, where he founded the Jüdischer
Verlag and produced designs on
commission, book-plates, posters, and

illustrations. An early Zionist, he gave
Jewish subjects an important place in his
art, and the books he illustrated include
Juda by Börries von Münchhausen
(Goslar 1900) and *Lieder des Ghetto* by
Morris Rosenfeld (Berlin 1902). In 1907,
a year after his first visit to Palestine, he
began to plan his illustrated Bible, which
was to be a complete Christian Bible (i.e.
including the New Testament) in ten
volumes, though in the event only three
volumes appeared (at a cost of 15 Marks

for vol. 1 and 10 Marks each for vols 6 and 7). His black-and-white drawings here, with their striking contrasts and simplified forms, show how much Jugendstil had to offer commercial art, but also a deep knowledge of Jewish symbolism and the landscape of Palestine. It is said that he gave his Moses the features of Theodor Herzl, the main proponent of political Zionism. The books are designed as integral units, with bold typography, and strong but sparing use of red and black printing and of decorative elements and initials.

Lothar Brieger, *E.M. Lilien*, Berlin and Vienna 1922

OSKAR KOKOSCHKA

See also 115–16

236

Die träumenden Knaben. (Geschrieben und gezeichnet von Oskar Kokoschka.) [Originally: Vienna: Wiener Werkstätte, 1908.] Leipzig: Kurt Wolff Verlag, 1917. [10] leaves, of which 8 are colour lithographs. 25 × 30 cm. no. 204 of 275 copies.　　　　C.103.g.34.

Kokoschka worked in the Wiener Werkstätte from 1907 to 1909 where *Die träumenden Knaben* (*The dreaming boys*) was produced in 1908. It was not a success at that time, however, and the surviving copies were acquired and sold by probably the most important and influential publisher of literary expressionism, the Kurt Wolff Verlag of Leipzig, in 1917, when Kokoschka's reputation as *avant-garde* writer and artist was firmly established. The entire edition, at 50 Marks, was sold out in no time.

The book is dominated by the strong primary colours of the large lithographs clearly derived from Vienna Jugendstil. The work is dedicated to the painter Gustav Klimt (1862–1918), who had left the Vienna Secession in 1905, and to whose group Kokoschka was close at that time. The text, relegated to the narrow right-hand column, is an attempt to recreate the dreams of a young adolescent boy, and a strongly erotic impetus runs through its exotic scenery and verbal echoes of the *Song of Songs*.

237

Hiob. Ein Drama. Berlin: Paul Cassirer, 1917. pp. 54, with 14 lithographs printed in black or red. 46 cm. no. 36 of 100 copies.
　　　　C.108.aaa.4.

This Expressionist drama was written by Kokoschka in 1907, and it had two pre-War private performances in Vienna. Then on 3 June 1917 it was performed at the Albert Theatre in Dresden with two more of his plays under the author's own direction and before an invited audience. Paul Kornfeld wrote at the time that the characters expressed themselves not merely in words, but more importantly in gesture and movement, and thought a new art-form might here be in the making – mime with a supporting text. The words survive, all in a lumpy kind of verse which deliberately mingles the pretentious and the bathetic, but well integrated on the page with the illustrations, which presumably preserve something of the lost action – surreal encounters surely within the author's psyche. The public form of drama seems a curious medium for these bizarre visions, for the inner logic would no doubt yield to psycho-analysis, but defeats the lay reader. Expressionism is above all the bursting of realist conventions by powerful feeling, the expression of inner truths through dislocation of traditional forms, but the more private the emergent languages, of word and image, the greater the obstacles to communication and the smaller the potential audience. The edition of a hundred copies only (1–10, with a second set of lithographs, at 500 Marks, 11–100 at 250 Marks) sold out immediately: the major art and literary publisher Cassirer had no difficulty in tapping a small collectors' market.

Henry I. Schvey, *Oskar Kokoschka: the painter as playwright*, Detroit 1982

FRANZ MARC

See also 117–18

238

Web-Muster, entworfen von Franz Marc. Text von A. Simon von Eckardt. Für den Plessmannschen Handwebstuhl. München: Verlag der Münchner Lehrmittelhandlung Wilhelm Plessmann, [ca. 1908]. pp. [4]: pl. [5], in a folder with title. 25 cm.
　　　　C.127.c.5.

This is a little-known foray into handicraft design by Franz Marc. Most of the introductory text consists of instructions for the small-size Plessmann loom, of which there is an illustration. It produced cloth 16 cm wide, and its designer Wilhelm Plessmann intended it as a training tool for children. Both Plessmann and von Eckardt, the latter tells us, hoped to further the handicraft revival by reawakening interest in hand-weaving, which in Germany had produced beautiful cloth in the past, particularly during the Middle Ages, but which more recently machine looms had sadly displaced. Marc's designs, deliberately kept 'as simple and childlike as possible', had all been tested by the girl pupils at the Textile School of Annette Simon von Eckardt in Munich. The subjects, in black and red on squared paper, are mainly animals (fox, bear, rabbits, lizard, horse, squirrels, and goat), but there are two of human couples (dancers, knights in combat), and three abstract border designs. Despite the severe simplification demanded by the medium, the animal shapes still seem characteristic of Marc, an extraordinarily direct vocabulary of form which may explain why he became, and has remained, widely popular in a way not achieved by his contemporaries. The cheap price of 1 Mark 20 Pfennigs is what one might expect for a simply produced pattern-book: the specialist purchasers' big outlay would have been on the loom and on materials.

Lothar Schreyer in his autobiography describes how, years later, Marc's widow Maria worked as a guest in the weaving-shop of the Weimar Bauhaus while living in the house which had belonged to Frau von Stein, one of Goethe's lovers, where she did not mind the mice because she loved animals as her husband had done.

7

8

9

238

VASILY KANDINSKY

See also 120–4

239

Der Blaue Reiter. Herausgeber: Kandinsky,
Franz Marc. München: R. Piper & Co.,
1912. pp. 140: plates, music. 30 cm.

C.107.h.16.

Although this volume has been called the
most important programme of twentieth-
century art, it is in fact an anthology of
work of wide-ranging scope by numerous
contributors, and was meant to be the
first of a series of yearbooks, though no
others ever appeared. It is therefore not a
systematic statement of policy, and
general attitudes must be inferred from
the variety of texts and reproductions
covering topics from folk art and primitive
art, literature and music (there are vocal
scores by Schönberg, Berg and Webern)
to current developments in painting and
something of their historical roots, all on
an international scale. Kandinsky supplies
a drama *Der gelbe Klang* (*The yellow
sound*) which consists mainly of
specification of music, movement and
light, with very little text, a precursor of
later Expressionist attempts at the
dramatic 'Gesamtkunstwerk'. Kandinsky
and Marc had been planning the volume
ever since their break-away in June 1911
from the Munich Neue Künstler-
vereinigung, and they attached its name
to exhibitions they assembled in 1911
and 1912. The publisher Reinhard Piper
played an important role in mediating
new movements in art, and in this case
the financial support of the Berlin
manufacturer and collector Bernhard
Koehler was crucial.

Kandinsky's cover design was printed
in black and blue on the paper-bound
copies (which sold at 10 Marks), while
on cloth-bound copies (14 Marks) red
was added: there was also a luxury
edition at 30 Marks. The total printing,
encouraged by subscriptions, reached
1200 copies. A second edition was
published in 1914.

Klaus Lankheit (ed), *The Blaue Reiter
almanac*, London 1974 (German edn
1965)

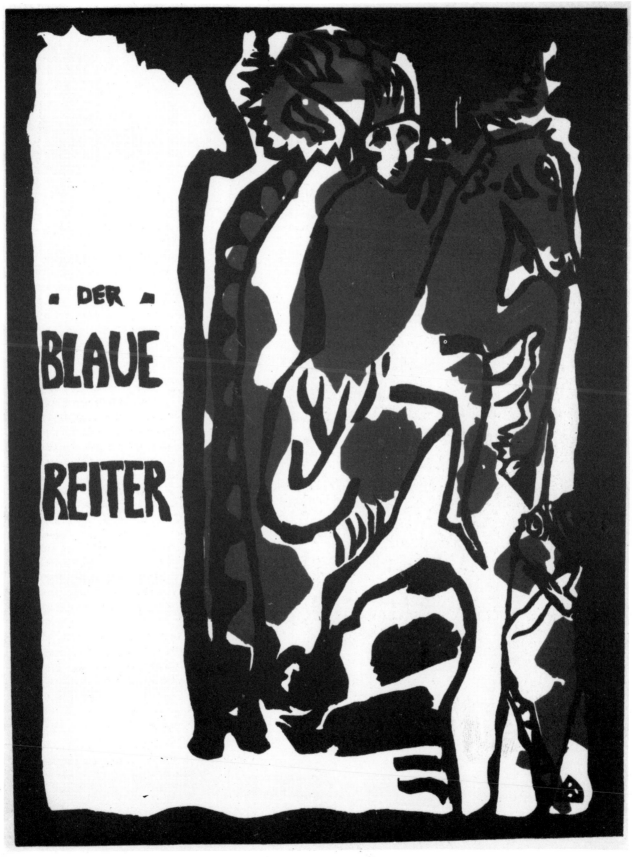

DER RISS

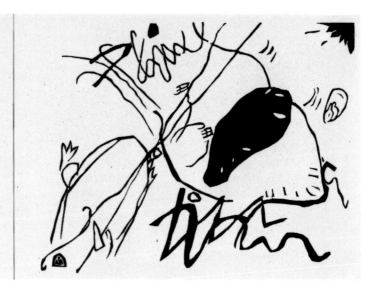

Der kleine Mann wollte die Kette zerreißen und konnte natür-
lich nicht. Der große Mann zerriß sie ganz leicht. Der kleine
Mann wollte sofort durchschlüpfen.
Der große Mann hielt ihn am Ärmel, beugte sich zu ihm und
sagte leise in's Ohr:
„das müssen wir verschweigen". Und sie lachten beide von
Herzen.

240

240

Klänge. München: R. Piper & Co., 1913. [57]
leaves; with 56 woodcuts, of which 12 are
coloured. 29 cm. no. 111 of 300 copies,
signed by the author/artist. C.106.k.8.
See colour illustration

One of the most beautiful books of the
twentieth century. Kandinsky's prose-
poems are experimental in technique but
fully assured, and are characterised by
strange juxtapositions and combinations,
of sometimes violent events, things seen
and acts of seeing, feelings, abstracts,
sounds and verbal encounters, the
results being frequently grotesque and
comic. The woodcuts range in style from
Kandinsky's early fairy-tale idiom to
fully-fledged abstracts of great power and
beauty. There are recurrent images of
horses and riders, and a human figure
with outstretched arms. *Klänge* means
'harmonies', and the texts and woodcuts
do not illustrate but complement each
other in a harmonious way. What unites
them is the logic of dreams and of feeling,
with its various synaesthetic embodi-
ments, not the logic of traditional
perception but a much more creative and
individual process, which at once
increases the scope of art and diminishes
its audience, whose training in percep-
tion and what constitutes public art has
not prepared them for it.

The book is finely and expensively
produced, and went on sale at 30 Marks.

MAX SLEVOGT

241

James Fennimore Cooper: Lederstrumpf-
Erzählungen. Übersetzt und bearbeitet von
K. Federn. Mit Original-Lithographieen von
Max Slevogt. Berlin: Paul Cassirer, 1909.
pp.473; with 321 lithographs, of which 52
are full-page, 180 half-page, and 140
background scenes in initial letters drawn
by Emil Rudolf Weiss. 48 cm. (Publikationen
der Pan-Presse. [no. 1]) no. 150 of 250
copies on white hand-made paper, from a
total edition of 310. C.105.k.17.

Max Slevogt (1868–1932), Impressionist
painter and graphic artist, studied in
Munich from 1885, and in 1898 went to
Holland to study the works of Rembrandt.
He produced his first book illustrations
around the turn of the century, and
began work on the very numerous
illustrations for the German version of
Cooper's *Leatherstocking tales* in 1908.
The translator's preface explains that
Cooper's wordy texts have been
somewhat abridged in order to make the
stories more lively, perhaps a similar
tendency to Slevogt's Impressionism,
which is stimulated by the action to
produce fluent and highly atmospheric
but not precise images. Cooper's stories
must have terrified generations of
imperialist children, but the vast format
and acres of type, not to mention the
price, of this omnibus edition, hardly

bring it into the category of reading-
books: it was originally published in
parts, or as a complete volume for 250
Marks (800 Marks with a set of mounted
plates), and may be contrasted with
the same publisher's contemporary five-
volume octavo edition (with initials
based on Slevogt's designs), sold at
3 Marks 80 Pfennigs. The text's function
in this luxury edition seems to have been
simply to generate the illustrations,
which are indeed so specific to their
placing in the stories that they cannot
stand without them, but the resultant
book lacks unity of purpose. In fact, the
publisher subsequently had second
thoughts about it, though on technical
grounds, and wrote in 1912: 'William
Morris would have died of shame if
anyone had thought his Kelmscott Press
capable of printing in its types on the
same paper as lithographed drawings.
Neither would it insult his memory to
maintain that he would not have allowed
an exception to the rule even had the
artist been Rembrandt'.

Johannes Sievers and Emil Waldmann,
Max Slevogt, das druckgraphische Werk, I,
1890–1914, Heidelberg and Berlin
1962.

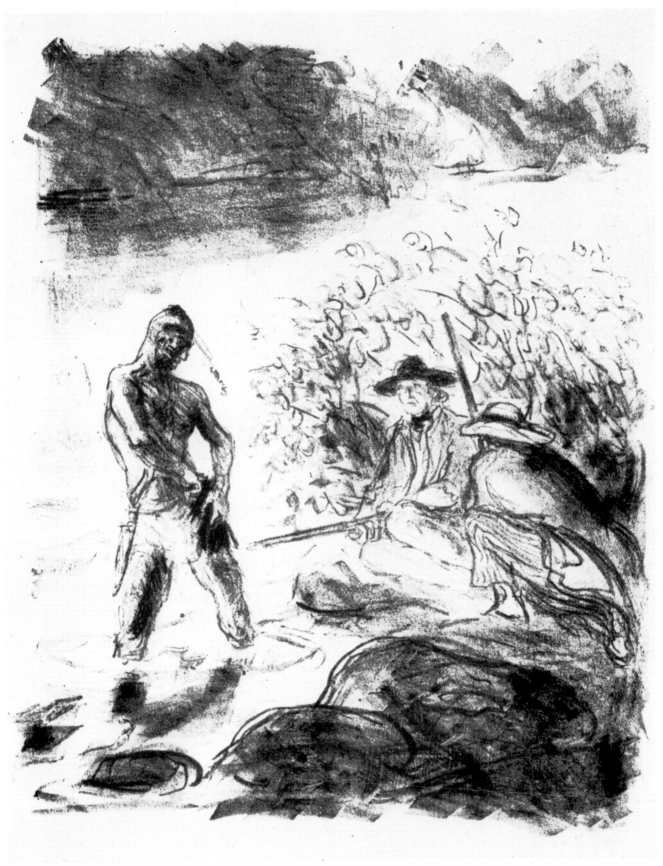

241

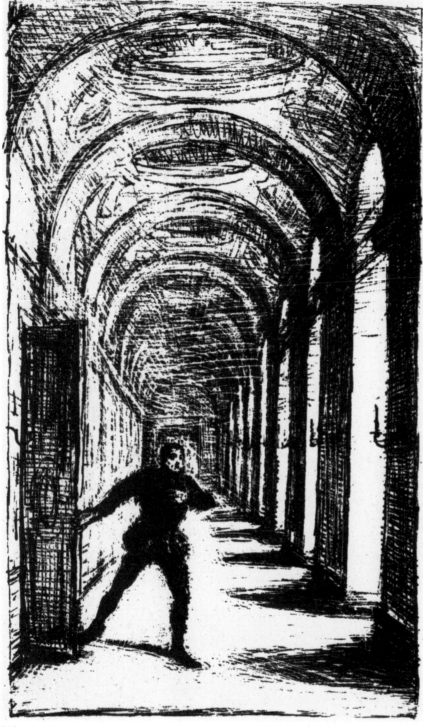

242

HANS MEID

242

Jakob Wassermann: Donna Johanna von
Castilien. Mit Ur-Steindrucken von Hans
Meid. München: Hans von Weber, 1914.
pp. 76; [16] lithographs. 30 cm. (Drei-
Angel-Druck. no. 1.) no. II of 25 copies on
Japanese paper. (There were also 500
copies on Van Gelder paper.) C.103.h.23.

Hans Meid (1883–1957), graphic artist
and painter, who taught graphic art at
the Berlin Hochschule für bildende
Künste from 1919 to 1934, was
particularly active as a book-illustrator,
producing work for more than sixty
publishers. This is his first independent
illustrated book, for which he chose a
very melodramatic story with a vague
Spanish setting by the popular novelist
Wassermann (1873–1934), which had
been first published in 1905. Meid's
stylistic dependence on Slevogt is
apparent, as is a certain staginess in the
romantic lithographs: it is no surprise to
find him producing designs in 1920 for
Max Reinhardt's *Midsummer Night's
Dream*. As the first product of a new
private press, the book is finely printed
and produced, the lithographs being
printed at Cassirer's Pan-Presse, and is
clearly aimed at collectors. The vellum-
bound luxury copies, of which this is one,
cost 200 Marks (100 to subscribers),
paper-bound copies 32 Marks (28), and
hardbacks 44 Marks (40). All the luxury
editions from this press, of which there
were twenty-one to 1926, seem to have
sold out swiftly.

Ralph Jentsch, *Hans Meid, das graphische
Werk*, Esslingen 1978

MAX BECKMANN

See also 126–55

243

Johannes Guthmann: Eurydikes Wiederkehr,
in drei Gesängen. (Steinzeichnungen von
Max Beckmann.) Berlin: Paul Cassirer,
1909. pp. 78; with 9 lithographs. 26 cm.
(Publikationen der Pan-Presse. [no. 3])
no. 59 of 60 copies. C.103.h.24.

With the exception of two engraved self-
portraits, of 1901 and 1904, this book
represents the earliest surviving graphic
work by Beckmann. Still entirely in the
Impressionist tradition, his lithographs
(Gallwitz 3) appropriately illustrate a
rather academic blank-verse version of

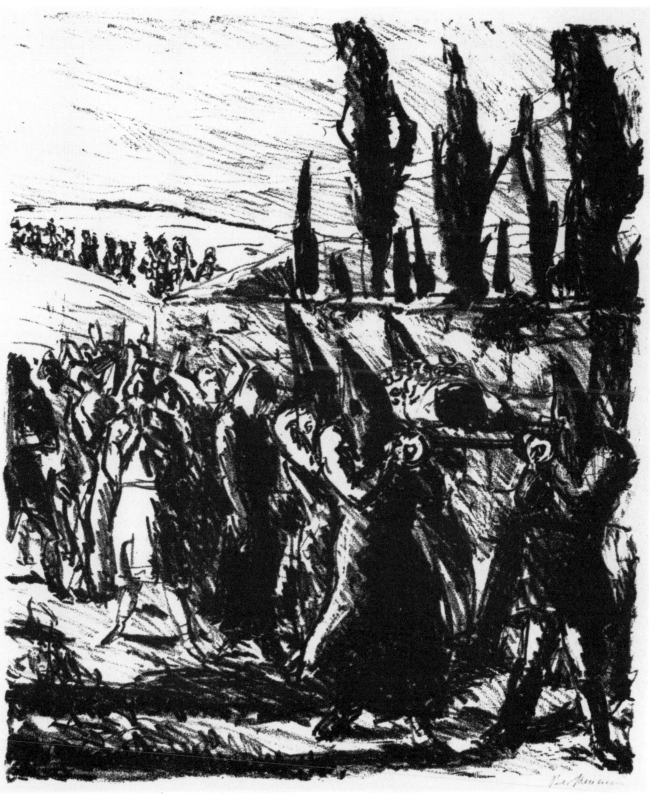

243

the story of Orpheus and Eurydice, with hints of the stylistic influence of Stefan George, by Johannes Guthmann (1876–1956) a minor writer of verse and prose as well as art criticism. The small limited edition sold at 60 Marks, while Cassirer also published a simultaneous unillustrated trade edition at 3 Marks.

244

Kasimir Edschmid (pseudonym of Eduard Schmid): Die Fürstin. Mit sechs Radierungen von Max Beckmann. Weimar: Gustav Kiepenheuer Verlag, 1918. pp.81. 30 cm. no.400 of 500 copies; bound in silk.
C.107.k.21.

Kasimir Edschmid (1890–1966) was a prolific writer who began as a journalist while simultaneously producing Expressionist prose pieces, of which *Die Fürstin* (*The princess*) is one. There is a continuous narrative, but what is presented is rather a heightened, even ecstatic, account of the emotional content of events, which has the effect of generalising the experiences. Their strongly erotic element is wonderfully matched by Beckmann's engravings in his mature style (Gallwitz 89), which add further depth through their characteristic hints of menace. The book was sold at 80 Marks.

245

Lili von Braunbehrens: Stadtnacht. Sieben Lithographien von Max Beckmann zu Gedichten von Lili von Braunbehrens. München: R. Piper & Co., 1921. pp.47. 28 cm. no.247 of 500 copies.
C.108.aaaa.12.

The amateurish poems of Lili von Braunbehrens (see 131) are in free forms and use Expressionist techniques. She employs low-life scenery as imagery, but is an outsider from another class and there is no sense of identification. In the title poem (*City night*) the devil appears to a prostitute in a tavern. Beckmann's powerful lithographs (Gallwitz 135–141) are true illustrations arising from the text, but transcend it. Not surprisingly, the book was marketed under the artist's name. It cost 120 Marks, and there was also a limited luxury edition of a hundred copies with an additional suite of plates at 240 Marks.

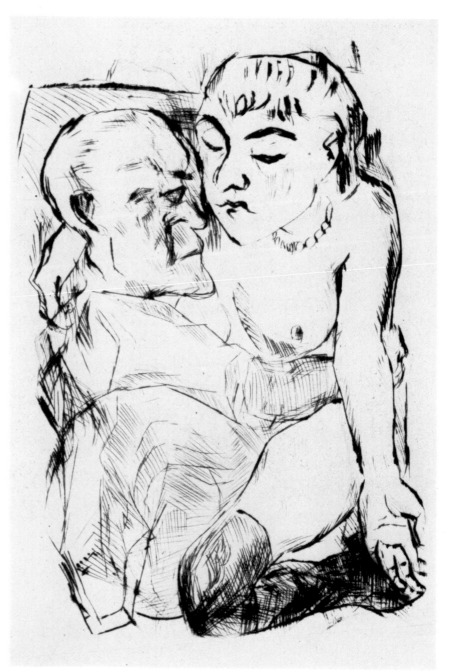

244

ERNST LUDWIG KIRCHNER

See also 73–83

246

Alfred Döblin: Das Stiftsfräulein und der Tod. Schnitte von E.L. Kirchner. Berlin-Wilmersdorf: Verlag A.R. Meyer, 1913. [8] leaves, with 5 woodcuts. 24 cm.
C.107.dg.17.

Alfred Döblin (1878–1957) was one of the master novelists to emerge from Expressionism, and, like his slightly younger contemporary, the brilliant Expressionist poet Gottfried Benn, was a Berlin doctor by profession. He was also a close friend of the artist, who painted a portrait now in the Busch-Reisinger Museum (Gordon 290). This brief piece of simple, vigorous prose is the chilling story of an old maid who, knowing she is

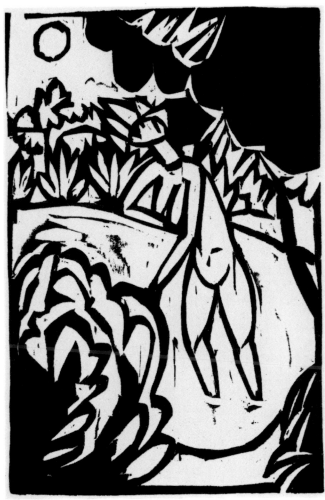

Die Bäuerin argwöhnte zuerst, es sei gemachtes, verliebtes Getue, aber allmählich ward es ihr zur Gewißheit, daß die beiden eben eines Herzens waren und eines Herzens schafften. Und daß dieser Zusammenklang sich gerade in der Arbeit offenbarte, erschien der tätigen, die Arbeit anbetenden

frau als etwas Wunderbares oder gar Heiliges. Sie wehrte

246 247

dying, prepares for death as for a bridegroom, but finds his coming violent and cruel. In his first illustrated book Kirchner's wonderfully powerful cuts (Dube 199–203) are true illustrations, but because they do not all follow the text slavishly add greatly to its resonance.

The Berlin publisher Alfred R. Meyer chose a number of major talents from amongst the young writers coming to the fore just before the First World War to figure in his uneven but very cheap series of unbound pamphlets – this one cost only 50 Pfennigs – often with one or more illustrations by artists also of the *avant-garde*, and can be considered to have played a significant role in the early history of Expressionism.

247

Jakob Bosshart: Neben der Heerstrasse. Erzählungen. Mit Holzschnitten von E.L. Kirchner. Zürich, Leipzig: Grethlein & Co., 1923. pp.434; with 24 woodcuts. 20 cm. C.107.df.41.

These realistic stories by Jakob Bosshart (1862–1924) are mostly about country people, people of powerful emotions, and his style is simple and direct. Their strength is a good match for the concentrated energy of Kirchner's marvellous cuts (Dube 808–831), as is the bold gothic type in which the text is printed. The book sold at 4 Marks, or 7 Marks in a half-cloth binding (as in this copy). There was also a signed, limited edition of 120 copies, with cloth binding, at 60 Marks.

248

Georg Heym: Umbra vitae. Nachgelassene Gedichte. Mit 47 Originalholzschnitten von Ernst Ludwig Kirchner. München: Kurt Wolff Verlag, 1924. pp.[69]. 24 cm. no.231 of 510 copies. C.107.dg.15.

This is justly considered one of the finest illustrated books of Expressionism, indeed of the century. Kirchner's inspired choice of these grand poems by Georg Heym (1887–1912), which were first published posthumously in 1912, confirms their status as a literary classic. Crackling and reverberating with apocalyptic visions and eroticism, they show what a prodigious talent was lost at Heym's premature death (he and a friend drowned in a skating accident). Kirchner worked on his equally striking cuts (Dube 758–807) from 1919 to 1923, and designed the whole beautiful book as a

unit, from the choice of the bold Roman typeface to the blue-on-red endpapers and the black-and-green on yellow woodcut design of the cloth binding. Nos 11–510 of the edition sold at 20 Marks, nos 1–10, with an engraved portrait of Heym and bound in leather, at 75 Marks.

It is appropriate that so representative a product of Expressionism should appear from the Kurt Wolff Verlag, which we have already noted as probably the most important publisher of Expressionist writing, in fact, since before the War, from stories by Franz Kafka to a whole gallery of often experimental works from his many-faceted generation.

249

Will Grohmann: Das Werk Ernst Ludwig Kirchners. München: Kurt Wolff Verlag, 1926. pp. 59: pl. 100. 28 cm. no. 21 of 50 copies of the luxury edition, with a signed woodcut and a signed engraving. C.129.i.7.

This is an account of Kirchner's development from 1902 to 1925, and the plates illustrate his work as a painter, graphic artist and sculptor. His stature was now recognised and a solid collectors' market was clearly able to absorb a lavish record of some of his extremely fertile production to date. Kirchner designed the whole work (Dube 850–858), and for the luxury edition provided a three-colour woodcut frontispiece (*Trial scene from Shaw's Saint Joan*, 1925, Dube 533b) and an engraving (*Seated peasant woman*, 1922, Dube 410). The limited edition, appropriately described in the trade as 'monumental edition', with full leather binding also designed by the artist, sold at 350 Marks, the remaining 800 cloth-bound copies of the ordinary edition at 120 Marks.

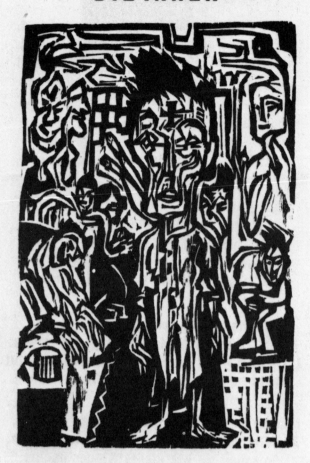

DIE IRREN

I.

Papierne Kronen zieren sie. Sie tragen
Holzstöcke aufrecht auf den spitzen Knien
Wie Szepter. Ihre langen Hemden schlagen
Um ihren Bauch wie Königshermelin.

24

249

ERICH HECKEL

See also 84–93

250

Woodcut: Am Strand (On the shore),
178 × 120 mm. (Dube I 253/IIB). In: Das
neue Pathos. Heft 3/4, August 1913.
Berlin: Officina Serpentis, 1913. 29 cm.
no. 53 of 100 copies. Cup.510.gg.4.

This issue of *Das neue Pathos*, of which
the British Library holds the first four
numbers, all 1913 (three more appeared
for 1914, though the last was not issued
until 1920, plus three yearbooks for
1914/15, 1917/18 and 1919), must
stand for the richly proliferating serials
which were so important a medium for
the transmission of literary and artistic
Expressionism from their early days. *Das
neue Pathos* was edited by Hans
Ehrenbaum-Degele, Robert R. Schmidt,
Paul Zech and, for the first two issues
only, Ludwig Meidner. A programmatic

text by Stefan Zweig opened the first
issue, proclaiming for the poet no longer
a quiet private role as communicator to
individuals, but a public role as
communicator of energy and formulator
of enthusiasms: 'The new passion must
contain not the will to a vibration in the
soul or a sensitive feeling of aesthetic
well-being, but the will to action'. The
direction the new activism was to take
was not yet clear, and it is not surprising
that the gradual imposition of control
and direction on the truly heterogeneous
Expressionist movement's manifestations
of energy, under the impact of events and
social conditions, should have led to
espousals of divergent political
tendencies. But the echoes in Zweig's
words of the Marxist imperative to
change the world prefigured the
substantial numbers of socialist writers
and activists who emerged from
Expressionist beginnings after the First
World War and Germany's political and

economic upheavals.

Das neue Pathos carried verse and prose
and graphic works of a generally high
quality, but its fine printing and the size
of its limited edition underline how far
the movement was from fulfilling Zweig's
popular aspirations through such
products.

ALFRED KUBIN

251

Paul Scheerbart: Lesabéndio. Ein Asteroïden-
Roman. (Mit vierzehn Zeichnungen von
Alfred Kubin.) München & Leipzig: Georg
Müller, 1913. pp. 282. 23 cm. 12552.v.3.

Alfred Kubin (1877–1959), graphic
artist, is chiefly remembered as a prolific
book-illustrator. Having studied in
Munich, he produced his first illustrative
work (the dust-jacket for Thomas Mann's
Tristan) in 1903. In 1909 he published
his own novel-fantasy *Die andere Seite*,
which has been reprinted several times
and still excites critical interest. His often
grotesque and always creepy world is
expressed in an individual style which
has affinities with both Impressionism
and Surrealism. He most frequently
worked in pen and ink, and while the
characteristic fog of hatching gives his
images a dreamlike quality, it also
suggests an unfulfilled desire for some
other medium. In retrospect he seems a
somewhat marginal figure, but in 1912
he was a member of the *Blauer Reiter*
group, and the startlingly original poetry
of the young Georg Heym was at the time
characterised by more than one
distinguished critic as being 'like Kubin'.

Lesabéndio is an extraordinary novel,
set on various imagined and real heavenly
bodies, and with a cast of non-human
characters with inventive physiologies
and a delight in quirky philosophical
discussion. Its author, Paul Scheerbart
(1863–1915), also an idiosyncratic
figure, wrote fantastic tales whose
optimistically imagined future worlds are
more spiritual visions than extrapolations
of technology. In 1889 he set up the
Verlag deutscher Phantasten, in which
his own early books appeared, as well as,
in 1893, Otto Erich Hartleben's German
version of Albert Giraud's (= Albert G.
Kayenbergh's) poems *Pierrot Lunaire*, to
be so memorably set to music in 1912 by
Schönberg.

251

252

Lesabéndio sold in three versions, paperback, hardback and luxury, at 6, 8, and 20 Marks respectively.

Paul Raabe, *Alfred Kubin: Leben, Werk, Wirkung*, Hamburg 1957

Abraham Horodisch, *Alfred Kubin, Taschenbibliographie*, Amsterdam 1962

Alfred Marks, *Der Illustrator Alfred Kubin, Gesamtkatalog seiner Illustrationen*, Munich 1977

MAX LIEBERMANN

See also 46–9

252

Lithograph: Nach dem Kampf (After the battle). In: Kunst und Künstler im Kriege, Heft 3. Berlin: Bruno Cassirer Verlag, [1915]. p.31. 32 cm. 9081.h.21.

Liebermann was not a book-illustrator. He used graphic media for recording immediate impressions, and during the First World War produced many vivid lithographs from the Front, as well as anti-British sheets. This lithograph was published by Paul Cassirer in an edition of fifty signed copies (Schiefler 201), but its photomechanical reproduction in this periodical made it available to a much larger public, particularly since each issue was sold at the deliberately low price of 25 Pfennigs. On the facing page is part of a text by A.W. von Heymel: *Der Tag von Charleroi*, illustrated by Walter Klemm.

Kunst und Künstler im Kriege was an irregular supplement to the long-lived monthly *Kunst und Künstler*, which appeared from 1902 until stopped by the Nazis in 1933, and had the expressed aim 'to show in brief how the war affects artists, and which interests and subjects of art are touched by it'.

HANS ARP

253

Richard Huelsenbeck: Phantastische Gebete. Verse. Mit 7 Holzschnitten von Hans Arp. Zürich: [printed by J. Heuberger] im Semptember [*sic*] 1916. pp.[16]. 23 cm. (Colection Dada.) A dedication copy by Huelsenbeck, describing himself as 'the great Dadaist'. Cup.408.u.2.

Richard Huelsenbeck (1892–1974), together with Hans Arp, Hugo Ball, Marcel Janco and Tristan Tzara, founded the Dada movement in Zurich in 1916, which centred on performances in the Cabaret Voltaire. Hans Arp (1887–1966), equally distinguished as painter, sculptor and poet, was bilingual in French and German, like his home town of Strasbourg. He began publishing poetry as a teenager, studied art in Weimar, in 1911–12 was associated with *Der Blaue Reiter*, from 1913 with Herwarth Walden's *Sturm*. He was in Zurich from 1915, when he exhibited his first collages, until 1919, when he

participated in the spread of Dada to Cologne.

This first book by Huelsenbeck was the third Dada publication, and consists mostly of prose poems in which surreal juxtapositions of nonsense, fragments of famous quotations and meaningless sounds create a sometimes funny and always provocative effect. Arp's beautiful symmetrical woodcuts which make so striking a use of the blocks' long grain, are entirely abstract, and prefigure his first abstract reliefs in wood of 1917. In no sense can the woodcuts be illustrations therefore, but their severity of form is a welcome contrast to the chaotic churning of the text. Copies like this one with the title woodcut on applied red paper are rare: more common are copies with a different cut printed directly on the (white) title-page.

Zurich Dada should not be considered entirely unpolitical, though abstraction was one of its aims, for its turning away from the War in a neutral country had a definite anti-militarist content, and its anti-intellectual tendency was simultaneously anti-bourgeois, though its audience remained both intellectual and bourgeois. In 1917 Huelsenbeck returned to his native Germany and with Raoul Hausmann founded the more overtly political Berlin branch of the Dada movement. There in 1920 his *Phantastische Gebete* were republished, this time with illustrations by George Grosz, in the recently founded Malik publishing house of Wieland Herzfelde (brother of John Heartfield), which was to become one of Germany's leading socialist publishers of the 1920s.

Carola Giedion-Welcker, *Jean Arp, Documentation Marguerite Hagenbach*, London 1957

Wilhelm F. Arntz, *Hans Arp, das graphische Werk 1912–1966*, Haag (Obb.) 1980

KURT SCHWITTERS

See also 210–11

254
Anna Blume. Dichtungen. Hannover: Paul Steegemann Verlag, 1919. pp. 37. 22 cm. (Die Silbergäule. Bd. 39/40.) Cup.408.u.1.

This was Schwitters's first book, and it swiftly became, and has remained, one of the most notorious books of the Dada movement. The texts are in verse and prose, and trivialise everything they touch, even the literary techniques they

253

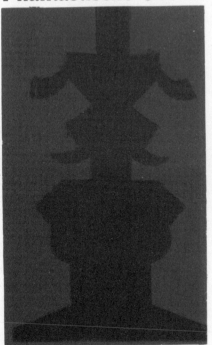

Verse von RICHARD HUELSENBECK mit 7 Holz-schnitten von HANS ARP Colection DADA Zürich im Semptember 1916

254

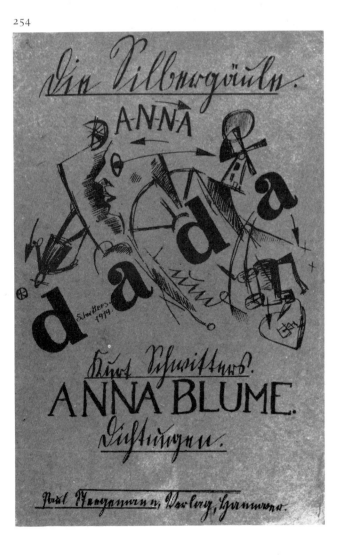

employ, such as a Stramm-like extension of German word-formation. They are intended to be abstract, and make use of literary collage of 'found' text fragments. 'These parts do not need to fit the sense, as there is no longer any sense', as Schwitters says in the concluding text. The chaotic design for the cover is in that spirit, but internally the typography and layout are entirely conventional. 'Die Silbergäule', the series in which the book appeared and which ran to 153 numbers from 1919 to 1922, included late Expressionist texts, Dada texts, and also politically radical works such as four Communist pieces by Heinrich Vogeler. Schwitters, however, was opposed to political art.

The first printing of 10,000 copies of *Anna Blume* sold out quite quickly at 2 Marks, and a second run of a further 3,000 copies had to be printed in 1922, a surprising success for a work intended to abuse its public.

255

Woodcut. 187 × 122 mm. In: Das Kestnerbuch. Herausgeber: Dr. Paul Erich Küppers. Hannover: Heinrich Böhme Verlag, 1919. pp. 150: pl. XII. 29 cm. (Plate XII.)
X.985/601.

The Kestner-Gesellschaft, a privately supported society devoted to modern art, was founded in Hanover in 1916, and Schwitters had contributed to its exhibitions since 1917. Paul Erich Küppers, editor of *Das Kestnerbuch*, was on the staff of the local Provinzialmuseum, and had been artistic director of the society from the beginning (he died in 1921). The book is an anthology of prose, verse and graphic works by both new and established figures: the text authors include Thomas Mann (a fragment of *Felix Krull*), Döblin, Lasker-Schüler, and the influential art critic Wilhelm Worringer (Notes on Cubism), the artists Heckel, Barlach, Klee and Feininger. Küppers disclaims in his preface any intention of trying to epitomise modern movements, and instead hopes to unite the calm inner view of his contributors into 'a melody . . . a gentle harmony far from the earth which the longing listener thinks he can occasionally hear amidst the shrill and discordant polyphony of the present'. It is difficult for us to fit the

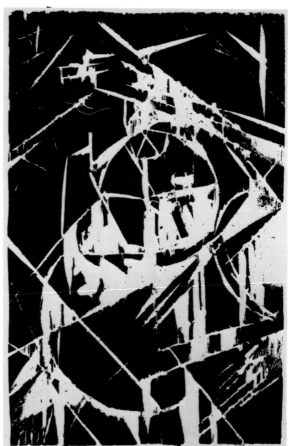

255

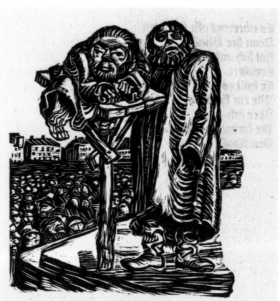

Das Jammerhaupt ist riesengroß,
Es drückt sich wie ein Berg
In das zerbrochne Tal der Schultern ein.
Es liegt wie abgehauen auf dem Brett.

256

Dadaist Schwitters into so vague and dreamy an aesthetic, and perhaps ironically appropriate that his abstract woodcut should have been placed here in the middle of the text of a drama (by Karl Schenzinger) in which Expressionist mannerisms are exaggerated to unwittingly comic effect. The book sold at 30 Marks, and there was also a limited hand-bound edition of 150 copies for collectors.

ERNST BARLACH

See also 64–6

256

Reinhold von Walter: Der Kopf. Ein Gedicht. Mit zehn Holzschnitten von Ernst Barlach. Berlin: Paul Cassirer, 1919. pp. 36. 32 cm.
Cup. 510.gg.20.

Immediately striking in this book is the wonderful harmony between the bold gothic type of the text (Rudolf Koch's Maximilian-type) and Barlach's extremely powerful cuts (Schult 101–11). The poem, mostly in free verse, however, is

257

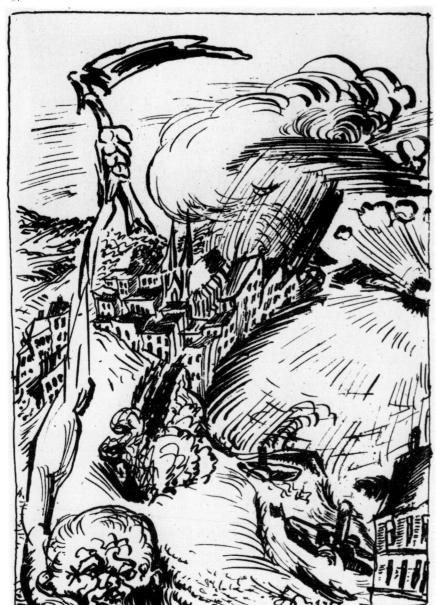

slow to yield its secrets. Reinhold von Walter (1882–1965) was born in Russia and made his name chiefly as a translator from Russian after his flight from revolutionary Petrograd in 1918 to Germany, where he became a teacher of Russian. His poem is indeed far from revolutionary, and seems to propose a pessimistic allegory of the tyrannical power of intellect in an extremely hostile world of suffering and poverty, to accept which a strong act of will, as well as religious faith, is required. A key to its dark visions seems lacking, though Barlach clearly found one and was inspired. His drawings and woodcuts for the book date from 1918, and were partly based on drawings he made on the visit to Russia in 1906 which had so liberating an effect on his personal style. In the work of the contemporary poet Rainer Maria Rilke a visit to Russia in 1899–1900 had had a similarly decisive influence, and Rilke had in common with *Der Kopf* a mystical attitude to poverty.

The book appeared in two editions, one, as no. 16 of the Pan-Presse series, a limited edition of 210 copies bound in half-leather with the cuts printed by hand (nos 1–20, bound in full leather, also had a separate portfolio of cuts), the other, in grey boards, with machine-printing of both text and cuts. Reversing the expected results, Schult is of the opinion that the cuts are better printed in the ordinary edition (of which this copy is part) than in the somewhat over-inked Pan-Presse version. The luxury edition went on sale at 300 Marks, the ordinary sold out at 15 Marks.

Gottfried Sello, 'Ernst Barlach als Illustrator' in *Philobiblon* 4, Hamburg 1960, pp. 199–230.

LUDWIG MEIDNER

See also 125

257

Septemberschrei. Hymen, Gebete, Lästerungen. Mit vierzehn Steindrucken. Berlin: Paul Cassirer, 1920. pp. 75: pl. [14]. 30 cm.
X.985/277.

This book of Expressionist prose (*September shout. Hymns, prayers, abuse*) was written in 1917 under the impact of Meidner's experiences in the War. Passionate, visionary, ecstatic, rhapsodic,

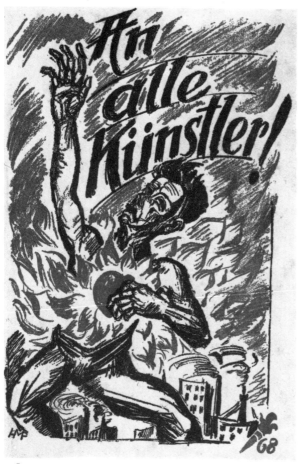

258

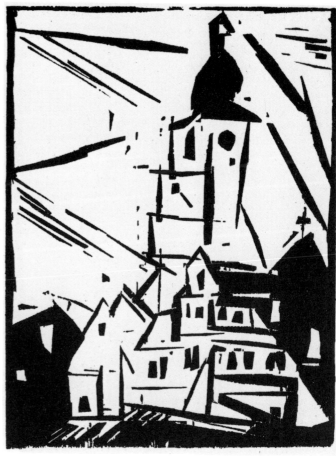

259

undisciplined, it is self-centred and yet full of a deep love of humanity. The lithograph reproductions of pen drawings, not illustrations but extensions of the text in another medium, hurl their figures with comparable energy into apocalyptic landscapes. 'This place looks like my pictures. The unexpected, the Last Judgement begins in vast space, shatters in the tumult of verticals . . . You shudder and run away from your painful visions' (p.21).

The book sold originally at 25 Marks, and there was also a limited edition of a hundred copies, bound in half vellum, at 800 Marks.

MAX PECHSTEIN

See also 101–4

258

An alle Künstler! Berlin, 1919. pp.47. 21 cm.
X.958/1315.

Pechstein's cover crudely conveys the almost religious fervour of this entirely secular, passionately utopian call for socialised art in a socialist state. The book is an anthology of texts by various Expressionist writers and politicians, and includes five illustrations by Feininger and others. It opens with famous verses by J.R. Becher proclaiming the political role of the poet: 'Let the poet avoid radiant chords./ He fires off tubas, whips the drum shrilly./ He stirs the people up with hacked-out sentences'. Pechstein's own text advocates that the practice of art become accessible to 'the sons of the people' through manual skills, with the slogan 'die Kunst dem Volke!' ('art for the people!'). There is also a long extract from a speech to the Munich Nationalrat by Kurt Eisner, whose assassination on 21 February 1919 in Munich sparked off the short-lived soviet republic there. He says: 'The artist must be an anarchist as an artist, and a socialist as a member of society, as a citizen who has to satisfy life's needs. The state can only advise the artist to follow his innermost impulse in freedom and independence, and that is the greatest demand the state can make of art, in giving the artist complete freedom of artistic activity'. This libertarian view of an engaged art was of course to be swept away by the authoritarian aesthetics of East and West in the 1930s.

An alle Künstler is cheaply printed on poor-quality paper (unfortunately the internal reproductions are wretched), as one would expect of a piece of propaganda for a wide audience.

LYONEL FEININGER

See also 193–6

259

Woodcut: Buttelstedt, 203 × 155 mm. (Prasse w 208). In: Jahrbuch der jungen Kunst. Herausgegeben von Georg Biermann. 1920. Leipzig: Klinkhardt & Biermann, 1920. pp.xi. 348: plates. 28 cm.

C.127.e.14.

The *Jahrbuch der jungen Kunst* ran for five years, from 1920 to 1924, and attempted to survey contemporary developments and movements in the European visual arts, with many articles of high quality, plentiful reproductions, and in each issue a number of original prints. The publisher Georg Biermann's preface to the first issue locates the beginnings of the whole modern movement well before the War as a revolution in art, 'an extreme necessity born out of protest against the materialism of a generation guilty of all our external misery'. The new art is seen as the common striving of the younger generation to return to inner truths, with a conscious repudiation of the bounds of space and time. 'Sworn enemy of all academic tradition which for three centuries has repeatedly strangled the best of individuality, the pioneer of our own day follows only the law of this inner voice.' The annual thus proclaimed a rather optimistic and unitary view of the in fact very heterogeneous tendencies which it documented.

Buttelstedt is a small place a few miles from Weimar, and the church tower seen in Feininger's woodcut has the baroque outline characteristic of this region. The dislocation of Feininger's familiar lines of force linking earth and heaven seems only to energise further the stripped-down image.

The 1920 *Jahrbuch* sold at 66 Marks, with a leather-bound edition at 300 Marks; the prices for subsequent volumes in different standard bindings were: 1921, 25/40 Marks; 1922, 25/40/100 Marks; 1923, 30/45 Marks; 1924, 36/50 Marks.

LOTHAR SCHREYER

See also 206–7

260

Kreuzigung. Spielgang Werk VII. Ausgabe II, Fünfhundert Werke, vom Stock gedruckt, handbemalt. Hamburg: Werkstatt der Kampfbühne, 1920. ff.lxxvii. 32 × 44 cm.

C.180.cc.8.

This elaborate book, composed entirely of woodcuts with watercolouring, is in effect the score of a drama for three masked characters (the mother, the beloved, the man), and prescribes by means of a simple notation both movement and verbal expression. The hieratic text, which identifies the sacrifice of men in war with the sacrifice of the Redeemer, has a certain cumulative power though it is couched in a very abstract language full of neologisms, in the manner of the poems and dramas of that most radical linguistic innovator August Stramm (1874–1915) whose *Sancta Susanna* (1914) had been Schreyer's first production at the Sturmbühne in Berlin in 1918. (He directed the Hamburg Kampfbühne from 1917 to 1920, the Sturmbühne from 1918 to 1920.) However, Schreyer's dramatic practice strove to attain a union of all means of expression, and the very form of the book demonstrates that text is but one constituent in the scheme. It was a demanding school for actors, and the first performance before an invited audience in the Hamburg Kunstgewerbeschule on 12 April 1920 had been preceded, like all Schreyer's productions, by more than a hundred rehearsals. The repertoire of expression permitted by the wood-block notation here may strike us as limited, but Schreyer's account in his autobiography of a conversation with Oskar Schlemmer at the Bauhaus in Weimar makes clear that the masks were humanised by the range of physical and vocal response natural to their wearers, an enrichment fully intended by both men in their stage works.

Schreyer rejected the commercial theatre and professional actors, and insisted that his ideals could be attained only in a community of friends by those capable of true feeling and without technical preconception. So the audience for that most public of art-forms, the drama, in this line of Expressionism became restricted to 'the new man', a status reserved, it would seem, for certain groups of intellectuals.

The whole conception and design of

260

this book were Schreyer's, though the cuts were executed and the watercolour applied by Max Billert and Max Olderock. *Kreuzigung* actually appeared in 1921, according to its prospectus, and at a price of 60 Marks, though the prospectus mentions two editions, the first on Japan paper of 25 copies at 5,000 Marks, the other on Deutsches Papier at 150 Marks.

LOVIS CORINTH

See also 53–63

261

Herbert Eulenberg: Anna Boleyn.
 Original-lithographien von Lovis Corinth.
 Berlin: Fritz Gurlitt, 1920. 57 cm. (Die
 neuen Bilderbücher. Reihe 3. no. 2.) no. 8 of
 fifty copies with three extra lithographs,
 and of the ten with all full-page illustrations
 signed by the artist, from an edition of 175
 copies. C.180.k.5.

In September and October 1920, when the director Ernst Lubitsch was filming *Anna Boleyn* (issued in Germany in December 1920), which inspired this narrative work of the dramatist Eulenberg (1876–1949), at the UFA studios in Berlin, Corinth sketched the actors and scenes for his highly atmospheric lithographs. The role of Henry VIII had been written for the great stage and screen actor Emil Jannings, probably best known in England for his first talkie *Der blaue Engel*, in which he played opposite Marlene Dietrich. In his autobiography (1951) Jannings wrote of his Henry, whom he took considerable pains to make a three-dimensional character: 'It was perhaps the first time ever that a figure was created on film able to bear comparison with great portrayals on the stage'. Silent films could reach a much wider international public than talkies, and *Anna Boleyn*, retitled *Deception*, ran for several months on Broadway.

In contrast to Slevogt's Cooper edition of 1909, the type size and generous margins here achieve a fully satisfactory optical balance between letterpress and lithographs.

Alfred Kuhn, 'Corinth als Illustrator' in *Monatshefte für Bücherfreunde und Graphiksammler* 1, 1925, pp. 87–99.

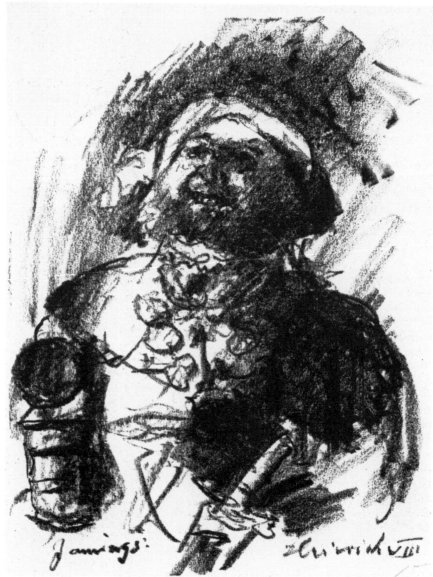

261

HUGO STEINER-PRAG

262

Auguste Hauschner: Der Tod des Löwen. Mit
Radierungen von Hugo Steiner-Prag.
Leipzig, Prag: Verlag der K.Andréschen
Buchhandlung, 1922. pp.173: pl.[11].
28 cm. no.81 of 400 copies. C.175.m.19.

Auguste Hauschner was a minor novelist
who had been publishing since 1895.
Her *Der Tod des Löwen* (*The death of the
lion*), first published in Berlin in 1916, is
a romantic tale of the Habsburg Emperor
Rudolf II and his encounter with a Rabbi
from the Prague ghetto. There are
cabbalists and alchemists, and the
mention of a Golem, a clay figure given
life by occult arts, suggests the author
may have been exploiting the success of
the film *Der Golem* made by Paul Wegener
and issued in 1915. Perhaps it is not a
coincidence that this 1922 edition of *Der
Tod des Löwen* should have followed the
appearance of Wegener's remake of *Der
Golem*, issued in October 1920, for there
is indeed a striking similarity between the
Prague of Steiner-Prag's illustrations here
and Hans Pölzig's settings for the film.
These developed into more real-seeming
yet still nightmarish depth the kind of
two-dimensional painted Expressionist
distortions of film décor to be seen in the
influential *Das Cabinet des Dr Caligari* of
1920 (designed by three artists associated
with the Berlin *Sturm* circle: Hermann
Warm, Walter Röhrig and Walter
Reimann).

The artist Hugo Steiner-Prag
(1880–1945) was active and influential
in promoting book design in Germany. In
the 1920s he was president of the Verein
Deutscher Buchkünstler, which from
1927 organised international exhibitions
of modern books. From 1919 to 1932 he
was art director of the important Berlin
publisher the Propyläen Verlag.

**Franz Hadamowsky and Josef Mayerhöfer
(eds)**, *Hugo Steiner-Prag, Festgabe*, Wien
1955

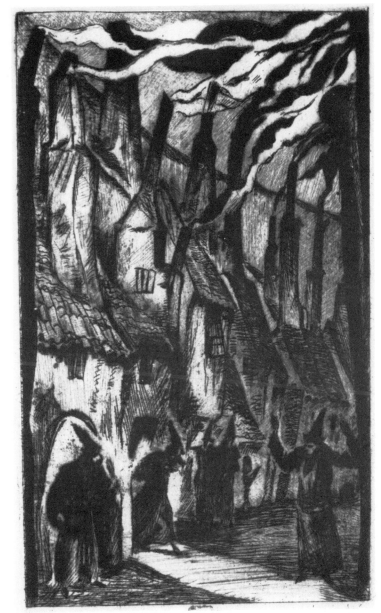

262

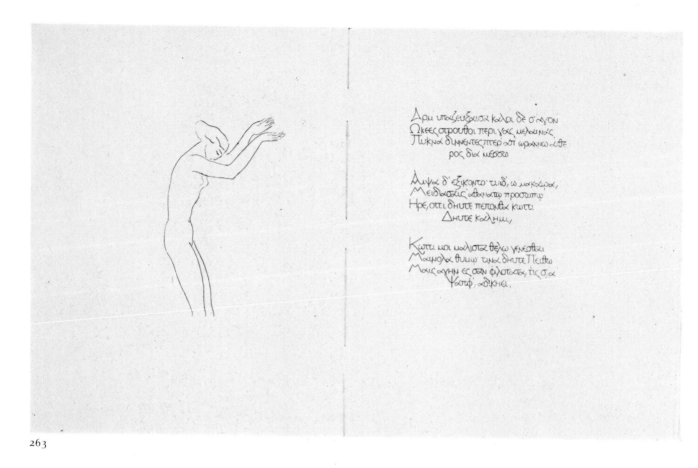

263

RENÉE SINTENIS

263

Sappho: [22 poems in Greek, in engraved
calligraphy by E.R. Weiss, with 12
engravings by Renée Sintenis.] Munich:
R. Piper & Co., 1921. [20] leaves. 27 cm.
(Marées-Gesellschaft. Druck 31.) no.171 of
185 copies. (There were also 65 copies with
an additional suite of the illustrations.)

Cup.408.u.3.

The sculptress Renée Sintenis
(1888–1965) married in 1914 the
painter, graphic artist, writer, and above
all distinguished and influential type-
and book-designer Emil Rudolf Weiss
(1875–1942). Best known for her small-
scale animal sculptures, nudes and
portrait busts, she also illustrated a
number of books. This admittedly beautiful
representative combines a number of the
characteristics of élitist book-production
aimed at collectors: the text is in a dead
language, an extreme example of the
tendency of private press publishing to
select long-established texts, as if they
were not intended to be read (or, failing
that, new texts in a conservative
tradition); the text is in calligraphy, not
type or the reproduction of an everyday
hand, almost always in the West a signal
that the target audience is small, select
and of exquisite taste; and the limited
edition selling at a high price, in this case
80 Marks. Private presses (with
honourable exceptions) exalt form above
content, the physical craft of book-making
above the book as communicator of ideas,
property above use.

Vita von Lieres, 'Renée Sintenis als
Buchillustratorin' in *Zeitschrift für
Bücherfreunde* 37, 1933, pp. 147–50.

ELSE LASKER-SCHÜLER

264

Theben. Gedichte und Lithographieen.
Frankfurt a/M, Berlin: Querschnitt-Verlag,
1923. [10 lithographs and 10 lithographed
poems printed on 15 unnumbered double-
fold leaves.] 33 cm. no.73 of 250 copies, of
which the first 50 were hand-coloured.
This copy dedicated by "Prinz Jussuf" (the
author) to Jakob Goldschmidt, Berlin,
2 June 1928, with all lithographs hand-
coloured and signed. C.107.h.22.

Else Lasker-Schüler (1869–1945) was
primarily a poet, though she also drew
and painted characters in her own
private mythology, in which she and her
friends were given exotic names. One of
the most fascinating figures of literary
Expressionism, in a rather uneven output
she did produce many poems of the
greatest beauty and immediacy of feeling.
She married a Berlin doctor in 1894,
published her first poems in 1899, then
from 1903 to 1911 was married for the
second time to Herwarth Walden, editor
of the leading Expressionist periodical
Der Sturm (1910–32), in which numbers
of her poems appeared. She had close
friendships with many writers and artists
of Expressionism, though they were of
younger generations. Very sensitive and
not a little eccentric, she did not find life
easy. Peter Hille called her 'the black
swan of Israel, a Sappho for whom the
world has fallen apart'. Maria Marc much
later described her as 'a poor soul . . . She
could not come to terms with life, living
in a state of almost continuous war with
people who made her existence bitter and
had no understanding of the uniqueness
and fantastic nature of her being and her
poetic gift'.

Theben (*Thebes*) is a republication of
poems from earlier collections, including
Mein Volk, which had been the opening
poem, dedicated to Karl Kraus, in the
pamphlet *Hebräische Balladen* originally
published in the epoch-making series of
Alfred Richard Meyer in 1913 (cf. 246):
it is full of a despairing longing for a lost
unity of feeling, of religion, and of land
and people. When the Nazis came to
power she fled first to Switzerland, then
in 1937 to Palestine, where she died in
poverty in 1945. *Theben* seems not to

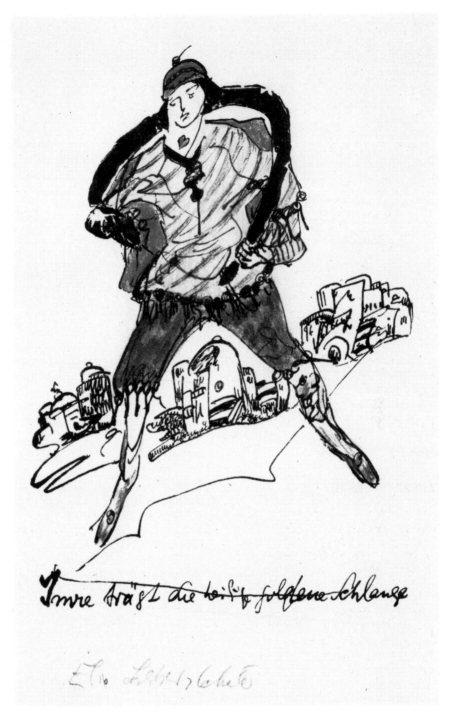

264

have sold well, as other copies are known
subsequently hand-coloured by the author
as gifts.

Sigrid Bauschinger, *Else Lasker-Schüler,
ihr Werk und ihre Zeit*, Heidelberg 1980

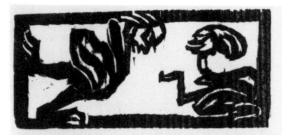

I Der Fuß der Mühle l. ist noch nicht durch einen hellen Strich vom dunklen Erdboden getrennt. An der schrägen Uferlinie des Kanals zwischen der Mühle r. und dem Gehöft eine Reihe heller Vierecke, die eine Spiegelung oder Schilfgewächs andeuten mögen.
Vier Exemplare.

II Unterhalb des Mühlenfußes (l.) einige helle Schnitte, welche ihn gegen das Terrain absetzen. Dicht oberhalb der hellen Vierecke längs des Kanalufers läuft nunmehr parallel mit der Uferlinie ein heller Streif, welcher diese Partie energischer von der dunklen Fläche dahinter scheidet.

1924

168–184 Buchschmuck. Kopfleisten, geschnitten für diesen Katalog, alle mit Umrahmungslinie.

168 Zwei Derwische in langen Mänteln, Mützen und weiten Ärmeln. Der eine steht mit ausgebreiteten Armen, der andere beugt sich. 050×105
Kopfleiste auf Seite 96 dieses Kataloges.

169 Zwei Kakteen, die r. scheint eine Hand auszustrecken. 050×108
Kopfleiste auf Seite 97 dieses Kataloges.

170 Schwimmende Fische. 050×108
Kopfleiste auf Seite 43 dieses Kataloges.

154

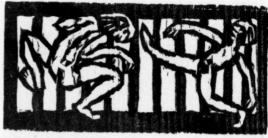

171 L. ein stehend sich vorbeugendes phantastisches Wesen, das den einen Fuß auf den unteren Bildrand setzt, den anderen gegen den Bildrand l. stemmt; r. ein kauerndes, das die eckig gebeugte Hand vorstreckt. 050×105
Kopfleiste auf Seite 154 dieses Kataloges.

172 L. zwei Reiherköpfe auf langen Hälsen, r. ein mit gefletschten Zähnen auf großen Tatzen dahertappendes Ungeheuer. 057×108
Kopfleiste auf Seite 135 dieses Kataloges.

173 Zwischen zwei Windmühlen am Himmel eine dunkle Wolke. 055×107
Kopfleiste auf Seite 42 dieses Kataloges.

174 L. steht eine Mutter mit ihren zwei Töchtern, von r. kommen zwei Freier. 038×108
Kopfleiste auf Seite 53 dieses Kataloges.

175 Zwei nackte Figuren in groteskem Tanz vor gegittertem Hintergrund. 054×105
Kopfleiste auf Seite 155 dieses Kataloges.

176 Zwei phantastische Gestalten: die l., nackt, halb vom Rücken gesehen, kauert froschartig am Boden und deutet mit

155

265

EMIL NOLDE

See also 105–14

265

Gustav Schiefler: Das graphische Werk von Emil Nolde 1910–1925. Berlin: Euphorion Verlag, [1927]. pp.172: plates; illus. 25 cm.
no.158 of 520 copies. 7859.pp.10.

This is the second of Schiefler's catalogues of Nolde's graphic work, and continues the numeration of the volume up to 1910, published in 1911, of which there is a copy in the Department of Prints and Drawings, British Museum. Such catalogues by perceptive critics both consolidate the reputation of their subjects and help to articulate the collectors' market. Nolde's progress to classic status, however, did not mean there had been any diminution in his creative energy from the days before the War, when for example George Grosz recalled his own excitement as a student at the liberating example of the new painting, including works by 'the terribly wild painter, Emil Nolde ... Nolde's name was one of the novel methods of frightening children at that time. When they were bad, they were threatened: "Look, I'm going to tell Nolde. He'll pick you up and smear you all over the canvas".'

Nolde supplied a number of woodcuts for this catalogue, printed from the original blocks and described in the text, as well as two colour lithographs dating from 1926. He had taken enormous pains over the design of Schiefler's first catalogue, and wanted the second to be equally distinguished. Of the edition of 520 copies, nos 1–12 sold at 200 Marks, nos 13–75 at 80 Marks, and the remainder at 25 Marks.

OSKAR SCHLEMMER

See also 208–9

266

Cover design (typography by Moholy-Nagy) for Die Bühne im Bauhaus. München: Albert Langen Verlag, [1925]. pp. 85: plate: illus. 23 cm. (Bauhausbücher. no.4.)
X.900/8260.

This anthology of articles, drawings and photographs presents the Bauhaus theory of theatre principally as conceived by Oskar Schlemmer, who in 1923 had succeeded Lothar Schreyer as head of the Bauhaus stage department. The aim was to combine all available means of expression, including abstract and formal elements, in an organic relationship. In Schlemmer's own theatre designs, especially for the ballet (he was choreographer too), the Bauhaus emphasis on technology appears in the translation of movement into geometric forms and in the Cubist schematisation of the human body in costume. Though undoubtedly rehumanised in performance by the natural expressive complexity of actors and dancers, the image of man which is the goal of these theatrical methods is bound to be generalised and abstract.

The series of *Bauhausbücher* ran to 14 numbers, from 1925 to 1931. Laszlo Moholy-Nagy prepared the typographic layout of the first eight in 1924, but they

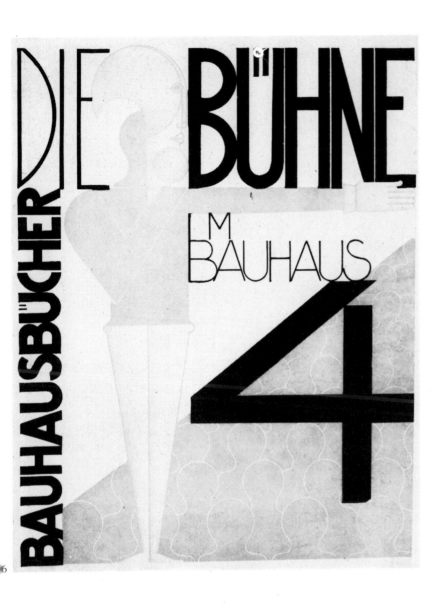

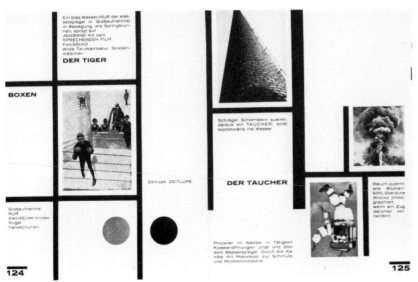

were not issued until 1925. No. 4 cost 5
Marks in paperback and 7 Marks in
hardback.

LASZLO MOHOLY-NAGY

See also 215–21

267

Malerei, Photographie, Film. München: Albert
 Langen Verlag, [1925]. pp. 133: plate; illus.
 23 cm. (Bauhausbücher. no. 8.)
X.410/1411.

'This book is an apologia for photography,
in which even today many people see
only a subordinate "mechanical"
technique for recording. That
photography can also be a creative
means of expression and forming is
almost unknown.' Moholy-Nagy's
opening words introduce a theoretical
consideration of new optical media, with
numerous examples from a variety of
sources, including trick photography,
collage, the combination of photography
and graphic elements, and film. There is
a particularly interesting section on the
integration of photography and text in
book design to improve communication,
and the book culminates in his own film
scenario *Dynamik der Gross-stadt*, here
presented in the new typographic
technique which he calls 'Typophoto'.
The scenario dates from 1921–2, when
he was in Berlin, and is for a collage of
city scenes intercut with shots of
sportsmen, circus performers, animals,
and so on. The film seems never to have
been made, but Moholy-Nagy himself
compares it with experimental films by
Fernand Léger and Francis Picabia shown
in 1924 in Vienna and Paris respectively,
and it surely prefigures the commercial
film *Berlin, Symphonie einer Grossstadt*,
conceived by Carl Mayer in 1925, directed
by Walther Ruttmann and issued in 1927,
a similarly plotless, and similarly
uncommitted, documentary impression
of twenty-four hours in the life of the
city. Moholy-Nagy subsequently produced
a great deal of photographic work, and
was involved in numerous experiments
with film, both at the Bauhaus and later
in Berlin, as well as during a period in
London in 1935–6. This book cost
7 Marks in paperback and 9 in hardback,
and was reprinted in 1927.

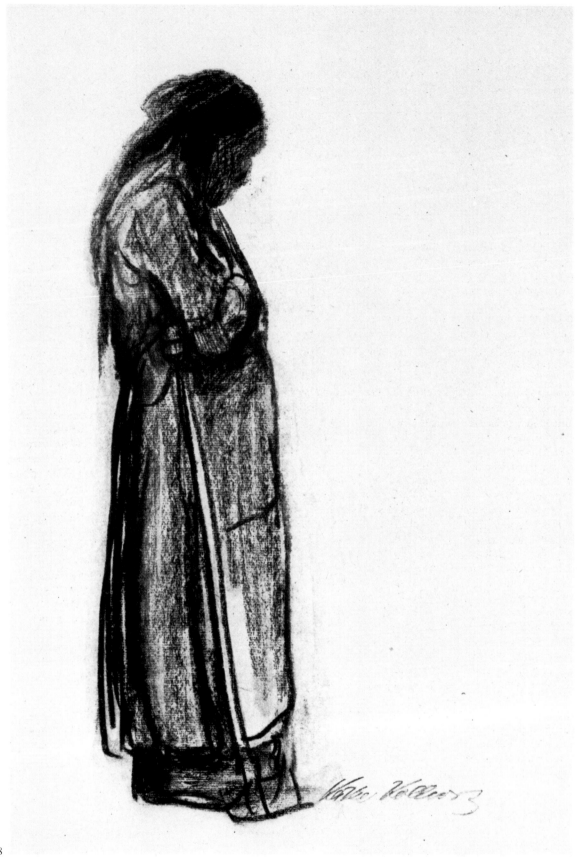

268

KÄTHE KOLLWITZ

See also 21–45

268

Für unsere kleinen russischen Brüder! Gaben westeuropäischer Schriftsteller und Künstler für die notleidenden Kinder in den Hungernotdistrikten Russlands. (Gesammelt und zusammengestellt von Marguerite E. Bienz.) Genf: Hohes Kommissariat Dr. Fridtjof Nansen, [1922]. pp.204: plates. 23 cm. C.132.b.25.

In his preface dated 20 June 1922, the great humanitarian and internationalist Fridtjof Nansen calls the current famine in the Soviet Union 'the most terrible catastrophe of its kind that has ever afflicted humanity', and the book was part of a fund-raising exercise mounted in Western Europe to relieve the suffering particularly of the Russian children. The writers and artists from many countries contributing to this multi-lingual anthology of verse and prose and of graphic work (thematically mainly quite unrelated to the campaign) range from Anatole France to John Galsworthy, from Knut Hamsun to Heinrich Mann; the honorary committee included Albert Einstein and Sigmund Freud, and from Britain H.G. Wells and G. Lowes Dickinson, the latter at that time *Manchester Guardian* correspondent at the Third Assembly of the League of Nations. It is not surprising to find Käthe Kollwitz in such company, contributing from her deep feelings of solidarity with the oppressed and suffering a drawing of an old woman (not in Nagel's catalogue of the drawings, so possibly the original does not survive), here in cheap but effective photographic reproduction. The year before she had produced a lithographed poster for the Berlin-based Internationale Arbeiterhilfe's campaign for Russia, and two years later would be producing another appealing for money to relieve starving children of the poor in Germany.

The volume, printed on cheap paper but bound in boards, was distributed in Germany by the Verlag für Politik und Wirtschaft, Berlin, for 2 Marks 30 Pfennigs.

HEINRICH ZILLE

269

Zwanglose Geschichten und Bilder von Heinrich Zille. Lithographien. Berlin: Fritz Gurlitt Verlag, [1919]. 48 unnumbered leaves, lithographed throughout. 39 cm. (Die neuen Bilderbücher. Folge 2.) no.180 of 200 copies. (There were a further 50 copies with all lithographs signed by hand, and of these numbers I–XV had several lithographs hand-coloured.) C.107.k.27.

Heinrich Zille (1858–1929) was born in Radeburg near Dresden, moved with his family to Berlin in 1867, and was to live and work there for the rest of his life. He had known poverty at first hand, and the urban poor were to remain his principal subject. After apprenticeship to a lithographer he had some of his drawings shown for the first time in 1898 in an exhibition of the Berlin Secession, which he joined the next year as a protégé of Max Liebermann. From 1903 his work began to appear in satirical and other journals, and he continued to produce realistic sketches of the way people lived, often with accompanying texts in which his mastery of Berlin dialect humour reveals rather than masks his anger at social conditions. A socialist without party adherence, his love and concern for the oppressed gives his work cumulatively the power of George Grosz's caricatures and the moving class solidarity of Kollwitz, though individually his works may not have the savagery of the one or the tragic grandeur of the other. Zille and Kollwitz were together dubbed 'the people's artists' in a critical study by Adolf Heilborn in 1925, and indeed Zille had by then become truly popular, with many editions of his books of drawings appearing in the 1920s.

This book of lithographs opens with a self-portrait of the artist sketching in a crowd in the rain, and the opening text defines his subject-matter: 'The fifth estate. People who cannot escape their fate, who are the result of the social order of today and yesterday . . . Crammed into tall tenement blocks with narrow airless stair-wells. Miserable refuges in damp cellars and over stinking stables with no air and sun. "People can be killed with housing just as well as with an axe!".'

The limited nature of this edition and its price, 250 Marks, shows that it was not Zille's usual audience but rich collectors who were his publisher's target in this instance.

270

Berliner Geschichten und Bilder. Mit 163 Bildern und einer Einleitung von Max Liebermann. Dresden: Carl Reissner, 1925. pp.[171]. 26 cm. X.421/24547.

This collection of old and new sketches, jokes and stories, priced at 5 Marks (7 Marks in cloth), includes reduced reproductions of the material from *Zwanglose Geschichten und Bilder* (269), so that was in fact soon made available to Zille's broader audience.

His firmly established, lively and painfully real world, as well as his popularity, inspired a number of films, starting with Gerhard Lamprecht's *Die Verrufenen* (known in English as *Slums of Berlin*) in 1925, which however lacked the political edge of later efforts, such as Piel Jutzi's *Mutter Krausens Fahrt ins Glück*, to a script by Zille, in 1929, and most notably Slatan Dudow's *Kuhle Wampe*, to a script by Bertolt Brecht and Ernst Ottwalt, in 1932.

The two drawings of Zille shown here make their critical points without overstatement and with varying degrees of comic irony. On the left a baby's corpse is discovered in a dustbin, prompting one woman to console another: 'Don't take on so. Out in the allotments they're always digging them up!' On the right a poster advertising a performance of 'Handel:Samson' is taken to be for a boxing-match: 'Samson, he's the new heavyweight champion. But Handel – he'll be slaughtered!' (Not that the gulf between bourgeois and working-class culture need always be unbridgeable: Handel was popular with German amateur choirs as in the Welsh mining valleys, and in June 1926 in Leipzig, for example, there was a workers' Handel festival.)

Walther G. Oschilewski, *Heinrich Zille Bibliographie* (ed. Gustav Schmidt-Küster), Hanover 1979

„Sie haben woll sonst keene Zeit, det se det noch
bei'n Regen müssen zurechte fingern!"
Die Aussprache der so wenig Vertrauen erweckenden Ge=
stalten in der verregneten Gasse hätten wohl zar=
teren Kunstjüngern das Zeichnen verleidet.
Mir sind die Menschen und Gassen seit langem
vertraut, wie mal jemand sagte: Det is' Zille sein
Milljöh'! Der fünfte Stand. Menschen, die ihrem
Geschick nicht entgehen können, die das Resultat
der heutigen und früheren Gesellschaftsordnung
sind. Bedauernswerte, in der "Charité" oder im
"Fröbel" geboren, finden sie ihren Lebensweg
schon in harten Lettern vorgeschrieben.

Die Kinderleiche. „Haben Se sich nich so, Schulzen, draußen in de Lauben buddeln se so wat alle Dage aus de Erde!"

Das mißverstandene Konzertplakat. Samson, det is der meie Schwerjewichtsmeesta in's Boxen. Aba Händel — Junge, Junge wird der Dresche kriejen!"

270

GEORGE GROSZ

See also 156

271

Abrechnung folgt! 57 politische Zeichnungen.
Berlin: Malik-Verlag, 1923. pp.61. 26 cm.
(Kleine revolutionäre Bibliothek. Bd.10.)
X.415/1822.

These ferocious drawings date from 1922–3 and mercilessly reveal some of the economic, social and political injustices in the Germany of the period of hyper-inflation. Though a Communist whose understanding of his society was clearly Marxist, Grosz was temperamentally too much of a pessimist, and too much of an individualist, for continuing commitment to the ideals of the Left. In his auto-biography, written in America before the McCarthy witch-hunts against Communism, he wrote 'I never had any faith in mass solidarity . . . I expect exactly nothing from the people. I have never indulged in worshipping them, not even when I pretended to believe in certain

political theories . . . I could not be a reformer. A reformer has to have faith in the good in man . . . I was not sufficiently gifted in the wild and genteel virtues of faith'. While objectivity is not the quality one first expects of caricature, Grosz's all-embracing cynicism does not allow his caustic vision to be softened by any sentiment. *Abrechnung folgt* (*The bill is on the way*), like several of Grosz's books of the 1920s, appeared in the Malik publishing house (which, being unequivocally left-wing, often suffered the attentions of the censor) at 2 Marks in paperback and 3 Marks 60 Pfennigs in hardback. There was also a signed edition of a hundred copies at 40 Marks.

One opening shows, on the left, a fat capitalist sitting on a pile of property, money and shares, and saying 'What do you mean, reparations due – I'm not going to have my seat pulled away from under my arse!', and, on the right, a garret scene of grinding poverty as a devastatingly critical illustration to the line Germany's best-known poet Rilke

had written in 1903 after visiting Russia: 'For poverty is a great light shining from within'.

272

Das neue Gesicht der herrschenden Klasse. 60 neue Zeichnungen. Berlin: Malik-Verlag, 1930. pp.126. 28 cm. 07874.t.40.

The new face of the ruling class is anti-bourgeois caricature at its best, with hints of the ominous political background breaking in here and there. The actors are not all anonymous: a Germanic fur-clad Hitler appears as 'the saviour'. The book's epigraph comes from the essays by Grosz and Wieland Herzfelde published in 1925 by the Malik Verlag under the title *Die Kunst ist in Gefahr* (*Art is in danger*): 'You pretend to be timeless and above party politics, you who protect in yourselves the "ivory tower" . . . Your brushes and pens, which should be weapons, are empty straws!'. The artist

had instead to choose, that source had continued, between serving capitalism through technology and identifying with the oppressed in a critical portrayal of social reality. – But of course the weapons of art are never enough to deal with fascism, as the German experience was to show. One is reminded of Wilfred Owen's words on the artist faced with the great political forces in his society: 'All the poet can do today is to warn'.

Grosz's book, of which 9,000 copies were printed, sold at 4 Marks in paperback and 6 Marks 50 Pfennigs in hardback. Facsimiles of this book and of *Abrechnung folgt* have been published in London in 1984 with introductions by Frank Whitford.

JOHN HEARTFIELD

273

Kurt Tucholsky: Deutschland, Deutschland ueber alles. Ein Bilderbuch von Kurt Tucholsky und vielen Fotografen. Montiert von John Heartfield. Berlin: Neuer deutscher Verlag, 1929. pp.231. 24 cm. X.700/8138.

This penetrating book, an indivisible unity of photographs and commentary, presents a critical picture of contemporary Germany. It begins with a quotation from Hölderlin castigating the Germany of more than a century before for its divisions and inhumanity, and proceeds to do the same for the Weimar Republic, using photographs of real people in real situations, whose anonymity allows them to embody typical aspects of the groups they represent. The book was the result of a true collaboration, with Tucholsky and Heartfield reacting to the material each proposed. Kurt Tucholsky

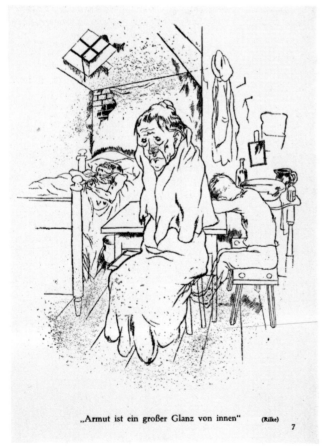

„Armut ist ein großer Glanz von innen" (Rilke)

7

271

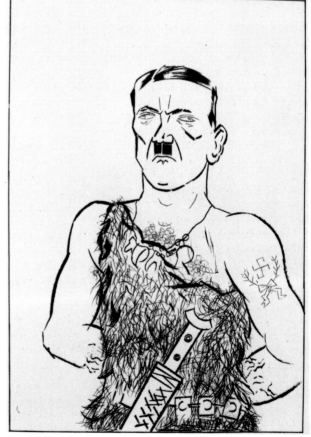

272 The Saviour

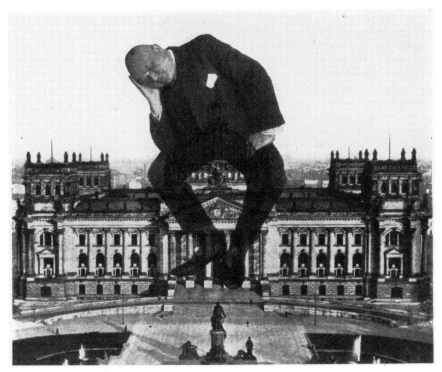

273 The Sleeping Reichstag

(1890–1935) was a journalist and satirist, whom the Nazis were to deprive of citizenship in 1933, while consigning his books to be burnt. John Heartfield (1891–1968), originally Helmut Herzfelde (he changed his name to the English form in protest against anti-British propaganda in 1916), was the great master of photomontage, though only a small minority of pictures in this book are in that technique. It is in a sense an Expressionist technique, combining fragments of disparate experiences into a new reality, though in Heartfield's hands not the non-objective reality of perhaps ambiguous individual feeling but a critical and unambiguous revelation of social and economic relationships. He joined the newly founded Communist Party in 1918, in 1920 took part in the more politically oriented Berlin Dada activities, fled to Prague in 1933, then in 1938 to London, and finally from 1950 lived and worked in the German Democratic Republic. Tucholsky committed suicide in 1935.

It was always Heartfield's aim to reach the widest possible public with his art-as-propaganda: this book sold at 3 Marks 20 Pfennigs in paperback and 5 Marks in hardback, and the first printing was of 20,000 copies. It ends with a strong statement of the German Left's internationalism rather than the national chauvinism of the Right, and at the same time a touching affirmation of love of one's native country, which fascism always tries to deny in its opponents.

Wieland Herzfelde, *John Heartfield, Leben und Werk*, Dresden 1962 (3rd edn 1976)

John Heartfield, exhibition catalogue, Deutsche Akademie der Künste, Berlin 1972

'DEGENERATE ART'

274

Führer durch die Ausstellung Entartete Kunst. Die Ausstellung wurde zusammengestellt von der Reichspropagandaleitung, Amtsleitung Kultur. Verantwortlich für den Inhalt: Fritz Kaiser. Berlin: Verlag für Kultur- und Wirtschaftswerbung, [1937]. pp. 30. 21 cm. 7813.de.51.

The coming to power of the National Socialists in 1933 put an end to a period of great creative freedom in German art and literature. Artists and writers were suppressed on racist, political, moral, psychological and aesthetic grounds, all these being united in the Nazi concept of 'cultural bolshevism'. On 10 May 1933 books 'un-German' in spirit were ritually burned in Berlin and a number of other cities, and this catalogue of the exhibition of 'degenerate art' shown first in Munich in 1937 and subsequently elsewhere in Germany lists the tendencies rejected from the new authoritarian canon of art. The exhibits are not described in detail, but there are reproductions of several, as well as quotations from left-wing theorists, all countered by populist quotations from Hitler. As one would expect of a piece of state propaganda, the catalogue was sold very cheaply, at 50 Pfennigs.

In June 1939 an auction was held in Lucerne of 125 selected works of 'degenerate art' removed from German public collections, ranging from the Nationalgalerie in Berlin to the Städtisches Museum in Stettin, with the aim of purging the nation of a dangerous influence. Works by most of the German artists in the present catalogue were included, in the excellent company of other modern masters from other countries, such as Braque, Gauguin, van Gogh, Matisse, and Picasso. Of the many thousands of other confiscated works, those regarded as unsaleable were burned.

Index of Artists

The numbers refer to catalogue entries.